Art & Visual Culture: A Reader

This book is published by Tate Publishing in assocation
with The Open University

The other books in the *Art & Visual Culture* series are:

Art & Visual Culture 1100–1600: Medieval to Renaissance
Edited by Kim M. Woods
ISBN 978 1 84976 093 5 (paperback)
ISBN 978 1 84976 108 6 (ebook)

Art & Visual Culture 1600–1850: Academy to Avant-Garde
Edited by Emma Barker
ISBN 978 1 84976 096 6 (paperback)
ISBN 978 1 84976 109 3 (ebook)

Art & Visual Culture 1850–2010: Modernity to Globalisation
Edited by Steve Edwards and Paul Wood
ISBN 978 1 84976 097 3 (paperback)
ISBN 978 1 84976 110 9 (ebook)

Art &
Visual Culture
A Reader

Edited by
Angeliki Lymberopoulou
Pamela Bracewell-Homer
Joel Robinson

Tate Publishing
in association with
The Open University

First published 2012 by order of the Tate Trustees by Tate Publishing,
a division of Tate Enterprises Ltd, Millbank, London SW1P 4RG
www.tate.org.uk/publishing

In association with

The Open University
Walton Hall
Milton Keynes MK7 6AA
United Kingdom
www.open.ac.uk

A catalogue record for this book is available from the British Library
ISBN 978 1 84976 048 5

Distributed in the United States and Canada by ABRAMS, New York
Library of Congress Control Number: 2012931255

Designed by O-SB Design, London
Printed and bound in Spain by Grafos S.A., Barcelona
Front cover: John Singer Sargent, *Claude Monet Painting at the Edge of a Wood*
c.1855, Tate (detail)

This publication forms part of The Open University module *Exploring art
and visual culture* (A226). Details of this and other Open University modules
can be obtained from the Student Registration and Enquiry Service,
The Open University, PO Box 197, Milton Keynes MK7 6BJ, United Kingdom
(tel. +44 (0)845 300 60 90, email general-enquiries@open.ac.uk)
www.open.ac.uk

Contents

Preface

Angeliki Lymberopoulou

This Reader fulfils two distinct, yet equally important, aims: to accompany the second level Open University art history module *Exploring art and visual culture* (A226) and to stand alone as a collection of source texts for anyone generally interested in art and visual culture from the era of the Crusades to the present day.

The fundamental and persistent question 'What is art?' has provided the rationale for the selection of texts. The challenge here was to assemble representative and relevant texts that span a period of roughly a thousand years. New and stimulating texts that could help the exploration of art practice from different perspectives were sought out. Since the availability and accessibility of sources have always been vital research tools, this volume prioritised texts that were difficult to locate (such as those which feature in currently out-of-print and old publications); texts that have thus far not been available in an English translation; and texts that (at the time the volume was compiled) were not available online. Alongside these documents the Reader reproduces certain texts (such as those by Giorgio Vasari, Johann Joachim Winckelmann and Clement Greenberg) that have shaped the discipline of art history and critical theory over the centuries. Well-researched and frequently cited sources can offer fresh perspectives of interpretation, especially when placed within a broader context of less well-known documents.

The Reader is arranged chronologically and divided thematically into six parts. The chapters within each of these contain texts related to the theme of the part. Together, they present a variety of points of view, discussing, assessing, debating, appreciating and at times rejecting certain forms of art. Furthermore, they approach the subject from a variety of different disciplines, including theology, philosophy, history, biography and autobiography, commentary, criticism, archaeology, anthropology, travelogue, journal writing, statement, manifesto, academic lectures,

modernist theory and tabloid. From the Venerable Bede via Joshua Reynolds to Le Corbusier, this Reader brings together in one volume a wealth of sources, showing how art has been discussed and debated over the centuries, representing a variety of artistic preoccupations and explorations within a range of contexts.

The latter point inevitably raises the question of whether we can examine Crusader visual culture in the same or similar manner as contemporary artistic practices – to draw from the two extreme ends of the texts included in this Reader. The art of these two (and any other) distinctive periods was created during and defined by different historical, social, political and economic circumstances, constrained by the availability of materials and means, and guided by particular interests, social and political imperatives and aesthetic choices. For example, until modern times, a video installation was not an option for any public or private patronage. Furthermore, different periods often require and have generated distinctive scholarly approaches. Research on Crusader visual culture (or any other artistic production that falls within the parameters of the so-called Early Modern period) relies predominantly on two groups of documents and collections of data: primary sources, which are contemporary to the artefacts being studied, and secondary sources, which are written by authors active at a later period. And while this distinction may cause some confusion over the categorisation of Vasari (should he be considered as a primary source for Michelangelo and as a secondary source for Giotto di Bondone?), the sources within the Early Modern period are relatively easy to divide in the relevant bibliographies. Similarly, it is easy to distinguish between the two categories in the first four parts of this Reader. However, the closer we progress to the present, the more such boundaries become blurred, up to the point where the distinction is rendered, if not redundant, certainly less relevant; this is, indeed, the case in the last two parts in this volume.

Scholars working on any period of art and visual culture do share a common goal: to present and to interpret facts, practices and ideas in such a (preferably objective) way that their audience can comprehend the parameters of the given subject, and can follow the argument and either agree or disagree with it. It is the presentation of the data that differs, reflecting both changes in thinking about visual culture over the centuries and in the modern exploration of artistic practices from different centuries. One could suggest that while scholars of the Early Modern period are proposing ways in which their audience can go through the looking glass of the past to view the art it produced, scholars of the Modern period are investigating various ways in which their audience may comprehend a range of preoccupations of their own time.

Art and visual culture do not have to be complicated to be interesting and challenging. The manufacture and production of art by humans for

specific functions (whether religious or secular, private or public, in a house or in a museum) requires the availability of financial and material means. While subject to contemporary fashions, some degree of artistic autonomy (whereby art develops according to its own imperatives and needs) is equally important for its creation. And this is why it is important to place artistic practices within a multi-layered context, such as the one provided by this Reader, where the differences between approaches can be used to explore the common ground shared by the different periods of art history. A glossary of figures and terms has been included in this volume, primarily to provide a quick point of reference and sense of chronology. These have been limited to entries that can be glossed briefly and concretely.

Editorial Policy

The editorial team is aware that alternative spellings of names and terms as well as alternative ways of recording titles exist. Regarding the transliteration of Greek names and words, following a trend that has been gaining acceptance recently, unless a word is standardised in English, it has been transcribed as closely to its original Greek spelling and pronunciation as possible. For example, in Greek male names the ending –os, reflecting better their origin (instead of –us, which is predominantly associated with Roman times), has been used (e.g. Athenodoros).

Whenever the original text carried a title, this is used in the heading in quotation marks. Titles of books are given in italics. In the absence of original published titles descriptive headings have been applied, without quotation marks. The dates for the texts provided on the Contents page corresponds as much as possible either to the time they were written or when they were originally published.

All editorial excisions within the extract, of whatever length, are indicated by ellipses within square brackets: [. . .]. Apart from a small number of amendments to the typographic presentation, the texts are as originally published, retaining any idiosyncracies of spelling and punctuation.

Passages cited from secondary literature have been included here because of the information, arguments or context they add to discussion of certain subjects. For reasons of legibility, the critical apparatus of these citations has been edited; in some passages, footnotes or endnotes have been completely omitted, while in others their number and content has been reduced. In both cases, it was judged that the notes interfered with or distracted from the message of the main text, e.g. by presenting the reader with long quotations in foreign languages or using abbreviated references to archival documents or literature that would need further

explanation. Readers who wish to use secondary literature cited here for purposes of scholarly research are advised to refer to the original publications. Where original notes have been retained, these have been renumbered using Arabic numerals. In cases where new editorial notes have been added, these are indicated with Roman numerals.

Similarly, original illustrations have been included only where they were judged necessary for reference. Captions to these illustrations are as provided by the current owner of the artwork.

Part 1 Visual cultures of medieval Christendom

Introduction

Angeliki Lymberopoulou

This first selection of texts aims at sampling various representative aspects and manifestations of medieval Christian art mainly through primary sources. 'Medieval' is a term used to identify a long period in European art history. Its time span varies according to different geographical locations; it is generally considered to cover the period between the ninth and the fifteenth centuries.

Appropriately, the first set of texts addresses an argument central to medieval Christian thought: should representations of the divine exist at all? What is their purpose? Does it not border on paganism and idolatry? The Venerable Bede supports the existence of images because they are a very strong means of communication: they visually strengthen an argument; they instruct the illiterate; and they convey the mysteries of the divine. Similarly, Bishop Lucas of Tuy strongly believes that images of the divine ensure good behaviour, while by visualising evil the faithful can be prevented from committing sinful acts. His position is that decoration and adornments of the images enrich the religious experience, a point contested by Bernard of Clairvaux who argues that excessive precious adornments have the opposite result because they distract the faithful from praying and contemplation. Another point that he raises here, which could provide an insight into the practice of some of his contemporaries, is that Bernard of Clairvaux seems to object to the way people mistreat and destroy images of the divine. Nicholas of Cusa introduces an additional and important dimension to this debate: he suggests that the existence of images make the faithful feel under the constant presence, protection and watchful eye of God. In other words, they exist not only to offer the faithful a window on to the divine, but they also act as God's window through which he watches over his creation.

Reflecting its importance, the texts engage passionately with the issue of the making of images, which is tied to their function. In turn, this

function is primarily related to their religious content, without, however, disregarding their artistic merit and power, which is both praised as an aid and condemned as a distraction.

The second set of texts engages with a very distinctive form of Christian culture, that of Gothic architecture. Through a selection of texts that spans five centuries (from the sixteenth to the twentieth) we sample different points of view on the architecture and the essence of the Gothic cathedral. The Gothic style, lacking the classical characteristics appreciated by the influential Italian artist and author Giorgio Vasari, met with his strong disapproval, an indication of Vasari's personal, contemporary and topographical preferences. On the other hand, Eugène Viollet-le-Duc, writing three centuries later, presents us with the interesting notion that Gothic architecture is a living architecture that can be adapted and be of great use to modern life. Taking this a step further, Émile Mâle suggests that French Gothic is the most successful of European Gothic styles, and that it is in Gothic that western medieval Christian belief finds a suitable and characteristic visual expression. Nikolaus Pevsner appreciates the aesthetic of the Gothic architectural style based on its structure and analyses its main components and their visual results, while Erwin Panofsky's description of Gothic church design as 'widely pictorial' probably reflects his main interest in painting. This section comes full circle and concludes with Rudolf Wittkower, who turns to Italy in an attempt to explain why Vasari rejected Gothic style: according to Wittkower, the Italian's opinion was not merely a personal dislike, but was mainly based on an understanding and application of art theory he shared with his contemporaries, an opinion that would probably support Vasari being labelled as the first art historian.

The third set of texts begins with sources that praise the artists' skill involved in creating the visual cultures of medieval Christendom. This marks the initial step in the process of the changing status of the artist – from a mere craftsman to a skilled, learned and talented professional – a concept that was advanced and consolidated during the Renaissance (explored further in Part 2). Nevertheless, from the artist Simone Martini's bequests to his family it is clear that, while artists by the fourteenth century had started being appreciated for their skills, their salaries were still far from competitive with the income of the upper classes. This section includes extracts of a text that invites and encourages meditation on the Annunciation – the moment when, according to Christian belief, the incarnation of Christ took place – as well as of a text with instructions for a dramatic performance of this feast, so important for the Christian faith. The text and re-enactment complement the visual examples of the Annunciation and together aim at facilitating the believers' understanding of the acts of God. Hence it becomes obvious once more that religious images play a vital part in making the divine 'real' to the faithful.

The existence of visual narratives based on literary sources could have enhanced the religious experience of the faithful during liturgical services or sermons or even at home while praying in private. They provided a focus and an explanation, they materialised the immaterial and abstract nature of the divine. Within the Byzantine culture icons have been described as 'writing in gold' – thus raising them above the status of mere texts.[1] The texts in the final section also deal with the visual 'likeness' of the divine as opposed to its symbolic representation. Hence, already in the seventh century the Council of Trullo decided that Christ should not be represented in an allegorical form, that is as a (the) lamb (of God), but rather in his human and incarnated form.

This last section is more specific to a unique hybrid art, known presently as Crusader art, a by-product of the Crusades, the military expeditions that travelled from western Europe to the Holy Land. This term was unknown to Vasari, for it dates to the twentieth century, when it was applied retrospectively to a group of art objects that display certain common, identifiable characteristics. Crusader art and visual culture offer a plateau for exploring aspects of artistic and cultural identity, some of which may be relevant to the present day. The extract from Bianca Kühnel is useful in highlighting all the problems in labelling Crusader art as well as the difficulties raised by the lack of documentation. The question explores various perspectives and the breadth of what the term 'Crusader artist' may entail. The blending of cultures as outlined in Kühnel's extract is further highlighted by the letter written by Eudes of Châteauroux, in which he describes the practice of placing the name of Mohammed on coins struck and used by Christians in the Latin kingdoms formed as a consequence of the Crusades in the Holy Land. This is indicative of a fusion between local (Muslim and Byzantine Christian) and western (Roman Catholic Christian) elements, which would have been impossible to understand, let alone accept, within western European Christian society. These elements, nevertheless, form a manifestation of another dimension of medieval Christianity, away from familiar and 'home' soil within an environment that invited, encouraged and facilitated both adoption and adaptation. The evidence of Muslims admiring Christian art and architecture, even amidst war and destruction, equally forms a testimony of such cultural exchange and mutual appreciation within this context.

During the medieval period Christian visual culture did not exist independently: from theological debates negotiating the most subtle of nuances in Christian belief, to theatrical re-enactment and contracts, one of the main aims of visual culture was to comprehend the divine

1. According to St Theodore (759–826) of the monastery of Stoudios in Constantinople, the Gospels were 'writing in words' but icons are 'writing in gold': R. Cormack, *Writing in Gold: Byzantine Society and its Icons*, London, George Philip, 1985 (quoted on the dust jacket). See also M.D. Lauxtermann, Byzantine *Poetry from Pisides to Geometres. Texts and Contexts*, vol.1, Vienna, Österreichischen Akademie der Wissenschaften, 2003, pp.271–84.

through visually acceptable forms and its relationship to mankind. Gothic cathedrals with their impressive proportions and complicated architecture visualise the different scale between human and divine – how small a man *is* in the presence of God. Obviously the theological debates were the privilege of a higher educated class; it was important for the working-class congregation to be able to understand what they were presented with. It was, perhaps, for this reason that the symbolic representation of Christ as the lamb was banned. The Council of Trullo could offer a basis for re-examining and re-addressing the extensive symbolism and symbolic meaning that has been proposed for a number of religious works of medieval and Renaissance art: the more complicated and hidden the meaning the more exclusive it becomes to its audience within the attending congregation. This may be perceived as going against the basic function and justification of the existence of religious visual narrative, as outlined in a number of texts included here.

At the same time Crusader art demonstrates that Christian art was not as rigid as is sometimes thought, especially for an art which is subject to extensive theological debate. It managed to adapt to its new surroundings in order to represent a manufactured identity so important for justifying the presence of the Crusaders in the Holy Land, hence adding a political dimension to a predominantly religious visual culture. The German art historian Hans Belting wrote, 'A picture is no longer to be understood in terms of its theme, but as a contribution to the development of art'.[2] Taking his quote a step further, the various forms of medieval Christian art were vital for the development of a religious as well as a social identity.

2. H. Belting, *Likeness and Presence: A History of the Image before the Era of Art,* trans. E. Jephcott, Chicago and London, University of Chicago Press, 1994, p.459.

Chapter 1
Sacred art as the 'Bible of the Poor'

Kim Woods

1. Venerable Bede
The Ecclesiastical History of the English People

Bede's Ecclesiastical History of the English People, ed. B. Colgrave and R.A.B. Mynors, Oxford, Oxford University Press, 1969, pp.73–7.

In his history of the English Church completed in 731, the scholar monk of Wearmouth and Jarrow, in north-east England, the Venerable Bede (672/3–735) described the arrival of the Christian missionary St Augustine (of Canterbury, d.604) in England in the year 597. Augustine was sent by Gregory the Great (Pope 590–604), whose defence of the usefulness of Christian art proved so influential in succeeding centuries. Albeit writing rather later, Bede's claim that Augustine and his followers brought with them on their sea journey from Rome a painted image of Christ shows the priority given to images during Pope Gregory's era. His account also offers a suggestion of how religious art was used in practice: to accompany both the religious ceremonies conducted before the ruler of Kent and their entry procession into the city of Canterbury. Pope Gregory promoted the didactic potential of art, but Bede does not go as far as suggesting specifically that this image was used to illustrate their missionary preaching. KW

So Augustine, strengthened by the encouragement of St. Gregory, in company with the servants of Christ, returned to the work of preaching the word, and came to Britain. At that time Æthelberht, king of Kent, was a very powerful monarch. The lands over which he exercised his suzerainty stretched as far as the great river Humber, which divides the northern

from the southern Angles. Over against the eastern districts of Kent there is a large island called Thanet which, in English reckoning, is 600 hides[i] in extent. It is divided from the mainland by the river Wantsum, which is about three furlongs wide, can be crossed in two places only, and joins the sea at either end. Here Augustine, the servant of the Lord, landed with his companions, who are said to have been nearly forty in number. They had acquired interpreters from the Frankish race according to the command of Pope St. Gregory. Augustine sent to Æthelberht to say that he had come from Rome bearing the best of news, namely the sure and certain promise of eternal joys in heaven and an endless kingdom with the living and true God to those who received it. On hearing this the king ordered them to remain on the island where they had landed and be provided with all things necessary until he had decided what to do about them. Some knowledge about the Christian religion had already reached him because he had a Christian wife of the Frankish royal family whose name was Bertha. He had received her from her parents on condition that she should be allowed to practise her faith and religion unhindered, with a bishop named Liudhard whom they had provided for her to support her faith.

Some days afterwards the king came to the island and, sitting in the open air, commanded Augustine and his comrades to come thither to talk with him. He took care that they should not meet in any building, for he held the traditional superstition that, if they practised any magic art, they might deceive him and get the better of him as soon as he entered. But they came endowed with divine not devilish power and bearing as their standard a silver cross and the image of our Lord and Saviour painted on a panel. They chanted litanies and uttered prayers to the Lord for their own eternal salvation and the salvation of those for whom and to whom they had come. At the king's command they sat down and preached the word of life to himself and all his *gesiths*[ii] there present. Then he said to them: 'The words and the promises you bring are fair enough, but because they are new to us and doubtful, I cannot consent to accept them and forsake those beliefs which I and the whole English race have held so long. But as you have come on a long pilgrimage and are anxious, I perceive, to share with us things which you believe to be true and good, we do not wish to do you harm; on the contrary, we will receive you hospitably and provide what is necessary for your support; nor do we forbid you to win all you can to your faith and religion by your preaching.' So he gave them a dwelling in the city of Canterbury, which was the chief city of all his dominions; and, in accordance with his promise, he granted them provisions and did not refuse them freedom to preach. It is related that as they approached the city in accordance with their custom carrying the holy cross and the

i. An old English measure of land sufficient to support one extended family, perhaps around 120 acres.

ii. An attendant or companion of the King.

image of our great King and Lord, Jesus Christ, they sang this litany in unison: 'We beseech Thee, O Lord, in Thy great mercy, that Thy wrath and anger may be turned away from this city and from Thy holy house, for we have sinned. Alleluia.'

2. Venerable Bede
On the Temple

Bede: On the Temple, trans. Sean Connolly, Liverpool, Liverpool University Press, 1995, pp.40, 63.

The Temple built by the Israelite King and prophet Solomon is described in some detail in the Old Testament Book of Kings and, in its lavish scale, precious materials and carvings of cherubim (angels with two or four wings), palm trees and flowers, constituted a potential literary model for subsequent high-status Christian buildings. *On the Temple*, written by the Venerable Bede, is an allegorical commentary on 1 Kings 5–7, in which he uses the Temple as a metaphor for Christ and his Church. In these two extracts, works of art serve as metaphors for the exemplary behaviour of the saints, and as a means of conveying the mysteries of the divine to the unlettered. These constitute two of the key functions of religious art, as outlined by Pope Gregory the Great in the letters he sent to Bishop Serenus of Marseilles in the years 599 and 600. In his reference to 'the instruction of the unlettered', Bede may even refer specifically to this letter. KW

11. How the Whole Building was Covered with Cedar and Gold
11.1 ‹6.18› 'And the whole house was covered inside with cedar, having its turnings and joints skilfully wrought and carvings in relief.' We have said of cedarwood that it betokened the unsurpassable beauty of the virtues. Now the entire house is covered inside with this wood when the hearts of the righteous begin to shine with nothing but the love of good works and the house has its turnings made of cedar boards and its joints skilfully wrought when these elect are joined to each other by the most beautiful bond of charity so that, though the multitude of the faithful is innumerable, they can nevertheless, with good reason, be said to have one heart and one soul on account of the community of the faith and love they share. For the turnings which were attached to the joints of the planks in order that they might all make one partition, are the very services of charity by which the holy brotherhood is bound together and formed into one house of Christ all over the world. Moreover, this house

has carvings standing in relief when, far from covering and hiding their works of virtue, the saints, by a clear outward expression, show forth to all, as an example for living, what they themselves are like and what they do, as did the apostle Paul who not only by preaching Christ to the gentiles and by personally suffering for Christ showed how outstanding he was, but also in his letters addressed to the churches declared how many perils he underwent for Christ, and by what great revelations he was raised aloft in a blessed glorification. And when he said to his listeners without any hesitation, *Be imitators of me just as I am of Christ*, what did he show them but the carvings standing in relief in the house of the Lord, which by the exceptional eminence of his virtue showed itself to be within the power of all to imitate? [. . .]

‹6:35› 'And he carved cherubim and palm-trees, and did carving in high relief; and he overlaid the whole evenly with gold leaf in square work,' has already been expounded above, because the same representations or carvings were wrought on the walls of the house and on the inner doors, and the meaning of the figure is obviously that the first door of the temple actually received the same representations and carvings and the same cherubim as the inner parts. The reason for this is that the same mysteries of faith, hope and charity which the sublime and the perfect each grasp in a sublime manner and which all the elect in heaven fully understand in the divine vision, are handed on also in the instruction of the unlettered for each one to learn and confess, in as much as those who have been initiated into the mysteries sometimes also succeed in understanding what they have devoutly believed.

3. Bernard of Clairvaux
Apologia: The 'Things of Greater Importance'

The 'Things of Greater Importance': Bernard of Clairvaux's Apologia *and the Medieval Attitude toward Art,* ed. C. Rudolph, Philadelphia, University of Pennsylvania Press, 1990, pp.279–83.

Like Pope Gregory the Great, St Bernard (1090–1153), the influential Cistercian Abbot of Clairvaux in north-eastern France, set out views on Christian art in a private letter probably written shortly after 1125. St Bernard clearly had grave reservations about the cost of decorating churches and the role of images in fundraising. Although he seems to have conceded a grudging toleration of the rich visual culture of the secular church, he was fundamentally opposed to it within a monastic context on grounds of distraction as well as cost. The art historian

Meyer Schapiro suggested that the very fact that he took this stance provides evidence of the strength at that time of the contrary view (expressed a little later by Bishop Lucas of Tuy in the following extract) and even that Bernard's detailed recollection of the cloister carvings reveals his own aesthetic vulnerability to visual enjoyment.[1] KW

On Paintings and Sculptures and Silver and Gold in Monasteries

XII. 28. But these are small things; I am coming to things of greater importance, but which seem smaller, because they are more common. I will overlook the immense heights of the places of prayer, their immoderate lengths, their superfluous widths, the costly refinements, and painstaking representations which deflect the attention while they are in them of those who pray and thus hinder their devotion. To me they somehow represent the ancient rite of the Jews. But so be it, let these things be made for the honor of God.

However, as a monk, I put to monks the same question that a pagan used to criticize other pagans: 'Tell me, priests,' he said, 'what is gold doing in the holy place?' I, however, say, 'Tell me, poor men' – for I am not concerned with the verse, but with the sense – I say, 'Tell me, poor men, if indeed you are poor men, what is gold doing in the holy place?' For certainly bishops have one kind of business, and monks another. We know that since they are responsible for both the wise and the foolish, they stimulate the devotion of a carnal people with material ornaments because they cannot do so with spiritual ones. But we who have withdrawn from the people, we who have left behind all that is precious and beautiful in this world for the sake of Christ, we who regard as dung all things shining in beauty, soothing in sound, agreeable in fragrance, sweet in taste, pleasant in touch – in short, all material pleasures – in order that we may win Christ, whose devotion, I ask, do we strive to excite in all this? What interest do we seek from these things: the astonishment of fools or the offerings of the simple? Or is it that since we have been mingled with the gentiles, perhaps we have also adopted their ways and even serve their idols?

But so that I might speak plainly, does not avarice, which is the service of idols, cause all this, and do we seek not the interest, but the principal? If you ask, 'In what way?' I say, 'In an amazing way.' Money is sown with such skill that it may be multiplied. It is expended so that it may be increased, and pouring it out produces abundance. The reason is that the very sight of these costly but wonderful illusions inflames men more to give than to pray. In this way wealth is derived from wealth, in this way money attracts money, because by I know not what law, wherever the more riches are seen, there the more willingly are offerings made. Eyes are

1. Meyer Schapiro, 'On the Aesthetic Attitude in Romanesque Art', in Meyer Schapiro, *Romanesque Art*, London, Chatto and Windus, 1977, pp.1–27.

fixed on relics covered with gold and purses are opened. The thoroughly beautiful image of some male or female saint is exhibited and that saint is believed to be the more holy the more highly colored the image is. People rush to kiss it, they are invited to donate, and they admire the beautiful more than they venerate the sacred. Then jewelled, not crowns, but wheels are placed in the church, encircled with lights, but shining no less brightly with mounted precious stones. And instead of candlesticks we see set up what might be called trees, devised with a great amount of bronze in an extraordinary achievement of craftsmanship, and which gleam no more through their lights on top than through their gems. What do you think is being sought in all this? The compunction of penitents, or the astonishment of those who gaze at it? O vanity of vanities, but no more vain than insane! The Church is radiant in its walls and destitute in its poor. It dresses its stones in gold and it abandons its children naked. It serves the eyes of the rich at the expense of the poor. The curious find that which may delight them, but those in need do not find that which should sustain them.

Why is it that we do not at least show respect for the images of the saints, which the very pavement which one tramples underfoot gushes forth? Frequently people spit on the countenance of an angel. Often the face of one of the saints is pounded by the heels of those passing by. And if one does not spare the sacred images, why does one not at any rate spare the beautiful colors? Why do you decorate what is soon to be disfigured? Why do you depict what is inevitably to be trod upon? What good are these graceful forms there, where they are constantly marred by dirt? Finally, what are these things to poor men, to monks, to spiritual men? Unless perhaps at this point the words of the poet may be countered by the saying of the prophet, 'Lord, I have loved the beauty of your house and the place where your glory dwells.'[i] I agree, let us put up with these things which are found in the church, since even if they are harmful to the shallow and avaricious, they are not to the simple and devout.

29. But apart from this, in the cloisters, before the eyes of the brothers while they read – what is that ridiculous monstrosity doing, an amazing kind of deformed beauty and yet a beautiful deformity? What are the filthy apes doing there? The fierce lions? The monstrous centaurs? The creatures, part man and part beast? The striped tigers? The fighting soldiers? The hunters blowing horns? You may see many bodies under one head, and conversely many heads on one body. On one side the tail of a serpent is seen on a quadruped, on the other side the head of a quadruped is on the body of a fish. Over there an animal has a horse for the front half and a goat for the back; here a creature which is horned in front is equine behind. In short, everywhere so plentiful and astonishing a variety of contradictory forms is seen that one would rather read in the marble than in books, and spend the

i. Psalm 26:8.

whole day wondering at every single one of them than in meditating on the law of God. Good God! If one is not ashamed of the absurdity, why is one not at least troubled at the expense?

4. Lucas, Bishop of Tuy
A polemic against the Albigensians

4a: G.G. Coulton, *Social Life in Britain: From the Conquest to the Reformation,* Cambridge, Cambridge University Press, 1919, pp.474–6; 4b and 4c: C. Gilbert, 'A Statement of the Aesthetic Attitude around 1230', *Hebrew University Studies in Literature and the Arts,* vol.13, no.2, 1985, pp.136–7, 150–1 (4b Latin passage trans. Martin Davies).

Lucas was Bishop of Tuy, south of Santiago de Compostela in the Iberian Peninsula, between 1239 and 1249. Some time between 1227 and his death in 1254 he wrote this polemic against the Albigensian heresy, which believed in opposing powers of good and evil, held the physical world in contempt and rejected the doctrine of the humanity of Christ. His views on art are somewhat contradictory. He considered painters who contravened orthodox modes of representation as blasphemous and heretical. However, the practice he particularly condemned of portraying Christ nailed to the cross with only three rather than four nails in fact prevailed throughout the late medieval period. By contrast, the Bishop appeared to endorse two purposes that images might serve in the Christian Church, which may in turn be traced back to the writings of Pope Gregory the Great: instruction and providing models of exemplary behaviour. Lucas goes further than Pope Gregory in specifying the use of terrifying images as a disincentive to sin and, in contrast to Bernard of Clairvaux (see previous extract), in suggesting that art may be justified simply as adornment. He also took the more radical stance that artistic images have the capacity to soothe and elevate viewers' minds and lead them to God not simply because of their subject matter but because of their aesthetic beauty, a view reminiscent of Abbot Suger (c.1081–1151), Abbot of St-Denis, Paris (see extract 4 in Chapter 2, pp.41–4 below). KW

4a. From Book 2, chapter 9
The heretics have another method of deceiving by means of pictures; which method we have thought fit not to pass over in silence, that the faithful may know it and be the more cautious to avoid it. For they oftentimes paint or carve ill-shaped images of Saints, that by gazing on such images the

devotion of simple Christian folk may be turned to loathing. In derision and scorn of Christ's Cross, they carve images of our Lord with one foot laid over the other, so that both are pierced by a single nail, thus striving either to annul or to render doubtful men's faith in the Holy Cross and the traditions of the sainted Fathers, by superinducing these diversities and novelties. This we will now demonstrate more clearly by relating that which took place in the land of France, in a town called Monculis [Montclus, Hautes-Alpes?], as hath been divulged by those who have told the facts.

In our own days, when the Manichaean heresy was spread abroad in France, and the poison of error was creeping everywhere, certain of these heretical mis-believers, instigated by the Devil, took [for their worship] a deformed and one-eyed image of the Holy Mother of God, giving this as their reason (though therein they lied wantonly, to the perdition of their own souls), that our Lord Jesus Christ so far humbled Himself as to predestine for the salvation of mankind a woman devoid of all comeliness. Thus these men thought within themselves, in their blind malice and falsehood, that they might the more easily deceive the simple, and wean their minds and thoughts from devotion to our most glorious Lady, Mary Ever-Virgin. Moreover, they suborned men who feigned themselves to be sick of divers diseases, and who seemed to be miraculously cured by this aforesaid image. These miracles were noised abroad, as though they had been true, through the towns and villages; and many even of the priests, with mistaken piety, caused like images to be made and set up in their churches. The heretics, seeing this, began now to discover what they had so long concealed, and to mock at those multitudes who flocked to pay their devotions to this image aforesaid.

About the same time, the said heretics made a cross with only three arms, whereon was carved an image with one foot laid over another, nailed by three nails only to the cross, which had no upper limb; which image the people came and adored most devoutly instead of the true Cross of Christ. Then these adversaries of the truth, disclosing the net which they had secretly spread, caught the souls of simple folk with their falsehoods, and rebuked even the Ministers of God, saying: 'If those things were true which ye have hitherto believed of the Cross, then is not that true which ye now adore; and, if what ye now believe be true, ye have hitherto taught falsehood. For if Christ was nailed to the Cross with four nails, and the cross itself had four arms, as ye have taught in the past, then is this which ye now adore and preach no true similitude of the Cross of Christ. Lo now ye halt between two opinions, and doubt, and lead ignorant folk into error by your own devious ways! Ye have no authority; your customs contradict one another!' Such blasphemies, and many more of the same sort, these heretics uttered against the Catholics, taking many simple souls in their snares; nay, even unto this day they cease not to spread abroad the wicked and schismatic doctrines which they have taken in hand.

4b. From Book 2, chapter 9

Let the painters seduced by shameless presumption hear this, those that strive to prove God's incomprehensible Holy Trinity comprehensible in physical space and mental intelligibility. For the Angelic Intellect cannot encompass the magnitude of God, and the Trinity is known only to itself – and yet the simple painter and practically every common person and layman strive to encompass it! Such is the immensity of God's magnitude that heaven and earth are embraced by it, but He is embraced by nothing. Whence the saying of Isidore, the preceptor of Spain: 'God does not fill the sky and earth that they may contain Him but so that they are contained by Him.' And again: 'God is said to be "simple", either by not losing what He has, or because He is not one thing and what is in Him another.' Since, then, no one can produce an image of something that cannot be circumscribed, either because it is both wholly within all things and wholly without all things, or because what it is in itself is not one thing and what is in it another, let the heretic and the painter cease to make blasphemous images and venerate idols of foolishness instead of God. Divinity indeed (as the supreme Doctor Augustine says) grows great in the heart of the just man, who reflects upon it always. But conversely I say, it grows ever lesser in the heart of arrogant heretic painters who strive to show three Gods in a sacrilegious picture or a single comprehensible God.

4c. From Book 2, chapter 20

It was said in what came before that the image of the Holy Trinity neither should nor can be painted by men. Now it is to be seen what images can be painted, in the church of Christ, and then how God or angels or souls of saints or sacraments of the church or men should be adored by the faithful.

Certain images are painted or carved in the church of Christ for the defense of the faithful, for doctrine, for imitation, and for adornment. Some are for doctrine, imitation and likewise for adornment, and some are for adornment only. Some are indeed for doctrine, so that in them men may learn to fear to behave sinfully. For the son of God consecrated the sign of his cross that it might be a defense for us against the subtleties of the enemy, be it through doctrine, how the son of the Virgin suffered for us, be it through imitation, in that we should die for him, as the appropriate occasion may offer itself, and the Cross in its visible glory is adornment and beauty for our faith. The images of the saints are for us doctrine about their blessed actions, urge imitation of sanctity, and lend adornment to the temple of God. There are in the church painted forms of animals, birds and serpents, and other things, which are for adornment and beauty only.

The images of some evil men, exposing their evil and their torments, and the virtual effigies of demons, are sculpted in church, so that seeing them men will be terrified, and, calling to mind present and future ills, will refrain from sinful deeds. These images must be made with subtle

fitness, so that they will show the beholders the beauty of good behavior and excite devotion of piety. For the house of God must shine with varied worship, so that its outward beauty itself will lead men to it, and not inflict weariness on those who are present; it should elevate the mind to heavenly things, representing the beauty of the heavenly home by striving for its beauty. While the outward beauty of the house of God soothes the eyes, its interior leads not rarely to God, as the wicked idolator King Jeroboam said in his heart, frightened about the return of the people of Israel to King Rehoboam: 'If the people go up to offer sacrifice in the house of the Lord in Jerusalem, then shall they turn to the Lord'[i] – and this because of the beauty of the temple. Solomon enriched this temple with a wonderful beauty of gems, gold and silver, and decorated it with images of varied sculpture, so that it would make the name of God famous everywhere, and draw the nations of divers peoples to itself.

5. Nicholas of Cusa
De Visione Dei

J. Hopkins, *Nicholas of Cusa's Dialectical Mysticism: Text, Translation and Interpretive Study of De Visione Dei,* second edn, Minneapolis, Arthur J. Banning Press, 1988, pp.112–27, 161, 243, 265.

Nicholas of Cusa (1401–64) was a cleric and philosopher from Kues on the River Mosel north-east of Trier, a cardinal from 1448 and Bishop of Brixen in Austria from 1450. *De Visione Dei*, or *The Vision of God*, written in 1453, is a philosophical treatise about the process of looking: how God looks at the world and how human beings look at God. It was addressed to the Abbot and monks of the monastery at Tegernsee south of Munich, and to launch his discussion he evidently sent the brothers an icon. The first section of the treatise, in which Nicholas demonstrates that the icon appears to fix its gaze on the viewer wherever he stands, is well known. In fact the icon recurs throughout the treatise as an extended metaphor to demonstrate that while we see we are also seen by God. The very brief extracts included here from this lengthy meditation introduce several themes essential to viewing medieval images: the visual as a stimulus to a personal affective response; the visual as a sign of a higher truth demanding 'the eyes of the mind'; physical viewing as the first step in the process of thought by

i. I Kings 12:27.

means of mental images. It seems clear that, for Cusa at least, mental images were but a short step from artistic images. Cusa was evidently well versed in visual culture, as the final extract on God as Divine Painter demonstrates. KW

2 If I strive to convey you by human means unto divine things, then I must do this through a likeness. Now, among human works I have not found an image more suitable to our purpose than the image of someone omnivoyant, so that his face, through subtle pictorial artistry, is such that it seems to behold everything around it. There are in existence many of these excellently depicted faces – e.g., the one of the archer in the forum at Nuremberg, the one [depicted] by the preeminent painter Rogier in his priceless painting in the city hall at Brussels, the one of Veronica in my chapel at Coblenz, the one, in the castle at Bressanone, of the angel holding the emblems of the church, and many others here and there. Nevertheless, so that you not be lacking in practical experience, which requires such a sensible figure, I am sending to Your Love a painting that I was able to acquire. It contains the figure of an omnivoyant [individual]; and I call it the 'icon of God.'

3 Hang this icon somewhere, e.g., on the north wall; and you brothers stand around it, at a short distance from it, and observe it. Regardless of the place from which each of you looks at it, each will have the impression that he alone is being looked at by it. To the brother who is situated in the east it will seem that the face is looking toward the east; to the brother in the south, that the face is looking toward the south; to the brother in the west, that it is looking westward. First of all, then, marvel at how it is possible that [the face] behold each and every one of you at once. For the imagination of the brother who is standing in the east does not at all apprehend the icon's gaze that is being directed toward a different region, viz., toward the west or the south. Next, let the brother who was in the east situate himself in the west, and he will experience the [icon's] gaze as fixed on him in the west, just as it previously was in the east. But since he knows that the icon is stationary and unchanged, he will marvel at the changing of the unchangeable gaze.

4 Moreover, if while fixing his sight upon the icon he walks from west to east, he will find that the icon's gaze proceeds continually with him; and if he returns from east to west, the gaze will likewise not desert him. He will marvel at how the icon's gaze is moved unmovably. And his imagination will be unable to apprehend that the gaze is also moved in accompaniment with someone else who is coming toward him from the opposite direction. Now, [suppose that,] wanting to experience this [phenomenon], he has a fellow-monk, while beholding the icon, cross from east to west at the same time that he himself proceeds from west to east. And [suppose] he asks the approaching brother whether the icon's gaze moves continually with

him. Thereupon he will be told that the gaze is also moved in this opposite manner; and he will believe his fellow-monk. And unless he believed, he would not apprehend that this [simultaneous opposition of motion] was possible. And so, through the disclosure of the respondent he will come to know that that face does not desert anyone who is moving – not even those who are moving in opposite directions. Therefore, he will experience that the unmovable face is moved toward the east in such way that it is also moved at the same time toward the west, that it is moved toward the north in such way that it is also moved [at the same time] toward the south, that it is moved toward one place in such way that it is also moved at the same time toward all other places, and that it observes one movement in such way that it observes all other movements at the same time. And while he considers that this gaze does not desert anyone, he sees how diligently it is concerned for each one, as if it were concerned for no one else, but only for him who experiences that he is seen [by it. This impression] is so strong that the one who is being looked upon cannot even imagine that [the icon] is concerned for another. [The one who is pondering all this] will also notice that [the image] is most diligently concerned for the least of creatures, just as for the greatest of creatures and for the whole universe. [. . .]

10 Now, O brother contemplative, draw near to the icon of God and situate yourself first in the east, then in the south, and finally in the west. The icon's gaze looks at you in equal measure in every region and does not desert you no matter where you go. Therefore, a speculative consideration will be occasioned in you, and you will be aroused and will say: O Lord, by a certain sense-experience I now behold, in this image of You, Your providence. For if You do not desert me, who am the least of all men, then You will never desert anyone. You are present to each and every thing – just as being, without which things cannot exist, is present to each and every thing. For You who are the Absolute Being of all things are present to each thing as if You were concerned about no other thing at all. [. . .]

11 You, O Lord, do not at all allow me to conceive, by any stretch of the imagination, that You, Lord, love anything other than me more than me, for it is me alone whom Your gaze does not desert. And since where Your eye is present Your love is also present, I experience that You love me, because Your eyes are most attentively upon me, Your lowly servant. O Lord, Your seeing is loving; and just as Your gaze regards me so attentively that it never turns away from me, so neither does Your love. And since Your love is always with me and is nothing other, Lord, than You Yourself, who love me, You Yourself are always with me, O Lord. You do not desert me, Lord; You safeguard me on all sides because You most carefully watch over me. Your Being, O Lord, does not forsake my being, for I exist insofar as You are with me. And since Your seeing is Your being, I exist because You look upon me. And if You were to withdraw Your countenance from me, I would not at all continue to exist. [. . .]

40 I stand before the image of Your Face, my God – an image which I behold with sensible eyes. And I attempt to view with inner eyes the truth which is pointed to by the painting. [. . .]

95 The eye of the mind cannot get enough of seeing You, O Jesus, because You are the fulfillment of all mental beauty. And by means of this icon I will conjecture about Your exceedingly marvelous and amazing gaze, O Superblessed Jesus. For while You, Jesus, walked amid this sensible world, You used fleshly eyes that were like ours. For with these eyes You perceived in no other way than do we men: viz., one thing and another. [. . .]

97 [. . .] For the human intellect, in order to be actualized, needs images. But images cannot exist without the senses; and the senses do not exist without a body. Consequently, the power of the human intellect is contracted and small and is in need of the aforementioned things. But the divine intellect is Necessity itself and does not depend on or need anything. Instead, all else needs it and cannot exist without it. [. . .]

111 [. . .] You, O Lord, who work all things for Your own sake, created this whole world on account of the intellectual nature. [You created] as if You were a Painter who mixes different colors in order, at length, to be able to paint Himself – to the end that He may have an image of Himself wherein He Himself may take delight and His artistry may find rest. Although the Divine Painter is one and is not multipliable, He can nevertheless be multiplied in the way in which this is possible: viz., in a very close likeness.

Chapter 2
Sacred architecture, Gothic architecture

Susie West

1. Giorgio Vasari
'German Work (the Gothic Style)'

Giorgio Vasari, *Vasari on Technique: Being the Introduction to the Three Arts of Design, Architecture, Sculpture and Painting, prefixed to the Lives of the Most Excellent Painters, Sculptors and Architects by Giorgio Vasari*, trans. Louisa S. Maclehose, ed. G. Baldwin Brown, London, J.M. Dent & Co., 1907, pp.83–4.

Giorgio Vasari (1511–74) was born in Arezzo, Tuscany, and lived a long and prolific life as a painter, architect, writer and collector of drawings. He published his *Lives of the Most Excellent Painters, Sculptors and Architects* in 1550. The book included essays on architecture, painting and sculpture, as well as three groups of artists' biographies. As a result of Vasari's interest in understanding what makes a work of art successful, the book was the first critical history of artistic style, and is viewed as the foundation work for the discipline of art history. A second, enlarged, edition was published in 1568, and had an immediate influence on the way in which new histories of art were written. This reading discusses an art style Vasari knew as German, or Gothic, after the Germanic tribes who repeatedly attacked the Roman Empire and in 410 CE seized Rome. For Vasari, Gothic art was a low point between the ancient classical world and the perfection he saw in the work of his contemporaries such as Michelangelo (1475–1564). He is less concerned with the dominant style attribute of the Gothic pointed arch, as opposed to the round arch of classical architecture, than with the forms of Gothic buildings (i.e. their proportions) and the uses of ornament. Vasari lacks a critical language to assess Gothic buildings, since they do not use the classical orders as the foundation for their

design. He finds the plurality of repeated forms and motifs, like niches and their ornaments, visually disturbing: to him, Gothic stone buildings look as flimsy as paper, doorways break the classical rules by being too tall within a wall. Lacking this critical vocabulary, and viewing the style as a departure from a classical norm, Vasari can only condemn Gothic architecture. SW

We come at last to another sort of work called German, which both in ornament and in proportion is very different from the ancient and the modern. Nor is it adopted now by the best architects but is avoided by them as monstrous and barbarous, and lacking everything that can be called order. Nay it should rather be called confusion and disorder. In their buildings, which are so numerous that they sickened the world, doorways are ornamented with columns which are slender and twisted like a screw, and cannot have the strength to sustain a weight, however light it may be. Also on all the façades, and wherever else there is enrichment, they built a malediction of little niches one above the other, with no end of pinnacles and points and leaves, so that, not to speak of the whole erection seeming insecure, it appears impossible that the parts should not topple over at any moment. Indeed they have more the appearance of being made of paper than of stone or marble. In these works they made endless projections and breaks and corbellings and flourishes that throw their works all out of proportion; and often, with one thing being put above another, they reach such a height that the top of a door touches the roof. This manner was the invention of the Goths, for, after they had ruined the ancient buildings, and killed the architects in the wars, those who were left constructed the buildings in this style. They turned the arches with pointed segments, and filled all Italy with these abominations of buildings, so in order not to have any more of them their style has been totally abandoned.

May God protect every country from such ideas and style of buildings! They are such deformities in comparison with the beauty of our buildings that they are not worthy that I should talk more about them, and therefore let us pass on to speak of the vaults.

2. Eugène Viollet-le-Duc
'Rational Building'

Eugène Viollet-le-Duc, *Dictionnaire raisonné de l'architecture française du XIe au XVIe siècle*. 1854–68, vol.4, pp.217, 81–2, in *The Architectural Theory of Viollet-le-Duc: Readings and Commentary*, ed. M.F. Hearn, Cambridge, MA, MIT Press, 1990, pp.115–16.

Eugène Emmanuel Viollet-le-Duc (1814–79) was born in Paris and trained as an architect. He joined a government office for state buildings and quickly became noted for ambitious restoration projects of prestigious buildings, including the three most nationally important medieval churches of Notre Dame, and Sainte-Chapelle (both in Paris), and the royal church of St-Denis (near Paris), all during the 1840s. He published his *Dictionnaire raisonné de l'architecture française du XIe au XVIe siècle* (1854–68) as an extended analysis of the construction and development of French Gothic architecture, through description and classification. The following selections from volume 4 of his *Dictionnaire raisonné* offer a model for understanding the structural properties of medieval buildings, using the term Gothic to stand for a complete system of design, construction and style. Viollet-le-Duc uses a biological metaphor, seeing the Gothic building as analogous to a living body. He goes on to argue that the contemporary (nineteenth-century) approach to Gothic buildings that only focuses on their surface style ignores the potential that the construction techniques offer. He believes that Gothic architecture has contemporary relevance, as a flexible system (able to use 'all the materials given by nature or industry', cast iron being of great interest) that can be put to new uses in devising buildings for the complexities of modern life. For Viollet-le-Duc, Gothic is a living architecture, if the lessons from the original builders are thoroughly understood. SW

Elasticity being the first of all the necessary conditions in monuments erected on slender supports, it was still necessary to find, besides that elasticity, absolute rigidity and resistance. [. . .] The builders at the beginning of the thirteenth century did not pile the stones one upon another without purpose and without noticing the effects that were produced in large edifices, in accordance with the laws of weight. Their masonry lives, acts, fullfils a function, is never an inert and passive mass. [. . .] the Gothic building has its organs and its laws of equilibrium and each of its members cooperates with the whole by an action or a resistance.

Gothic Structure as a Source of Inspiration for Modern Architecture
Now [. . .] Gothic construction, despite its defects, its errors, its attempts, and perhaps because of all these, is a preeminently useful study; it is the surest

initiation into that modern art that does not yet exist but is struggling, because it establishes the true principles to which we ought still to submit today; because it has broken with antique traditions, and because it is fertile in applications. [. . .]

Beauty is not, in an art wholly conventional and logical, linked forever to one single form; it can always reside there when the form is but an expression of satisfied need, of judicious use of the material given. Because the multitude sees in Gothic architecture only its ornamentation, and because this ornamentation no longer belongs to our time, is this a proof that the construction of these edifices can no longer find an application? One might just as well maintain that a treatise on geometry is worth nothing because it is printed in Gothic characters, and that students reading in such a book that 'the angles opposite the vertex are equal to each other' are learning mere folly and are being misled. Now, if we can teach geometry with books printed yesterday, we cannot do the same in construction, and we must necessarily seek these principles where they are traced – in the monuments; and this book of stone, strange as are its type and its style, is as good as any other, in reality, as to the ideas that it has suggested.

In no other order of architecture do we find these ingenious and practical means of solving the numerous difficulties that surround the constructor living in the midst of a society whose needs are complicated to excess. Gothic construction is not, like antique construction, immutable, absolute in its means; it is supple, free, and as inquiring as the modern spirit: its principles permit the use of all the materials given by nature or industry in virtue of their own qualities; it is never stopped by a difficulty; it is ingenious: this word tells all. The Gothic builders are subtle, ardent and indefatigable workers, reasoners, full of resources, never stopping, liberal in their methods, eager to avail themselves of novelties, all qualities or defects that place them in the front rank of modern civilization. These builders are no longer monks submissive to rule or tradition; they are laymen who analyze everything and recognize no other law than that of reason. Their faculty of reasoning scarcely halts at natural laws, and if they are forced to admit these, it is in order to conquer them by opposing them one to another [. . .] .

We do not pretend [. . .] to disguise any of the defects of the systems presented; this is not a plea in favor of the Gothic construction, but a simple exposition of its principles and their consequences. If we are well understood, there is no sensible architect who, after having listened to us with some attention, will not recognize the uselessness, to say no more, of *imitations* of Gothic art, and who will not understand at the same time the advantage that one can derive from the serious study of that art, and the innumerable resources presented by that study so closely allied to our genius.

3. Émile Mâle
The Gothic Image

Émile Mâle, *The Gothic Image: Religious Art in France of the Thirteenth Century. A Study in Mediaeval Iconography and its Sources of Inspiration,* trans. D. Nussey, London, J.M. Dent & Co., 1913, pp.ix, x.

Émile Mâle (1862–1954) changed his career from teaching literature to researching French medieval art and architecture, and published in 1898 a comprehensive and pioneering approach to the iconography of French art, as a unified system of thought across four centuries, which was translated into English in 1913. Mâle introduces his research on thirteenth-century French art with a bold claim, that it represents the fullest expression of unity between intellectual and artistic expression. He traces a direct line of evolution from the earliest surviving Christian art of the fifth century to his chosen 'end point' as a process of amplification and reflection on the Christian message. France is argued to be the place in which art visibly expressed theology most successfully, citing the façades of the great French churches built in this century. Mâle draws on recent historiography of architectural history, which by the end of the nineteenth century and thanks largely to Viollet-le-Duc's detailed research on and restoration of French great churches, saw French Gothic as the most artistically successful of the European Gothic style. Mâle finds the explanation for the perfection of Gothic art contained within the ultimate purpose, the expression of medieval Christian belief. SW

The thirteenth century is the period when the thought of the Middle Ages was most fully expressed in art – hence our choice of it – but it was very far from originating all the modes of expression which it perfected. It had inherited a multitude of types, of dispositions, and of ideas from previous centuries. The long evolution of Christian art is one of the most interesting, as it is one of the most elusive subjects of research that can be undertaken by the scholar. Nothing could be more instructive than to follow the representation of a given person or scene, from the art of the catacombs to that of the cathedrals. Careful study of the same type, observing its development in chronological order from fifth-century mosaics, through Byzantine miniatures, Carlovingian ivories and Romanesque capitals to the sculpture and glass of the thirteenth century, would reveal a long series of stages in the evolution of Christian thought. It would be seen, for example, that the art of the catacombs does not venture to show to the faithful the image of the crucified Christ, that Romanesque art of the early period represents Him on a jewelled cross,

crowned and triumphant, with open eyes and lifted head, and that the art of the thirteenth century, less doctrinal and more human, shows the crucified figure with closed eyes and drooping form. The final appeal is to the heart rather than to the head.

Close study of subtle changes of this kind would show how fluid and mobile, in a word how living a thing mediæval Christianity was, but it would be the work of a lifetime. [. . .] We propose to follow another method. We shall consider the art of the thirteenth century as a living whole, as a finished system, and we shall study the way in which it reflects the thought of the Middle Ages. In this way we shall gain some idea of the majesty of the whole, some notion of the truly encyclopædic range of mediæval art in its prime. The thirteenth century is the central point of our study, for it was then that art with admirable daring tried to express all things. The iconography of the richest Romanesque work is poor indeed beside the wealth of Gothic imagery, and the period we have chosen is precisely that in which the façades of the great French churches were thought out and executed. Occasionally it has been necessary to go beyond the limits of the thirteenth century; the old west porch of Chartres, for example, was carved about the year 1150, and the exterior decoration of Notre Dame at Paris was not finished until the beginning of the fourteenth century. It is evident that it would have been artificial to confine our research to the period between 1200 and 1300.

It is not because we believe that the art of neighbouring nations obeys different rules that we have limited our study to that of French art. On the contrary the character of the art of the thirteenth century was as truly universal as was its Christian teaching. We have satisfied ourselves that the great subjects in which it delighted were conceived of at Burgos, Toledo, Siena, Orvieto, Bamberg, Friburg, just as they were at Paris or at Reims. But we are convinced that Christian thought was not expressed elsewhere so fully or so richly as in France. In the whole of Europe there is no group of works of dogmatic art in the least comparable to that presented by the cathedral of Chartres. It was in France that the doctrine of the Middle Ages found its perfect artistic form. Thirteenth-century France was the fullest conscious expression of Christian thought. There is little to be learned from foreign cathedrals when one knows Chartres, Amiens, Paris, Reims, Laon, Bourges, Le Mans, Sens, Auxerre, Troyes, Tours, Rouen, Lyons, Poitiers and Clermont, but we have occasionally taken examples from Germany, Italy or England to give added force to a demonstration. French art is none the less the subject of our study.

4. Nikolaus Pevsner
'The Early and Classic Gothic Style
c.1150–c.1250'

Nikolaus Pevsner, *An Outline of European Architecture,*
Middlesex, Penguin Books, 1943–57, pp.135, 152–4.

**Nikolaus Pevsner (1902–83) was born in Germany; in 1933 he joined
the exodus of German academics who had lost their jobs for political
or racial reasons and came to England in 1933, accepting that he was
in permanent exile from 1935. Trained as an art historian, Pevsner
combined a great breadth of interest in art, design and architecture
across Europe and the centuries. Pevsner sums up Gothic architecture
with incisive clarity as an aesthetic system in which three construction
features are hailed for their style: pointed arch, flying buttress and rib-
vault. What Pevsner takes for granted is that these features principally
define the construction of Gothic great churches, which is the real
subject of this discussion. He retains the canonical list of great churches
used by Émile Mâle half a century earlier (see previous extract), but
Pevsner's concerns are with the aesthetics of stone, which serves to
harness light and define line. For Pevsner, the great churches of the
thirteenth century, which he classes as High Gothic after the rebuilding
of Chartres, express not Christian theology but aesthetic dynamism.
He prioritises the viewer's gaze, shaped and accelerated by the forests
of Gothic pillars encountered in the interiors. It is above all the viewer's
own response, and personal experience of the space, that is controlled
by the pace and rhythm of the design. SW**

In 1140 the foundation stone was laid for the new choir of St Denis Abbey
near Paris. It was consecrated in 1144. Abbot Suger, the mighty counsellor
of two kings of France, was the soul of the enterprise. There are few
buildings in Europe so revolutionary in their conception and so rapid
and unhesitating in their execution. Four years was an exceptionally short
time in the 12th century for rebuilding the choir of a large abbey church.
Whoever designed the choir of St Denis, one can safely say, invented the
Gothic style, although Gothic features had existed before, scattered here
and there, and, in the centre of France, the provinces around St Denis even
developed with a certain consistency.

The features which make up the Gothic style are well enough known,
too well in fact, because most people forget that a style is not an aggregate
of features, but an integral whole. Still, it may be just as well to recapitulate
them and re-examine their meaning. They are the pointed arch, the flying
buttress, and the rib-vault. Not one of them is a Gothic invention. Pointed
arches appear occasionally in Romanesque churches, e.g. in Burgundy

and Provence, and at Durham. Flying buttresses were common in several parts of France and also used at Durham. They are not usually realized as such, because they were kept underneath the roofs. Of the ribs of Durham and North Italy something has been said in the previous chapter. What the Gothic style brought to these motifs was their combination for a new aesthetic purpose. This purpose was to enliven inert masses of masonry, to quicken spatial motion, to reduce a building to a seeming system of innervated lines of action. These aesthetic advantages are infinitely more significant for an understanding of the Gothic style than whatever technical advantages the use of ribs, flying buttresses, and pointed arches may have meant. Such technical advantages were not absent, although they have been vastly overestimated by Viollet-le-Duc and his innumerable followers. [. . .]

The movement which had grown from St Denis to Noyon and from Noyon to Paris reached maturity in the cathedrals designed from the end of the 12th century onwards. Early Gothic changed into High Gothic. Chartres was rebuilt after a fire in 1194 [fig.1]. The new choir and nave at last do away with the sexpartite vault and return to vaults with only diagonal ribs. But whereas the Romanesque rib-vaults were placed over square or squarish bays, the bays now are roughly half that depth. The speed of the eastward drive is thereby at once doubled. The piers remain circular, but they have on each side a circular attached shaft. Toward the nave this shaft reaches right

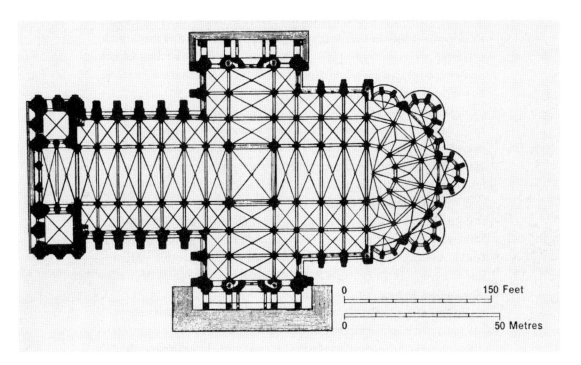

Fig.1
Chartres Cathedral,
begun c.1194

up to where the vault starts (as the shafts of Jumièges and Winchester had already done). So the isolation of the circular column is overcome. Nothing at arcade level stops the vertical push. And the wide and tall gallery has disappeared. There is now only a low triforium, dividing the tall arcades from the tall clerestory windows. These innovations constitute the High Gothic style. The plan is less radical than that of Paris, but has the transept also mid-way between the west front and the choir end.

Once Chartres had introduced the new type of piers, the three-storeyed elevation, and the simplified vaulting, Rheims, Amiens, and Beauvais did nothing more than perfect it and carry it to the boldest and most thrilling extremes. As in the plans so in the interiors a balance is achieved no doubt – but not the happy, seemingly effortless and indestructible balance of the Greeks. High Gothic balance is a balance of two equally vehement drives towards two opposite directions. One's first impression is of breathtaking height. At Sens the relation between width and height of nave had been only 1:1.4, at Noyon 1:2, at Chartres 1:2.6, in Paris 1:2.75. In Amiens it has become 1:3, and in Beauvais 1:3.4. The absolute height at Noyon had been approximately 85 feet. In Paris it is 115 feet, in Rheims 125, in Amiens 140, and in Beauvais 157. The drive upward is just as forcible as, or, owing to the slenderness of all members, even more forcible than, was the drive eastward in early Christian churches. And the eastward drive has not by any means slackened either. The narrowness of the arcades and the uniform shape of the piers do not seem to call for even a momentary change of direction. They accompany one on one's way, as closely set and as rapidly appearing and disappearing as telegraph poles along a railway line. There is not time at first to stop and admire them. Yet in pressing forward, the transept halts us and diverts our eyes to the right and left. Here we stop, here we endeavour for the first time to take in the whole. In an Early Christian church nothing of this kind was provided, in a Romanesque church so much of it that movement went slowly from bay to bay, from compartment to compartment. At Amiens there is only one such halt, and it cannot be long. Again nave and aisles, now of the chancel, close round us, and we do not come to an ultimate rest until we have reached the apse and the ambulatory, gathering with splendid energy the parallel streams of east-bound energy and concentrating them in a final soaring movement along the narrowly spaced piers of the apse and the narrow east windows up to the giddy heights of the vault ribs and vaulting bosses.

This description is an attempt at analysing a spatial experience, ignoring of course the fact that a normal 13th-century church-goer would never have been admitted to the chancel. What will have become evident from it is how spectacularly Rheims, Amiens, and Beauvais are the final achievement of an evolution which had begun back in the 11th century in Normandy and at Durham and had worked, one after another, seemingly small but very significant changes at St Denis, Noyon, Laon, Paris, and

Chartres. This final achievement is, to say it once more, far from reposeful. It possesses the tension of two dominant directions or dimensions, a tension transformed by a supreme feat of creative energy into a precarious balance. Once one has felt this, one will recognize it in every detail.

5. Erwin Panofsky
Gothic Architecture and Scholasticism

Erwin Panofsky, *Gothic Architecture and Scholasticism (1951)*, New York, Meridian Books, 1957, pp.39, 43–5, 59–60.

Erwin Panofsky (1892–1968), primarily writing about painting, was interested in intellectual and cultural contexts, particularly the philosophy of the period of the artwork, to understand the visual as the expression of the dominant conceptual framework of the time. Panofsky returns to Émile Mâle's theme (see previous extract) of the unity of Christian intellectual traditions and medieval art, focusing on architecture. In contrast to Nikolaus Pevsner's viewing of the interior of the great church as fast-paced, even explosive, in its aesthetic effects (see previous extract), Panofsky finds it to be 'wildly pictorial' and 'apparently boundless'. Panofsky investigates the architecture of the great church as a direct parallel with the dominant theology of the period, scholasticism. He finds them to be in step, by treating both intellectual and aesthetic system as having aims that are perfectly expressed in their outward forms. The evidence for this is drawn from Panofsky's own distillation of the Gothic systems into a set of ideals, 'the High Gothic plan', rather than a close reading of individual buildings. The canon of French great churches must be assumed to underpin the analysis. SW

[. . .] the visual arts become articulated through an exact and systematic division of space, resulting in a 'clarification for clarification's sake' of narrative contexts in the representational arts, and of functional contexts in architecture. [. . .]

It was, however, in architecture that the habit of clarification achieved its greatest triumphs. As High Scholasticism was governed by the principle of *manifestatio*, so was High Gothic architecture dominated – as already observed by Suger – by what may be called the 'principle of transparency.' Pre-Scholasticism had insulated faith from reason by an impervious barrier much as a Romanesque structure conveys the impression of a space determinate and impenetrable, whether we find ourselves inside or outside the edifice. Mysticism was to drown reason in faith, and nominalism was to completely

disconnect one from the other; and both these attitudes may be said to find expression in the Late Gothic hall church. Its barnlike shell encloses an often wildly pictorial and always apparently boundless interior and thus creates a space determinate and impenetrable from without but indeterminate and penetrable from within. High Scholastic philosophy, however, severely limited the sanctuary of faith from the sphere of rational knowledge yet insisted that the content of this sanctuary remain clearly discernible. And so did High Gothic architecture delimit interior volume from exterior space yet insist that it project itself, as it were, through the encompassing structure; so that, for example, the cross section of the nave can be read off from the façade.

Like the High Scholastic *Summa*, the High Gothic cathedral aimed, first of all, at 'totality' and therefore tended to approximate, by synthesis as well as elimination, one perfect and final solution; we may therefore speak of *the* High Gothic plan or *the* High Gothic system with much more confidence than would be possible in any other period. In its imagery, the High Gothic cathedral sought to embody the whole of Christian knowledge, theological, moral, natural, and historical, with everything in its place and that which no longer found its place, suppressed. In structural design, it similarly sought to synthesize all major motifs handed down by separate channels and finally achieved an unparalleled balance between the basilica and the central plan type, suppressing all elements that might endanger this balance, such as the crypt, the galleries, and towers other than the two in front. [. . .]

Where the humanistic mind demanded a maximum of 'harmony' (impeccable diction in writing, impeccable proportion, so sorely missed in Gothic structures by Vasari, in architecture), the Scholastic mind demanded a maximum of explicitness. It accepted and insisted upon a gratuitous clarification of function through form just as it accepted and insisted upon a gratuitous clarification of thought through language.

6. Rudolf Wittkower
'The Cathedral of Milan: Prelude'

Rudolf Wittkower, *Gothic vs. Classic: Architectural Projects in Seventeenth-Century Italy,* New York, George Brazilier, 1974, pp.17–20.

The contribution of Rudolf Wittkower (1901–71) to the understanding of Renaissance architecture was innovative in its search for a Renaissance theory, or aesthetic, of building, its attention to documentary sources and to the relationship of architecture to society. In this extract, Wittkower investigates the reception of Gothic architecture after the sixteenth century, by exploring the historiography of architectural history that begins with Vasari (see extract 1, pp.35–6 above). Wittkower prioritises Italy as a focus of investigation not just because Vasari was Italian, but because the Italian Renaissance was the earliest and strongest 'break with Gothic traditions'. He draws attention to Vasari's interest in order, against the perceived disorder of Gothic style. Wittkower argues that a sense of order is historically specific, and that Vasari's own sense of order compelled him to use components of the Gothic style in situations where harmonious additions to older Gothic artefacts were desirable. For example, as a collector, Vasari drew a Gothic frame for a fourteenth-century drawing. Vasari's practices can thus be understood as the product of his understanding of art theory, rather than simply of subjective like or dislike. SW

In 1960, Paul Frankl published a work entitled *The Gothic, Literary Sources and Interpretations through Eight Centuries.* It is a tome of over nine hundred pages that begins with Abbot Suger's mid-twelfth-century treatises and follows the theme through the centuries to modern interpretations of the Gothic style by such art historians as Henri Focillon, Ernst Gall, Dagobert Frey, Jean Bony, and Hans Sedlmayr. When one turns the pages of Frankl's book, one has the feeling that everything of interest and importance has been covered by a fine mind who devoted a large part of a long life to gaining a balanced assessment of opinions about Gothic architecture in all ages and countries.

Upon consideration, however, it appears that some periods are perhaps treated all too briefly: Frankl has less than thirty pages on views about the Gothic style in France, Italy, and Spain between the years 1530 and 1600 and less than fifteen pages on the same countries in the seventeenth century. But it would seem – and I hope to prove – that the late sixteenth and the seventeenth centuries are of exceptional importance in sorting out the problems that the legacy of the Gothic period posed to the central European countries. [. . .]

[. . .] a focus on Italy has its special rewards, because it is there that we can expect to find the most pointed and revealing views on Gothic. The reasons are obvious. Italy led Europe intellectually and artistically until the end of the seventeenth century. Only in fifteenth-century Italy was a conscious, programmatical, and forceful break with Gothic traditions accomplished; it was only there that the rise of the Renaissance was accompanied by an art theory that took its bearings from the authors of classical antiquity; and it was only there that a vision of historical evolution arose and took root, according to which the long period between the fall of the Roman Empire and the rise of the Renaissance appeared as a period of decline caused by barbaric invasions. All this would seem to be a clear pointer to the Italian approach to the Gothic style in the post-medieval period. Frankl called his chapter covering the Renaissance and Baroque era (i.e., the centuries from the fifteenth to the early eighteenth): 'The Period of Reaction against Gothic.' Indeed, a long book could be compiled from quotations of literary criticism of the Gothic style during those centuries. There was probably no Italian architect of importance during the sixteenth and seventeenth centuries whose terms of reference were other than classical. Nevertheless, we shall find that occasionally compelling circumstances arose in which Gothic projects superseded classical ones.

In order to get a feeling for the situation, one turns, of course, to the father of art-historical writing, Giorgio Vasari, whose *Lives of the Artists* appeared first in 1550 and, much amplified, in 1568. Vasari not only skillfully summarized the Italian approach to Gothic as it had developed over the previous hundred years but added to it a personal note of strong prejudice; he also had a formative influence on the opinions of later generations. Vasari expressed his considered opinion on Gothic – which at his time was called interchangeably *maniera tedesca* (German manner) and Gothic manner – in the celebrated introduction to his *Lives*.

After discussing the classical orders, Vasari turns to the work known as German, which, he tells his readers, is now avoided by the best architects 'as monstrous and barbarous, and lacking everything that can be called order. Nay it should rather be called confusion and disorder.' This idea is of central importance and we shall later consider the specific meaning of the concepts of order and disorder in the sixteenth and seventeenth centuries. Vasari then enumerates a great deal of Gothic detail which shows that he had studied Gothic buildings rather carefully. 'Doorways [he informs us] are ornamented with columns which are slender and twisted like a screw, and cannot have the strength to sustain a weight, however light it may be. Also on all the façades … they build cursed little niches, one above the other, with no end of pinnacles and points and leaves … so that it appears impossible that the parts should not topple over at any moment.' He goes on to discuss the endless projections and breaks and corbellings

and flourishes that throw the architects' work all out of proportion; 'and often, with one thing being put above another, they reach such a height that the top of a door touches the roof. This manner [he concludes] was the invention of the Goths, for, after they had ruined the ancient buildings, and killed the architects in the wars, those who were left constructed the buildings in this style. They constructed pointed arches, and filled all Italy with these abominations of buildings … their style has been totally abandoned. May God protect every country from such ideas and style of buildings!'

One has to acknowledge that Vasari gave a shrewd characterization of the Gothic style, though its appreciation was marred by an almost physical aversion. Vasari's strictures on Gothic are encountered in many passages of his writings. In the same introduction from which I have quoted, he mentions that 'in our time certain vulgar architects … have worked … almost as if by chance, without observing decorum, art, or any order; all their things are monstrous and worse than the Gothic ones.' Or to give another example: in order to underline emphatically his dislike of Antonio da Sangallo's wooden model of St. Peter's in Rome, a model that was harshly

Fig.2
Giorgio Vasari's frame
for fourteenth-century
'Cimabue' drawing,
now attributed to
Aretino Luca Spinello,
*Scenes from the Life of
a Saint*)
Ink on paper
École Nationale Superieure
des Beaux-Arts, Paris

criticized by Vasari's adored master Michelangelo, he says that it reminds one 'of the style and manner of the Germans rather than of the good manner of the ancients which the better architects nowadays follow.'

Vasari's approach to the Gothic manner was, however, more complex than would appear from the remarks quoted here. It was Erwin Panofsky who first observed a strange paradox or seeming contradiction in Vasari's attitude. Vasari had been an avid collector of drawings, a fair number of which are still known: they are to be found in many great collections all over the world and are easily identifiable by the carefully rendered framing devices which Vasari himself designed for each of them. One of the treasures of his collection was a fourteenth-century drawing showing many small figures (now in the Bibliothèque de l'Ecole des Beaux-Arts in Paris) ascribed by Vasari to Cimabue and for which he designed a Gothic frame [fig.2]. In 1930 Erwin Panofsky dedicated to this phenomenon one of his penetrating investigations, which he entitled 'The First Page of Giorgio Vasari's "Libro." A Study on the Gothic Style in the Judgment of the Italian Renaissance.'

Two points made by Panofsky are of specific interest in the present context. First, with psychological insight he recognized that it was precisely the opposition to the Middle Ages that enabled the Renaissance – as he says – 'to confront Gothic art, and thereby, even though through glasses tinted by hostility, to *see* it for the first time ... as an alien and contemptible, yet for this very reason truly characteristic, phenomenon which could not be taken too seriously.' Panofsky concluded that the North, 'for want of distance, needed a long time ... to understand Gothic works as manifestations of a great and serious style [while] the very enmity toward the Gothic established the basis for its recognition in Italy.' Secondly, he emphasized that the problem of stylistic unity loomed large from the beginning of the Renaissance on. Thus, briefly, Vasari's knowledge of Gothic stylistic features, combined with the demand for stylistic consistency, determined his Gothic frame for the so-called Cimabue drawing.

Chapter 3
Sacred in secular, secular in sacred: the art of Simone Martini

Diana Norman

1. Inscriptions on pulpits by Nicola and Giovanni Pisano

John Pope-Hennessy, *Italian Gothic Sculpture*, New York, Vintage Books Editions, 1985, pp.170, 177–8.

Between 1260 and 1311, first the Italian sculptor Nicola Pisano (active 1258–78), and then his son Giovanni Pisano (active 1265–1314), sculpted a series of four monumental stone pulpits for churches in Tuscany. Comprising narrative reliefs depicting scenes from the early life and death of Christ and the Last Judgement as well as sculpted figures of prophets, saints, angels, allegorical figures and animals, three of these pulpits also displayed prominent inscriptions giving the name of the artist. As can be seen from the texts below, these became more complex and poetic in tone and made increasingly assertive claims for the skill and achievement of the artist concerned. DN

a) The pulpit, the Baptistery, Pisa (1260): The inscription below the relief of the Last Judgement.

> ANNO MILLENO BIS CENTUM BISQUE TRICENO
> HOC OPUS INSINGNE SCULPSIT NICOLA PISANUS
> LAUDETUR DINGNE TAM BENE DOCTA MANUS.

In the year 1260 Nicola Pisano carved this noble work. May so greatly gifted a hand be praised as it deserves.

b) The pulpit, Sant'Andrea, Pistoia (1301): the inscription running around the pulpit beneath the narrative reliefs.

LAUDE DEI TRINI REM CEPTAM COPULO FINI
CURE PRESENTIS SUB PRIMO MILLE TRICENTIS.
PRINCEPS E(ST) OP(ER)IS PLEBBAN(US) VEL DATOR ERIS
ARNOLD(US) DICTUS QUI SEMP(ER) SIT BENEDICTUS.
ANDREAS UN(US) VITELLI . . . QUOQ(UE) TIN(US)
NAT(US) VITALI BENE NOT(US) NOMINE TALI
DISPE(N)PSATORES HI DICTI S(UN)T MELIORES
SCULPSIT JOH(ANN)HS QUI RES NO(N) EGIT INANES
NICOLI NAT(US) SENSIA MELIORE BEATUS
QUE(M) GENUIT PISA DOCTU(M) SUP(ER) OMNIA VISA.

In praise of the triune God I link the beginning with the end of this task in thirteen hundred and one. The originator and donor of the work is the canon Arnoldus, may he be ever blessed. Andrea, (son?) of Vitello, and Tino, son of Vitale, well known under such a name, are the best of treasurers. Giovanni carved it, who performed no empty work. The son of Nicola and blessed with higher skill, Pisa gave him birth, endowed with mastery greater than any seen before.

c1) The pulpit, the Cathedral, Pisa (1302–11): the inscription running beneath the narrative reliefs.

LAUDO DEUM VERUM PER QUEM SUNT OPTIMA RERUM
QUI DEDIT HAS PURAS HOMINEM FORMARE FIGURAS.
HOC OPUS HIC ANNIS DOMINI SCULPSERE IOHANNIS
ARTE MANUS SOLE QUONDAM NATIQUE NICHOLE
CURSIS UNDENIS TERCENTUM MILLEQUE PLENIS
JAM DOMINANTE PISIS CONCORDIBUS ATQUE DIVISIS
COMITE TUNC DICO MONTISFELTRI FREDERICO
HIC ASSISTENTE NELLO FALCONIS HABENTE
HOC OPUS IN CURA NEC NON OPERE QUOQUE IURA
EST PISIS NATUS UT IOHANNES ISTE DOTATUS
ARTIS SCULPTURE PRE CUNCTIS ORDINE PURE
SCULPENS IN PETRA LIGNO AURO SPLENDIDA TETRA
SCULPERE NESCISSET VEL TURPIA SI VOLUISSET.
PLURES SCULPTORES: REMANENT SIBI LAUDIS HONORES
CLARAS SCULPTURAS FECIT VARIASQUE FIGURAS
QUISQUIS MIRARIS TUNC RECTO JURE PROBARIS
CRISTE MISERERE CUI TALIA DONA FUERE. AMEN.

I praise the true God, the creator of all excellent things, who has permitted a man to form figures of such purity. In the year of Our Lord thirteen hundred and eleven the hands of Giovanni, son of the late Nicola, by their own art alone, carved this work, while there ruled over the Pisans, united and divided, Count Federigo da Montefeltro, and at his side Nello di Falcone who has exercised control not only of the work but also of the rules on which it is based. He is a Pisan by birth, like that Giovanni who is endowed above all others with command of the pure art of sculpture, sculpting splendid things in stone, wood and gold. He would not know how to carve ugly or base things even if he wished to do so. There are many sculptors, but to Giovanni remain the honours of praise. He has made noble sculptures and diverse figures. Let any of you who wonders at them test them with the proper rules. Christ have mercy on the man to whom such gifts were given. Amen.

c2) The pulpit, the Cathedral, Pisa (1302–11): The inscription located on the step beneath the pulpit. The 'hostile injuries' apparently experienced by Giovanni Pisano suggest that work on the pulpit did not proceed smoothly. In this context it is worth noting that Burgundio di Tado, the official responsible for the commission of the pulpit in 1302, was replaced in 1307 by Nello di Falcone, the man mentioned in the first inscription (extract c1, above**).**

> CIRCUIT HIC AMNES MUNDI PARTESQUE IOHANNES
> PLURIMA TEMPTANDO GRATIS DISCENDA PARANDO
> QUEQUE LABORE GRAVI NUNC CLAMAT NON BENE CAVI
> DUM PLUS MONSTRAVI PLUS HOSTITA DAMNA PROBAVI
> CORDE SED IGNAVI PENAM FERO MENTE SUAVI
> UT SIBI LIVOREM TOLLAM MITIGEMQUE DOLOREM
> ET DECUS IMPLOREM VERSIBUS ADDE ROREM
> SE PROBAT INDIGNUM REPROBANS DIADEMATE DIGNUM
> SIC HUNC QUEM REPROBAT SE REPROBANDO PROBAT.

Giovanni has encircled all the rivers and parts of the world endeavouring to learn much and preparing everything with heavy labour. He now exclaims: 'I have not taken heed. The more I have achieved the more hostile injuries have I experienced. But I bear this pain with indifference and a calm mind.' That I (the monument) may free him from this envy, mitigate his sorrow and win him recognition, add to these verses the moisture (of your tears). He proves himself unworthy who condemns him who is worthy of the diadem. Thus by condemning himself he honours him whom he condemns.

2. Account books recording bequests of Simone Martini

Archivio di Stato, Siena (Gabella Contratti, no.50, f.292v), published in the original Latin in Pierluigi Leone de Castris, *Simone Martini*, Milan, Federico Motta, 2003, p.370 (trans. Diana Norman).

When he died in 1344, the Italian painter Simone Martini (b.1284) left land, property, goods and money to close members of his family in his will. They then had to pay death duties to the Sienese government, which were recorded in an entry in the account books of the Gabella, the official body responsible for such matters. From this brief record, it is clear that Martini had acquired urban property (in Siena itself) and agricultural land and property just outside the city, a practice that was common among painters and other such skilled workers in fourteenth-century Italy. The value of this property was, however, relatively modest when compared to land owned by members of Siena's major banking and merchant families and valued at many thousands of pounds. In order to get a sense of the value of the painter's various bequests, it is worth noting that the annual salary of the treasurer of the Gabella was a hundred pounds, that of the city's official musicians only twenty pounds. A family of four would spend thirty pounds a year on bread and the cost of a horse would have been approximately sixty pounds. DN

On the last day of June, the twelfth indiction, in the year of our Lord 1344, Ser Geppo [son of] Ser Buonaiuto Galgano of Florence, drew up this will, as written below, namely that Master Simone Martini, painter, had agreed his will, and, among other things contained in the said will, he left to his wife, Joanna, his entire room, namely the bed in which they lay, and all the other objects, goods and hangings described in the will.

Item: he left the use and habitation of his house to the same [beneficiary], his wife, under the specific conditions described in the will. Valuation [made] of 200 pounds.[1]

On 3 August the said lady Joanna paid [to the Gabella] 3 pounds, 6 shillings and 8 pennies.

Item: he [Simone Martini] left to his niece, Francesca, daughter of the deceased Salvuccio, a piece of land planted with vines in Piano di Vico, valued at 95 pounds.

1. Sienese currency was organised in pounds, shillings and pence. Twelve pennies equalled one shilling, and twenty shillings equalled one pound.

The pound, however, was not a coin but an imaginary monetary unit used for accounting purposes.

Item: he left to the same [beneficiary] the use and habitation of the part of the house that the testator and his brothers bought from the heirs of Alesso, valued at 30 pounds.

Item: he left to the same [beneficiary] all the livestock and other goods, and another piece of land with vines in the neighbourhood of Vico, valued at 50 pounds.

On 11 August [the beneficiary] paid 2 pounds, 16 shillings.

Item: he left his niece, Joanna, [daughter of the deceased] Salvuccio, and wife of Agnotto, 10 florins.[2]

On 11 August [the beneficiary] paid the agreed sum of 8 shillings.

Item: he left and willed that Caterina, daughter of Donato, brother of the testator, first born of her sisters, is given a vineyard as a dowry that the testator owns with the said Donato and, in addition, the sum of 120 florins from the said testator's money.

On 11 August [the beneficiary] paid the agreed sum of 3 pounds, 6 shillings.

Item: he left and willed that the later born daughters of the said Donato, Agnola and Diambra, known as Landoccia, be given unplanted land and a vineyard bought from Vanno Signorini, whose residence is in Monasterio di Vico and, at the inclination of the said Donato, 80 pounds of his [Simone Martini's] money.

On 11 August [the beneficiary] paid 1 pound, 6 shillings.

In [respect of] all of his other moveable and immoveable goods, he makes his nephews, Giovanni, Barnaba and Simone, born of the same Donato outside legal marriage, his heirs. Valuation [made] of 50 pounds.

On 11 August [the beneficiary] paid 16 shillings.

2. During the fourteenth century the relative value between the gold florin of Florence and the Sienese pound fluctuated a great deal, but the florin was generally valued as slightly more than three pounds.

3. Attributed to Giovanni de Caulibus
Meditations on the Life of Christ

Meditations on the Life of Christ: An Illustrated Manuscript of the Fourteenth Century: Paris, Bibliothèque Nationale MS. Ital. 115, c.1346, trans. Isa Ragusa, ed. Isa Ragusa and Rosalie B. Green, Princeton, NJ, Princeton University Press, 1961, pp.15–20.

This text, which describes the biblical subject of the Annunciation, is part of a much longer devotional work, known as the *Meditations on the Life of Christ*. Addressed to a nun, it is now generally agreed that the author was Giovanni de Caulibus, a Franciscan friar, from the Tuscan town of San Gimignano, and that he wrote his *Meditations* around 1346. Most recently it has been proposed that the earliest surviving manuscript of the *Meditations* (from which this translation is taken) was produced around 1350 for the Franciscan convent of San Martino in Pisa. While the text of the meditation on the Annunciation suggests that Giovanni de Caulibus was writing for a literate audience familiar with the doctrinal complexities of the unified nature of the Trinity (the Father, Son and the Holy Ghost) and the miracle of the Incarnation (God made flesh in the person of Jesus Christ), its very direct form of address and passages of descriptive detail provide evidence of how fourteenth-century audiences were encouraged to imagine the event of the Annunciation taking place in front of their very eyes and within their own physical surroundings. Such acts of visualisation would have been aided by their recall of sculptures and paintings of this religious subject, such as *The Annunciation* altarpiece by Simone Martini and Lippo Memmi (c.1291–1356), now in the Uffizi Gallery in Florence. Conversely, devotional practice of this sort would have enhanced their appreciation of and emotional involvement with such visual images. DN

Here Begins the Meditation on the Life of Our Lord Jesus Christ and on His Incarnation

The time for the Incarnation of the Son, moved in His mercy by His love of the human race, entreated by the supernal spirits for the aid of the human race, as decided upon by the Supreme Trinity, had come. And since the Blessed Virgin had returned to Nazareth, the omnipotent God called the archangel Gabriel and said to him, 'Go to our beloved daughter Mary, wedded to Joseph, and dear to us above all creatures, and tell her that my Son, desiring her beauty, has chosen her as His mother. Beg her to receive Him with gladness, for I have ordered the salvation of the human race to be effected by her and will forget the injury done to me.' Let us pause here and remember what I told you in the beginning, that you must learn all

the things said and done as though you were present. Thus here you may imagine God and regard Him as best you can, although He has no body, beholding Him as a great God seated on a raised chair, with benign face, compassionate and paternal almost as though wishing to be or already reconciled as He speaks these words. And Gabriel with glad and joyful face, kneeling with bowed head respectful and reverent, received attentively the embassy of his Lord. Then he arose cheerfully and gaily and flew down from heaven and in a minute stood in human form before the Virgin, who was in a room of her little house. But his flight was not so swift that God did not enter before him, and thus the Holy Trinity was present, entering before His messenger.

For you must know that the exalted labor of the Incarnation belonged to the whole Trinity, though only the person of the Son was incarnated, as when one person is dressing with the aid of two others who stand at his sides holding the sleeves of the gown. Now give heed to understand everything that was said and done, as though you had been present. What a small house it was in which these Persons entered, and what events They caused! Although the Holy Trinity is everywhere, consider that at this time and place It was here in a singular way for a singular purpose. When the faithful emissary Gabriel entered, he said to the Virgin, 'Ave gratia plena; dominus tecum; benedicta tu in mulieribus' (Luke i, 28). 'Hail, you who are full of grace; the Lord is with you; blessed are you among women.' But she was perturbed and did not reply. It was not guilt that confused her or the sight of the angel, for she was accustomed to seeing him often. But according to the Gospel she was perturbed by his words, meditating on the innovation in his words, that is, his salutation, because he had not greeted her in that way before. Hearing herself thrice commended in this salutation, the humble woman could not but be disturbed. She was praised that she was full of grace, that God was with her, and that she was blessed above all women. Since humble persons are unable to hear praise of themselves without shame and agitation, she was perturbed with an honest and virtuous shame. She also began to fear that it was not true, not that she did (not) believe that the angel spoke truthfully, but that like all humble people she did not consider her own virtues but memorized her defects, always considering a great virtue to be small and a little defect very big. Therefore, because she was sagacious and cautious, modest and timorous, she did not reply at all. What should she have said? Learn by this example to remain silent and to love taciturnity, as this virtue is great and very beneficial. Twice she heard before she replied once, for a loquacious virgin is an odious thing. But the angel, recognizing the cause of her doubts, said, 'Do not fear, Mary, or feel shame at the praise I have spoken, for it is true; and you are not only full of grace but with it you have redeemed all mankind. Behold, you will conceive and give birth to a sublime Son, who has elected you to be His mother and who will save all who hope in Him.' Then she replied, neither

admitting nor denying the earlier praise but desiring to allay her doubts by ascertaining how she might not lose her virginity. Therefore she asked the angel about the nature of this conception, saying, 'How can this be, since I have firmly promised my virginity to my Lord who is God and may never at any time know a man?' The angel said, 'This will be by the Holy Spirit, who will pervade you in a singular way. By His virtue you will conceive and yet keep your virginity intact. And thus your son will be called the Son of God, for with Him nothing is impossible. Behold your kinswoman Elizabeth, old and barren, who conceived a son six months ago by virtue of God.'

Consider this for God's sake, contemplate how the whole Trinity is here, awaiting the answer and the consent of this unique maiden, considering her modesty and her manner and words with love and delight. See also how the angel wisely and assiduously introduces and chooses his words, kneeling reverently before his Lady with pleasing and joyful countenance and fulfilling his embassy faithfully. Attentively he heeds the words of his Lady, that he may reply appropriately and accomplish the will of God regarding this wonderful deed. And see how the Lady remains timorous and humble, with modest face, as she is accosted by the angel, not becoming proud and boastful after his unforeseen words, in hearing such wonderful things as had never been told to anyone before, but attributing everything to divine grace. Thus you may learn by her example to be modest and humble, because without these attributes virginity is worth little. But finally the prudent Virgin understood the words of the angel and consented, and, as is related in the aforementioned revelations, she knelt with profound devotion and, folding her hands, said, 'Behold the handmaid of God; let it be to me according to your word' (Luke i, 38). Then the Son of God forthwith entered her womb without delay and from her acquired human flesh, wholly remaining in His Father's bosom. Your devout imagination can now show you how, on assuming His painful mission, the Son bowed obediently and commended Himself to the Father. At that very point the spirit was created and placed into the sanctified womb as a human being complete in all parts of His body, though very small and childlike. He was then to grow naturally in the womb like other children, but the infusion of the soul and the separation of the limbs were not delayed as in others. Thus He was a perfect God as well as a perfect man and as wise and powerful then as now. Then Gabriel and the Lady both knelt and, when they rose after a few seconds, he bowed again to the ground. Bidding farewell to the Lady he disappeared and returned to his Home. He recounted everything and there was again joy and festivity and great exultation in heaven. Glowing with an even greater love of God than ever and feeling that she had conceived, our Lady knelt in happiness and rendered thanks to God for this great gift. With humility and devotion she prayed that He condescend to teach her about the events ahead of her that she might do without error whatever was necessary for the Son.

4. Instructions for a dramatic performance of the Annunciation in the cathedral of Padua

Biblioteca Capitolare, Padua, MS C. 56, ff.35v–38r, trans. Joseph Spooner, in Laura Jacobus, *Giotto and the Arena Chapel: Art, Architecture and Experience*, London and Turnhout, Harvey Miller Publishers, 2008, pp.375–6.

This text records the instructions for a dramatic performance of the Annunciation (Luke 1:26–38) and of the Visitation (Luke 1:39–56) known as the Golden Mass that regularly took place in the cathedral of Padua during the fourteenth century. Involving the participation of the clergy and lay men and boys, who between them took the roles of the Archangel Gabriel, the Virgin Mary, her husband Joseph, her cousin Elizabeth and her husband Zacharias (although the text mistakenly gives his name as Joachim, Mary's father), the performance appears to have combined music, speaking and acting. It provides further evidence of how fourteenth-century devotees and congregations were schooled in the various stages of this religious narrative and also encouraged to become emotionally involved in the event. This, in turn, must have enhanced their appreciation of artists' representations of the Annunciation, be they painted statues of the Virgin and the Archangel Gabriel or painted altarpieces and murals depicting the event of the Annunciation itself. DN

On the feast of the Annunciation after lunch at the usual hour, the great bell should be rung, and in the meantime the clerics should come to the church, and some of the clerics should prepare themselves in the larger sacristy with pluvials and other necessary items. And in the said sacristy Mary, Elizabeth, Joseph and Joachim should stand prepared, with a deacon and subdeacon, carrying silver books in their hands. And at the appointed hour they [Mary, Elizabeth, Joseph and Joachim] should leave the sacristy in procession and proceed to the places prepared for them. When they have gone, they [the deacon and subdeacon] should arrive in procession at the baptistery, where a boy dressed as Gabriel should be standing on a throne; the boy should be picked up and carried from the baptistery to the church from the square, and should be carried up the stairs towards the choir. And the clerics should stand in the middle of the church, like a choir; and in the meantime the subdeacon should begin the prophecy, that is 'The Lord spoke to Achac, saying'. When the prophecy is finished, the deacon should begin the gospel, that is 'The angel Gabriel was sent by God', until the point 'And the angel entered and said unto her'. Then Gabriel, on bended knee, with two fingers of the right hand raised, should begin the following

antiphon in an elevated voice: 'Hail Mary, full of grace, the Lord is with thee. Blessed are thou among women.' When the antiphon is finished, the deacon continues with the gospel to the point 'And the angel said unto her'. When this is finished, the angel, now standing, with right hand raised and fully open, should further begin the following antiphon: 'Do not be afraid, Mary; you have found favour with God. Behold, you will conceive and bear a son.' When the antiphon is finished, the deacon continues to the point 'But Mary said to the angel'. When this is finished, Mary should respond with the following antiphon in a clear voice: 'How can that be, angel of God, since I have not known man?' When the antiphon is finished, the deacon continues: 'And in reply the angel said unto her'; and the angel should further begin the following verse: 'Hear, Mary, Virgin of Christ: the Holy Spirit will come upon you, and the virtue of the most high will overshadow you.' But when he comes to the place, that is 'The Holy Spirit will come upon you', then a dove should be shown a little. When the verse is finished, the deacon should continue further to 'Yet Mary said unto the angel'. When this is done, Mary should stand up, and standing with open arms should begin in an elevated voice: 'Behold the handmaid (of the Lord).' Before the end of the said antiphon, the dove should be released, and Mary should take the said dove under her garment. (There should follow the) antiphon 'Behold the handmaid of the Lord; be it done unto me according to thy word'. When these things are finished, the deacon continues with the other gospel, that is 'Then Mary rose up and went to the mountains', up to 'And crying out in a great voice said'. Then Mary should come down from her position and should go to the position of Elizabeth and Joachim, and both of them should welcome her, as it says in the gospel. When this has been done, Elizabeth should kneel down and, touching the body of Mary with both hands, begin the following antiphon in a humble voice: 'Blessed are thou amongst women, and blessed is the fruit of your womb.' When the antiphon is over, Elizabeth stands up, and from her standing position should further begin the following antiphon: 'Wherefore should the mother of my Lord come to me? For behold, when your greeting reached my ears, the child in my womb leapt for joy. And you are blessed, Mary, because you believed; may the things told you by the Lord be accomplished in you.' When these things are finished, the deacon should continue further: 'And Mary said . . .' And Mary should turn herself towards the people, and sing in an elevated voice in the eighth mode the following three verses: 'My soul magnifies the Lord, and my spirit rejoices in God my Saviour. For He has regarded the low estate of His handmaiden. For behold, henceforth all generations shall call me blessed.' When these things have been sung, there should be one verse of response with organ, and from the chorus another in this manner, continuing until the end. And when these things are finished, they should all return to the sacristy.

Chapter 4
To the Holy Land and back again: the art of the Crusades

Angeliki Lymberopoulou

1. Eighty-second Canon, Council in Trullo

The Council in Trullo Revisited, eds. G. Nedungatt and
M. Featherstone, Rome, Pontificio Istituto Orientale, 1995,
pp.162–4 (no.82).

**The Council in Trullo (so-called because it was held in a domed hall)
took place in Constantinople in 692 under Emperor Justinian II (r.685–
95 and 705–11). Its 82nd canon declared that Christ should not be
represented as the Lamb of God anymore but rather in his human form,
because the bishops opted for 'grace and truth'. While the English
translation mentions 'artists', it should be noted that the original Greek
and Latin mention 'ζωγράφους' and 'pictores' respectively, that is
'painters'. AL**

That artists are not to portray the Forerunner pointing to a lamb.
In some depictions of the venerable images, the Forerunner is portrayed
pointing with his finger to a lamb, and this has been accepted as a
representation of grace, prefiguring for us through the law the true
Lamb, Christ our God. Venerating, then, these ancient representations
and foreshadowings as symbols and prefigurations of truth handed
down by the Church, nevertheless, we prefer grace and truth, which we
have received as fulfilment of the law. Therefore, in order that what is
perfect, even in paintings, may be portrayed before the eyes of all, we
decree that henceforth the figure of the Lamb of God who takes away the
sins of the world, Christ our God, should be set forth in images in human
form, instead of the ancient lamb; for in this way we apprehend the depth

of the humility of the Word of God, and are led to the remembrance of his life in the flesh, his passion and his saving death, and of the redemption which thereby came to the world.

2. Description of a miracle of St George

Saint Thècle, Saints Côme et Damien, Saints Cyr and Jean (Extraits), Saint George, ed. A.-J. Festugière, Paris, Editions A. & J. Picard, 1971, pp.313–15 (no.9) (trans. Angeliki Lymberopoulou).

A series of posthumous miracles performed by St George is described in this collection of stories about various saints. This extract narrates one that took place on St George's name day (a feast dedicated to the saint, celebrating his memory and his exemplary faith to God), in which St George saved a boy from the Greek island of Mytilene. The youth had been taken to Crete as a prisoner by Saracen pirates during one of the raids on his native island. The saint responded to the tearful entreaties of the boy's mother to release her son. The capture of Crete by the Saracens (Arabs) in the ninth century offers a *terminus post quem* for this narrative. Nikephoros II Phokas (r.963–9) reclaimed Crete for the Byzantine Empire in 961 and it is possible that such narratives became popular shortly after that date to reflect this strategically important re-conquest. AL

Another miracle (on the boy from Mytilene who was taken prisoner)
The miracle that took place in Mytilene was astonishing. In this island (Mytilene, also known as Lesbos) there is a very famous church dedicated to the great saint and martyr George. As customary, every year, on the feast day of the saint, a large crowd climb up to the church to celebrate the saint's feast day. One evening, at the time the celebrations were taking place, the Saracens of Crete attacked the inhabitants of the island. They tied up and captured all those who were in the church; most of those who were outside the church managed to escape, but they [i.e. the Saracens] managed to retain a few of them and took them to Crete. Among those there was a young boy who was offered to the emir by the Saracen who captured him.

When it was time again for the glorious martyr's feast day, the boy was about to serve the emir. His parents, who never stopped believing, whose hearts were not hardened by the fact that they had lost their son, but had placed their hope in the Saviour and thanked the saint, after having

celebrated his [St George's] feast, went (as was their custom) to call those who had been invited for dinner. In the meantime, the mother of the boy returned to the church and found herself alone there. She fell to the ground and entreated and begged the saint to deliver her son from captivity, with the means and the grace of almighty God. The saint, responding quickly and not despising the tears of the woman, went to Crete in a flash to rescue the boy and bring him back, safe and unharmed, to his parents. The woman [the boy's mother] finished praying, by which time dinner was ready, and her husband suggested a prayer to ask for the protection and help of the saint while the cup-bearers were getting ready to serve the wine. Then, with God's help (grace), a miracle took place, unheard of and extraordinary, almost unbelievable for those who are not familiar with the miraculous works of God; but if one looks at the story of Habakkuk and considers how he was carried by an angel in a wink of an eye from Jerusalem to Babylon (Daniel 14:33 ff.), then this miracle, too, in my opinion is not unbelievable.

At the same moment that the boy had poured wine into a cup and was about to give it to the emir on Crete, he miraculously found himself offering the wine to his mother in Mytilene instead. When they saw him the guests were astonished and asked him where he had been and how he came to be there among them. The boy replied: 'I had filled a goblet with wine to give to the emir on Crete, when suddenly I was lifted by a radiant man. I sat on his horse holding on tight with one hand and holding the cup with the other, and now here I am, as you can see, among you.' The whole company was astonished by his words and by this extraordinary spectacle. And they all rose from the table and spent the rest of the night chanting hymns in recognition of almighty God.

3. Wilbrand of Oldenburg
An account of Ibelin Palace, Beirut

J. Prawer, *The Crusaders' Kingdom: European Colonialism in the Middle Ages*, New York and Washington, Praeger Publishers, 1972, pp.451–2.

Today nothing survives from the Ibelin palace at Beirut, built by the Crusader noble John of Ibelin sometime after 1197, the year the Crusaders conquered Beirut. We can only imagine its luxury and artistic splendour by reading the surviving account of Wilbrand of Oldenburg (c.1180–1233, Bishop of Paderborn and of Utrecht, and later saint), who was in the Holy Land between 1211 and 1212 as a German imperial envoy. The following extract from Wilbrand's account, dated 1212, specifically mentions the multi-cultural artistic collaboration that went into its construction. AL

In one of those towers, newly constructed (in the city walls) we saw a most beautifully decorated palace, which I intend, as far as I can, to describe to you briefly. It is strongly built in a well-chosen place. On one side there is the sea with its trafficking ships, and on the other there are meadows, orchards and most pleasant surroundings. Its pavement is made of marble, which imitates water moved by a light breeze. And this is done so subtly that whoever treads on it feels as if he were wading, marvelling at not leaving any impression on the depicted sand. The walls are entirely covered by marble slabs in which ingenious work wrought various vases. The ceiling is so appropriately painted in the selfsame colour of the air that you seem to distinguish the floating clouds, here a zephyr breeze, there the sun, the year, the months, days, and weeks, hours and minutes moving in the zodiac. In all these, the Syrians, Saracens and Greeks take pride in the masterly art of an ever-changing marvellous work. In the interior of the palace, in the middle, there is a pool constructed of marble composed of pieces in various colours . . . They represent a variety of innumerable flowers. When the onlooker tries to discern them, they dissolve and convey an illusion. In the middle there is a dragon, who seems to inhale the animals depicted. He ascends from a crystal clear fountain that splashes water so abundantly that it rises into the air which streams in through a beautifully ordered window and in time of heat makes the air humid and cool. The water that overflows on each side of the pool drains through small openings and brings, through its quiet whisper, repose to the lords who sit around.

4. Letter from the Papal Secretariat to Eudes de Châteauroux, Bishop of Tusculum

E. Berger, *Les Registres d'Innocent IV, publiés ou analyses d'après les manuscrits originaux du Vatican et de la Bibliothèque Nationale*, vol.3, Paris, Ancienne Librairie Thorin & Fils, 1897, p.176 (no.6336) (trans. by Martin Davies).

This letter is included in the Registry of Pope Innocent IV (1195–1254). It was written by the Pope's secretariat and was addressed to Eudes of Châteauroux, Bishop of Tusculum (c.1190–1273). The Bishop had accompanied Louis IX of France (St Louis, 1214–70) on the seventh crusade, and came to Acre and to Tripoli, where he was displeased (to say the least) to discover the use and mention of the name Muhammad on coins struck and used by Christians. Responding to a letter from the Bishop in which he expressed his opposition to the practice, the Papacy (i.e. Innocent IV) agrees with the objection and endorses the ban of such coins. AL

Let the Bishop of Tusculum [Eudes of Châteauroux], legate of the Apostolic See, ensure that the sentence of excommunication passed on those who inscribe the name of Mohammed and the Mohammedan era on bezants and drachmas, or who cause it to be done, is observed without breach.

To the Bishop of Tusculum, legate of the Apostolic See.
In the report passed on to us you have shown that when it had come to your attention that the bezant and drachma coins made by Christians in the cities of Acre and Tripoli were being inscribed with the name of Mohammed and the number of years since his birth, you promulgated a sentence of excommunication against all those who were inscribing the name and number on the said bezants and drachmas, variously in gold or in silver, or causing it to be done in the kingdom of Jerusalem, principality of Antioch and county of Tripoli. You have accordingly sought to obtain from us the required confirmation and endorsement of the sentence. Mindful that it is not merely disgraceful but abominable to commit a blasphemous name of this sort to such a solemn record, we therefore order that by our authority the sentence should be inviolably observed without right of appeal.
Issued at Perugia, 12 February 1253

5a. Qāḍī ʿIzz al-Dīn Muḥammad Description of Jerusalem
5b. Anonymous Letter regarding the conquest of Craq des Chevaliers

Ayyubids, Mamlukes and Crusaders: Selections from the Tārīkh al-Duwal waʾl-Mulūk of Ibn al-Furāt, 2 vols., trans. U. and M.C. Lyons, vol.2, *The Translations*, Cambridge, W. Heffer and Sons Ltd, 1971, pp.60, 201–2, 146.

The first passage (5a), dated 1262–3, gives a brief topographical description of the city of Jerusalem. The second (5b), dated 1270–1, is a letter regarding the conquest of the famous Crusader castle, Craq des Chevaliers, in Syria. In both accounts the point of interest lies in the fact that the Muslim narrators praise the architecture of the Church of the Holy Sepulchre and the decoration of Craq respectively. In the latter case the admiration is all the more remarkable, since it took place at a time of war and siege. AL

5a

The following account was given by the Qāḍī ʿIzz al-Dīn Muḥammad b. ʿAlī b. Ibrahīm Ibn Shaddād al-Ḥalabī in his work Al-Aʿlāq al-Khaṭīra fī Dhikr Umarāʾ al-Shām waʾl-Jazīr. He said:

‘In our time, the city of Jerusalem is like this: it stands on a hill and one can climb up to it from all sides. It is a long city with, at its west end, the Gate of the Miḥrāb, this being the one on which is the Dome of David – on whom be peace – while at its east end is the Gate of Mercy. This is kept closed, only to be opened at the Festival of the Olives. On the side of the Miḥrāb it has a gate known as that of Sion, while to the north is the so-called Ghurāb Gate.[1] Those who enter by the Gate of the Miḥrāb go eastwards along a narrow street leading to the main church known as that of al-Qiyāma (Holy Sepulchre) which the Muslims call Qumāma. The architecture of this church is amongst the wonders of the world. . . .’

1. These gates are now known as: Bāb al-Khalīl (Gate of Hebron) or Jaffa Gate; the Golden Gate of which Bāb al-Raḥma (Gate of Mercy) forms one of the two arches; Bāb al-Nabī Dāʾūd (Gate of the Prophet David) or Sion Gate; and Bāb al-ʾAmūd (Gate of the Pillar) or Damascus Gate. This last Gate was St. Stephen's Gate to the Franks and to contemporary Arab historians Bāb ʾAmūd al-Ghurāb (Gate of the Crow's Pillar). [. . .] The Festival of Olives is Palm Sunday.

5b

An account giving some information about Ḥiṣn al Akrād (Crac des Chevaliers) and its conquest.

This fortress in former times used to be called Hisn al-Safḥ. As to why it is linked with the Kurds (al-Akrād), Muntakhab al-Din Yaḥyā Ibn Abī Ṭayy al-Najjār al-Ḥalabi tells us in his History how the emir Shibl al-Daula Naṣr b. Mirdas, the ruler of Homs, settled some Kurds in it in the year 422 (1030–1) and it was then named after them. During the time of the Atabek Ṭughtakīn's rule in Damascus, a truce was made between him and the Franks, on condition that Ḥiṣn Maṣyāf and Ḥiṣn al-Akrād should be included in the peace terms, with their inhabitants paying out a fixed sum of money each year to the Franks. This arrangement held for a while. But Ibn ʿAsākir tells how Raymonf of St. Gilles (Ṣanjīl), may God Almighty curse him, after he had come down against Syrian Tripoli, kept on launching raids on Ḥiṣn al-Akrad and other fortresses near it; and then in the year 496 (1102–3) he marched against it and laid seige to it. He pressed it hard and was on the point of taking it when it happened that Janāḥ al-Daula, the ruler of Homs, was killed. Raymond was eager to take Homs, so he left Ḥiṣn al-Akrād, but then, as it chanced, he died. He was succeeded by his son Bertrand (Badrān) who followed his father's course in trying to damage this fortress and in laying waste its lands, so that its inhabitants were in fear of him. But then he set off to lay seige to Beirut, and Tancred (Ṭanklī), the ruler of Antioch, came out and took possession of most of those lands, being given a flattering welcome by the Syrians. He came down against Ḥiṣn al-Akrād when its garrison was in a state of extreme weakness, and its commander surrendered it to him, hoping to be left there as he had preferred Tancred to Bertrand of St. Gilles (Ṣanjīl). But Tancred brought out its inhabitants and took the commander with him, stationing a Frankish garrison there to hold the fortress. This is the end of Ibn Asākir's account.

According to another version, Tancred (Ṭankrīd), the ruler of Antioch, set out from Antioch and, after he had come down against Ḥiṣn al-Akrād, it was surrendered to him by its garrison in the latter part of the year 503 (1110). It stayed in Frankish hands until the events which we shall relate, if God Almighty wills.

Ibn Munqidh, in the Kitāb al-Buldān, tells that al-Malik al-ʿĀdil Nūr al-Dīn Maḥmūd al-Shahīd, the ruler of Syria – may God be pleased with him – had made an arrangement with one of the Turkman soldiers serving with the Franks who held Ḥiṣn al-Akrād, this being that when he came to it the Turkman and a number of his companions in the fortress should stage a rising and hoist his standard there, crying out his name. For this man had sons and brothers who were in the confidence of the Franks in the fortress. The signal arranged between him and Nūr al-Dīn was that he should stand at the top of a bāshūra.[i] As it happened, Nūr al-Dīn did not tell anyone about

this arrangement, so that when the troops advanced and saw the Turkman, they shot him dead. His relatives were distracted by his death and as a result the stratagem came to nothing. Ḥiṣn al-Akrād was not among Saladin's Frankish conquests, and it remained in the hands of the Franks until Sultan Baibars attacked Tripoli in this year, as we have already told.

On the 9th of the month of Rajab al-fard in this year (21 February 1271), the Sultan came down against Ḥiṣn al-Akrād, and on the 20th (4 March) the rabaḍs[ii] were taken. Al-Malik al Manṣūr, the ruler of Hama, arrived with his army and, as he was on foot, the Sultan met him on foot and then rode beneath his banners, with no jamdārīs[iii] and no silāḥ-dārs[iv] out of courtesy towards him; he had a dihlīz[v] despatched to him which he ordered to be erected. Then the emir Saif al-Dīn, lord of Ṣahyūn (Saone), arrived, as well as the chief of the Isma'ilis, al-Ṣāḥib Najm al-Dīn.

At the end of Rajab (14 March), they finished setting up a number of mangonels, and on the 7th of Sha'ban in this year (21 March) the bāshūra was stormed. A place was made for the Sultan from which he could shoot arrows; and he began to distribute gifts of money and robes of honour. On the 16th of Sha'ban (30 March), a breach was made in one of the towers of the citadel and the Muslims advanced up to the citadel and took it, while the Franks retired up to the keep. A number of Franks and Christians were brought in but the Sultan let them go as a charitable gift in the name of al-Malik al-Sa'īd. The mangonels were then moved to the citadel where they were set up against the keep, and the Sultan wrote letters to the garrison of the keep purporting to come from the Frankish leader in Tripoli ordering them to surrender. Thereupon, they asked for a safe-conduct which was written out for them on condition that they should go to their own territory. On Tuesday, the 24th of Sha'ban (7 April), they came out and were sent off to their own lands, while the Sultan took possession of the fortress. A letter was then written to the Master of the Hospitallers, the owner of Ḥiṣn al-Akrād, giving the good news of this victory. It ran as follows:

'This letter is sent to Frère Hugh (Revel) (Ifrīr Ūk) – may God make him one of those who do not oppose destiny nor rebel against Him who has made victory and conquest the servants of his army: may he not be one who believes that precautions can save men from God's decree, or that the confines of buildings or structures of stone are a protection against it. We bring the news that God has granted us an easy conquest of Ḥiṣn al-Akrād. You fortified it, built it up and adorned it, but you would have been more fortunate had you abandoned it. You relied on your brothers to preserve it, but they were of no avail to you. You lost them by making them stay there, as they lost it and caused your ruin. No fortress can hold out when these Muslim armies come down against it, and as they serve a 'fortunate' man (Sa'īd) they cannot be unlucky.'

i. Tower barbican (outer fortification).
ii. Outskirt.
iii. Sword-bearer.
iv. Esquire, armour bearer.
v. Royal tent.

6. Bianca Kühnel
'The Local Character of Crusader Art:
A Re-definition'

Bianca Kühnel, *Crusader Art of the Twelfth Century:
A Geographical, an Historical, or an Art Historical Notion?*,
Berlin, Gebr. Mann Verlag, 1994, pp.164–8.

**In this extract, Bianca Kühnel addresses an interesting and
complicated question – that of the 'local' character of the art of the
Crusades. Within this question she also tackles the issue of the
anonymity of the 'Crusader artist'. The extract encourages further
thought and discussion on a rather problematic subject. AL**

Not much has been said so far about the Crusader artist. His identity is
one of the main preoccupations of earlier research on Crusader art. The
few attempts made up to now to define Crusader art as a local art have
also been based essentially on the alleged local identity of the artists, great
effort being directed to demonstrate their very existence through written
evidence. These attempts have included the detection of historical,
circumstantial evidence of the work of indigenous Christian artists in
pre-Crusader times. However, an over-intensive dealing with problems
of identity distracts attention from what should be the major goal of any
study trying to outline a school of art, namely the definition of its profile
and character. The obstinate hunt for the ethnic identity of anonymous
artists and the emphasis on historical and religious circumstances that
could be seen to testify to indigenous artistic activity, mean bringing the
background into focus and leaving the monuments in shadow.

Crusader works do give us a few direct hints concerning the 'identity'
of their makers. Those hints are names: Ephraim, Basil. Only the Syriac
inscription in Bethlehem reveals more than a name: Basil the mosaicist
was a deacon. And he knew Syriac, which had a much narrower
distribution than Greek, a fact contributing to a closer characterization
of our artist's personal background. But what about his artistic education,
career, biography? What about the other artists, who did not inscribe
their names, or whose names have not survived to trouble or enlighten
us? The architects, the builders, the sculptors in stone and in ivory, the
artisans of the 'souvenir'-industry (crosses, ampullae, etc.)? In those few
cases where they are known, the names of medieval artists are matters
for speculation and points of departure for arbitrary denominations
of schools. They rarely help to characterize works of art or reconstruct
their artistic appurtenance.

It is therefore preferable, because closer to medieval anonymity, to speak of Crusader ateliers. This would provide the proper framework for a scenario which speaks for the bringing together, for shorter or longer periods, of artisans from various places and with various training, in a fruitful artistic encounter. During the twelfth century the Holy Sepulchre undoubtedly housed the most flourishing and influential Crusader scriptorium, a bureau of architects, and at least three other workshops, one responsible for the wall mosaics, one for stone carving, and another for ivory and metalwork, producing portable liturgical objects. The fact that we were able to find parallels between ivories and metalwork, together with the shared Muslim sources, suggests a common workshop.

A workshop responsible for church furniture, marble and stone carving existed on the Temple Mount. At an earlier stage it might also have been responsible for the Mount of Olives work, given the similarities between some re-used El Aqsa and Qubat-al-M'iraj capitals and those of the Ascension. Bethlehem had its own atelier for wall paintings and mosaics, functioning for a rather lengthy period and, probably, also an atelier for stone carving, given the peculiar capitals of the cloister. This workshop may have shared some of its leading artisans with Abu Gosh, their presence connected with Manuel Comnenus' involvement in the decoration of the Nativity basilica. In Galilee, three different ateliers for stone carving possess a profile of their own during the twelfth century: Nazareth, Belvoir, and Acre. All of them have strong Romanesque affiliations to different schools of Romanesque art: Burgundy and the Rhône Valley, Provence, Northern Italy. These ateliers show no apparent links with each other, nor a continuity toward later periods or different environments. These features are completely opposed to those observed for the Jerusalem region. Two explanations are possible: a. considerably fewer Crusader monuments are left standing in Galilee than in the Jerusalem area, so that an overall appreciation is impossible; b. Galilee possessed no centre with the radiant power and stability of Jerusalem.

All the Crusader monuments around Jerusalem show a combination of Western Romanesque and Oriental-Byzantine-Muslim elements. Certain media show clear preponderances: the monumental sculpture is more inclined towards the Western Romanesque, the monumental painting and mosaic toward the Eastern Byzantine. The minor arts, including manuscripts and icons, as far as I can judge at this moment of only partial knowledge, were closer to a real mingling of diverse sources than any monumental medium, up to the point of concealing the origin of the artist, or, of revealing the true nature of Crusader creation.

The Western element came from the lands of origin of the Crusaders, or from their route to the Holy Land. Poitou-Charentes fits the first possibility, while Apulia and Abruzzi more probably belong to the second.

Specific occasions causing the migration of sources of influence and/
or artists to the Latin Kingdom are sometimes obvious. Such was the
connection between Fulk, Fontevrault, and Jerusalem around the year
1129, a connection which makes possible the dating of the Ascension
capitals. However, most of the sources of influence must be outlined
almost exclusively on the basis of stylistic similarities operating within
the borders of a plausible conjectural historical background.

Byzantine elements are not only historically possible, but are
sometimes safely and specifically documented. The presence of Manuel
Comnenus in Bethlehem, for example, is witnessed by the bilingual
mosaic inscription of which significant fragments still exist. The style
of the Abu Gosh wall paintings, so similar to those of the St. Neophytos
monastery church in Cyprus and those of St. Panteleimon in Nerezi,
Macedonia, is a no less clear proof of their appurtenance to the Comnenian
dynamic phase of twelfth century Byzantine art. The same is true for
the mosaics and part of the column paintings in the Nativity church in
Bethlehem, which show significant similarities with mosaics and wall
paintings in Sicily and Cyprus. The figures of the six emperors on the
back cover of Queen Melisende's Psalter and the New Testament scenes
in the manuscript itself are very clear iconographic evidence of Byzantine
influence. Although sometimes only Byzantine-provincial parallels are
available and the visual evidence is not always backed up by explanatory
inscriptions, the Byzantine influence was clearly present in the Crusader
Latin Kingdom of Jerusalem.

The very diversity in the parallels cited to demonstrate the presence
of the Muslim element in Crusader art suggests that it might have been
of twofold origin: external and local. The Cordoba caskets and the South
Italian ivories point towards Muslim influences coming from outside,
a plausible scenario in view of the fact that Western Romanesque art
was in itself very much aware of Muslim art. On the other hand, a local
Muslim component of Crusader art could have been stimulated either by
previously existing monuments, like the Dome of the Rock and El Aqsa
buildings and mosaics, or by Muslim artists working with the Crusaders,
as indicated by a certain continuity transmitted to Mamluke metalwork,
which reflects some of the features in the Melisende bookcovers.

If we accept the possibility of all these influences reaching Jerusalem
separately and mingling on the spot, then we must suppose the existence
of large ateliers, extending their activity over long periods and absorbing
a variety of artists and model books. Large ateliers possess the ability
to create and maintain a tradition, which does not necessarily mean
uniformity. The leading forces guiding these ateliers certainly changed
from time to time, according to the power and wishes of their patrons,
or according to their own abilities in certain media, or even due to more
trivial circumstances. The joint Temple Mount and Mount of Olives atelier

is a good example of such vicissitudes of fate. This atelier was dominated in the thirties and forties by artists from Fontevrault brought by Fulk, and in the late seventies and early eighties by Apulian artists. The Bethlehem and Abu Gosh workshops were dominated during the sixties by Byzantine or Byzantine-trained artists brought by Manuel Comnenus. However, earlier in Bethlehem (the earliest dated column painting is from the 1130s), western or/and local painters had already started to shape the Crusader decoration of the basilica and they continued their participation in the 1160s, as witnessed by the latest column paintings and the Syriac mosaic inscription. The Crusader element was in any case very important, bridging the gap between the various directions of influence and anchoring them in the Bethlehem soil. Its leading force was Bishop Radulphus, a churchman of English origin, deeply involved in the process of building up diplomatic relations with the Byzantine Empire. On the other hand, his English origins, as well as those of another prominent Crusader churchman, William, Patriarch of Jerusalem, are probably responsible for some English presence of artists or movable objects in Jerusalem during the thirties and forties. Various elements of possible English origin are visible in the manuscripts and ivories of the Holy Sepulchre ateliers.

The element of continuity and unity in this apparently chaotic artistic life of the Crusader kingdom, as it emerges from the tentative reconstruction above, was assured by the general sensibility towards the loca sancta and by the obvious attention accorded to their artistic history and appearance. This attention must therefore be understood as an act of will, a conscious effort to mold artistic training according to conditions and traditions existing on the spot. The same effort also implied an enhanced adaptability to Byzantine and Muslim taste on the part of some Western artists, as demonstrated in Queen Melisende's Psalter and its book-covers, as well as in the Crusader icons. The receptivity of the Crusader artist, whatever his place of origin or his training, towards Eastern sources, Byzantine, Muslim, or local, went far beyond that of contemporary Western artists working in the West. All these factors together confer its specific character upon Crusader art.

However, another possible interpretation of the same facts is possible. All the sources of influence labelled and documented as Byzantine, provincial-Byzantine, local early Christian, and Muslim, may be considered as one, local. They may well be separate features with a common denominator, different aspects of a Christian school of art existing with no interruption from the early Christian period, during and in spite of the long Muslim occupation of the Holy Land, and experiencing a revival with the re-establishment of Christian rule over the holy places. The driving force behind the preservation of a Christian artistic presence in the Holy Land before the Crusades would naturally be local Orthodox

Christianity under the Byzantine Protectorate. And, again naturally, while living among and working with Muslims, they must have been impressed and influenced by the shining beauty, the elegance and sophistication of Muslim objects and ornaments. So we can easily imagine that when Christian rule was renewed in Jerusalem and the arts flourished in the service of the new masters, the local Orthodox Christian artists were enrolled. Perhaps not immediately after the conquest, but after a little while, and in cases where local skill was needed, either because Western artists were not always sufficiently available, or because the locals had particular crafts unknown in the West, and therefore especially attractive.

However seductive and logical this theory may seem, it cannot, at the moment at least, go beyond the theoretical level. The only evidence to support it is circumstantial, belonging either to history or church history. We almost completely lack any direct art historical evidence. The eleventh century cross-in-square churches are too poorly documented, archaeologically as well as historically, to allow us a glimpse into their planning or construction processes. In those cases where certain documentation is available, there are clear indications of foreign involvement: the Monastery of the Cross and its church were commissioned by the Georgian Christian community; the reconstruction of the Holy Sepulchre church was probably carried out by Byzantine architects, while our knowledge of its decoration is indirect, from written sources, and therefore limited to iconography. The still extant eleventh-century mosaics in the dome of El Aqsa are somewhat more relevant to the Crusader mosaics of Bethlehem than are the Ummayad mosaics of the Dome of the Rock or of the Great Mosque in Damascus. The stone relief on the reverse of the Holy Sepulchre lintel is too isolated and unsure in dating to be useful. The situation today is that we have a very fragmentary knowledge of the art exercised by the Christians, and a still poorer knowledge of Muslim art in the Holy Land during the period between the eighth and twelfth centuries. It is too large a gap to be bridged by theories. On the other hand, the lack of visual proof does not in itself negate the possibility of the existence of a local Christian school of art continuously active from the fourth to the twelfth century, open to various influences caused by changing historical conditions, and undergoing a renaissance with the Crusaders. But the lack of visual evidence to support the alleged uninterrupted existence of Christian artists in the Holy Land during the Muslim domination cannot just be disregarded.

It seems to me more correct to baptize the various ingredients of Crusader art with names reflecting their respective appurtenances, which can be documented, and seek the local character of Crusader art in its local roots and not in hypothetical attributions to putative locally-bred artists of an unbroken tradition. As we have seen, 'local' does not necessarily and exclusively mean local artists, but mainly local past, local interests, local

beliefs. This definition of the local character of Crusader art may be much more productive than the search for lost identities or indirect, written proofs of artistic activities. Its advantage consists in giving priority to monuments, weight to their similarities and dissimilarities, preference to form and style, and importance to content and intrinsic message.

Part 2 The shifting contexts of Renaissance art

Introduction

Angeliki Lymberopoulou

This second part presents texts that are relevant to the period generally known as the Renaissance. Originally associated with Italy in the fifteenth and sixteenth centuries, the Renaissance has recently been reinterpreted as a pan-European phenomenon with fluid chronological and geographical boundaries, and this is partly reflected in the selection of the texts.

Chapter 5 engages with art at court, and the first text associated with this theme harks back to ancient Greece. Written by the Greek philosopher Aristotle, it examines how the concept of magnificence is understood and how it is put into practice. Its relevance lies in the fact that 'magnificence' was a central issue in the Renaissance among the upper and ruling classes and, therefore, influenced the nature of artistic production and commissions: it was deemed appropriate to spend wisely and within acceptable parameters to achieve this ideal. Hence the Dutch humanist Desiderius Erasmus, writing many centuries later and driven by the desire to help the future Emperor Charles V to achieve magnificence as a ruler, wrote a text that adopted and adapted Aristotle's main points within his contemporary social context. Erasmus believed that a good ruler should rely on his actions and not on visual reminders of himself (sculptures, for example) in order to promote a positive image. By contrast, the sculptor Leone Leoni strongly supported visual reproductions such as sculpture as an important complement to a ruler's actions. It is hardly surprising that an artist, whose living was dependent on commissions, would favour the notion of reproducing a ruler's likeness. It is further possible, however, that this opinion is related to the appreciation and praise of artistic excellence. Whereas the artistic skill and high quality of production involved in the creation of a work of art had always been important factors, the acknowledgement of the expertise of the artist who created it was a concept that was developed in the Renaissance. It is clearly reflected in Leoni's letters, where one can detect the pride of an artist in

his creation, as well as in the letter written by Aretino, who concurs with Leoni's opinion of the sculptor's skills. The appreciation of artistic skill and quality is also touched upon in the text that suggests a non-European context for the Renaissance. The Spanish historian Bernal Díaz praises the creations by Mexican artists of the period producing work outside the 'familiar' European Renaissance geographical boundaries. In so doing he offers a wider perception of art appreciation as well as a wider angle for comprehending the 'Renaissance'.

The next chapter focuses on texts regarding Sandro Botticelli and his art. Writing some forty years after the artist's death, Vasari included the celebrated early Renaissance artist in his *Lives of the Most Excellent Painters, Sculptors, and Architects*. Despite Botticelli's fame during his lifetime, Vasari was the major source of information on the painter over the following centuries. The Victorian Walter Pater's essay on Botticelli, probably based on personal preferences and far removed from what we presently associate with a scholarly work, was nevertheless pivotal in reviving interest in the artist, who today ranks as one of the best-known artists and representatives of the Italian Renaissance. One could argue that a similarity exists between Vasari's and Pater's writings in their approach to the artist's work through their personal response. One could further suggest that, to an extent, these preferences also reflect their respective geographic and social circumstances, which tend to influence how artists and their work are viewed and received.

Examining for whom, where, why and when a work of art was commissioned has been an important aspect of art historical research that allows us to understand artworks better by reconstructing the context in which they were created. The next section explores the role and social standing of women during this period, offering another perspective on comprehending the Renaissance. The exhibition *At Home in Renaissance Italy* at the Victoria and Albert Museum, London, in 2006, engaged with the position of women within their own homes, which offered an illuminating reflection of their social standing. But how did women relate to the visual arts as buyers, viewers, users and owners in this period? A useful group of sources comprises handbooks on social conduct advising women on the kinds of objects they should surround themselves with. One text, however, suggests that the concept of 'magnificence' may not have been applicable to women, whose social identity is distinctly different from that outlined in Aristotle's text. This is hardly surprising when we consider that a different set of social rules governed the conduct of women in this era.

Contracts and letters form a distinct category of sources, and offer insights into how and why women commissioned works of art. Contracts tended to state, in the words of a notary, exactly what was required by female patrons from the artists they employed. The Poor Clares (Franciscan nuns) of Santa Maria di Monteluce in Perugia were able

to decide what artworks were needed for their convent and acquire
it accordingly. Women of the ruling class were also able to state their
artistic preferences (and thus demonstrated the level of their education
and knowledge) in letters addressed to the artists, although one should
bear in mind that many such letters were written under the guidance
of advisers, another indication of the limitations society at the time
imposed on women.

The final chapter in this selection of texts concerns the artist born
Domenikos Theotokopoulos on the island of Crete, better known as El
Greco. His case reflects how much the Renaissance changed the social
status of the artist as well as artists' perception of the value of their
profession. El Greco lived and worked during an era that was consolidating
the artistic changes that had begun with the Renaissance. Appropriately,
in the first text we read that the confraternity of painters in El Greco's
home town, Candia, the capital of Crete and now known as Herakleion
(or Heraklion, or Iraklion), raised serious objections to the Venetian
authorities on the island that the confraternity of sailors should precede
them in the annual procession of the Catholic feast of the Corpus Domini.
The sailors played a crucial role in the naval empire of Venice, and were
entrusted with the banner of the patron saint of Venice, St Mark, during
the procession; this objection therefore reflects the increasing confidence
of artists of their elevated place in society. The incident took place roughly
ten years after El Greco had left Candia for Venice, since the document
included here negotiating the auction of one of his paintings is generally
considered as evidence that he was raising money for his impending trip.
Nevertheless, this would have been the context within which El Greco was
trained: the artists' confident objections probably reflect the current state
of affairs not only in the capital of Crete, but also in the wider European
artistic community.

By the time El Greco arrived in Venice in around 1567, Titian had
already acquired the reputation as one of the foremost artists of his time.
It is not surprising, therefore, that El Greco would have been eager to
stress any association he may have had with the great Venetian master. An
example of this is offered in a letter of reference written by Guilio Clovio,
an artist and friend of the Cretan, used to introduce El Greco to wealthy
Roman patrons. By the time El Greco was in Venice, Titian was rather old,
however, and it is questionable whether he would have been either able
or willing to personally oversee the training of young students. El Greco's
appreciation of Titian's skills as a colourist is crucial to our understanding
of what could be perceived as bold and arrogant statements by the Cretan:
his claim that he would have been able to create a Last Judgement to rival
Michelangelo's depiction of the subject in the Sistine Chapel,[1] as well as his
statement to the painter and writer Francisco Pacheco that Michelangelo

was a good man but he did not know how to paint. These comments should be regarded as expressing a conscious artistic choice. Vasari's narrative indirectly confirms this: El Greco, as a follower of Titian and of the Venetian school, valued colour over drawing, whereas the latter skill lies at the core at the Florentine Michelangelo's approach to art.

El Greco's current reputation derives predominantly from his Spanish works, which were often surrounded by controversy at the time. His talent was, nevertheless, recognised and praised by some of his contemporaries. José de Sigüenza, for example, acknowledges that some were of the opinion that El Greco produced excellent work. Considering that Sigüenza was not favourably disposed towards the artist, his statement could be viewed as further proof of the social appreciation of artistic skill and talent, echoing the letters of Leoni and Aretino. Finally, Roger Fry's text on El Greco, clearly addressing a knowledgeable audience, is an attempt to question El Greco's 'uniqueness'. To an extent, Fry, like Pater a generation before, expresses personal preferences as well as contemporary social perspectives on art.

It may, perhaps, seem limiting to the modern reader that these changes during the Renaissance principally concern the white male component of society at the time. There is little question that women were lagging behind, as the list of famous female artists is much shorter than that of their male counterparts. At the same time we should not underestimate the significance of the changes in the role of women as patrons and men as artists that these extracts reflect. The fact is that the Perugian nuns *did* have some control over their environment – indeed, women were patrons of art despite the limitations that contemporary society had imposed on their sex. Equally, Fry's attempt to compartmentalise El Greco's art and place it within a wider context of artistic development partly carries the risk of not allowing Fry's (and subsequent) audiences to grasp fully the artist's 'boldness' during his own time. However, El Greco's attitude towards his own art and his style of living may well be compared with present-day artist 'stars'. It is changes within defined contexts like the world in which El Greco lived and worked, that eventually led to groundbreaking shifts in the role and public perception of the artist.

1. Michelangelo carried out the fresco decoration on the ceiling of the Sistine Chapel between 1508 and 1512, while his Last Judgement on the altar wall was executed between 1536 and 1541; this work is one of the most influential, widely reproduced and best-known examples of Renaissance art. See *Michelangelo: La Cappella Sistina. Documentazione e Interpretazioni*, vol.1, Vatican City, Tokyo, Novara, 1994; *Michelangelo: La Cappella Sistina. Rapporto sul restauro degli affreschi della volta*, ed. F. Mancinelli, vol.2, Vatican City, Tokyo, Novara, 1994*; Michelangelo: La Cappella Sistina. Atti del Convegno Internazionale di Studi Roma, marzo 1990*, ed. K. Weil-Garris Brandt, vol.3, Vatican City, Tokyo, Novara, 1994.

Chapter 5
Art at court

Kim Woods

1. Aristotle
Nicomachean Ethics

Aristotle, *Nicomachean Ethics*, ed. and trans. Roger Crisp, Cambridge, Cambridge University Press, 2000, pp.65–7.

The Greek philosopher Aristotle (384–322 BCE) was one of the most influential thinkers during the Middle Ages and Renaissance. His *Nicomachean Ethics,* so-called because they are thought to have been edited by Aristotle's son Nichomachos, constitute an exploration of the exercise of moral and intellectual virtue, which Aristotle identified as most conducive to human good. The date at which they were written remains uncertain. In the section on magnificence in Part 4, Chapter 2 of Aristotle's book, he considers moral virtue in relation to money. Aristotle defines magnificence as a fitting liberality of expenditure in order to achieve something noble and worthy of admiration. The rules for honourable expenditure are contingent upon social rank, he argues, and should be appropriate to the object of that expenditure. This is a text often cited in relation to the elite material culture of Renaissance Italy, but the *Ethics* were well known during the Middle Ages and arguably also applied to court culture elsewhere in Europe. KW

Next in order of discussion would seem to be magnificence, since it also seems to be a virtue concerned with wealth. Unlike generosity, however, it covers not all those actions concerned with wealth, but only those concerned with heavy expenditure; and in this it surpasses generosity in its large scale.

For, as its name (*megaloprepeia*) implies, it is expenditure that is fitting in its large scale (*megathei prepousa*); but the scale is relative, since the expense of equipping a trireme [warship] is not the same as that of being chief ambassador in a state delegation. What is fitting, then, is relative to the agent, to the circumstances, and to the object.

If someone spends on small or ordinary matters what they merit, as in the line, 'Many times I gave to a wanderer',[1] he is not called magnificent, but only if he does this in important matters: while the magnificent person is generous, this does not mean that the generous person is magnificent.

The deficiency of this state is called niggardliness, and its excess vulgarity, lack of taste and the like, which are excessive not because of the largeness of the amount spent on the right objects, but because of ostentatious expenditure on the wrong things and in the wrong way. These vices we shall discuss later.

The magnificent person is like an expert, since he can see what is fitting and spend large amounts with good taste. As we said at the beginning, a state is determined by its activities and its objects; the expenditures of the magnificent person will be large and fitting; so too, then, are the results, since this will make the expense large and fitting to the result. So the result should be worthy of the expenditure, and the expenditure worthy of the result, or even in excess of it.

The magnificent person will spend such amounts for the sake of what is noble, since this is a feature common to the virtues. Again, he will do it with pleasure and lavishly, because precise counting of the cost is niggardly; and he will think more about how he might achieve the most noble and fitting result than about the cost or the cheapest way to produce it.

The magnificent person, then, must also be generous, since the generous person too will spend the right amount in the right way. But it is in meeting these criteria that we see the greatness, the largeness of scale, of the magnificent person, these being the things with which generosity is concerned, and he will produce a more magnificent result even at the same expense. For the virtue of a possession is not the same as that of an achieved result; the most honourable possession is that which is worth most, such as gold, while the most honourable result is that which is great and noble, because the contemplation of such a thing excites admiration, and what is magnificent excites admiration. Virtue in an achieved result on a large scale – that is magnificence.

Magnificence is found among the sorts of expenditure we call honourable, such as those connected with the gods – votive offerings, temples, and sacrifices – and similarly those concerning religion as a whole; and all those that are appropriate objects of public-spirited ambition, such as when people somewhere decide that a splendid chorus or warship or feast for the city must be provided.

1. Homer, *Odyssey* xvii.420.

But in all cases, as we have said, the expenditure is to be seen as relative to the identity and resources of the agent; the amounts should be worthy of these, and fitting not only for the result but also for the person bringing it about. So a poor person could not be magnificent, because he does not have resources from which he can spend large sums in a fitting way; and anyone who tries is a fool, since he spends beyond what is worthy of him and what is right, whereas correct expenditure is that which is in accordance with virtue.

Great expenditure is appropriate to those who have the resources, either through their own efforts, or those of their ancestors or connections, and to those of high birth, high reputation, and so on; for all these involve greatness and distinction. In particular, then, the magnificent person is like this, and magnificence is shown in expenditures of this kind, as we have said, for these are the greatest and most honoured.

But it is seen also on those private occasions that happen only once, at weddings and suchlike; and on those that might excite the whole city or those in high places – arrangements for receiving and sending off foreign guests, for gifts and reciprocal gifts. For the magnificent person spends not on himself but on the community, and his gifts are rather like votive offerings.

It is also typical of the magnificent person to furnish his house in a way appropriate to his wealth (even this is a sort of ornament), and to spend more on those results that will last for a long time (because they are the noblest), and in each case to spend what is fitting: what befits the gods is not the same as what befits human beings, what befits a temple not the same as what befits a tomb.

And since each expenditure will be great relative to its kind; and the expenditure most magnificent without qualification is when it is great and for a great object, and in a given case that which is great for that kind of case; and greatness in the result is different from that in the expense (for a very noble ball or oil-flask is magnificent as a gift for a child, though its cost is small and petty); since these things are so, it is characteristic of the magnificent person, whatever kind of thing he is producing, to do it in a magnificent way (because a result like this will not easily be surpassed) and so that it is worthy of the expenditure.

Such, then, is the magnificent person.

The person who goes to excess and is vulgar, as we have said, exceeds by spending more than he should. For in small matters, he spends a great deal and puts on an unharmonious display, feasting the members of his dining-club, for example, as if they were at a wedding; or, when funding the chorus for a comedy, bringing them onto the stage in purple, as they do at Megara. And all such things he will do, not for the sake of what is noble, but to show off his wealth and because he thinks it will win him admiration. Where he ought to spend much, he spends little, and where little, much.

The niggardly person, however, will be deficient in everything, and having spent the greatest sums will ruin something noble to save a tiny amount. In

whatever he does, he is hesitant and considers how he may keep the cost as low as possible; he complains even about this, and thinks he is doing everything on a grander scale than is required.

These states are vices, but they do not bring opprobrium, because they are neither harmful to one's neighbours nor particularly offensive.

2. Alfonso X ('Alfonso the Wise') Law VI: How images painted or sculpted in the king's likeness should be respected and preserved and the punishment due to those who break them

G.M. Díez (ed.), *Leyes de Alfonso X. I: Espéculo*, Avila, 1985, p.167 (trans. Michelle Marie Homden).

Alfonso X (1221–84), known as 'the Wise', was ruler of Castile in the Iberian peninsula between 1252 and his death. Alfonso's court became a centre of learning, and he was responsible for the compilation of a series of laws known as the *Siete Partidas* because they were divided into seven sections. This extract is taken from a slightly earlier and apparently incomplete series of laws entitled *El Espéculo*, and comes from section 14, concerning the court. It is one of the earliest known documents to make a policy statement concerning images of a ruler. It reveals the importance of artistic images, whether painted or sculpted, to the public presence of the monarch and, in its discussion of any acts of wilful damage to such images, even points to their use as a focus of political protest. KW

Referring to the principles which we stated above in the law relating to how the king's seal should be preserved, on account of his likeness which appears on it, we now state that it is according to these same principles that all other images painted or sculpted in the king's likeness should be preserved, whoever may have created them. Therefore, we say that whoever breaks or damages or marks them, doing so wilfully with the intention of causing harm to the king, let him pay a thousand sueldos to the king and let him be obliged to return the image to its original state.

3. Desiderius Erasmus
The Education of a Christian Prince

Erasmus: The Education of a Christian Prince, trans. N.M. Cheshire and M.J. Heath, Cambridge, Cambridge University Press, 1997, pp.13–17.

Desiderius Erasmus (1466–1536) wrote this treatise between 1515 and 1516 for the young Habsburg Prince Charles, the future Emperor Charles V (1500–58), whose service he entered in 1516. The treatise is very much in the tradition of the genre of literature known as the *Mirror for Princes*, texts offering moral instruction to equip princes with the virtues necessary for a good ruler. As in all his work, Erasmus combines immense classical learning with his own particular viewpoint. The extracts selected come from the first section of the treatise, on the qualities, education and significance of the Christian prince. Here Erasmus highlights the generic characteristics of a ruler: virtue, cultivation, and a mindset and behaviour set apart from that of ordinary people. This moral virtue is contrasted with self-aggrandisement through statues and portraits, to which Erasmus is opposed. KW

Therefore the tutor should first see that his pupil loves and honours virtue as the most beautiful thing of all, the greatest source of happiness, and especially fitting for a prince, and that he loathes and shrinks from depravity as being the most appalling and wretched of things.

Lest the boy who is destined for the throne should get into the habit of regarding wealth as something of exceptional value, to be gained by fair means or foul, he should learn that true honours are not those commonly acclaimed as such; true honour is the spontaneous consequence of virtue and right action, and the less sought after it is the brighter it shines.

The pleasures of the common people are so far beneath a prince, especially a Christian prince, that they are hardly worthy of mankind at all. Let it be shown that there is another kind of pleasure, which will last, pure and unchanging, all through a man's life.

Teach the young prince that nobility, statues, wax masks, family trees, and all the heraldic pomp which makes the common people swell with girlish pride, are only empty gestures, except in so far as they have been the consequence of honourable acts.

A prince's prestige, his greatness, his regal dignity must not be established and preserved by noisy displays of privileged rank but by wisdom, integrity, and right action. [. . .]

But at this point some idiot courtier, who is both more stupid and more misguided than any woman ever was, will protest: 'You are making

a philosopher for us, not a prince.' 'I am indeed making a prince', I reply, 'although you would prefer a loafer like yourself to a prince. Unless you are a philosopher you cannot be a prince, only a tyrant. There is nothing better than a good prince, but a tyrant is such a bizarre beast that there is nothing as destructive, nothing more hateful to all.

'Do not think that it was an ill-considered thesis of Plato's, praised by the most laudable men, that the state will eventually be blessed if and when either the rulers take up philosophy or the philosophers take over the government. Further, you must realise that "philosopher" does not mean someone who is clever at dialectics or science but someone who rejects illusory appearance and undauntedly seeks out and follows what is true and good. Being a philosopher is in practice the same as being a Christian; only the terminology is different.'

What could be more foolish than to judge the prince by accomplishments like these: dancing gracefully, playing dice expertly, drinking liberally, giving himself airs, plundering the people on a regal scale, and doing all the other things which I am ashamed to mention but which some people are not ashamed to do?

The true prince should avoid the degrading opinions and interests of the common folk to the same extent that the common run of princes are keen to avoid the dress and life-style of the lower classes. The one thing which he should consider degrading, low, and unbecoming to him is to think like the common people, who are never pleased by the best things.

Consider, I beg you, how ridiculous it is to be so much superior to everyone in that you are decked out with jewels, with gold, with the royal purple, with a train of courtiers, with the rest of the physical decorations, wax images, and statues, and with riches that clearly are not your own, and yet as regards real riches of the spirit to be seen to be inferior to many from the very dregs of the people.

What else does the prince do, when he displays jewels, gold, the royal purple, and all the rest of his privileged pomp in the eyes of his subjects, except teach them to envy and admire that which gives rise to the filthy sludge of nearly all the crimes that are punishable by the prince's own legislation?

In other people, frugality and a simple way of life can always be maliciously interpreted as due to poverty or to parsimony, but in a prince these same qualities are clear evidence of moderation, since he uses sparingly the unlimited resources which he possesses.

How can it be right for the same man to incite criminality and then punish criminal acts? And would it not be very disgraceful to allow himself to do what he forbids to others?

If you want to show that you are an excellent prince, see that no one outdoes you in the necessary qualities of wisdom, magnanimity, restraint, and integrity. If you want to compete with other princes, do not consider

yourself superior to them if you take away part of their realm or rout their troops, but only if you have been less corrupt than they, less greedy, less arrogant, less irascible, and less impulsive.

We can take it as read that the highest nobility is becoming for a prince. Since, however, there are three kinds of nobility – the first derived from virtue and good actions, the second from having experienced the best training, and the third as judged by ancestral portraits and family trees or by wealth – consider how inappropriate it is for a prince to pride himself on this third and lowest sort of nobility, which is so low that it is no sort at all unless it has itself sprung from virtue, to the neglect of that highest sort, which is so far the highest that it alone can strictly speaking be regarded as nobility at all.

If you are eager for the recognition of fame, do not make a display of statues or portraits, for if there is really anything to praise in them, it is due to the artist whose talent and effort they represent; it is far better to create in your character a monument to virtue.

If all else fails, the very trappings of your high rank can serve to remind you of your duty. What does the anointing mean, if not great mildness and civilised restraint on the part of the prince, since cruelty tends to go along with great power? What does the gold signify, except outstanding wisdom; and what the bright sparkle of the gems, except extraordinary virtues as different as can be from the common run? What does the warm, rich purple mean, if not the essence of love for the state? And why the sceptre, except as a mark of a spirit which grasps hold of justice and is diverted from the right by no tempting distraction? But if someone conspicuously lacks these qualities, then for him these symbols are not decorations but reproaches for his defects.

4. Leone Leoni
Letters to Ferrante Gonzago

G. Campori (ed.), *Gli artistici Italiano e Stanieri negli stati estensi*, Modena, R.D. Camera, 1855, pp.290–1, 286–7 (trans. Martin Davies).

These two letters were written by the Renaissance sculptor Leone Leoni (1509–90) to patron Ferrante Gonzaga (1507–57), Imperial Governor of Milan. In the first (undated) letter (?1546) Leoni outlines the commemorative purposes he believes that statues of the emperor serve both in his own day and in antiquity. His emphasis on what is appropriate to rank is commensurate with Aristotle's views on magnificence, while his acknowledgement of the need to avoid adulation is reminiscent of Erasmus's warnings to the Christian prince (see previous extract). During the sixteenth century there was a dispute over the primacy of painting or sculpture, known as the 'paragone'; predictably, as a sculptor Leone was on the side of sculpture. The equestrian statue he refers to here seems never to have been made.

In the second letter (29 June 1549) Leoni talks about his activities as court portraitist (three of his portrait busts are now in the British Royal Collection). His claim that Charles V came to chat with him is reminiscent of the account by the ancient Roman writer Pliny the Elder (23–79 CE) of the familiarity between the Greek painter Apelles (active in the fourth century BCE) and Alexander the Great (356–323 BCE) in his influential *Natural History* (77 CE), which Leoni may well have known. In keeping with sixteenth-century claims to the liberal (as opposed to mechanical) status of the artist he stresses his intellectual application rather than his earning power. Nevertheless, he also complains about poverty, suggesting that however great their status, court artists were not necessarily adequately paid. KW

Leone Leoni to Ferrante Gonzaga: I (?1546)
My most distinguished and excellent Lord,

 You desired that his Majesty should be served by having some perpetual memorial set up in Italy (that is, here in Milan) by which men of present and future ages might see the likeness of his Majesty and some measure of his victories. You observed very soundly that, beautiful as it is, painting is less enduring in this respect, inasmuch as it limits art to effects of light and shade on a plane surface, representing Nature under only one aspect, whereas it is quite the reverse with sculpture: one may see it and touch it from all sides, seeing both plane and solid surfaces. Sculpture, besides, cannot deteriorate with advancing age, especially in the case of sculptures

made of metal, as your Excellency had already observed, meaning to say that marble is less durable. Your Excellency now wishes me, as your servant and agent, to tell you my thoughts on the art of sculpture and how I would conduct myself if such a great lord should wish to make use of me, which I do very readily.

In the first place I mention that the ancient emperors took great pains to ensure that their statues were made while they were still alive, and also paid much attention to decorum, unlike our modern sculptors who allow themselves to rush headlong into adulation rather than observing their subjects' actual qualities. But I do not mean to rehearse here where the statues of the worthies of antiquity are to be found, in Rome and elsewhere, nor do I wish to give a roll call of the statues of Genoa, or that statue in Padua or the other one in Venice, and all the mass of other statues of various lords, whether each of them is mounted on a horse in armour and sporting the purple senatorial stripe, set on top of a pedestal with a multitude of adornments, with a view to calculating how huge a colossus would befit our Emperor.

But to come to what I think needs to be done about it, leaving aside adulation and sticking to the plain facts of the matter: I would make a metal horse of striking stature and very lifelike – as to its size, I mean. On top of the horse I would set a portrait statue of the Emperor, equally life-size, in an attitude of command and encouraging the troops with a gesture of his right hand. I would have the said statue placed on top of a Doric pedestal. On the four sides of the pedestal I would have sculpted scenes of some of the victories won by his Majesty, ornamented with many trophies and with some inscriptions testifying to his great and successful enterprises. But not to go on endlessly, and not wishing to enter at length into the skill that would be needed to handle such a mass of material, I shall keep it for face to face discussion at such time as your Excellency favours me with closer enquiry on the matter, and I meanwhile humbly kiss your hand.

Your Excellency's most humble servant, Leone of Arezzo.

Leone Leoni to Ferrante Gonzaga: II (1549)

To the most distinguished and excellent lord, Lord Ferando Gonzaga lieutenant of his Imperial Majesty and my lord Patron

My Lord and Patron,

Do not take it amiss if I, your servant, continue to write to you as a negotiator or somebody out to make a profit. Take what I have written in good part: there is no need to go to the trouble of replying – I could much more easily counterfeit your seal than your hand, not having so far seen any letter requiring that I perform some service for you. You may well imagine that I do not lack things to do, as is indeed true. And to stick with

the fancy of my being on an equal level with your Excellency, I may tell you that I am unburdened of a greater load than I have ever yet had, since I am now sure that his Majesty is entirely satisfied with my work.

I have made the illustrious prince's head life-size and all so exactly measured that there is not a hair's breadth of difference from the real thing. Everyone here at court was amazed at the work – not so much the head, which has not a line more or less than his Majesty's own, but by those of the two queens (and of the prince) that you ordered me to do, both of whom wear veils made in relief, looking just as they do in real life. The business of the horse is over and done with. I have satisfied his Majesty and the Duke of Alba and the court at large, and, what is more important to me, I shall satisfy the demands of art, which I had at times found hard to believe, since a number of people expressed the wish that I should employ certain mannerisms in designing the horse or the arms or the poses which did not square with the principles of sculpture.

So I have satisfied everyone, which is no small thing, and there is no one at court, my Lord, who does not love me, thanks to you, and many a time his Majesty stays two or three hours talking with me and my son Pompeo, who worships you. Most recently his Majesty has commanded me to send him soon two gold medals, one of himself and the other of her Majesty the Empress. He also wanted me to go to Italy to have them made, perhaps to get me out of these barbarous lands,[i] with their customs as different from ours as butter from the beer they swig down like animals.

I shall soon make up my mind, then, and apply all my efforts, consecrating them as if to God, and so that your Excellency may not henceforth have to complain of my imprudence, it would be good if you would deign to mention it to the Bishop of Arras [Granvelle], in order that his Majesty may now settle the matter of payment for the work at Milan, since it will require both time and money. That I leave to his good judgement, and I shall not speak of it to him again.

I have carried the day in two disputes: the first is that Monsieur Le Grand had had brought to the coronation (or some time later for all I know) a fine head of his Majesty, made in marble by I know not who, as if to say that it would be a service to his Majesty to see it, and when he had brought it there, mine stood to such advantage beside it that those people could not have gained the upper hand if the Tiber had turned into beer and been brought here. The other dispute was that certain grandees wanted the work to stay in Mechelen; when I saw that his Majesty was inclined to your wishes, I began to make it plain that he wanted the first bit in Italy and then the remainder would be made there; and so I won the second dispute.

Now it only remains for me to crave your indulgence to listen to a couple of words on my part. My patron, I have never till now wished to ask for

i. Leoni is referring here to the Low Countries.

anything, through the benevolence of his Majesty or just out of hopefulness, and God knows how much good I have had of it. I am indeed not rich, nor am I stupid, but I have thought it right to serve my patron with honourable diligence rather than for monetary reward. So I beg of your Lordship's generosity that he takes a couple of words to assure his Majesty that to this day I have had no stable belongings under the sun worth so much as a scudo. The only reason for my poverty is that in the past I attended to my studies and not to profit, so as to reach this point where God and he have now placed me. Once I have sloughed off my ill fortune, I trust your Excellency will be willing, as I asked, to write to his Majesty, for I shall be able to do much better for his Majesty, serve him with a mind at ease, and create for him with my talent more than has perhaps been imagined.

I believe that the Cardinal of Arras, who wants to help me, will write to you about a certain country house: it would be good for doing the work if he could get it from his Majesty, and certainly one is needed for the business. On this matter, as on the other, I submit myself to his good judgement. For the rest, except that he should have a good report of my efforts – and I shall write later of other events – my only care is that the Lord our Saviour keep you in good health and give you contentment (rather than the abundant wealth that Caesar's favour brings) and that God may inspire you to write a word or two to him on my behalf. 29 June 1549.

Your Most Distinguished and Excellent Lordship's humble servant, Leone

5. Pietro Aretino
Letter to Leone Leoni

Il Quinto Libri delle lettere di M. Pietro Aretino a la bonta somma del Magnanimo Signore Baldovino di Monti, Paris, Matteo il Maestro Press, 1609, pp.180–1 (trans. Martin Davies).

The humanist writer Pietro Aretino (1492–1556) and Leoni shared a common birthplace in Arezzo. Known as the 'Scourge of Princes', Aretino was a friend and mentor to Leoni, who produced a medal of him in 1537 (presently housed in the British Museum). In the letter Aretino sent to Leoni in September 1549 he expressed his pleasure that Leoni managed to convince Emperor Charles V of the damage it would do should portraits of him not be there for posterity. His claim that Leoni was granting a greater favour to Charles V than the Emperor was offering him is evidence once again of the increasingly exalted status claimed for artists. KW

To the sculptor Lione.

Since the fourth book of my letters, issued from the press but two days ago, bears witness to whether I love you, and whether I have replied to your letters or not, on that I say nothing further. [. . .]

Meanwhile I do not so much rejoice for you for the favour with which the Emperor looks on you, but rather congratulate his Majesty for the regard he has for virtuosity, since the medals which are about to render his name immortal are much more valuable than any kind of monetary reward they might bring to your style of life. But to be sure, I am absolutely delighted at the way in which as a true gentleman you have been able to impress upon him the great wrong that would be done to posterity in every age and every century if images, copies and portraits of our invincible Caesar Augustus could not be seen in the future as they are today: not indeed those sculpted, impressed and formed with casts, intaglios and punches, but the compositions and impressions and sculptures in bronze, silver and gold made by you yourself, the very soul of singular excellence in art of this sort. *Venice, September 1549.*

6. Leone Leoni
Letter to Antoine Perrenot de Granvelle

Eugène Plon, *Les Maîtres italiens au service de la maison d'Autriche: Leone Leoni sculpteur de Charles Quint et Pomeo Leone, sculpteur de Philippe II*, 2nd edn, Paris, Libraire Plon, 1887, pp.362–3, no.21 (trans. Martin Davies)

Antoine Perrenot de Granvelle (1517–86) (addressed as 'Bishop of Arras' in the letter) was made Archbishop of Mechelen, in 1560 and Cardinal the following year; he was a leading minister of Charles V and a connoisseur of art. Kelley Helmstutler di Dio points out that he and Aretino 'terrified' most people, yet Leoni was on familiar terms with them both.[1] The letter Leoni sent to Granvelle in 1550 explains what his sculpture *Charles V Vanquishing Fury* (one of eight sculptures commissioned from Leoni in 1549) was intended to convey. The rather unconvincing emphasis on modesty may be an attempt to allay criticisms such as those expressed in Erasmus's *The Education of a Christian Prince* (see extract 3, pp.84–6 above). KW

1. Kelley Helmstutler di Dio, *Leone Leoni and the Status of the Artist at the End of* *the Renaissance*, Farnham, Ashgate, 2011, p.1.

To his Distinguished and Reverend Patron.

I wanted to hold off writing to your lordship so as not to give you all day in which to reply to me, but I am obliged to by my wish to satisfy and reply to the request of her Majesty the Queen by paying the debt I still owe to his Catholic Majesty. I admit the debt, into which I entered on a fancy some months ago when I saw a wonderful piece of stone, and decided that if it came off it would be the most beautiful thing I had ever devised. So I have carved the Emperor and his son on the front for her, just as a sculptor once displayed Caesar and Augustus, and on the back the Empress, so beloved of the Emperor. And I am so satisfied with the work that I think it certain that in terms of the skill of the artistry and the quality of the stone, I have never made or seen anything comparable. For those reasons I am obliged to ask you, for the love you bear me (who love you even more), to let his Majesty know of my efforts and enthusiasm; and since you are the greatest man of my acquaintance, please present it to him in my name, saying: 'Here is a sculptor by no means ungrateful or whimsical, who speaks of your Majesty with all his heart's affection.'

This will be the reward for two months of toil that I have at various times stolen from myself, so as to give the most exquisite thing one could behold to so great a patron. Don Ferrando is amazed by it, and everyone who has seen it feels the same, and for that reason I am sure that it will appeal all the more to your Lordship for your being even more amply endowed with erudition and judgement. Please do not fail, then, to make him acquainted with it.

But as I said above, since I must reply to the request that you make of me on behalf of her Majesty the Queen, I shall not give you any further reply, since your Lordship was a true prophet when you said that you believe that I would not be capable of understanding it, whereas I am a sworn enemy of promises and a sound friend of action, one that knows neither fatigue nor delay . . . [there is a lacuna at this point] . . . that their Majesties will be content with it.

But to reveal my secrets to you, and before others tell you them, I shall give you an account of what I have achieved so far, and if what has been done should perhaps seem extraordinary, do not credit it to my account but rather to your goodness in making me this proposal and polishing up my poor genius which had so long been buried. I first made a frame two and a half yards square for the portrait of the Empress, with so many ornaments, compartments and figures and swags of foliage and cornices that when your Lordship sees it, you will think a lifetime's work has gone into it. Beyond that, I have created three new statues, which I do not want your Lordship or anyone else to see until I have placed them on their bases (each of them has to have one made of metal); I have already made the moulds and am fixing them up.

Well, I then had a fancy to enlarge the statue of His Majesty, but since in his great modesty he was unwilling to have a province or some other fruit of victory placed under it, I decided to give him all those praiseworthy qualities without flattery of any sort. Wishing to allude to his modesty, his character, his religion and piety, I had him trampling a statue of Madness beneath his feet. While the Emperor's statue appears benign and serious and magnanimous in aspect, that of Madness appears furious and cringing, with a horrid face, gnashing its teeth and with a menacing air, enough to put fear into an onlooker. Besides which, the style of the musculature conforms to the figure's rough character, and with great artistry I have arranged the two figures on a small base so that the one does not obstruct the view of the other; and from all four viewpoints that the statue must have, the figure of Madness does not prevent you from seeing the whole; but the least beautiful view is the best. But because the explanation and the other things concerning the design, along with all that I have in my crazy head, would take up much space, I shall forbear to tell your Lordship the rest . . . [another lacuna at this point] . . . a work, and one so well arranged in such a short space of time.

I am very sorry indeed that your Lordship cannot see this device of mine, for I am sure you would love me even more than you do when you see that I am more than a medallist. Under the statues there are arms inscribed with that motto of Virgil: *saeva sedens super arma*,[1] and if I had not bound him with knots and chains, it would not be so good. It is necessary, then, illustrious Monsignor, that you inform the Emperor of this as well, telling him that our age has produced no work more sober or exquisite than this, so that if by chance it should not prove as welcome to his Majesty as it deserves, I shall never be happy again; and by the true Christ, Monsignor Patron, I have not had one hour of happiness since I left Flanders, so wrapped up in anxiety have I been to please this great Emperor and to perform creditably.

The other statue I mention is the one of our Lord the Prince. When his Lordship saw it, he was astonished and did not know what to say, since, apart from the figure's naturalness, I had there expressed what his Lordship reckoned to be his imperiousness of spirit, the quality of repose in his person and the symmetry of his limbs, to such a point that the prince was stupefied, like all those who have seen it. I on the other hand was so happy, beside myself with joy that my work was going so well. Your Lordship could therefore give the Queen such samples of my work as you see fit; and do not fail to promise her all manner of great things on my part, for which I shall always hold you in the highest honour, for I cannot tell which is the greater, the respect that I bear your Lordship, or the

1. *Aeneid* 1.295, '[the madness of war] sitting on savage arms', at the moment when Aeneas shut Furor up in the Temple of Janus and so brought peace to the land of Latium.

love. I do not know what to send you at the moment, but I'm sure that you will soon have some piece of work by me from the hands of others. I shall never fail . . . [the last lines cut away]

 To my respected Noble and Right Reverend Bishop of Arras, President of His Majesty's Supreme Council, at court.

7. Bernal Díaz del Castillo
The Conquest of New Spain

Bernal Díaz del Castillo, *The Conquest of New Spain*, trans. J.M. Cohen, London, Folio Society, 1974, p.199.

Bernal Díaz (1492–c.1584/5) wrote this eyewitness account of the 1517–19 conquest of Mexico by Spain in his old age. This short extract shows that, although Mexican artists worked outside the European artistic tradition and outside the conventions of the Christian church, their skills might still be admired. Comparison with the ancient Greek artist Apelles was a literary convention in the western tradition, but its use in relation to Mexican artists is noteworthy here. KW

I must now speak of the skilled workmen whom Montezuma employed in all the crafts they practised, beginning with the jewellers and workers in silver and gold and various kinds of hollowed objects, which excited the admiration of our great silversmiths at home. Many of the best of them lived in a town called Atzcapotzalco, three miles from Mexico. There were other skilled craftsmen who worked with precious stones and *chalchihuites*[i] and specialists in feather work, and very fine painters and carvers. We can form some judgement of what they did then from what we can see of their work today. There are three Indians now living in the city of Mexico, named Marcos de Aquino, Juan de la Cruz, and El Crespillo, who are such magnificent painters and carvers that, had they lived in the age of the Apelles of old, or of Michael Angelo, or Berruguete in our own day, they would be counted in the same rank.

i. A Mexican term denoting a green stone.

Chapter 6
Botticelli

Piers Baker-Bates

1. Giorgio Vasari
Lives of the Painters, Sculptors and Architects

Giorgio Vasari, *Lives of the Painters, Sculptors and Architects* (1568 edn), trans. Gaston du C. de Vere, London, Everyman's Library, 1996, vol.1, pp.35–42 (Latin passage trans. Martin Davies).

Lives, written by the Florentine artist Giorgio Vasari, first published in 1550 and revised in 1568, was the first and remains the main primary source for the life and work of the majority of Renaissance artists, including Sandro Botticelli. Vasari should be treated critically as a source, since he is both biased and not always accurate. He nevertheless includes a large amount of material not available elsewhere, and for many centuries was the only source for Botticelli's life and career. PBB

SANDRO BOTTICELLI
[ALESSANDRO FILIPEPI OR SANDRO DI BOTTICELLO],
Painter of Florence

At the same time with the elder Lorenzo de' Medici, the Magnificent, which was truly a golden age for men of intellect, there also flourished one Alessandro, called Sandro after our custom, and surnamed Di Botticello for a reason that we shall see below. This man was the son of Mariano Filipepi, a citizen of Florence, who brought him up with care, and had him instructed in all those things that are usually taught to children before they are old enough to be apprenticed to some calling. But although he found it easy to learn whatever he wished, nevertheless he was ever restless, nor was he

contented with any form of learning, whether reading, writing, or arithmetic, insomuch that his father, weary of the vagaries of his son's brain, in despair apprenticed him as a goldsmith with a boon-companion of his own, called Botticello, no mean master of that art in his day.

Now in that age there was a very close connection – nay, almost a constant intercourse – between the goldsmiths and the painters; wherefore Sandro, who was a ready fellow and had devoted himself wholly to design, became enamoured of painting, and determined to devote himself to that. For this reason he spoke out his mind freely to his father, who, recognizing the inclination of his brain, took him to Fra Filippo of the Carmine, a most excellent painter of that time, with whom he placed him to learn the art, according to Sandro's own desire. Thereupon, devoting himself heart and soul to that art, Sandro followed and imitated his master so well that Fra Filippo, growing to love him, taught him very thoroughly, so that he soon rose to such a rank as none would have expected for him.

While still quite young, he painted a figure of Fortitude in the Mercatanzia of Florence, among the pictures of Virtues that were wrought by Antonio and Piero del Pollaiuolo. [. . .]

He made many works in the house of the Medici for the elder Lorenzo, particularly a Pallas on a device of great branches, which spouted forth fire: this he painted of the size of life, as he did a S. Sebastian. In S. Maria Maggiore in Florence, beside the Chapel of the Panciatichi, there is a very beautiful Pietà with little figures. For various houses throughout the city he painted round pictures, and many female nudes, of which there are still two at Castello, a villa of Duke Cosimo's; one representing the birth of Venus, with those Winds and Zephyrs that bring her to the earth, with the Cupids; and likewise another Venus, whom the Graces are covering with flowers, as a symbol of spring; and all this he is seen to have expressed very gracefully. Round an apartment of the house of Giovanni Vespucci, now belonging to Piero Salviati, in the Via de' Servi, he made many pictures which were enclosed by frames of walnut-wood, by way of ornament and panelling, with many most lively and beautiful figures. In the house of the Pucci, likewise, he painted with little figures Boccaccio's tale of Nastagio degli Onesti in four square pictures of most charming and beautiful workmanship, and the Epiphany in a round picture. For a chapel in the Monastery of Cestello he painted an Annunciation on a panel. [. . .]

At this time Sandro was commissioned to paint a little panel with figures three-quarters of a braccio in length, which was placed between two doors in the principal façade of S. Maria Novella, on the left as one enters the church by the door in the centre. [. . .]

And at that time it brought him such great fame, both in Florence and abroad, that Pope Sixtus IV, having accomplished the building of the chapel of his palace in Rome, and wishing to have it painted, ordained that he should be made head of that work; whereupon he painted therein with

his own hand the following scenes – namely, the Temptation of Christ by the Devil, Moses slaying the Egyptian, Moses receiving drink from the daughters of Jethro the Midianite, and likewise fire descending from Heaven on the sacrifice of the sons of Aaron, with certain Sanctified Popes in the niches above the scenes. Having therefore acquired still greater fame and reputation among the great number of competitors who worked with him, both Florentines and men of other cities, he received from the Pope a good sum of money, the whole of which he consumed and squandered in a moment during his residence in Rome, where he lived in haphazard fashion, as was his wont.

Having at the same time finished and unveiled the part that had been assigned to him, he returned immediately to Florence, where, being a man of inquiring mind, he made a commentary on part of Dante, illustrated the Inferno, and printed it; on which he wasted much of his time, bringing infinite disorder into his life by neglecting his work. He also printed many of the drawings that he had made, but in a bad manner, for the engraving was poorly done. The best of these that is to be seen by his hand is the Triumph of the Faith effected by Fra Girolamo Savonarola of Ferrara, of whose sect he was so ardent a partisan that he was thereby induced to desert his painting, and, having no income to live on, fell into very great distress. For this reason, persisting in his attachment to that party, and becoming a Piagnone[1] (as the members of the sect were then called), he abandoned his work; wherefore he ended in his old age by finding himself so poor, that, if Lorenzo de' Medici, for whom, besides many other things, he had done some work at the little hospital in the district of Volterra, had not succoured him the while that he lived, as did afterwards his friends and many excellent men who loved him for his talent, he would have almost died of hunger. [. . .]

It is also said that he had a surpassing love for all whom he saw to be zealous students of art; and that he earned much, but wasted everything through negligence and lack of management. Finally, having grown old and useless, and being forced to walk with crutches, without which he could not stand upright, he died, infirm and decrepit, at the age of seventy-eight, and was buried in Ognissanti at Florence in the year 1515.

In the guardaroba[i] of the Lord Duke Cosimo there are two very beautiful heads of women in profile by his hand, one of which is said to be the mistress of Giuliano de' Medici, brother of Lorenzo, and the other Madonna Lucrezia de' Tornabuoni, wife of the said Lorenzo. [. . .] He was among the first to discover the method of decorating standards and other sorts of hangings with the so-called inlaid work, to the end that the colours might not fade and might show the tint of the cloth on either side. By his

[1] Mourner, or Weeper.
[i] Wardrobe, i.e. most intimate space.

hand, and made thus, is the baldacchino of Orsanmichele, covered with beautiful and varied figures of Our Lady; which proves how much better such a method preserves the cloth than does the use of mordants, which eat it away and make its life but short, although, being less costly, mordants are now used more than anything else.

Sandro's drawings were extraordinarily good, and so many, that for some time after his death all the craftsmen strove to obtain some of them; and we have some in our book, made with great mastery and judgment. His scenes abounded with figures, as may be seen from the embroidered border of the Cross that the Friars of S. Maria Novella carry in processions, all made from his design. Great was the praise, then, that Sandro deserved for all the pictures that he chose to make with diligence and love, as he did the aforesaid panel of the Magi in S. Maria Novella, which is marvellous. Very beautiful, too, is a little round picture by his hand that is seen in the apartment of the Prior of the Angeli in Florence, in which the figures are small but very graceful and wrought with beautiful consideration. Of the same size as the aforesaid panel of the Magi, and by the same man's hand, is a picture in the possession of Messer Fabio Segni, a gentleman of Florence, in which there is painted the Calumny of Apelles, as beautiful as any picture could be. Under this panel, which Sandro himself presented to Antonio Segni, who was much his friend, there may now be read the following verses, written by the said Messer Fabio:

INDICIO QUEMQUAM NE FALSO LÆDERE TENTENT
TERRARUM REGES, PARVA TABELLA MONET.
HUIC SIMILEM ÆGYPTI REGI DONAVIT APELLES;
REX FUIT ET DIGNUS MUNERE, MUNUS EO.

[This little picture warns the kings of the earth
Not to try to do anyone harm with false witness;
Apelles gave the like to the king of Egypt;
The king deserved the gift, and the gift the king.]

2. Walter Pater
'Sandro Botticelli'

Walter Pater, *The Renaissance: Studies in Art and Poetry: The 1893 Text*, ed. D.L. Hill, University of California Press, Berkeley, Los Angeles, London, 1980, pp.39–48.

After Vasari wrote about Botticelli in 1568, the artist disappeared from scholarly view until his reputation was almost single-handedly revived by the essayist Walter Pater (1839–94) in 1870. Although he was not an art historian and his approach to his subject is perhaps too subjective, Pater's essay should nonetheless be seen as the fountainhead for a revival of critical interest in the life and career of Botticelli. Pater created a predominantly literary picture of Botticelli's life and career, which proved immensely engaging and popular particularly in the early twentieth century. PBB

In Leonardo's treatise on painting only one contemporary is mentioned by name – Sandro Botticelli. This pre-eminence may be due to chance only, but to some will rather appear a result of deliberate judgment; for people have begun to find out the charm of Botticelli's work, and his name, little known in the last century, is quietly becoming important. In the middle of the fifteenth century he had already anticipated much of that meditative subtlety, which is sometimes supposed peculiar to the great imaginative workmen of its close. Leaving the simple religion which had occupied the followers of Giotto for a century, and the simple naturalism which had grown out of it, a thing of birds and flowers only, he sought inspiration in what to him were works of the modern world, the writings of Dante and Boccaccio, and in new readings of his own of classical stories: or, if he painted religious incidents, painted them with an under-current of original sentiment, which touches you as the real matter of the picture through the veil of its ostensible subject. What is the peculiar sensation, what is the peculiar quality of pleasure, which his work has the property of exciting in us, and which we cannot get elsewhere? For this, especially when he has to speak of a comparatively unknown artist, is always the chief question which a critic has to answer.

 In an age when the lives of artists were full of adventure, his life is almost colourless. Criticism indeed has cleared away much of the gossip which Vasari accumulated, has touched the legend of Lippo and Lucrezia,[i] and rehabilitated the character of Andrea del Castagno. But in Botticelli's

i. Fra Filippo Lippi (also called Lippo Lippi, c.1406–69) a Florentine painter, who took the Carmelite vows in 1421 (hence 'Fra') and Lucrezia Buti, a nun with whom Lippi fell in love. Their affair resulted in the birth of Filippino Lippi (c.1457–1504), who followed in his father's footsteps as an artist.

case there is no legend to dissipate. He did not even go by his true name: Sandro is a nickname, and his true name is Filipepi, Botticelli being only the name of the goldsmith who first taught him art. Only two things happened to him, two things which he shared with other artists: – he was invited to Rome to paint in the Sistine Chapel, and he fell in later life under the influence of Savonarola, passing apparently almost out of men's sight in a sort of religious melancholy, which lasted till his death in 1515, according to the received date. Vasari says that he plunged into the study of Dante, and even wrote a comment on the *Divine Comedy*. But it seems strange that he should have lived on inactive so long; and one almost wishes that some document might come to light, which, fixing the date of his death earlier, might relieve one, in thinking of him, of his dejected old age.

He is before all things a poetical painter, blending the charm of story and sentiment, the medium of the art of poetry, with the charm of line and colour, the medium of abstract painting. So he becomes the illustrator of Dante. In a few rare examples of the edition of 1481, the blank spaces, left at the beginning of every canto for the hand of the illuminator, have been filled, as far as the nineteenth canto of the *Inferno*, with impressions of engraved plates, seemingly by way of experiment, for in the copy in the Bodleian Library, one of the three impressions it contains has been printed upside down, and much awry, in the midst of the luxurious printed page. Giotto, and the followers of Giotto, with their almost childish religious aim, had not learned to put that weight of meaning into outward things, light, colour, everyday gesture, which the poetry of the *Divine Comedy* involves, and before the fifteenth century Dante could hardly have found an illustrator. Botticelli's illustrations are crowded with incident, blending, with a naïve carelessness of pictorial propriety, three phases of the same scene into one plate. The grotesques, so often a stumbling-block to painters, who forget that the words of a poet, which only feebly present an image to the mind, must be lowered in key when translated into visible form, make one regret that he has not rather chosen for illustration the more subdued imagery of the *Purgatorio*. Yet in the scene of those who 'go down quick into hell,' there is an inventive force about the fire taking hold on the upturned soles of the feet, which proves that the design is no mere translation of Dante's words, but a true painter's vision; while the scene of the Centaurs wins one at once, for, forgetful of the actual circumstances of their appearance, Botticelli has gone off with delight on the thought of the Centaurs themselves, bright, small creatures of the woodland, with arch baby faces and mignon forms, drawing tiny bows.

Botticelli lived in a generation of naturalists, and he might have been a mere naturalist among them. There are traces enough in his work of that alert sense of outward things, which, in the pictures of that period, fills the lawns with delicate living creatures, and the hill-sides with pools of water, and the pools of water with flowering reeds. But this was not enough

for him; he is a visionary painter, and in his visionariness he resembles Dante. Giotto, the tried companion of Dante, Masaccio, Ghirlandajo even, do but transcribe, with more or less refining, the outward image; they are dramatic, not visionary painters; they are almost impassive spectators of the action before them. But the genius of which Botticelli is the type usurps the data before it as the exponent of ideas, moods, visions of its own; in this interest it plays fast and loose with those data, rejecting some and isolating others, and always combining them anew. To him, as to Dante, the scene, the colour, the outward image or gesture, comes with all its incisive and importunate reality; but awakes in him, moreover, by some subtle law of his own structure, a mood which it awakes in no one else, of which it is the double or repetition, and which it clothes, that all may share it, with visible circumstance.

But he is far enough from accepting the conventional orthodoxy of Dante which, referring all human action to the simple formula of purgatory, heaven and hell, leaves an insoluble element of prose in the depths of Dante's poetry. One picture of his, with the portrait of the donor, Matteo Palmieri, below, had the credit or discredit of attracting some shadow of ecclesiastical censure. This Matteo Palmieri, (two dim figures move under that name in contemporary history,) was the reputed author of a poem, still unedited, *La Città di Vita*, which represented the human race as an incarnation of those angels who, in the revolt of Lucifer, were neither for Jehovah nor for His enemies, a fantasy of that earlier Alexandrian philosophy about which the Florentine intellect in that century was so curious. Botticelli's picture may have been only one of those familiar compositions in which religious reverie has recorded its impressions of the various forms of beatified existence – *Glorias*, as they were called, like that in which Giotto painted the portrait of Dante; but somehow it was suspected of embodying in a picture the wayward dream of Palmieri, and the chapel where it hung was closed. Artists so entire as Botticelli are usually careless about philosophical theories, even when the philosopher is a Florentine of the fifteenth century, and his work a poem in *terza rima*.[ii] But Botticelli, who wrote a commentary on Dante, and became the disciple of Savonarola, may well have let such theories come and go across him. True or false, the story interprets much of the peculiar sentiment with which he infuses his profane and sacred persons, comely, and in a certain sense like angels, but with a sense of displacement or loss about them – the wistfulness of exiles, conscious of a passion and energy greater than any known issue of them explains, which runs through all his varied work with a sentiment of ineffable melancholy.

ii. An interlocking three-line rhyming verse stanza, first used by the Italian poet Dante Alighieri.

So just what Dante scorns as unworthy alike of heaven and hell, Botticelli accepts, that middle world in which men take no side in great conflicts, and decide no great causes, and make great refusals. He thus sets for himself the limits within which art, undisturbed by any moral ambition, does its most sincere and surest work. His interest is neither in the untempered goodness of Angelico's saints, nor the untempered evil of Orcagna's *Inferno*; but with men and women, in their mixed and uncertain condition, always attractive, clothed sometimes by passion with a character of loveliness and energy, but saddened perpetually by the shadow upon them of the great things from which they shrink. His morality is all sympathy; and it is this sympathy, conveying into his work somewhat more than is usual of the true complexion of humanity, which makes him, visionary as he is, so forcible a realist.

It is this which gives to his Madonnas their unique expression and charm. He has worked out in them a distinct and peculiar type, definite enough in his own mind, for he has painted it over and over again, sometimes one might think almost mechanically, as a pastime during that dark period when his thoughts were so heavy upon him. Hardly any collection of note is without one of these circular pictures, into which the attendant angels depress their heads so naïvely. Perhaps you have sometimes wondered why those peevish-looking Madonnas, conformed to no acknowledged or obvious type of beauty, attract you more and more, and often come back to you when the Sistine Madonna and the Virgins of Fra Angelico are forgotten. At first, contrasting them with those, you may have thought that there was something in them mean or abject even, for the abstract lines of the face have little nobleness, and the colour is wan. For with Botticelli she too, though she holds in her hands the 'Desire of all nations,' is one of those who are neither for Jehovah nor for His enemies; and her choice is on her face. The white light on it is cast up hard and cheerless from below, as when snow lies upon the ground, and the children look up with surprise at the strange whiteness of the ceiling. Her trouble is in the very caress of the mysterious child, whose gaze is always far from her, and who has already that sweet look of devotion which men have never been able altogether to love, and which still makes the born saint an object almost of suspicion to his earthly brethren. Once, indeed, he guides her hand to transcribe in a book the words of her exaltation, the *Ave*, and the *Magnificat*, and the *Gaude Maria*, and the young angels, glad to rouse her for a moment from her dejection, are eager to hold the inkhorn and to support the book. But the pen almost drops from her hand, and the high cold words have no meaning for her, and her true children are those others, among whom, in her rude home, the intolerable honour came to her, with that look of wistful inquiry on their irregular faces which you see in startled animals – gipsy children, such as those who, in Apennine villages, still hold out their long brown arms to beg of you, but on Sundays become

enfants du chœur [altar boys and girls], with their thick black hair nicely combed, and fair white linen on their sunburnt throats.

What is strangest is that he carries this sentiment into classical subjects, its most complete expression being a picture in the *Uffizii*, of Venus rising from the sea, in which the grotesque emblems of the middle age, and a landscape full of its peculiar feeling, and even its strange draperies, powdered all over in the Gothic manner with a quaint conceit of daisies, frame a figure that reminds you of the faultless nude studies of Ingres. At first, perhaps, you are attracted only by a quaintness of design, which seems to recall all at once whatever you have read of Florence in the fifteenth century; afterwards you may think that this quaintness must be incongruous with the subject, and that the colour is cadaverous or at least cold. And yet, the more you come to understand what imaginative colouring really is, that all colour is no mere delightful quality of natural things, but a spirit upon them by which they become expressive to the spirit, the better you will like this peculiar quality of colour; and you will find that quaint design of Botticelli's a more direct inlet into the Greek temper than the works of the Greeks themselves even of the finest period. Of the Greeks as they really were, of their difference from ourselves, of the aspects of their outward life, we know far more than Botticelli, or his most learned contemporaries; but for us long familiarity has taken off the edge of the lesson, and we are hardly conscious of what we owe to the Hellenic spirit. But in pictures like this of Botticelli's you have a record of the first impression made by it on minds turned back towards it, in almost painful aspiration, from a world in which it had been ignored so long; and in the passion, the energy, the industry of realisation, with which Botticelli carries out his intention, is the exact measure of the legitimate influence over the human mind of the imaginative system of which this is perhaps the central subject. The light is indeed cold – mere sunless dawn; but a later painter would have cloyed you with sunshine; and you can see the better for that quietness in the morning air each long promontory, as it slopes down to the water's edge. Men go forth to their labours until the evening; but she is awake before them, and you might think that the sorrow in her face was at the thought of the whole long day of love yet to come. An emblematical figure of the wind blows hard across the grey water, moving forward the dainty-lipped shell on which she sails, the sea 'showing his teeth,' as it moves, in thin lines of foam, and sucking in, one by one, the falling roses, each severe in outline, plucked off short at the stalk, but embrowned a little, as Botticelli's flowers always are. Botticelli meant all this imagery to be altogether pleasurable; and it was partly an incompleteness of resources, inseparable from the art of that time, that subdued and chilled it. But his predilection for minor tones counts also; and what is unmistakable is the sadness with which he has conceived the goddess of pleasure, as the depository of a great power over the lives of men.

I have said that the peculiar character of Botticelli is the result of a blending in him of a sympathy for humanity in its uncertain condition, its attractiveness, its investiture at rarer moments in a character of loveliness and energy, with his consciousness of the shadow upon it of the great things from which it shrinks, and that this conveys into his work somewhat more than painting usually attains of the true complexion of humanity. He paints the story of the goddess of pleasure in other episodes besides that of her birth from the sea, but never without some shadow of death in the grey flesh and wan flowers. He paints Madonnas, but they shrink from the pressure of the divine child, and plead in unmistakable undertones for a warmer, lower humanity. The same figure – tradition connects it with Simonetta, the mistress of Giuliano de' Medici – appears again as Judith, returning home across the hill country, when the great deed is over, and the moment of revulsion come, when the olive branch in her hand is becoming a burthen; as *Justice*, sitting on a throne, but with a fixed look of self-hatred which makes the sword in her hand seem that of a suicide; and again as *Veritas*, in the allegorical picture of *Calumnia*, where one may note in passing the suggestiveness of an accident which identifies the image of Truth with the person of Venus. We might trace the same sentiment through his engravings; but his share in them is doubtful, and the object of this brief study has been attained, if I have defined aright the temper in which he worked.

But, after all, it may be asked, is a painter like Botticelli – a secondary painter, a proper subject for general criticism? There are a few great painters, like Michelangelo or Leonardo, whose work has become a force in general culture, partly for this very reason that they have absorbed into themselves all such workmen as Sandro Botticelli; and, over and above mere technical or antiquarian criticism, general criticism may be very well employed in that sort of interpretation which adjusts the position of these men to general culture, whereas smaller men can be the proper subjects only of technical or antiquarian treatment. But, besides those great men, there is a certain number of artists who have a distinct faculty of their own by which they convey to us a peculiar quality of pleasure which we cannot get elsewhere; and these too have their place in general culture, and must be interpreted to it by those who have felt their charm strongly, and are often the object of a special diligence and a consideration wholly affectionate, just because there is not about them the stress of a great name and authority. Of this select number Botticelli is one. He has the freshness, the uncertain and diffident promise, which belong to the earlier Renaissance itself, and make it perhaps the most interesting period in the history of the mind. In studying his work one begins to understand to how great a place in human culture the art of Italy had been called.

Chapter 7
Did women patrons have a Renaissance? Italy 1420–1520

Catherine King

1. Giovanni Dominici
Rule for family management

Giovanni Dominici, *Regola del governo di cura familiare*, ed. D. Salvi, Florence, 1860, pp.131–2, 122 (trans. Catherine King).

Texts prescribing the use of art and architecture by Italian women at this period, such as the treatise by Giovanni Dominici (1356–1420) are rare. Dominici was a Florentine cardinal who dedicated his manuscript to a member of the Florentine elite, Bartolommea degli Alberti. As her husband had been exiled, she had charge of the children because she could remain in the city. In his 'rule for family management' as a wife, mother and perhaps as widow, Dominici, writing in 1416, included counsel on her relationship with the visual arts and architecture as maker, user and commissioner. As a wife he allowed that she might sew or buy pieces to adorn churches, drawing on her dowry with her husband's permission.[1] Within the house he affirmed the importance of images to educate the children (without mentioning who commissioned these). Were she to become widowed, Dominici considered she might commission artworks to assist pious institutions, but should not seek personal prominence by erecting new ones. CK

The first thing is to have in the house paintings of holy boys and virginal young women, in which your child while still in swathing bands can

1. Giovanni Dominici, *Regola del governo di cura familiare* (1416), ed. D. Salvi, Florence, 1860, p.59.

delight itself, since like calls to like, with the deeds and characteristics that appeal to childhood [. . .] Suitable themes are the Virgin Mary with the Child in her arms, and a little bird or a pomegranate in his hand. A good motif would also be the suckling Christ, Christ asleep in the mother's lap [. . .] Thus let the child mirror himself in the Holy Baptist dressed in a camel's skin [. . .] It would not harm him to see Christ and the Baptist painted [. . .] and the Massacre of the Innocents. One should similarly nurture the little girls with the sight of the Eleven Thousand Virgins running about, praying and fighting.[1] I would like them to see Agnes with a fat lamb, Cecilia crowned with roses, Elizabeth carrying roses, Catherine on her wheel, with other figures, so that along with their milk they will be given love of virginity, desire for Christ, hatred of sin, loathing of vanity, dislike of bad company, and, in sum, an introduction to contemplating the Saint of Saints [Christ] through the consideration of Saints. [. . .]

Certainly widows may spend their wealth on building churches, monasteries, hospitals, on endowing poor women so that they may marry, on freeing prisoners, or on clothing the naked [. . .] but if you wish to spend a quantity of money I would advise you to repair a ruined church or a hospital that is declining through want of funds rather than building a new one, for thereby you will receive the greatest prize in heaven because you sought the least fame in this world.

2. Contract between Andrea del Sarto and the Chapter of San Francesco, Florence

John Shearman, *Andrea del Sarto*, 2 vols., Oxford, Clarendon Press, 1965, vol.2, p.391, trans. Diana Norman, in Diana Norman, *The Altarpiece as an Artistic Form*, Milton Keynes, The Open University Press, 1979, pp.22–3.

Although fewer women than men commissioned artists during this period, contracts such as that dated 1515 between the Florentine painter Andrea del Sarto (1486–1531) and the female Chapter of San Francesco, in Florence, gave women the same legal powers as those of men. However, the conditions under which they bought art were

1. Eleven Thousand Virgins legendarily accompanied St Ursula across Europe fighting for Christianity, carrying as their standard the cross.

gendered. For example, many female chapters,[1] like this one, commissioned works for the exterior church,[2] which they never saw in position, because (unlike monks) they lived an enclosed existence.[3] CK

As set out below in the year announced [1515] on the fourteenth May it was enacted in the Church of the Franciscan nuns, Florence, by consent of the said nuns, Zenobio Buonacolti Ser Mini of the congregation of San Simone, Florence and Raphaello Giovanni Francesco Buonamici present and witness.

Sister Constantia Joanna de Meleto, abbess of the said convent and . . . [names of nineteen nuns follow] all nuns who have taken vows in the said Franciscan convent gathered and assembled together in the customary place for their chapter by consent of the convent, at the sound of the bell and by the summons of the Abbess, this assembly of nuns claiming that they were two parts and more of the said assembly of nuns who had a vote in this chapter all in harmony and by acclamation agreed on their own behalf and their successors in the said convent, to contract with Andrea Angelo Francesco painter of San Marco, Florence, who agreed to be hired to paint with his own hand a panel at least three *bracchia* wide and three and a half *bracchia* high excluding the ornament [i.e. the frame] so that the said measurement covers the panel without the ornament. On it they agreed that there should be painted the image of the Blessed Mary ever a Virgin with her son in her arms and two angels at the sides of the upper part who are crowning this image of Mary the Virgin Mother. The azure pigment used on the said Virgin Mary must be at least the value of five full florins of gold and on one side must be the image of the most blessed John the Evangelist and on the other Saint Bonaventure dressed as a cardinal; and the ornament of this picture must be appropriate and the colours the finest and all at the expense of the said contractor including the woodwork . . . at the price of forty florins in gold. From this the said Andrea in the presence of my [the abbess is speaking here] notary and the above witnesses has had and received the sum total of six florins in cash and for this amount he says he is well paid. And they agreed that the remainder be paid thus: nine florins as soon as Andrea has produced half the work and fifteen florins in gold as soon as the said panel shall be finished and ten florins the said Andrea has freely given to the convent for love of God. As soon as the said panel shall be finished it

1. Chapters were groups of nuns or monks who elected their leaders and voted on the actions of a monastery.
2. Female convents had interior churches exclusively for the use of nuns and exterior public churches exclusively for the use of the public.
3. Some monks, such as male Franciscans and male Dominicans worked and lived in the ordinary community partly outside the cloister while others like male Carthusians led a very secluded life.

should be examined by friends chosen by both parties and a third party[i] as is the custom for selecting and making a decision in arbitration according to Florentine law and if they decided that this panel was valued at less than forty ducats.[ii] Andrea should get less than thirty ducats by the same amount and if it were valued at more he should give the extra amount to the convent. With this agreement that the panel must be finished a year from now and that if he did not finish the said picture within the time the nuns would have the right to give the commission to someone else and have restored the payment made.

3. Isabella d'Este
Letter to Pietro Perugino

David S. Chambers, *Patrons and Artists in the Italian Renaissance*, London, Macmillan, 1970, pp.186–7 (trans. David S. Chambers).

When artists and patrons were geographically separated, letters sometimes served to state the requirements of a commission. For example, the Marchioness of Mantua, Isabella d'Este (1474–1539) specified in 1503 to the painter Pietro Perugino (c.1450–1523; born Pietro Vannucci, he acquired fame under the name denoting his native city, Perugia) the subject matter, and the sizes and disposition of the figures for a picture. The following letter was attached to the legal contract for her painting, which was witnessed in Florence by her agent. Like males of her rank Isabella adopted an imperious tone, exuded confidence in artistic judgement and advertised understanding of the latest theories concerning the similarity between poetry and painting, derived from Horace's *Art of Poetry* of 18 BCE ('our poetic invention'). Like them she could call on court scholars for advice. However, the conditions in which she commissioned were gendered, for instance in the way her education had been confined to the vernacular. She sought to improve it with Latin lessons following her marriage to Francesco Gonzaga in 1490, but it seems likely that she was more reliant on erudite men in her retinue for advice on suitable subject matter than would be the case with the better

i. The third party was chosen by the two arbitrators representing the contracting parties.
ii. A ducat had roughly the same value as a florin. To give an idea of the contemporary cost of this altarpiece at

40 florins, Raphael, in 1516, was ready to pay 100 ducats to buy what he called a good house in Rome. For further explanation in putting Renaissance prices in context, see Rembrandt Duits, 'Art, Class and Wealth', in Kim W.

Woods, Carol M. Richardson and Angeliki Lymberopoulou (eds.), *Viewing Renaissance Art*, New Haven and London, 2007, p.56.

tutored men of her rank. Furthermore, in all hercommissions she obeyed the social rules for the good feminine (represented in treatises such as that by Dominici, see extract 1, pp.105–6 above) enjoining women to encourage moral virtue, especially female chastity. CK

Our poetic invention, which we greatly want to see painted by you, is a battle of Chastity against Lasciviousness, that is to say Pallas and Diana fighting vigorously against Venus and Cupid [fig.3]. And Pallas should seem almost to have vanquished Cupid, having broken his golden arrow and cast his silver bow under foot; with one hand she is holding him by the bandage which the blind boy has before his eyes, and with the other she is lifting her lance and about to kill him.[i]

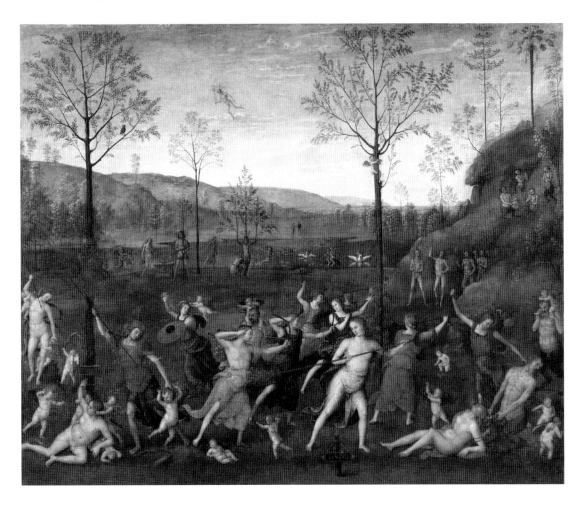

Fig.3
Pietro Perugino
Combat between Love and Chastity 1505
Tempera on canvas 160 x 190 cm
Musée du Louvre, Paris

By comparison Diana must be seen to be having a closer fight with Venus for victory. Venus has been struck by Diana's arrow only on the surface of the body, on her crown and garland or on a veil she may have around her; and part of Diana's raiment will have been singed by the torch of Venus, but nowhere else will either of them have been wounded.

Beyond these four deities, the most chaste nymphs in the train of Pallas and Diana, in whatever attitudes and ways you please, have to fight fiercely with a lascivious crowd of fauns, satyrs and several thousand cupids; and these cupids must be much smaller than the first [the God Cupid], and not bearing silver bows and gold arrows but bows and arrows of some baser material such as wood or iron or what you please.

And to give more expression and decoration to the picture, beside Pallas I want to have the olive tree sacred to her, with a shield leaning against it bearing the head of Medusa, and the owl, the bird peculiar to Pallas, perched among the branches. And beside Venus I want her favourite tree, the myrtle, to be placed. But to enhance the beauty a fount of water must be included, such as a river or a sea, where fauns, satyrs and more cupids will be seen, hastening to the help of Cupid, some swimming through the river, some flying, and some riding on white swans, coming to join such an amorous battle. On the bank of the said river or sea stands Jupiter with the other gods, as the enemy of Chastity, changed into the bull which carried off fair Europa; and Mercury as an eagle circling above its prey, flies around one of Pallas' nymphs, called Glaucera, who carries a casket engraved with the sacred emblems of the goddess. Polyphemus, the one eyed Cyclops, chases Galatea, and Phoebus chases Daphne, who has already turned into a laurel tree; Pluto having seized Proserpina, is bearing her off to his kingdom of darkness, and Neptune has seized a nymph who has been turned almost entirely into a raven.

i. For the characterisation that erotic love is blind, see Erwin Panofsky, *Studies in Iconology: Humanistic Themes* *in the Art of the Renaissance*, New York, Harper, 1962, pp.95–106. Cupid as God of Charitable Love had no blindfold.

4. Franciscans of Santa Maria di Monteluce, Perugia
Chronicle of Santa Maria di Monteluce

Memoriale di Monteluce: cronaca del monastero delle clarisse di Perugia dal 1448 al 1838, ed. Chiara Augusta Lainati, Porziuncola, Santa Maria degli Angeli, 1983, pp.38, 41, 52, 76, 85–6 (trans. Catherine King).

Most decorative and building programmes were commissioned and recorded by men. However some female convents narrated their activities for future members of their community to read. The following are sample entries from the chronicle of the Franciscan nuns (Poor Clares) of Santa Maria di Monteluce, Perugia. This was an enclosed community, so writers recorded commissions for their public church that they may have seen only in drawings or small models. Equally, entry to their convent was prohibited except on official visitations (when a team of clerics or monks would enter to examine how well they were following the regulations for worship) or in emergencies. Such chronicles document the way groups of women felt about the convent buildings and the contents that they accepted (as gifts), selected and conserved. CK

1482 It was decided to increase the size of the interior orchard of the sisters for the greater consolation and usefulness of the aforesaid sisters present and future.

1484 Our Venerable Father Confessor Brother Mariano da Castiglione Artino, before he was ordained, was a master maker of hour glasses, especially ones using water. As a charitable act he made one of them for us with his own hands, and it may be seen on the wall outside the dormitory.

1491 In the time of Abbess Lucia da Foligno the sisters were suffering great difficulties in the winter since they had little facility for heating. Realising that there was insufficient space to add a larger kitchen to the refectory, they rebuilt towards the garden taking over the old bakery as the kitchen and erecting a new bakery beside it. For the refectory the Abbess had painted figures of the Crucifixion with the Virgin Mary, St John the Evangelist, St Francis and St Clare.

1503 Many times we discussed having a railing of iron or wood in our exterior church to protect our priests, because they were being jostled when they celebrated mass by the crowd of laypeople next to the altar, and

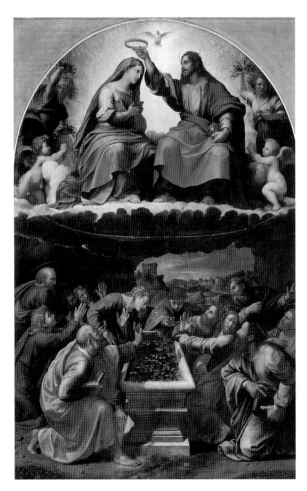

Fig.4
Raphael and his pupils
Assumption and Coronation of the Virgin
1505–25
Tempera and oil on panel 354 x 230 cm
Pinacoteca Vaticana, Rome

so as to guard the valuable things which honour the altar. Consequently we obtained the services of the excellent master Brother Michele del Borgo to make a wooden screen like those elsewhere in the province . . . This was a work which was beautiful and worthy.

1505 In the time of the office of the above mentioned Abbess Battista da Perugia it was decided that an altarpiece for the high altar of the external church should be made, as had many times been discussed, painted with the Assumption of the Virgin Mary as was appropriate in this church [fig.4]. This was decided in her third year of office, so she did not have time to do more than have the artist found: one called Raphaello da Urbino [Raphael]. He was considered the best according to the advice of many citizens and also of our Venerable Fathers, who had seen his works. It was with him that the pact with the contract was made when the witnesses were assembled at the counting house of Cornelio de' Randoli da Perugia by our factor the notary Bernardino da Chanaia, and the thirty ducats *de camera* of gold which Master Raphaello had stipulated were given into Raphaello's hand.

5. Anna Bellavitis and Isabelle Chabot
'People and Property in Florence and Venice'

In Marta Wollheim-Ajmar and Flora Dennis (eds.), *At Home in Renaissance Italy*, London, Victoria and Albert Museum, exhibition catalogue, 2006, pp.77–9.

One of the distinctive aspects of the Renaissance in Italy has been identified as an increase in domestic patronage for household use. However, research into the legal position of women in the family has highlighted the relative lack of control by women of such domestic commissioning. Few women owned houses as dowry properties and could will them on to whom they pleased. Most women were in the position of being required to care for their husband's artworks, whilst the choice of what to purchase was a masculine privilege. Small numbers of widows might purchase for themselves or on behalf of the children in their charge, but usually the house in which they lived was controlled by their spouse's will. Research charts this largely temporary, detached and provisional relationship of most wives and widows to dwellings and their furnishings, except for the few who owned houses and their contents as dowries. In contrast to the secular domestic sphere where women rarely commissioned artworks and hardly ever willed them on to future generations of women, nuns planned their artistic and architectural purchases to benefit the nuns who would follow them. CK

For elite families the identification of *casa* (house) with *casata* (family), often manifested by the presence of family coats of arms on the façade, was reinforced by the ownership of the building and the convergence of several nuclear families of different generations living under the same roof. Not everyone, however, owned a 'family house'. Late-medieval tax records, such as the famous Florentine *catasto* of 1427, clearly demonstrate that within working-class families cohabiting groups were much smaller, with less complex structures, and were generally based in rented houses or parts of them. While a degree of residential mobility characterized the experience of the less well off, the directly owned house, the 'permanent address', anchored the families of rich artisans, merchants and patricians in urban space and time, giving them a sense of perpetuity that was immediately obvious to the eyes of the entire community. For many the house was a symbolic as well as a material possession that was passed down and inherited. The strong identification between house and family raises several questions. Who in the family was most associated with the Renaissance house? Within the inheritance structure of Renaissance Italy, was the 'family house' fundamentally a male asset? Whatever the answers to these questions,

the house was a space where the lives of men and women intertwined and generations succeeded one another.

Was the Renaissance house a male possession? The communal statutes of central and northern Italy appear to provide a conclusive answer: between the twelfth and sixteenth centuries a new legal system excluded women from owning immobile property belonging to the family line, and accorded it exclusively to men. Daughters and sisters who left home in order to marry or enter a convent received a portion of the inheritance, in the form of a *dote*, or dowry, calculated on the basis of the family's mobile goods. Among the land-owning elites, daughters were provided with money, while the rest of the inheritance was divided equally between all the sons. But attempts were made to preserve the integrity of strategic goods, as well as symbolic ones, such as any houses, towers, city palaces (*palazzi*) or castles situated on the land owned. In Venice, however, some immobile goods were more easily accessed by women: these were *de foris* goods, located outside the city, and were the first items from a dowry to be returned to a widow on the death of her husband, as was customary. *De foris* and mobile goods were as one in Venetian law, resulting in the paradox that immobile sites on the mainland were considered to be 'mobile', and therefore inheritable by women, while houses and *palazzi* built in the lagoon, on the uncertain divide between earth and water, were 'immobile'. Retaining urban palaces within the family and preventing them from being dispersed along the female line was a common preoccupation among European patricians and nobility. In Venice, where the built and buildable environment, shored up from the waters, was so precious and limited, this strategy became a necessity for survival.

Legal records confirm that this was a universal phenomenon. In Florence very few houses were included in the dowries of the daughters of the elites marrying for the first time. If the dowry could not be given in money, it was preferable to relinquish land than to hand over built property. On his deathbed a father generally preferred to leave the family house to his sons. Matteo Strozzi's will of 12 October 1429 is emblematic of this desire to keep the family house within the line of direct descendance and, in the absence of heirs, within the lateral branches of the family line:

> I wish that the house where I live in corso Strozzi should be left to my sons and their descendants and that it should never be sold or given up in any other way, except to my descendants in the male line, and if they fail, to the descendants of Filippo di Messer Lionardo, and if they fail, to the descendants of Messer Iachopo degli Strozzi.

[. . .] The most common experience for a new bride was to move into her husband's house and live with his family. The daughters of Venetian patricians and citizens were destined to leave their fathers' houses between sixteen and eighteen. When she moved into her new home, the young bride

took many family possessions with her: typically, her trousseau, jewellery, a 'walnut chest' or some other pieces of furniture. Francesca Michiel, the wife of Domenego de Zuanne, a 'ship owner', even took her own portrait with her. It was customary in Venice for the bed to feature in inventories of marriage dowries, and it was always 'furnished', that is, equipped with bedding. This included 'gold curtains' like the ones owned by Medea Morosini, who married Francesco Becicheni, or 'two cushions and two bolsters' as in the case of Ludovica Scotto, a widow who was remarried to Cornelio Zambelli. The same bed sometimes reappeared in women's wills, bequeathed to a grandchild or servant 'for her marriage' or to a charitable institution. In Florentine patrician households, however, women contributed very little to the furnishings of the nuptial chamber, which were normally provided by the husband. In this intimate space belonging to the couple, brides only supplied the chests containing their trousseaus: up until the mid-fifteenth century these itinerant pieces of furniture followed new brides – and eventually also widows – as they moved from one house to another. Later on, they were acquired by the husband and remained in the chamber. The bed, the most permanent element of the room's furnishings, does not feature in dowry inventories and a widow was only able to continue sleeping in it if her husband left it to her in his will. Only very personal items were brought by new brides into patrician Florentine houses, duly inventoried and valued. These formed part of their dowry and could be reclaimed if they were widowed. In the country or among the city's lower-class neighbourhoods trousseaus of workers and peasants followed a less standard pattern, consisting of fewer, more utilitarian objects. This reminds us that for these social groups setting up home required a concerted, joint effort on the part of the couple after the marriage.

Studies on the Renaissance home have been keen to point out that domestic spaces were organized very differently according to the gender of the occupants. Alberti's possibly unrepresentative precepts go so far as to suggest that wives were not provided with the key to the study, the supreme male space, while husbands did not even set foot in the kitchen, where the 'queen of the house' reigned undisturbed. Among the elites, the type of inheritance, the residence of the married couple (whether in the house of the father or that of the husband) and the ownership of the furnishings gave a decidedly male imprint to houses at a material and symbolic level. Although this does not mean that women were only 'guests' in their homes, the fragile nature of their connection with houses is demonstrated by the fact that their residency, use of spaces and domestic furnishings were matters for negotiation.

Chapter 8
From Candia to Toledo: El Greco and his art

Angeliki Lymberopoulou

1. Two documents concerning a dispute between the confraternities of painters and sailors on Crete

Μ. Κωνσταντουδάκη-Κιτρομηλίδου, 'Ειδήσεις για τη συντεχνία των ζωγράφων του Χάνδακα τον 16° αιώνα', *Πεπραγμένα του Δ' Διεθνούς Κρητολογικού Συνεδρίου (Ηράκλειο, 29 Αυγούστου – 3 Σεπτεμβρίου 1976)*, vol.2, Athens, 1981, pp.134, 138–9 (trans. Guido Giglioni)

These two documents, dated 27 June and 4 July 1579, are indicative of the shifting social context of the Renaissance. They narrate the incident where the confraternity of painters, addressing the Venetian authorities on the island of Crete, objected to the confraternity of the sailors preceding them during the Corpus Domini procession in the island's capital, Candia (present-day Herakleion). This was a very significant procession celebrating an important feast within the Catholic calendar, which was established in the thirteenth century and was celebrated every year on the second Thursday after the Pentecost. This objection is telling, not only because the confraternity of sailors was entrusted with the banner of St Mark, the patron saint of Venice, but also because Venice was a maritime city – its wealth and power was based on its navy and sailors. The overruling of this objection by the Venetian authorities is therefore hardly surprising. Nevertheless, the fact that the painters felt they had the right to challenge this could be indicative of the change in the status and the prestige their profession had acquired and continued to acquire within their social context. AL

27 June 1579

The most illustrious Regiment of Crete, having heard in a case the
reasons of the conflicting parts indicated below, that is, of Messer
Marco Franco, the keeper of the school of seamen, on the one hand,
and of Sir Nicolò Sclavo, the keeper of the school of painters, has decided
that Sir Nicolò should be summoned bringing a lawyer, legal papers
and other documents necessary for the case, on the next coming
Tuesday, on the 30th of the current month, so that the disagreement he
has with Messer Marco may come to a solution, both parts being present
and participating.

4 July 1579

His Excellency Messer Nadal Donato, the most honourable General,
on behalf of his Excellency the Duke, and of the most illustrious Messer
Marin Sanudo, most honourable Counsellor, and of Messer Domenego
Avonal, honourable Camerlingo and Vice-counsellor, has heard the
reasons adduced by Messer Marco Franco, keeper of the school of sea
men, called 'La Misericordia'. Having brought an action against
Master Nicolò Sclavo, keeper of the school and fraternity of painters,
Messer Marco Franco explained that it is customary in this city to
organize processions in various periods of the year, and also during
the day of the Corpus Domini, when the most holy Body of Christ is
shown in praise and glory to our Lord and in honour of the most serene
Republic of Venice, and that in different respects the school or college of
seamen should walk before and precede that of painters, both because
the knowledge they represent is worthier than the one represented by
painters and because seamen are a member of society that is more useful
and necessary in every occasion to the affairs of the most serene Republic
than the school of painters. And during the festivity of the most holy
Body of Christ, the banner of the most holy Evangelist Mark, patron of
this most fortunate and glorious republic, is given to the aforementioned
school of seamen. However, the painters raise objections when they have
to yield to the seamen, for they do not allow the school of seamen to have
its due place and to walk before the college of painters. Therefore Messer
Franco asked that your Excellencies should rule in a just way that in this
procession and in any other procession the school and college of seamen
should walk before the school of painters, because of the aforementioned
reasons and also for other reasons, set out by the honourable Messer
Michel Scordilli, a doctor, his [i.e. Marco Franco's] lawyer; and for the
other part, by Master Nicolò Sclavo, keeper of the school of painters, on
his behalf and of the other fellows, while the honourable Messer Giacomo
Benedetti, a doctor and his [i.e. Nicolò Sclavo's] defending counsel,
is asking that this obligation that has been unfairly imposed to the
fraternity and school of painters, was referred to the illustrious Messrs

giustitieri and *proveditori*,[i] as to competent judges, so that each one of the two parties could use their reasons, both in the Court of First Instance and in that of Appeal. He is also objecting to Messer Marco Franco, the keeper of the school of seamen and said that such a case cannot be put forward by him [i.e. Marco Franco], nor by his other fellows [i.e. sailors], but by the esteemed Admiral, to whom the aforementioned banner has been given, when in due course the competent judge decides to explain the matter more clearly, adducing in favour of his reasons the order enacted during the year 1554 by the most illustrious Regiment and Captain, through the intervention of the aforementioned Messrs *giustitieri* and *proveditori*. These reasons having therefore been heard and the arguments that are worth considering having been considered, your Excellencies have declared and decided that the school of seamen should walk before that of the painters, the aforementioned parts being present and participating.

2. Document on the auction of El Greco's *Passion of Christ*

Mary Constantoudaki, 'Domenikos Theotokopoulos (el Greco) from Candia to Venice: Unpublished documents (1566–1568)', *Δελτίον της Χριστιανικής Αρχαιολογικής Εταιρείας* series 4, vol.8, 1975–6 (published 1976), p.59 (in Greek with an English summary) (trans. Guido Gigliani).

This document informs us that El Greco (1541–1614), referred to here as Domenico Theotocopulo, decided to auction one of his works depicting the *Passion of Christ* while still living in the capital of the Venetian-dominated island of Crete, Candia (presently known as Herakleion). The document addresses El Greco as 'master', which means that by this time El Greco was an accomplished artist. This painting has been identified by Nano Chatzidakis, but the identification remains controversial.[1] AL

26 December 1566
 Upon request of master Domenico Theotocopulo a painter, who is asking whether he may be allowed to auction a painting representing the Passion of our Lord Jesus Christ, decorated with gold, provided that

i. High-ranking officials in Venetian-dominated Crete (1211–1669).
1. N. Chatzidakis, *Icons: The Velimezis*

Collection, Thessaloniki, Benaki Museum, exh. cat., 1997, pp.184–227.

it is assessed by experts, the most illustrious government has decided that, once the painting has been appraised, it can be auctioned by master Domenico, according to his request.

27 December 1566

Priest Janni de Frossego and master Giorgi Cloza, both painters, have been summoned to appear in the chancery and they have stated under oath that the aforementioned painting, after having been carefully examined by them, is worth eighty ducats according to the priest and seventy ducats according to master Giorgi. Master Domenico was satisfied with the appraisal of seventy ducats and has therefore agreed for the painting to be auctioned.[i]

3. Giulio Clovio
Letter introducing El Greco to Cardinal Alessandro Farnese

Ellis K. Waterhouse, 'El Greco's Italian Period', *Art Studies: Medieval, Renaissance and Modern*, Harvard, Harvard University Press, 1930, p.63; reprinted in *El Greco: Byzantium and Italy*, ed. N. Hadjinicolaou, Rethymno, Crete University Press, Literary Sources of Art History, 1990, p.199.

This letter (dated 16 November 1570), by Guilio Clovio (1498–1578), the Croatian artist and friend of El Greco, to Cardinal Alessandro Farnese, is assumed to be the reference that introduced El Greco to the Cardinal's circle (Farnese was from the Italian family of rulers, ecclesiastics, patrons and collectors, and was made Vice-Chancellor of the Holy Roman Church in 1534 and Cardinal in 1580). Accepting that the young artist from Candia to which the letter refers to is, indeed, El Greco, the letter suggests that he was a disciple of Titian (c.1488/90–1576). At the time El Greco was in Venice, however, the great Venetian master was getting rather old, and it is questionable whether he would have been able to oversee the training of young artists personally in his studio. It was only natural that, because of Titian's reputation, any form of association between the young Cretan and the Venetian master was bound to be made much of in Clovio's letter. AL

i. For placing this price within its contemporary context, see Nikolaos M.

Panagiotakes, *El Greco: The Cretan Years*, Farnham, 2009, pp.31–3.

There has arrived in Rome a young Cretan, a pupil of Titian, who seems
to my judgment to have a rare gift for painting: among other things he has
done a portrait of himself which causes astonishment to all our painters
in Rome. I should like to introduce him to the protection of your most
illustrious and most Reverend Lordship, if your Lordship will contribute
nothing else towards his livelihood than a room in the Palazzo Farnese for
such little time as may be necessary until he finds better accommodation.
Wherefore I pray and beseech your Lordship to be pleased to write to your
Majordomo, Count Lodovico, that he provide him with one of the upper
rooms in the Palace. You will be doing a virtuous action, worthy of your
Lordship, and one for which I should be very grateful.

I kiss your hands with respect
Your humble servant,
Don Giulio Clovio.

4. Giulio Cesare Mancini
On El Greco's willingness to repaint
Michelangelo's *Last Judgement*

Ellis K. Waterhouse, 'El Greco's Italian Period', *Art Studies:
Medieval, Renaissance and Modern*, Harvard, Harvard University
Press, 1930, p.65, reproduced in *El Greco: Byzantium and Italy*, ed.
Nicos Hadjinicolaou, Rethymno, Crete University Press, Literary
Sources of Art History, 1990, p.200.

**Pope Pius V (1504–72) expressed his wish to conceal the nudity of the
figures in the Last Judgement depicted by Michelangelo on the altar
wall of the Sistine Chapel. The Florentine master completed this work
between 1536 and 1541. According to Giulio Cesare Mancini's anecdotal
report, not recorded until 1619, five years after El Greco's death, the
Pope's wish led to El Greco's declaration that if the decision was made
to destroy the whole artwork and start again, he would be able to
produce a work of equal artistic merit that would be appropriately
modest in its depiction of the figures. AL**

Under the Papacy of Pius V of holy memory . . . came to Rome and was
sufficiently reputed to earn the title of 'il Greco' by which he was usually
known. Having studied at Venice, in particular the paintings of Titian,
he had arrived at considerable success in the profession and in the

Titianesque manner. He came from Venice to Rome at a time when painters were few and such as there were lacked the decisiveness and spontaneity of his style; and he developed a high conceit of himself as the result of giving great satisfaction in executing some private commissions. One of these can be seen today in the hands of the lawyer Lancilotti, where it has been mistaken by some for a Titian. Consequently, when the occasion arose for overpainting certain figures in Michelangelo's 'Last Judgment,' which Pius V considered insufficiently decent for their location, he burst out with the remark that, if they would demolish the whole work, he would do another, not a whit worse than Michelangelo's as a work of art, which would be both chaste and decorous in addition.

All the painters and patrons of the arts resented this and it became necessary for him to retire to Spain, where, under Philip II, he produced many works of very fine quality. However, he arrived unasked, and Pelegrin da Bologna, Federico Zuccaro and several Flemings held precedence over him by their painting and by their intrigues, so that he left the court and retired to . . . where he died a very old man, almost unheard of in the world of art. In his prime, however, he ranked among the foremost painters of his generation.

5. Francisco Pacheco
'The Art of Painting, its Antiquity and Glories'

Francisco Pacheco, 'Arte de la Pintura, su antigüedad y grandezas' [The art of painting, its antiquity and glories], original manuscript written 1638, in *Arte de la Pintura*, with introduction, notes and indices by F.J. Sánchez Cantón, 2 vols., Madrid, Instituto de Valencia de Don Juan, 1956; reprinted in José Álvarez Lopera, *El Greco. Estudio y Catálogo. Volumen 1. Fuentes y Bibliografía*, Madrid, Fundación de Apoyo a la Historia del Arte Hispánico Madrid, 2005, pp.421–2 (trans. Michelle Marie Homden).

The Spanish painter and writer Francisco Pacheco (1564–1644) narrates the incident when El Greco (referred as 'Dominico Greco' in the text) in a discussion confided in him that Michelangelo was a good man but did not know how to paint. Michelangelo was an acclaimed representative of the Florentine school, which stipulated that successful painting was based on detailed drawing. El Greco, however, was trained in Venice and adhered to the Venetian principles of painting, which gave precedence to the application and use of colour. His statement,

therefore, should be viewed as a reflection of his own training (see also following extract). AL

On Drawing and its Aspects

Which is why I find it extraordinary (and excuse me for telling this story, I am not trying to impress) that when I asked Dominico Greco in 1611 which was more difficult, the drawing or the colouring, he replied that it was the colouring. But that is not quite as extraordinary as hearing him speaking of Michelangelo, the father of painting, with so little esteem, saying that he was a good man but that he did not know how to paint. Anyone who heard that opinion will not be surprised by this divergence from the general feeling of other artists, knowing that he was an original in all things as he was in painting.

6. Giorgio Vasari
Lives of the Painters, Sculptors and Architects

Giorgio Vasari, *Lives of the Painters, Sculptors and Architects* (1568), trans. Gaston Du C. de Vere, London, Everyman's Library, London, 1996, vol.2, pp.791–2.

The Florentine Giorgio Vasari included the following passage in his *Lives* in his discussion of the Venetian artist Titian, which is indicative of the different attitudes towards painting and the requirements for a quality finish. Artists like Michelangelo clearly valued the careful and meticulous execution of drawing as opposed to the quality and importance of colour that was valued by artists such as Titian. The two masters are representatives of the ideas assigned to the so-called Florentine and Venetian schools respectively. This passage could offer an explanation for El Greco's claim (see previous two extracts) that he would have been able to repaint the Sistine Chapel with comparative artistic skill to Michelangelo, who he said 'was a good man but . . . did not know how to paint': this does not reflect an arrogant attitude on El Greco's part, but rather his artistic preferences and convictions. He grew up in an environment heavily influenced by Venetian artistic preferences, since he was born and raised in Venetian-dominated Crete; he then moved to Venice and was a follower of Titian, of Tintoretto (1518–94) and, therefore, of the Venetian school. AL

The year 1546 having come, he went at the invitation of Cardinal Farnese to Rome, where he found Vasari, who, having returned from Naples, was executing the Hall of the Cancelleria for the above-named Cardinal; whereupon, Tiziano having been recommended by that lord to Vasari, Giorgio kept him company lovingly in taking him about to see the sights of Rome. And then, after Tiziano had rested for some days, rooms were given to him in the Belvedere,[i] to the end that he might set his hand to painting once more the portrait of Pope Paul, of full length, with one of Farnese and one of Duke Ottavio, which he executed excellently well and much to the satisfaction of those lords. At their persuasion he painted, for presenting to the Pope, a picture of Christ from the waist upwards in the form of an 'Ecce Homo,' which work, whether it was that the works of Michelagnolo, Raffaello, Polidoro, and others had made him lose some force, or for some other reason, did not appear to the painters, although it was a good picture, to be of the same excellence as many others by his hand, and particularly his portraits. Michelagnolo and Vasari, going one day to visit Tiziano in the Belvedere, saw in a picture that he had executed at that time a nude woman representing Danaë,[ii] who had in her lap Jove transformed into a rain of gold; and they praised it much, as one does in the painter's presence. After they had left him, discoursing of Tiziano's method, Buonarroti commended it not a little, saying that his colouring and his manner much pleased him, but that it was a pity that in Venice men did not learn to draw well from the beginning, and that those painters did not pursue a better method in their studies. 'For,' he said, 'if this man had been in any way assisted by art and design, as he is by nature, and above all in counterfeiting the life, no one could do more or work better, for he has a fine spirit and a very beautiful and lively manner.' And in fact this is true, for the reason that he who has not drawn much nor studied the choicest ancient and modern works, cannot work well from memory by himself or improve the things that he copies from life, giving them the grace and perfection wherein art goes beyond the scope of nature, which generally produces some parts that are not beautiful.

i. The word derives from the Italian *bello* ('beautiful') and *vedere* ('to see') was used to denote buildings located on hills in order to acquire a view. The 'Belvedere' mentioned here was part of the Vatican Palace in Rome.

ii. The painting discussed here is dated 1544–6 and is presently housed in the Museo Nazionale di Capodimonte, Naples.

7. José de Sigüenza
History of the Order of St Jerome, Doctor of the Church

José de Sigüenza, *La Fundación del Monasterio de El Escorial* [The Founding of the Monastery at El Escorial], Madrid, Aguilar, 1963; reprinted in José Álvarez Lopera, *El Greco. Estudio y Catálogo*, vol.1, *Fuentes y Bibliografía*, Madrid, Fundación de Apoyo a la Historia del Arte Hispánico Madrid, 2005, pp.412–13 (trans. Michelle Marie Homden).

In this extract from Part Three of his *History of the Order of St Jerome, Doctor of the Church* (1605), the historian, poet, Spanish theologian and Prior of the monastery of El Escorial, José de Sigüenza (1544–1606), offers his opinion on El Greco's *Martyrdom of St Maurice* 1580–2, a work that was commissioned by Philip II of Spain (1527–98), which the King subsequently rejected. The statement of the Prior is intriguing in view of the fact that Philip II decided to keep the work, and paid more to acquire it than he did for the painting he chose to hang in El Escorial (by the Florentine Romulo Cincinnato, 1502–93). AL

There was here a painting of Saint Maurice and his soldiers by one Dominico Greco who is still living and doing excellent work in Toledo. He painted it especially for the altar of these holy men. His Majesty was not pleased with it. This is not surprising as few people liked it although it is said to be very clever and the artist very knowledgeable as excellent works of his show. On this matter, there are many opinions and tastes. This seems to me to be the difference between works executed with judgement and skill and those which lack these attributes. The former are pleasing to all, the latter to some. For art always corresponds to judgement and nature and this is imprinted in every soul and thus is pleasing to all. Poorly produced works may, with some adornment or scene-shifting, fool the uninformed mind and thus please the unthinking and ignorant. Therefore, as our own Mudo[i] used to say in his own way, the saints must be painted in such as way as not to remove the desire to pray with them. Put devotion before everything, as this must be the principal function and purpose of paintings of the saints.

i. 'Mudo', a nickname meaning 'mute', identifies the Spanish painter Juan Fernández Navarrete (1526–79), who worked on El Escorial.

8. Roger Fry
Vision and Design

Roger Fry, *Vision and Design*, London, Chatto and Windus, 1923, pp.205–13.

In this extract, the English artist and art critic Roger Fry (1866–1934) discusses El Greco and his art. His focus and starting point is *The Agony in the Garden of Gethsemane* 1590s, acquired by the National Gallery in 1919 by Sir Charles John Holmes (1868–1936; Director of the National Gallery 1916–28) as a work by the Cretan master, but currently thought to have been executed by El Greco's Studio. Fry's text, which does not mention the name of the painting, is a narrative that assumes a substantial level of familiarity with the subject from its readers and includes his personal views on the art of the painter. Furthermore, Fry is attempting to categorise El Greco's art as 'baroque' and thereby brush aside claims of its originality. AL

El Greco

Mr. Holmes has risked a good deal in acquiring for the nation the new El Greco. The foresight and understanding necessary to bring off such a *coup* are not the qualities that we look for from a Director of the National Gallery. [. . .] Even before the acquisition of the El Greco there were signs that Mr. Holmes did not fully understand the importance of 'muddling through.' And now with the El Greco he has given the British public an electric shock. People gather in crowds in front of it, they argue and discuss and lose their tempers. This might be intelligible enough if the price were known to be fabulous, but, so far as I am aware, the price has not been made known, so that it is really about the picture that people get excited. And what is more, they talk about it as they might talk about some contemporary picture, a thing with which they have a right to feel delighted or infuriated as the case may be – it is not like most old pictures, a thing classified and museumified, set altogether apart from life, an object for vague and listless reverence, but an actual living thing, expressing something with which one has got either to agree or disagree. Even if it should not be the superb masterpiece which most of us think it is, almost any sum would have been well spent on a picture capable of provoking such fierce æsthetic interest in the crowd.

That the artists are excited – never more so – is no wonder, for here is an old master who is not merely modern, but actually appears a good many steps ahead of us, turning back to show us the way. Immortality if you like! But the public – what is it that makes them 'sit up' so surprisingly, one wonders. What makes this El Greco 'count' with them as surely no

Old Master ever did within memory? First, I suspect, the extraordinary completeness of its realisation. Even the most casual spectator, passing among pictures which retire discreetly behind their canvases, must be struck by the violent attack of these forms, by a relief so outstanding that by comparison the actual scene, the gallery and one's neighbours are reduced to the key of a Whistlerian Nocturne.[i] Partly, for we must face the fact, the melodramatic apparatus; the 'horrid' rocks, the veiled moon, the ecstatic gestures. Not even the cinema star can push expression further than this. Partly, no doubt, the clarity and the balanced rhythm of the design, the assurance and grace of the handling; for, however little people may be conscious of it, formal qualities do affect their reaction to a picture, though they may pass from them almost immediately to its other implications. And certainly here, if anywhere formal considerations must obtrude themselves even on the most unobservant. The extraordinary emphasis and amplitude of the rhythm, which thus gathers up into a few sweeping diagonals the whole complex of the vision, is directly exciting and stimulating. It affects one like an irresistible melody, and makes that organisation of all the parts into a single whole, which is generally so difficult for the uninitiated, an easy matter for once. El Greco, indeed, puts the problem of form and content in a curious way. [. . .]

Strange and extravagantly individual as El Greco seems, he was not really an isolated figure, a miraculous and monstrous apparition thrust into the even current of artistic movement. He really takes his place alongside of Bernini as a great exponent of the Baroque idea in figurative art. And the Baroque idea goes back to Michelangelo. [. . .]

When the figure is draped the Baroque idea becomes particularly evident. The artists seek voluminous and massive garments which under the stress of an emphatic pose take heavy folds passing in a single diagonal sweep from top to bottom of the whole figure. In the figure of Christ in the National Gallery picture El Greco has established such a diagonal, and has so arranged the light and shade that he gets a statement of the same general direction twice over, in the sleeve and in the drapery of the thigh.

Bernini was a consummate master of this method of amplifying the unit, but having once set up the great wave of rhythm which held the figure in a single sweep, he gratified his florid taste by allowing elaborate embroidery in the subordinate divisions, feeling perfectly secure that no amount of exuberance would destroy the firmly established scaffolding of his design. [. . .]

But to return to the nature of Baroque art. The old question here turns up. Did the dog wag his tail because he was pleased, or was he pleased

i. References to 'Nocturnes', paintings created in the 1870s by the American-born and British-based artist James Abbott McNeill Whistler (1834–1903). The name derives from Whistler's habit of painting London's modern urban landscape at night in an attempt to disguise its industrial ugliness.

because his tail wagged? Did the Baroque artists choose ecstatic subjects because they were excited about a certain kind of rhythm, or did they elaborate the rhythm to express a feeling for extreme emotional states? There is yet another fact which complicates the matter. Baroque art corresponds well enough in time with the Catholic reaction and the rise of Jesuitism, with a religious movement which tended to dwell particularly on these extreme emotional states, and, in fact, the Baroque artists worked in entire harmony with the religious leaders.

This would look as though religion had inspired the artists with a passion for certain themes, and the need to express these had created Baroque art.

I doubt if it was as simple as that. Some action and reaction between the religious ideas of the time and the artists' conception there may have been, but I think the artists would have elaborated the Baroque idea without this external pressure. [. . .] Moreover, the general principle of the continued enlargement of the unit of design was bound to occur the moment artists recovered from the debauch of naturalism of the fifteenth century and became conscious again of the demands of abstract design.

In trying thus to place El Greco's art in perspective, I do not in the least disparage his astonishing individual force. That El Greco had to an extreme degree the quality we call genius is obvious, but he was neither so miraculous nor so isolated as we are often tempted to suppose. [. . .]

No wonder, then, that for the artist of to-day the new El Greco is of capital importance. For it shows us the master at the height of his powers, at last perfectly aware of his personal conception and daring to give it the completest, most uncompromising expression. That the picture is in a marvellous state of preservation and has been admirably cleaned adds greatly to its value. Dirty yellow varnish no longer interposes here its hallowing influence between the spectator and the artist's original creation. Since the eye can follow every stroke of the brush, the mind can recover the artist's gesture and almost the movements of his mind. For never was work more perfectly transparent to the idea, never was an artist's intention more deliberately and precisely recorded.

Part 3 **City and country**

Introduction

Joel Robinson

The selection of readings in Part 3 concerns developments in artistic and architectural culture in the seventeenth century and the first half of the eighteenth. The first set of texts revolves around the concept of the Baroque in art history, and particularly the work of the sculptor and architect Gian Lorenzo Bernini (1598–1680), who changed the face of Rome. Not long after this artist's death, Filippo Baldinucci published his *Life of Bernini* (1682). Since at least the mid-sixteenth century, it had been customary for biographies like this to be written about artists considered 'great'. This is therefore one of the oldest forms of art writing. Baldinucci's text probably provides more insight into a contemporary view of the artist than it does into the artist himself. Nonetheless, it sheds some light on Bernini's ideas about nature, beauty and the unity of the arts. It is a favourable assessment, yet not everyone shared the enthusiasm expressed there.

The distinguished art historian Irving Lavin has recently made Bernini's efforts to bring painting, sculpture and architecture into an expressive 'unity' the subject of a book, but it is known that some of the artist's own contemporaries saw these theatrical attempts to meld the arts as his very undoing. One critic of the day, for instance, 'pilloried' his equestrian statue of Constantine unveiled at the Vatican's entrance in 1666, cautioning the artist in future to avoid the site of St Peter's, 'where on the rocks of both architecture and sculpture he has always been shipwrecked'. In his criticism of Bernini, this writer almost anticipated the scorn later heaped upon the extravagances of the Baroque within academic circles, where a return to the noble grandeur and calculated poise of antique art was instead being promoted.

If subsequent periods have not always been sympathetic to the Baroque, however, this has not necessarily been the case from the early twentieth century onwards. Heinrich Wölfflin was among a generation of art historians who sought to avoid the usual debate about what was good

or bad art, and instead explain its historical development in more scientific terms. A key example of this is his treatment of the Baroque and the classical in one of the founding texts of the field, *Principles of Art History* (1915). In this volume, he argues that 'Vision itself has its history', and that the classical and the Baroque ultimately reflect two very different modes of seeing (and representing) the world. What is so innovative here – paving the way for a formalist approach to style that would predominate over twentieth-century art history – is the intentional disregard for biographies of the artists on the one hand, and on the other the social, political and religious contexts in which artists worked.

The next set of texts pertains to Dutch painting of the so-called 'golden age'. Where Wölfflin is concerned, the 'five pairs of concepts' that applied to art south of the Alps applied equally to northern art, meaning that Dutch genre and landscape painting was considered just as 'Baroque' as anything sculpted by Bernini. This was in spite of the fact that Dutch paintings were being produced in a very different context, affected by Protestant Reformation as against the Catholic Reformation to which the Roman Baroque was so integral. In contradistinction to the old mythological or biblical subjects customarily promoted by the Church and the Court in Italy and France, Dutch art of the same time was influenced by new markets for art and a new kind of patronage, which led to new genres of painting – for example, scenes of everyday domestic, urban and rural life. More generally, this context was affected by new developments in science and technology, colonial expansion abroad and the awareness of new worlds, the competitiveness of banking and trade, and the growth of the middle classes (the bourgeoisie).

What is more, unlike the Italian and French contexts, in which academies had been founded to educate students of fine art, Dutch artists were still under the influence of the guilds. This is a crucial difference, for what it meant was that the Netherlands did not produce much in the way of theoretical treatises on art. One exception to this is Philips Angel's *In Praise of Painting*, a 1641 lecture delivered to the painters' guild of Leiden. Like other treatises on the subject, it is concerned with what constitutes the 'good' in art. However, what is striking here is the relative lack of appeal to past authority, usually so characteristic of such texts; there is a strong emphasis on the observation of nature instead, and only scorn for those who would merely copy old masters.

If Angel is counselling his fellow painters to look more studiously at the world, what the present-day art historian Svetlana Alpers finds in the art of this period is evidence of precisely that kind of meticulous looking. This is a 'looking' rooted in what she calls the 'age of observation', with its scientific reason and its new instruments for enhancing vision. In the abridged essay reproduced here, she takes issue with a school of iconographers who have in her view largely projected literary, symbolic and moralising

interpretations onto seventeenth-century Dutch painting. Her argument is that the visually descriptive (and even socially constructive) aspect of this painting is what makes it so distinctive; it is also what explains why a more expository discourse on art did not take a foothold here, as it did in other European contexts (such as Italy or France) where the theoretical codification of rules was foremost.

The third set of texts included here relates to the British context, and particularly to the City of London between the Great Fire of 1666 and the rise of neo-Palladianism in the early eighteenth century. While Rome was being made over by Bernini and others into the Baroque city *par excellence*, European urban centres such as London (and to a large extent those of France, Germany and the Netherlands as well) were increasingly subject to what the social philosopher Jürgen Habermas, in his inquiry into the concept of the bourgeoisie, called the 'structural transformation of the public sphere'. This is manifest in town planning and architectural design after the Great Fire, inasmuch as they register an increasing concern with the differentiation of public and private spaces.

The London that was left after the medieval buildings had been consumed in the inferno of 1666 presented planners with the idea that it might be designed from scratch, for the greater public good, and in a way that made it worthy of comparison with the great cities of antiquity. The proto-environmentalist gardener John Evelyn was among those who submitted a proposal. Just before the Fire, though, he had addressed Charles II and Parliament in his pamphlet *Fumifugium* (1661). In this, he laments how this 'Glorious and Antient City' 'should wrap her stately head in Clowds of Smoake and Sulphur' and be 'so full of Stink and Darknesse', with its buildings 'compos'd of such a Congestion of mishapen and extravagant Houses', and its streets 'so narrow and incommodious'. His is a plea for a more populist kind of planning that is orderly and hygienic, but every bit as monumental as Rome.

A key text in the eighteenth-century architectural movement that sought to revive the Roman manner in architecture was the *Vitruvius Britannicus*, published in three volumes between 1715 and 1725 by the architect Colen Campbell. This is not a treatise like Vitruvius's *De Architectura*, the first-century BCE text to which Campbell's title alludes. Rather, it is a cataloguing of what was considered good British architecture in country and city alike, ever since Inigo Jones first brought the Italian Renaissance to Britain. Its introduction proclaims the superiority of the classical language of Andrea Palladio over the 'affected and licentious' art of Bernini, and points to the emergence of what is now commonly called neo-Palladianism.

The final set of texts addresses aspects of the early eighteenth-century landscaped garden, in which this neo-Palladianism flourished. These are all recent pieces of scholarship addressing oversights in garden history, or

taking issue with some of the clichés that have formed around the concept of the landscaped garden. The first two texts are more concerned with the representation of landscape in art than its physical construction, and raise questions about how landscape is bound up with power and politics even as it conceals and naturalises these more sinister realities beneath pastoral scenery. The extracts from John Bonehill's catalogue essay for the travelling exhibition of the paintings of Paul Sandby discuss the new genre of country estate portraiture in terms of social relations and national identity, while W.J.T. Mitchell's essay asks whether landscape might more productively be seen, not just as a genre, but as a *medium* shaping social or imperial identities, and thus an instrument of power.

The last two extracts add to existing explanations for the informality of the English garden, as against its Baroque counterpart on the Continent. The landscape designer Bianca Maria Rinaldi's essay presents a corrective to the Eurocentrism of the discourse by surveying European knowledge of Chinese gardens during the early seventeenth century; it explains that reports on such gardens by Jesuit missionaries were making their way into Britain at this time, thus encouraging a greater naturalism in garden design. Yet, as the historian Katherine Myers argues, this predilection for naturalism and the picturesque in the English garden may be due in part to different concepts of vision being formulated on either side of the Channel. The theories of the philosopher George Berkeley, for instance, are said to be antithetical to the Rationalist or Cartesian ideas about vision that found an outlet in France's Baroque gardens, which were more formal and geometrical. Such an argument bears some resemblance to Wölfflin's contrasting of the classical and Baroque ways of seeing.

Chapter 9
Bernini and Baroque Rome

Carol M. Richardson

1. Filippo Baldinucci
The Life of Bernini

Filippo Baldinucci, *The Life of Bernini* (1682), trans. Catherine
Enggass, University Park, PA, Pennsylvania State University
Press, 2006 (first published 1966), pp.73–82.

**The genesis of the *Life of Bernini* by Filippo Baldinucci (1624–97),
the Florentine intellectual and critic, is much debated. It was probably
written in the 1670s at the behest of the Bernini family and included
their testimony as well as the artist's own reminiscences over his long
life to counter accusations and rebuild Bernini's faltering reputation.
After a chronological account of the artist's life and work, Baldinucci
assembles a number of statements in an attempt to sum up the values
and principles that Bernini worked to. They are more a reflection of the
artistic context of the second half of the seventeenth century than
Bernini's particular achievements, and may represent Baldinucci's
attempt to associate himself and his subject with influential critics such
as Cardinal Sforza Pallavicino (1607–67) who had published treatises on
art and the Church. According to Pallavicino, artists achieved what they
did not through the chance of having been graced with genius but
through sheer hard graft. CMR**

So far in my account of Bernini's works I have tried to follow an historical
chronology. I would now like to touch in a general way on some other of
his fine qualities, qualities either given him by nature or which, through
long and diligent effort, were always and everywhere the inseparable
companions of his deeds and had become second nature to him. First

of all, we can with good reason affirm that Cavalier Bernini was most singular in the arts he pursued because he possessed in high measure skill in drawing. This is clearly demonstrated by the works he executed in sculpture, painting, and architecture and by the infinite number of his drawings of the human body which are to be found in almost all the most famous galleries in Italy and elsewhere. [. . .] In these drawings one notes a marvelous symmetry, a great sense of majesty, and a boldness of touch that is really a miracle. I would be at a loss to name a contemporary of Bernini who could be compared with him in that skill. A particular product of his boldness in drawing was his work in that sort of sketch we call caricature or 'charged strokes,' which for a joke distort in an uncomplimentary way the appearance of others, without taking away the likeness or grandeur if the subjects were, as often happened, princes. Such personages are inclined to be amused at such entertainment even when their own appearance is concerned and would pass around the drawings for other persons of high rank to see.

The opinion is widespread that Bernini was the first to attempt to unite architecture with sculpture and painting in such a manner that together they make a beautiful whole. This he accomplished by removing all repugnant uniformity of poses, breaking up the poses sometimes without violating good rules although he did not bind himself to the rules. His usual words on this subject were that those who do not sometimes go outside the rules never go beyond them. He thought, however, that those who were not skilled in both painting and sculpture should not put themselves to that test but should remain rooted in the good precepts of art. He knew from the beginning that his strong point was sculpture. Thus, although he felt a great inclination toward painting, he did not wish to devote himself to it altogether. We could say that his painting was merely diversion. Nevertheless, he made such great progress in that art that besides the paintings by his hand that are on public view, there are more than one hundred and fifty canvases, many owned by the most excellent Barberini and Chigi families and by Bernini's children. [. . .]

Before Bernini's and our own day there was perhaps never anyone who manipulated marble with more facility and boldness. He gave his works a marvelous softness from which many great men who worked in Rome during his time learned. Although some censured the drapery of his figures as too complex and sharp, he felt this, on the contrary, to be a special indication of his skill. Through it he demonstrated that he had overcome the great difficulty of making the marble, so to say, flexible and of finding a way to combine painting and sculpture, something that had not been done by other artists. This was the case, he said, because they did not have the courage to render stones as obedient to the hand as if they were dough or wax. [. . .] Bernini used to say that in order to give great praise to something it was not sufficient that it contain few errors but that it have

great merits. To this judgment Cardinal Pallavicini, his intimate friend, added, 'What you say of your art I say of mine, that the fact that there are insoluble arguments against something is not a sign of the falsity of the hypothesis, although it raises doubts, but whether there are solid and convincing reasons that prove the conclusion. Yet the philosopher Zeno used such arguments as proofs, and to this day that which he left has not been demolished.'

Moreover, Bernini used to say that the worthy man was not he who made no errors, since that is an impossibility for those who do things, but he who made fewer errors than others; and that he, himself, had made more errors than any other artist, since he had made more works than any other. To one of his disciples who questioned him because he criticized beautiful things, he replied that there was no need to criticize ugly things, but rather the blameworthy aspects of beautiful things, thus seeking the perfect by the reflection of the good on the defects. [. . .]

Bernini wanted his students to love that which was most beautiful in nature. He said that the whole point of art consisted in knowing, recognizing, and finding it. He, therefore, did not accept the thesis of those who stated that Michelangelo and the ancient masters of Greece and Rome had added a certain grace to their work which is not found in the natural world. Nature knows how to give to every part its commensurate beauty, Bernini said, but one must know how to recognize it when the opportunity arises. In this regard he used to relate that in studying the Medici Venus he had at one time come to the same conclusion in observing her most graceful gesture. But since that time, having made profound studies of nature, he had clearly observed exactly the same graceful gesture on many occasions. He held that the story of the Venus that Zeuxis made was a fable: that is to say, the story that Zeuxis had made her from the most beautiful parts of many different girls, taking one part from one and another part from another. He said that the beautiful eyes of one woman do not go well with the beautiful face of another woman, and so it was with a beautiful mouth, and so on. I would say that this is absolutely true, since the various parts are not only beautiful in themselves but in their relationship to other parts. Thus the beautiful shaft of a column is praiseworthy for the proportions it has by itself, but if one adds a beautiful base and a fine capital that do not go with it, the column as a whole loses its beauty. This principle of Bernini's agrees with another of his concepts. He said that in making a portrait from life everything consisted in being able to recognize the unique qualities of individuality that nature gives to each person rather than the generality common to all. In choosing a particularity one must pick one that is beautiful rather than ugly. In order to achieve this end Bernini had a practice very different from the general run. He did not want the person he was drawing to remain immobile. Rather he wished him to move about and talk, since he said he then could see all his beauty

and, as it were, capture it. He said that a person who poses, fixed and immobile, is never as much himself as he is when he is in motion, when those qualities which are his alone and not of a general nature appear. Such individuality gives a portrait its likeness. But a complete grasp of this is not a game for children.

In order to make the portrait of His Majesty the King of France[i] Bernini first made many models. He removed all these models when he set to work in the presence of the King. When the monarch, wondering at his actions, asked why he did not want to make use of his work, Bernini replied that he had used models in order to introduce into his mind the features that he had to trace, but that once they had been envisaged and it was time to make them manifest, such models were no longer necessary: on the contrary, they impeded his purpose which was to conceive a likeness of reality rather than a likeness of the models. Since we are speaking of that great King, I will repeat what Bernini used to say of him, that he never knew a mind as able as the King's to adapt itself to the cognition of beauty.

He used to say that all the delight of our senses is in imitation. As an example of this he pointed out the great enjoyment that comes from seeing a fine painting of a rancid and loathsome old woman, who in living and breathing flesh would nauseate and offend us.

In his works, whether large or small, Bernini strove with everything in him to make resplendent all the conceptual beauty inherent in whatever he was working on. He said that he was accustomed to putting in no less study and application in designing an oil lamp than in designing a very noble edifice. In preparing his works he would consider one thing at a time. He gave this procedure as a precept to his disciples, that is to say, first comes the concept, then reflection on the arrangement of the parts, and finally giving the perfection of grace and sensitivity to them. As an example he cited the orator who first conceives, then orders, elaborates, and embellishes. He said that each of these operations demanded the whole man and that to do more than one thing at a time was impossible. [. . .]

He used particularly beautiful aphorisms regarding nobility or pre-eminence in the arts. Bernini declared that painting was superior to sculpture, since sculpture shows that which exists with more dimensions while painting shows that which does not exist, that is, it shows relief where there is no relief and gives an effect of distance where there is none. However, there is a certain greater difficulty in executing a likeness in sculpture and, as proof, Bernini pointed to the fact that a man who loses his color no longer looks like himself, whereas sculpture is able to create a likeness in white marble. [. . .]

i. Louis XIV of France (1638–1715), also known as Louis the Great or the Sun King.

Bernini had splendid precepts concerning architecture: first of all he said the highest merit lay not in making beautiful and commodious buildings, but in being able to make do with little, to make beautiful things out of the inadequate and ill-adapted, to make use of a defect in such a way that if it had not existed one would have to invent it. Many of his works attest that his skill came up to that level. It is seen, especially, in Urban VIII's coat of arms in the Church of Aracoeli. There, since the logical space to place the emblem was occupied by a large window, he colored the glass blue and on it represented the three bees as if flying through the air, and above he placed the triple crown. He proceeded in a similar way in the tomb of Alexander VII and in the placement of the cathedra, where the window was turned from an impediment into an asset: around it he represented a Vision of Glory, and in the very center of the glass, as if in place of the inaccessible light, he portrayed the Holy Spirit in the form of a dove which brings the whole work to a consummation. He put such ideas in practice more than once in the designing of fountains. The fountain for Cardinal Antonio Barberini at Bastioni is a fine example. Since there was very little water and very thin jets, he represented a woman who, having washed her hair, squeezes it to produce a thin spray of water which satisfies both the needs of the fountain and the action of the figure. [. . .] Another of his precepts should be brought forth since we are speaking of fountains. It is that since fountains are made for the enjoyment of water, then the water should always be made to fall so that it can be seen. It was with such a precept in mind, I believe, that in his restoration of the bridge of Sant'Angelo by order of Clement IX, he had the side walls lowered so that the water could better be enjoyed. The eye then may see with double pleasure from the banks of the river the flow of water as well as the bridge above, ornamented with angels that allude to its ancient name.

Bernini's ingenuity did not stop at matters of art. He brought forth noble concepts, acute sayings, and witty pleasantries on every occasion. [. . .] To a great prelate who was saying that he could not endure the aforementioned architect's inordinate desire to break the rules of the good designer and modeler that he was, who had in some cases so far missed the mark in his works that some of them seemed to draw from the Gothic style rather than from the good modern or antique mode, Bernini responded, 'What you are saying, sir, is very pertinent, but I think it is better to be a bad Catholic than a good heretic.'

2. Report on Bernini's statue of Constantine the Great

'Constantine Brought to the Pillory', in George C. Bauer, *Bernini in Perspective*, Englewood Cliffs, NJ, Prentice Hall, 1976, pp.46–7, 53.

Despite his popularity among his powerful patrons, Bernini's success was not universal. His jealous grip on the art market and his controversial style made him many enemies. On its unveiling in 1670, Bernini's equestrian statue of the Emperor Constantine the Great (who ruled 324–37), located part way up the Scala Regia, the royal staircase and ceremonial entrance to the Vatican Palace, and visible from the portico of St Peter's Basilica, was met with mixed responses. The audacious design of the rider on a rearing horse had to be supported against the wall behind it. In this extract from an anonymous contemporary report, the author enters into a long critique of the statue, ending with a brief attack on other works by Bernini. He includes Bernini's many works in St Peter's, among them the bell tower which had to be demolished due to insufficient foundations, and proved a major blow to the artist's reputation. It offers a corrective to – and context for – Baldinucci's effusive praise. CMR

At last, on the first Sunday of Advent, the good – but not the best – Constantine arrived to take his station – but without plenary indulgences – at the stair and *ad limina* of St. Peter's and to hear on the Vatican Hill, as in the Valley of Jehoshaphat,[i] the Gospel and the sermon of Judgment . . . Nor shall it be *parturient montes*,[1] so long as from those of the Chigi, after so many centuries, has come a topic for all the satires, a monster stained with more spots than a leopard and more blemishes than the Cavalier Gonnella [a buffoon]. Who would ever have dreamed – not even for a chimera, let alone for a Pegasus generated from the stony head of Medusa – that for a great Emperor and the greatest benefactor of the Church such a statue should be erected? And then by an Alexander, greatest and best? An equestrian statue of low and half-relief, it is imbedded in the wall like an embryo of the first horse once roughed-out of stone by the trident of Neptune; or to describe it better, like a beastly centaur, half-horse and half-man, bisected lengthwise with one half supported by the air and the other by iron driven into the wall; and as if it were the ass of Balaam pressing his master's leg so tightly to the wall, it would take not only the knotty staff

i. Joel 3:2.
1. From Horace, *Ars poetica*, 139:
"Mountains will labor, a laughable mouse is born!"

of Balaam, but the eloquent tongue of the animal, and the flaming sword of the angel to detach it and give it in the round.

Was it then a poor block of Carrara marble or the Vatican piazza as the site that denied to the perfect and complete statue (today incaved within the confines of a niche) the freedom to caracole in the open? And is it for this reason that we must take on faith what's missing and the Emperor's other leg, and that he is supported below without a miracle from St. Peter who gave legs to a cripple? [. . .]

Truly out of charity would I advise the Cavalier Bernini to avoid forever as an unfortunate arena the church of St. Peter's where on the rocks of both architecture and sculpture he has always been shipwrecked. He can well remember and content himself with that cupola, bound in iron so that it does not split itself – more for the smile, than for anger at the *Longinus* who, with both legs withered, extends his right arm to the bloodletting without reaching the major artery of the bell tower, which even on the ground resounds in wrath, and screams for vengeance more loudly than the blood of Abel; with that Cathedra unloaded like an insupportable burden on the shoulders of those Greek porters and resting by two ribbons on the fingers of those two Latin ones; and with the *probatica piscina*[2] of the colonnade within which, it itself remains incurable for all the centuries and will never have anyone who, with his hand or foot, wants to raise it. I leave aside his Costanza[3] transformed into a Charity with so many (I don't know whether they are sons or fathers) at her breast that she should rather be Justice, her companion, of whom it is proper that she give of herself to everyone. Nor shall it be strange that one virtue is exchanged for another and a nursing sheep for the Roman wolf by one who, in forming his *St. Teresa* in the church of the Vittoria, dragged that most pure Virgin not only into the Third Heaven, but into the dirt, to make a Venus not only prostrate but prostituted.

2. John, V, 2–9.
3. I.e., Costanza Bonarelli, Bernini's mistress at one time. The Charity referred to is the allegorical figure on the tomb of Urban VIII.

3. Irving Lavin
Bernini and the Unity of the Visual Arts

Irving Lavin, *Bernini and the Unity of the Visual Arts*, New York and London, Pierpont Morgan Library / Oxford University Press, 1980, pp.6–15.

Included in Baldinucci's writings on Bernini's artistic principles is a short paragraph that describes his achievement in bringing together the three arts – painting, sculpture and architecture – in a beautiful composition (*bel composto*). The art historian Irving Lavin drew particular attention to this passage, using it to characterise Bernini's work as a whole and arguing that it was the rule that the artist deliberately developed through his practice. For instance, he calls the *Ecstasy of St Teresa* 1647–52, in the famous Cornaro Chapel of Rome's Santa Maria della Vittoria, a fulfilment of these ideals. Lavin's contention has remained influential and is often used to typify both Bernini and the Baroque. CMR

Underlying Bernini's challenge to the viewer was a revolutionary new attitude toward the arts of architecture, sculpture and painting as traditionally conceived. This reinterpretation is expressed verbally in one of the most remarkable, often quoted and inadequately understood contemporary statements about Bernini's art, which occurs with slight variations in the biographies written by the critic and historian Filippo Baldinucci and the artist's son Domenico. 'It is the general opinion,' they say, 'that Bernini was the first to attempt to unify architecture with sculpture and painting in such a way as to make of them all a beautiful whole [un bel composto], and that he achieved this by occasionally departing from the rules, without actually violating them.' Although the statement is couched in impersonal terms, it fits so well with others by the artist himself that I have no doubt the formulation reflects Bernini's own view of his place in the history of the visual arts.

It is an astonishing claim on several counts. It makes no reference to the qualities of style by which Bernini's art is commonly measured – expressiveness, realism, movement, opulence, even illusionism – but involves rather the media themselves, the very constituents of art. [. . .] The point seems so obviously exaggerated that one is tempted to reject it at face value and instead to refer it simply to Bernini's undeniable versatility and apparently unrestrained use of disparate art forms. In this sense, the statement becomes crucial to our understanding of Baroque art generally, which is often regarded as a licentious assault upon the senses. The passage has a more exact meaning, however, and it should be taken at

face value, for it says that in order to unify the arts Bernini challenged the rules that governed them; his innovation, therefore, lay not generically in the use of all three arts, however expert and sumptuous, but specifically in the way he related them to one another.

The statement is also remarkable precisely because it embodies a unified conception of the visual arts. It has been observed repeatedly that the so-called Fine Arts, or Beaux-Arts, were not fully distinguished from the other liberal arts until the eighteenth century. We are less commonly aware that a coherent notion of the visual arts, as distinct from the mechanical arts or crafts, is also a relatively recent development. The first publication to isolate architecture, sculpture and painting was Vasari's *Lives* of 1550; even here, it is the biographical interest that predominates, and the arts are discussed together only incidentally in the introduction and various prefaces. No work devoted to a unified theory of the arts appeared before Federico Zuccaro's *Idea de' pittori, scultori e architetti* of 1607. [. . .]

In the early sixteenth century a veritable genre of literature emerged – the *Paragone* or Comparison of the Arts – in which their differences and relative merits were argued. Subsequently, their affinities became a central theme in the final phase of the development wherein the creative artist was distinguished from the craftsman.

Insofar as a coherent notion of the visual arts emerges from this great body of late Renaissance art-theoretical literature, the common denominators may be classified under four main headings. First and foremost was the concept of design, or *disegno*, which Vasari called the father of the arts. The heart of the concept was its ambivalence: since drawing was the primary creative instrument in all three media, it provided the connecting thread; and since disegno was identified as well with the artist's mental image or idea, it substantiated the claim that his was an intellectual activity. The second unifying factor frequently cited was that architecture, sculpture, and painting were imitative arts. This notion also functioned on two levels, the obvious one being the direct imitation of nature. Architecture might be included here because its proportions were derived from the human body, and the orders from the sexes. On a more abstract plane, imitation was conceived as the reproduction both of nature in its actual state, *natura naturata*, and of the process whereby nature imposes order on raw matter, *natura naturans*. The artist thus replicated the organizational activity inherent in the physical world. A third and partially overlapping category was the theory of proportions. In this view the community of the arts consisted in their employment of a systematic method of relating the parts of a work to each other and to the whole. Since proportions were based on nature, notably on the human body, they became means toward the end of imitation. Finally, the visual arts were distinguished by the simple fact that their product was a physical object.

When we turn to consider Bernini's position in these matters, certain limitations must be kept in mind. Above all, he was not a theoretician; he neither wrote nor planned to write any treatises on art. The nearest thing we have to a coherent presentation of his attitudes is the record of a discourse he delivered at the French Academy during his visit to Paris in 1665; but here Bernini was concerned rather with the training of young artists than with theory. [. . .]

Let it be said at once that Bernini was heir to many of the ideas we have enumerated. He, too, emphasized the importance of design, and regarded art as an imitation of nature in more perfect form. Proportion, he said, was the basis of all beauty, and he reiterated the ancient theory that certain geometric configurations such as the circle and the square are more perfect than others. What Bernini added can best be introduced through a concept that seems to have been his own invention, and which he called 'i contrapposti.' The singular noun, *contrapposto* – from *contrapporre*, to place opposite or against – is an old and still current term referring to the dynamics of counterbalance among the parts of the body; it has an English equivalent in 'ponderation.' The word was also used more generically and in the plural, especially in rhetorical theory, to describe any juxtaposition of opposites that served to embellish a work. Bernini employed the term in a new way, shifting the reference from the effect of such contrasts in achieving variety, to that of their interaction in achieving unity. Things do not appear only as they are, he said, but as they seem in relation to things nearby, which change their appearance. A building will appear larger if it is juxtaposed with others that are small; the head of a statue will appear smaller than it is if the figure's shoulder is draped; a man dressed in one color will appear larger next to a man dressed in several colors; a mile on the flat surface of the sea seems longer than a mile on multicolored terrain. The attitude implicit in this concept led to some revolutionary conclusions. Bernini rejected the all but sacred canon attached to the famous story about Zeuxis' *Helen of Croton*, whose beauty was achieved by combining the most perfect features of different maidens; he dismissed the tradition as a fable, observing that one woman's eye, for example, would not look well on another's face. The chief merit of an architect, he said, lies not in making beautiful and commodious buildings but in exploiting shortcomings and disadvantages to make beautiful things, so that if the obstacles did not exist one would have to invent them. In making portraits Bernini wanted the sitter not to be still but to move, since only thus could he capture the subject's individuality. In designing monumental paintings the artist should compose first in terms of 'macchie' ('splotches,' a word that would become famous with *i Macchiaioli*, the Italian nineteenth-century impressionists) to achieve a beautiful contrapposto, and only then proceed to the individual figures. Bernini regarded it as the greatest achievement of his chisel to have rendered stone malleable as wax, and to have in a certain sense fused

painting and sculpture. The full weight of this statement is felt only if one bears in mind that from antiquity on it had been the rule to distinguish two kinds of sculpture – sculpture by adding, i.e., terracotta, or wax for bronze; and sculpture by taking away, i.e., stone. Bernini shifted the whole frame of reference, and instead defined painting as the art of adding and sculpture as that of taking away. Hence by conceiving of stone as if it were wax he was in effect creating a new medium.

It will have become evident that what underlay all these novel ideas was an unprecedented awareness of the interdependence of physical appearances. This new way of seeing – for it was nothing else – led Bernini into conflict with the conventional distinctions among the arts and provides, in the dictum quoted by Baldinucci and Domenico Bernini, the inner connection between the idea of unifying the arts and that of overstepping the rules.

It will also have become evident that Bernini's contribution lay in his purely visual conception of relationships among the arts. Disegno, while it isolated the visual arts, was based on their mode of creation, not their appearance. Conversely, imitation and proportion involved formal qualities, but were applicable to the non-visual arts as well. Bernini's point of departure was the physical nature of the arts, and by raising to a principle of design the optical effects of physical relationships, he conceived of their unification in literal terms.

Bernini, I repeat, was not a theoretician and he did not invent a proper technical term for what he was about, but he did have a name for it – 'un bel omposto,' a beautiful whole. So far as I can discover, this is the first explicit identification of the unity of the visual arts under the rubric 'beautiful,' and thus constitutes a major step toward our modern notion of the Fine Arts.

4. Heinrich Wölfflin
Principles of Art History

Heinrich Wölfflin, *Principles of Art History: The Problem of the Development of Style in Later Art* (1915), trans. M.D. Hottinger, Mineola, New York, Dover Publications, 1950 (first published 1932), pp.11–16.

The last decades of the nineteenth century saw a number of German-speaking art historians reassessing the 'Baroque', a style that had been derided through the previous decades of the century. Heinrich

Wölfflin (1864–1945), who taught at a number of Swiss and German universities, was concerned with the way in which style was simply assumed as a given and therefore not defined by his peers. He set up the term 'Baroque' as a corollary to 'classical' or 'Renaissance' as a means of explaining the transition of one artistic style to another. He first outlined his system in *Renaissance und Barock* (1888) and subsequently refined it in *Principles of Art History* (1915). He repeatedly uses Bernini's work to exemplify the Baroque in the following extract from his 1915 publication. CMR

Vision itself has its history, and the revelation of these visual strata must be regarded as the primary task of art history.

Let us try to make the matter clear by examples. There are hardly two artists who, although contemporaries, are more widely divergent by temperament than the baroque master Bernini and the Dutch painter Terborch. Confronted with the turbulent figures of Bernini, who will think of the peaceful, delicate little pictures of Terborch? And yet, if we were to lay drawings by the two masters side by side and compare the general features of the technique, we should have to admit that there is here a perfect kinship. In both, there is that manner of seeing in patches instead of lines, something which we can call painterly, which is the distinguishing feature of the seventeenth century in comparison with the sixteenth. We encounter here a kind of vision in which the most heterogeneous artists can participate because it obviously does not bind them to a special mode of expression. Certainly an artist like Bernini needed the painterly style to say what he had to say, and it is absurd to wonder how he would have expressed himself in the draughtsmanly style of the sixteenth century. But we are clearly dealing with other concepts here than when we speak, for instance, of the energy of the baroque handling of masses in contrast to the repose and reserve of the High Renaissance. Greater or less movement are expressional factors which can be measured by one and the same standard: painterly and draughtsmanly, on the other hand, are like two languages, in which everything can be said, although each has its strength in a different direction and may have proceeded to visibility from a different angle. [. . .]

We denote the series of periods with the names Early Renaissance, High Renaissance, and Baroque, names which mean little and must lead to misunderstanding in their application to south and north, but are hardly to be ousted now. Unfortunately, the symbolic analogy bud, bloom, decay, plays a secondary and misleading part. If there is in fact a qualitative difference between the fifteenth and sixteenth centuries, in the sense that the fifteenth had gradually to acquire by labour the insight into effects which was at the free disposal of the sixteenth, the (classic) art of the Cinquecento and the (baroque) art of the Seicento

are equal in point of value. The word classic here denotes no judgment of value, for baroque has its classicism too. Baroque (or, let us say, modern art) is neither a rise nor a decline from classic, but a totally different art. The occidental development of modern times cannot simply be reduced to a curve with rise, height, and decline: it has two culminating points. We can turn our sympathy to one or to the other, but we must realise that that is an arbitrary judgment, just as it is an arbitrary judgment to say that the rose-bush lives its supreme moment in the formation of the flower, the apple-tree in that of the fruit.

For the sake of simplicity, we must speak of the sixteenth and seventeenth centuries as units of style, although these periods signify no homogeneous production, and, in particular, the features of the Seicento had begun to take shape long before the year 1600, just as, on the other hand, they long continued to affect the appearance of the eighteenth century. Our object is to compare type with type, the finished with the finished. Of course, in the strictest sense of the word, there is nothing 'finished': all historical material is subject to continual transformation; but we must make up our minds to establish the distinctions at a fruitful point, and there to let them speak as contrasts, if we are not to let the whole development slip through our fingers. [. . .]

If we are not mistaken, the development can be reduced, as a provisional formulation, to the following five pairs of concepts:

(1) The development from the linear to the painterly, *i.e.* the development of line as the path of vision and guide of the eye, and the gradual depreciation of line: in more general terms, the perception of the object by its tangible character – in outline and surfaces – on the one hand, and on the other, a perception which is by way of surrendering itself to the mere visual appearance and can abandon 'tangible' design. In the former case the stress is laid on the limits of things; in the other the work tends to look limitless. Seeing by volumes and outlines isolates objects: for the painterly eye, they merge. In the one case interest lies more in the perception of individual material objects as solid, tangible bodies; in the other, in the apprehension of the world as a shifting semblance.

(2) The development from plane to recession. Classic art reduces the parts of a total form to a sequence of planes, the baroque emphasises depth. Plane is the element of line, extension in one plane the form of the greatest explicitness: with the discounting of the contour comes the discounting of the plane, and the eye relates objects essentially in the direction of forwards and backwards. This is no qualitative difference: with a greater power of representing spatial depths, the innovation has nothing directly to do: it signifies rather a radically different mode of representation, just as 'plane style' in our sense is not the style of primitive art, but makes its appearance only at the moment at which foreshortening and spatial illusion are completely mastered.

(3) The development from closed to open form. Every work of art must be a finite whole, and it is a defect if we do not feel that it is self-contained, but the interpretation of this demand in the sixteenth and seventeenth centuries is so different that, in comparison with the loose form of the baroque, classic design may be taken as *the* form of closed composition. The relaxation of rules, the yielding of tectonic strength, or whatever name we may give to the process, does not merely signify an enhancement of interest, but is a new mode of representation consistently carried out, and hence this factor is to be adopted among the basic forms of representation.

(4) The development from multiplicity to unity. In the system of a classic composition, the single parts, however firmly they may be rooted in the whole, maintain a certain independence. It is not the anarchy of primitive art: the part is conditioned by the whole, and yet does not cease to have its own life. For the spectator, that presupposes an articulation, a progress from part to part, which is a very different operation from perception as a whole, such as the seventeenth century applies and demands. In both styles unity is the chief aim (in contrast to the pre-classic period which did not yet understand the idea in its true sense), but in the one case unity is achieved by a harmony of free parts, in the other, by a union of parts in a single theme, or by the subordination, to one unconditioned dominant, of all other elements.

(5) The absolute and the relative clarity of the subject. This is a contrast which at first borders on the contrast between linear and painterly. The representation of things as they are, taken singly and accessible to plastic feeling, and the representation of things as they look, seen as a whole, and rather by their non-plastic qualities. But it is a special feature of the classic age that it developed an ideal of perfect clarity which the fifteenth century only vaguely suspected, and which the seventeenth voluntarily sacrificed. Not that artistic form had become confused, for that always produces an unpleasing effect, but the explicitness of the subject is [no] longer the sole purpose of the presentment. Composition, light, and colour no longer merely serve to define form, but have their own life. There are cases in which absolute clarity has been partly abandoned merely to enhance effect, but 'relative' clarity, as a great all-embracing mode of representation, first entered the history of art at the moment at which reality is beheld with an eye to other effects. Even here it is not a difference of quality if the baroque departed from the ideals of the age of Dürer and Raphael, but, as we have said, a different attitude to the world.

Chapter 10
Meaning and interpretation: Dutch painting of the golden age

Jason Gaiger

1. Philips Angel
In Praise of Painting

Philips Angel, *In Praise of Painting*, 1642, in Charles Harrison, Paul Wood and Jason Gaiger (eds.), *Art in Theory 1648–1815*, Oxford, Blackwell, 2000, pp.254–9).

Philips Angel (c.1618–c.1683) worked as a painter in Leiden until 1645 when he joined the Dutch East India Company. He spent the rest of his life in Batavia in the Dutch East Indies (now Jakarta, Indonesia), apart from the period between 1651 and 1656, which he spent in Persia, serving for a time as court artist to Shah Abbas II (1632–66). Almost nothing of his work as an artist survives. *In Praise of Painting* originated as a lecture delivered by Angel to the painter's guild of Leiden in 1641. It was published as *Lof der schilder-konst* in 1642. One of the few extant theoretical statements concerning Dutch seventeenth-century painting, Angel's text is noteworthy for its emphasis on close observation of the external world and the achievement of a convincing illusion. Whereas most authors of art treatises in this period insisted that artists should treat their subjects in accordance with the dictates of classical idealism, Angel presents painting as a craft, seeking above all to delight the eye. This text is taken from a facsimile of the original edition, and edited and translated by Hester Ysseling for the 2000 publication *Art in Theory 1648–1815*. EB

Let us conclude by examining what qualities a painter must have if he is to be counted amongst the number of praiseworthy artists without being subject to ridicule. [. . .]

First, we observed that the first and foremost requirement of a painter is right judgement. [. . .] Someone who has a sound understanding of a painting when it is shown to him and who judges it to be pleasing and unsurpassable as far as he is concerned, knowing that he would not be able to imitate it, would not make the same careless mistakes which are all too common today. When he copies the work he will do no more than he is asked and refrain from wanting, as many do these days, to play the hypocrite and pretend that, having added something of his own composition, the whole piece was an object of his own invention. [. . .] But someone might ask: is it not allowed, then, to borrow from other masters? This I do allow, for otherwise I would be contradicting the teaching of Karel van Mander in his *Grontleggingen van de Schilder-Konst* [Outlines of the Art of Painting], chap. I v. 46, where reasons are given as to why this is permitted.

It is quite a different thing, however, to borrow something in order to elevate one's own imperfection to a higher degree of perfection than it is to add something defective to something which is already good. The one pays homage to the master from which it was taken, whereas the other, a careless addition, does him nothing but harm. [. . .]

Second, a painter also needs a steady hand for drawing, which is of the utmost importance, since it will help to avoid gross mistakes, such as are made only too often by bands of good-for-nothings. When they produce a head, one finds that one eye is higher than the other, or that the ears are too small, the nose too short or too long, the mouth too thin and so forth. [. . .]

Third, the artist requires a mind which can combine things in a fluid and natural manner. That this is indeed the case can be concluded from the fact that the artist who is fluent in composing will never be embarrassed by a difficult composition. When he concentrates his thoughts and makes them play around a single idea, his fertile mind produces thousands of changeable devices. When this fluency is accompanied by naturalness [*eyghentlijckheyt*], and when the two work together like sisters, this brings such a pleasing and graceful lustre to the art that it can better be understood from the example of master painters than it can be explained in words. [. . .]

Fourth, besides this smoothly flowing naturalness, no lesser radiance is added to the art by an abundance that pleasingly embellishes it. That a painter should be mindful of this can be seen from the warm affection which it arouses in the art lover's heart. This we see every day in those who embellish their works with abundance so that they delight the eyes of enthusiasts and fill them with a wishful desire for things represented. Through this their paintings will sell readily. In view of the profit it brings us, we should pay the strictest attention to the representation of elegant abundance.

Fifth, on account of the gracefulness [*welstandigheyt*] it lends to our

art, the proper arrangement of light and shadow is one of the most important laurels with which a good painter ought to be adorned. For shadows, if arranged well and put in the right place, render magical force and marvellous grace. Many things whose colours are barely imitable by any brush are made to appear highly realistic. [. . .] Because of the imperfections remaining in us, we cannot lend to our works such grace and such force as real things appear to us to have. We can bring this about only if we properly arrange shadow and light together. [. . .]

Sixth, it may sound strange to some of you if at this point I add to this chain of the art of painting a link which is the observation of actual things in nature. [. . .] I have often noticed a serious mistake which is made not only by the lowliest, but also (I mention it respectfully) by the greatest and most esteemed masters. This mistake follows from nothing other than a failure to pay close attention to the observation of actual things in nature. This is particularly noticeable when artists paint a wagon. They make it seem as if the horses were in full gallop, whilst the wheels of the carriage remain standing still.

[. . .] If they had paid strict attention to the proper observation of actual things in nature, they would have avoided these mistakes by closely observing the natural movements and conceiving the form which appears the most adequate. When a wagon-wheel or a spinning-wheel moves at full speed we see that because of the fast turning no spoke is actually visible but only a vague shimmer. Even though I have seen many pieces with wagon-wheels in them, I have never seen this phenomenon properly represented. [. . .]

Seventh, a well-practised understanding of perspective is required for the art of painting. I will show that this is the case in seven or eight words (to be brief). Through her rules, this art reveals to us that what is below our eyes should be seen as if we were looking down on it, whereas what is above our eyes should be seen as if we were looking up at it. Many people think that this is a trivial matter and say that this can be seen without any knowledge of perspective. But it is not true. They themselves reveal it in their work, where it is constantly shown up. Knowledge of perspective also helps in choosing the appropriate horizon for our works, such as in landscapes, temples, houses, tables and the like. This gives the appearance of a fixed position to things, whereas in the work of inexperienced artists the things which are depicted usually seem to be toppling. [. . .]

Eighth, a no less experienced understanding and knowledge of histories is needed in order to avoid those misunderstandings in their representation which the inexperienced often make as a consequence of their negligence with respect to reading. [. . .]

* * *

Now let us see why it is necessary for a painter to have some knowledge of mathematics, the usefulness of which I will point out in one or two words. The reason is that it allows him to judge competently the features of a face and its proportions, which is of great importance for a painter. [. . .]

Further, I will consider to what end a profound knowledge of anatomy is useful. A good grasp of anatomy gives us the advantage that we learn from it the knowledge of muscles, where they originate and where they end, how they move and how they change in their movements, how they recede and protrude again, and how a body should be divided so as to be well proportioned. Knowledge of anatomy shows us the difference between the bodies of a man and of a woman, and the difference in proportion between children and adults. Moreover, we learn from it how always to find a straight perpendicular or plumb line in the figure of a human being, and also an isosceles triangle, a square, a perfect circle, and many other useful things. To acquire this knowledge, Michelangelo and many other excellent men dissected several bodies, and split muscles apart to learn about them. I often regret that in this city the artists are not given so much freedom, and that they do not have at their disposal a freely accessible dissecting room which could further this useful science. [. . .]

I will now show that it is much more laudable to follow nature than to follow the manner of painting of other masters. It is contemptible to imitate the manner of painting of other masters, whereas it is advisable to follow nature. Let us, then, prefer what is advisable to what is contemptible, and follow life conscientiously. But how are we to go about this? Should we paint in such a way that every one can see that the work is by this or that master because of the manner in which it was painted? No, on the contrary, for as long as this can be known and identified the master is still adding too much of himself. But if he knows how to follow life to such an extent that we are in a position to judge whether his work adequately approaches life without being able to trace the manner of the master who made it – such an artist deserves praise and credit, and will be esteemed above others. [. . .]

Having added this link of the imitation of nature to the chain of the art of painting, let us now swiftly forge the next link and see what lustre can be brought to our art by the flesh-like [*vleysighe*] blending of colours. First, it takes away the dull sallowness; second, the green unnaturalness; third, the harsh stone-like quality, and instead of these despicable qualities it brings the highly esteemed naturalness of a fleshy, skin-like colour, which makes our art pleasant to the eye of art-loving enthusiasts. This virtue is so great that we have no further need to prove its necessity or to enlarge upon it in any more detail. Keeping to the terms we set ourselves, we proceed to the next necessity that is required of a painter, to wit, that he must know how to distinguish between silk, velvet, woollen and linen-worsted.

Velvet clothes which actually appear to have the lustre of velvet are rarely seen, and the difference between woollen and linen-worsted, with respect to the way it creases and folds, often escapes the attention of the painter. Neither does he observe the shine which is more brilliant in silk than in satin. He also neglects the fine delicacy [*dunne eellicheyt*] which should be imitated in fine linen and chiffon velvet. A praiseworthy painter

should be able to represent these differences in a manner most pleasing to the eye (by means of his brush-work), distinguishing the roughness of worsted and the smoothness of satin. This is something in which that brilliant German [i.e. Dürer] exceeds other painters and for which he is still famous.

2. Svetlana Alpers 'Picturing Dutch Culture'

Svetlana Alpers, 'Picturing Dutch Culture', 1994, in Wayne Franits (ed.), *Looking at Seventeenth-Century Dutch Art: Realism Reconsidered*, Cambridge, Cambridge University Press, 1997, pp.57–67.

Svetlana Alpers was Professor of Art History at the University of California at Berkeley from 1962 to 1998. She is the author of books on the work of Peter Paul Rubens, Rembrandt, Diego Velázquez and Giovanni Battista Tiepolo, but is best known for *The Art of Describing: Dutch Art in the Seventeenth Century* (Chicago 1983). In it, she challenged the then standard iconological approach to Dutch painting of this period, maintaining that the surface realism characteristic of this type of art was of interest in its own right and not simply as the means by which some hidden moral message was conveyed. Although Alpers' argument is highly distinctive, it can broadly be aligned with the concern with visual culture that has developed within the discipline of art history in recent decades. In the essay reprinted here, which was first published in 1994, she reiterates some of her central claims about Dutch painting before considering the significance of the household and family as subjects for the type of picture that is now categorised as a genre scene. More specifically, she emphasises that such scenes do not simply reflect the culture in which they originated, but instead actively construct it, often by exploring tensions between different social roles. EB

It has been a pervasive and limiting assumption of the study of art history that meaning takes the form of 'iconicity,' that the sense that pictures make is located in the meaning of the people or objects represented. In the study of the predominantly secular and nonnarrative Dutch art of the seventeenth century, this has been coupled with the assumption (one with ancient precedent) that such meaning or sense is a message,

instructionally intended: You may delight in the people and objects in pictures but are meant to attend to the moral instruction that they offer. The model for such pictures has been located in emblem books. It was a major accomplishment of the work of Eddy de Jongh to discover the relationship between certain motifs in Dutch painting and the images accompanied by texts in the popular emblem books. Images so conceived lend themselves to words, they originate with texts in mind.

The 'reality effect' peculiar to much Dutch painting has persuaded many viewers that the art registers how things are or how they were. Art historians have argued that things are not what they seem to the eye – they are devised with meanings in or (if hidden) out of view. But the notion that therefore Dutch pictures are only apparently real (because they have hidden meanings) or selectively or subjectively real (because the painted world is creatively chosen and one person's view) is misleading. For, along with the appeal to moral meanings, it effectively suggests that we can bracket, or bypass the pictorial mode itself – the reality effect – so basic to these pictures. Painters make paintings, not meanings. It is to the mode – the reality effect – that I turned my attention. And it was with reference to this pictorial mode that I tried to ground Dutch painting in its culture.

It was while looking at Johannes Vermeer's *Art of Painting* that I began to consider another manner of interpretation. The wall map depicted by Vermeer does not signify a longing for a lost political unity, nor is it a sign of the vanity of worldly concerns; it is a piece of painting. Vermeer painted a map and incidentally signed his name on it as its maker. This painted map first drew my attention to the link between painting and mapping at the time. The map-painting relationship can be described as a matter of *format*: the absence of a positioned viewer as if the world came first before the viewer; the absence of a prior frame; a formidable sense of surface on which words along with objects can be inscribed. It can also be described as a matter of *function*: Maps as pictures and picture-like maps were both engaged in gaining knowledge of the world [fig.5]. [. . .]

Dutch paintings were like maps, but they were also like mirrors. When Johannes Kepler, in his study of the mechanism of the eye, defines *to see* as *to make a picture*, he provides a model for the particular relationship between finding and making, between nature and art, that characterizes much painting in northern Europe. The operation of the eye is, so he proposed, like a camera obscura – and this illustration of its operation is a good analogy to a picture like Vermeer's *View of Delft*. Like so many Dutch pictures, this is produced in an age of observation – the sky is scanned, land surveyed, flora and fauna observed and described. Instead of a direct confrontation with nature, we find a trust to devices, to intermediaries that represent nature to us. The major example of such a device is, of course, the lens. Painting can be described as another such intermediary.

If we take the pictorial mode – the reality effect – not as hiding moral

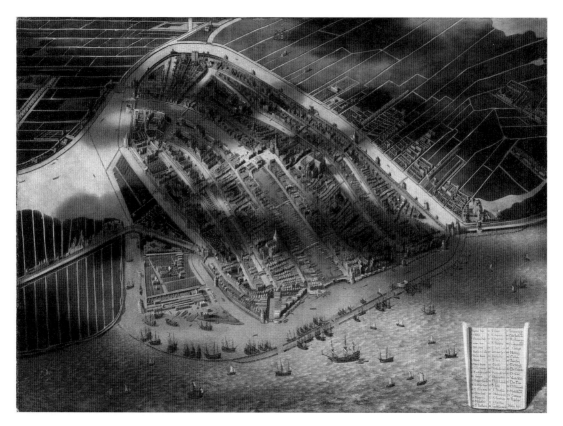

Fig.5
Jan Christiaensz. Micker
View of Amsterdam 1652–60
Oil on paper 100 x 137 cm
Amsterdam Historical
Museum, Amsterdam

instruction, but as offering a perceptual model of knowledge of the
world, then pictures are related to the empirical interests of this age of
observation. The picture takes its place beside the many other devices –
the eye, the microscopic lens – which squeeze and press nature so that we
can experience (or experiment, in the seventeenth-century use of the word)
her. The attentive eye and crafty hand of the painter are here related to the
eye and hand of the experimenter. Painting itself is like an experiment.

Readers outside the field of art history have been receptive to this
analysis. The definition of a mapping impulse brought landscape painting
to the attention of geographers and offered new confirmation of their
already expanding and problematizing notion of maps as conventional
representations. The definition of Dutch painting as sharing a perceptual
view of knowledge and an interest in craft with seventeenth-century
experimental science has made links with current studies in the history
and sociology of science. There historians are also concerned with the
conventional and crafted nature of natural knowledge at the time.

But the academic specialists studying Dutch art remained upset and unconvinced. Indeed, it appeared to them that I was not even looking at the same objects that they were. Why? I think it is largely a matter of certain professional habits.

Art historians who study Dutch art have made two objections – one basic and one less so. The basic one involves a misunderstanding or simple nonattention to the place of the word *art* in the title *The Art of Describing*. The book is not about describing but about the *art* of describing. Artifice, one might say, is assumed from the beginning. The phrase 'the art of describing' does not claim that pictures picture the world as it is but rather the world as it is seen, microscoped, mapped, crafted, in short as it is represented. The argument is that pictures are an attempt to make sense (by which I mean produce understanding) rather than meaning out of the world.

The second objection had been the worry about the subtitle: *The Art of Describing: Dutch Art in the Seventeenth Century*. The distinction I drew between two modes – descriptive and narrative, northern and southern, Netherlandish and Italian – was of course noted in the past. There is a famous remark attributed to Michelangelo that described northern art in its particularity as an art appealing to women. The distinction was for me at least partly a heuristic device, a way to get away from what I see as the dominance of an Italian or Albertian model of the picture in European writing on painting. I anticipated that exceptions could be found and indeed built them into my account. I defined a mode of painting that can be generally, but is not uniquely, attached to the pictorial tradition of a specific part of Europe. One could say that within each pictorial tradition, northern and Italian, the other is possible: Caravaggio, for example, is Italian by tradition but descriptive in mode. [. . .]

It is notable that in the seventeenth century, when travelers and policy makers from abroad repeatedly marvel at the economic miracle of the Netherlands and comment on what seemed to them striking about the society, the native people lacked chauvinism. So many cultural norms were under construction in Dutch seventeenth-century life, and I would argue, in Dutch seventeenth-century painting; our bourgeois way of living, sense of individuality, and ways of organizing society from banking to the bourse, notions of punishment, civic charity, and most particularly the household and the family. [. . .]

In my study of Dutch art, I situated the interest in the art in attention to a pictorial mode. The circumstances were registered as constraints, or conditions, on the enterprise of creating knowledge of the world. Effectively, I defined the place that the practice of painting took up or made for itself within a particular epistemological or economic system. It is, then, production rather than consumption that was my primary interest. This distinguishes my work from those circumstantial studies – mostly

of the modern period where the evidence is so rich – that take reception as their major evidence and concern.

I would like now to turn to the home, to the territory of household and family that is the subject of so much Dutch so-called genre painting. These images have been the site of the most insistent emblematic readings. They have been read as showing how not to behave or, in more recent accounts and with attention to different cases, how in fact one ought to behave. What, if not illustration or moral example in particular about the life of women, can the impetus to make such pictures have been? Why did painters so obsessively paint the household? [. . .]

Nicolaes Maes and Gerard ter Borch – two of the most ambitious painters of the home – seem to me not to be warning or recommending this or that, nor [. . .] simply making skillful paintings. Rather, they are examining, through representing, tensions in the system of social behavior. There are indeed some pictures that seem to illustrate the system proposed in the *Houwelyck* (Marriage) of 1625 of Jacob Cats that divides lives of women into six ages: *maeght* (girl), *vrijster* (maid), *bruyt* (bride), *vrouwe* (wife), *moeder* (mother), and *weduwe* (widow). Cats was a political figure and a popular, didactic poet whose works, so they say, stood on the shelf next to the Bible and served as a kind of Bible of Dutch manners. Ter Borch's painting of a *Woman Spinning* (Rotterdam, Museum Boymans-van Beuningen) is related to an emblem illustrating the behavior of the virtuous housewife. And although moralizers have tried to take it over (calling the woman a miser, a miseress, or an image of sloth), a drowsy *Housekeeper* by Maes (St. Louis, The Saint Louis Art Museum) is veridical in its depiction of a woman handling accounts. It was a task for which Dutch women were particularly praised. To judge from their size, the books are mercantile rather than domestic in nature.

There are a number of paintings by artists such as Willem Buytewech or Esaias van de Velde that represent young couples enjoying themselves in a garden as *vrysters*, or betrothing maids and youths. It is the world of flirtation and courting that we sometimes find illustrated in the engraved frontispieces of song books intended for such occasions. This is the stage in a woman's life preparatory, as it were, to marriage. But how did a woman transform herself from the necessarily flirtatious, erotically engaged courting girl into the worker in and manager of a household? or, to use Cats's terms, from *vryster* to *vrouwe?* And how was the transformation viewed? I am not making up these questions. They seem to me to be posed by a number of ambiguous, intentionally puzzling, mid-century paintings by Maes and Ter Borch.

Maes represents the problem in terms of the relationship between mistress/housewife and maid: As mistress is to maid, so *vrouwe* is to *vryster*. He investigates this doubled or split persona of a woman in a series of distinctive paintings featuring divided domestic interiors with

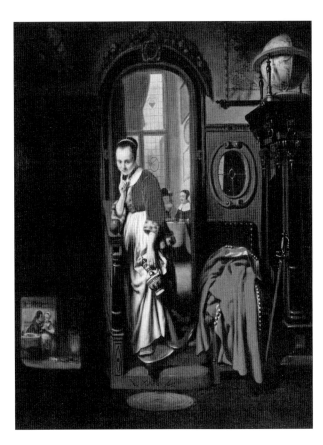

Fig.6
Nicolas Maes
*The Listening Housewife
(The Eavesdropper)* 1656
Oil on canvas 84.7 x 70.6 cm
The Wallace Collection, London

the housewife situated between the flirtatious maid down in the kitchen
and the refined guests above. The narrow, tall Dutch house is offered as a
setting parcelled out – as indeed was then happening to Dutch houses –
for different roles. In one painting by Maes (London, The National Gallery),
we see the kitchen beneath, the main room above, and the housewife in-
between on the staircase. The mistress of the house directs our attention to
the maid asleep on the job, perhaps neglecting the guests visible upstairs.
A not too subtle erotic note (referring to the dreams of the maid?) is added
by a rapacious cat. But a moralistic account about the censuring of duty
neglected for thoughts of love is undermined by the sense that the mistress
is concerned with someone very much like herself. The maid is her double,
as it were. It is as if, under the pressure of her situation, this wife was
split into two persons: house manager but also still lovelorn maiden. The
appearance of the housewife – her youth, cheerful, careless demeanor, jug
in hand – relates her to the appearance of the maid. Her gesture and glance
at the viewer seem to indicate that she, the maid, also is me, the mistress.

 In another painting by Maes, the maid, once again with cat, is in the
kitchen making love, and a couple sit decorously at table upstairs [fig.6].
The markedly young housewife on her way, in place of the maid, to refill
the wine pitcher is between two scenes and part of neither. Beside her are

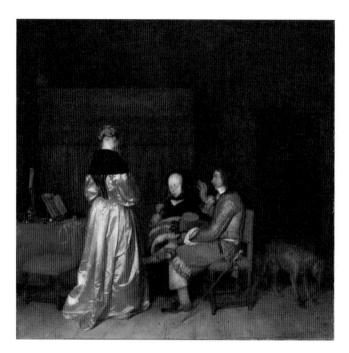

Fig.7
Gerard ter Borch
The Paternal Admonition or
Gallant Conversation c.1654
Oil on canvas 71 x 73 cm
Rijksmuseum, Amsterdam

a map, a globe, and the discarded outer jacket and sword of an unseen man.
But which man and where? upstairs or down? Indeed, her attitude (finger
raised, and amused face turned out of the picture toward the viewer)
seems less a warning than a kind of amused invitation to collude with the
kitchen goings-on. The pictorial handling does not warn or recommend,
does not blame or praise, but instead registers the tensions in the social
order of things.

What Maes does by doubling, Ter Borch does by what I shall call
'overlapping.' While Maes concentrates on the running of a household
and how or if the woman of the house has left flirtation behind, Ter Borch,
in an impressive group of pictures, concentrates on courtship. A woman's
conflicting roles are posed as a question of identity: *vryster*-whore. The
erotic and the domestic aspects are represented in one and the same
woman, and his pictures take a certain delight in the uncertainty that
results. What kind of negotiation is going on in his famously puzzling
painting known as *The Paternal Admonition*[i] [fig.7]? [. . .]

It is Goethe's staging of a *tableau vivant* (in his novel *Die
Wahlverwandtschaften*) based on an engraving after Ter Borch's painting
that put the problem of the subject in play. Goethe took the painting to
depict a father admonishing his daughter. But Goethe was made to seem
a bit of a fool with the discovery of painted traces of something, perhaps
a coin, in the man's upheld hand. Could it be the picture of a young man

i. The Rijksmuseum suggests that this
picture should be called *Gallant*

Conversation, and that the man is not
the father of the woman depicted.

Fig.8
Johannes Vermeer
The Concert c.1658–60
Oil on canvas 72.5 x 64.7 cm.
Isabella Stewart Gardner,
Museum, Boston

negotiating to pay a whore? If the hand originally held a coin, we would
have the negotiation for a prostitute. If, however, the hand had once held
a portrait medallion rather than a coin, as in a painting by Caspar Netscher
(Budapest), then it could represent a proposal of marriage. Whichever the
case, Goethe's emphasis on the appearance of propriety was not mistaken.
And marital arrangements, in this respect not unlike arrangements
with whores, were also concerned with money and sex. Women, after
all, brought dowries to marriage and, in the Netherlands at least, could
maintain control over their share in the marital economy. In his painting,
Ter Borch appears to delight in the suggestion that if the woman in the
house might be represented as behaving like the woman in the brothel,
so the reverse might also be true.

Money, then, seems to have entered Ter Borch's picture not simply as
part of the domestic economy, as in the Maes *Housekeeper*, but also as
part of the alternative economy of prostitution. This economy was taken
as a subject by Dutch painters as, for example, by Dirck van Baburen
in his so-called *Procuress* (hanging on the wall in [fig.8]) depicting a man,
coin in hand, with two women – a pimp and a whore. The link between
women and money had become a feature in painting in mid-sixteenth-
century Antwerp. Money and its proper use were a matter of concern in
this great center of banking. Writers on the subject distinguished illicit
gain from usury with approved profit, meaning that which was earned
from investment in land or good partnerships, of which marriage was
a prime example. Painters treated the behavior of women as a vehicle
for distinguishing between economic virtue and economic vice. If the

household economy, the economy in the Aristotelian sense, with which women were properly concerned, was a model for the proper use of money, prostitution represented its obverse. [. . .]

Though doubt may always remain about what is represented in the painting by Ter Borch, there is no doubt that the rituals of courting and whoring were represented by Dutch artists as overlapping each other. The overlap was not only a matter for art. In an interesting book about the Amsterdam bordellos published in 1681, a male visitor who is being shown around by the devil mistakes the whores for wives. Seeing a man with an elegantly dressed woman wearing a gold ring, he asks his guide why a man would take his wife to such a place. That's not his wife, he is told, that is a whore. Simon Schama has suggested that there was a balance struck between the good home and the bad – the musicos or brothels as the negative alternative to the orderly household. But Ter Borch shows that the problem was that the difference was not clear. Until this day, prostitutes in Amsterdam display themselves through the windows, or at the doors, of domestic interiors. For Amsterdam to construct bordellos on the model of the domestic house is not a demonstration of balance but a testimony to the continuing uncertainty about whether there is any difference between the two. It was a problem for women as well as for men. [. . .]

Fig.9
Frans van Mieris the Elder
The Studio c.1660
Oil on canvas 60 x 46 cm
Formerly in Gemäldegalerie
Alte Meister, Dresden; now
presumed destroyed

There is no need to argue the centrality of the household/family to Dutch social and political organization, but this would not necessarily have made it a central subject for painting. It is worth inquiring why it should have become such. An important and generally overlooked element is the identification of the painter with the family. Painting was celebrated in a familial context. Parents, wife, and children all take their place beside the artist: The so-called Frankfurt Master decorates his 1496 self-portrait with his wife with emblems of the painter's guild and chamber of rhetoric; Jacob Jordaens celebrates his entry into the painter's guild by making a portrait of himself with his family; Gerrit Dou, a committed self-portraitist, on one occasion depicts himself holding a painting of his parents; and Adriaen van der Werff depicts his wife with child as his muse even when sending a painting off to a court patron. There is a practical basis for this. Family members often served the artist as models. But more importantly, the family provided the artist's ambience: A room in the house was the painter's working space. [. . .]

Historically, European artists had deserted the house for the court. And the court artist, as we see him, for example, in an engraving by Abraham Bosse, looked down on the vulgarity of the house-holder. But most Dutch artists did not have the choice.

It was in the middle of the seventeenth century that some Dutch painters registered the house as their workplace by accounting for their own place in it. This acknowledgment of the house as the painter's workplace produced diverse pictorial results. Frans van Mieris the Elder, in a painting (formerly in Dresden, Gemäldegalerie) distantly related to Vermeer's *Art of Painting*, represented himself in the midst of the social activity of the household: A maid is coming in the door, the model/sitter poses for us as much as for him, and he too poses for us [fig.9]. The painter represents himself engaged in a public activity. By contrast, a painting of the interior of a house by Pieter Janssens Elinga (Frankfurt, Städelsches Kunstinstitut) shows the mistress reading, the maid sweeping, and most extraordinary notations of direct light, reflected light, and shadow. Light, of course, is represented in paintings of Dutch house interiors by Pieter de Hooch, and with a similar diminished attention to figures. But there is an intensity, an obsessiveness even about Elinga's attention to the effects of light in this house. Perhaps he represents it as a light box because he is marking it and hence observing it as his workplace. Through the door in the far room, the painter lets us catch sight of his back, legs, and perhaps an arm raised to work at an unseen easel. We are permitted a glimpse of Vermeer in his house, too, secreted in an even more complex way in the reflected leg of the easel in the mirror of the so-called *Music-Lesson* (London, Collection of Her Majesty the Queen). In the *Art of Painting*, he appears to celebrate the painter's place in the home as his studio. This is Van Mieris with a difference: Though in the home, the painter's room is

Fig.10
Johannes Vermeer
*Young Woman with a Water
Pitcher* c.1662
Oil on canvas 45.7 x 40.6 cm
The Metropolitan Museum
of Art, New York

not subject to the comings and goings depicted by Van Mieris (though Vermeer, we must remember, fathered at least eleven children and lived in a troubled household.) And what Vermeer attends to in the doorless room that is his studio is not the Elinga's play of light but the woman in view in the light. The painter paints with a single woman in view. Beneath the trappings assembled to make her into the *Art of Painting* (the title goes back to an inventory drawn up by Vermeer's wife), the painter has fashioned a woman in the home into his model.

Whereas Rembrandt as a painter deserted the home to construct a studio apart and brought the world, including Hendrickje Stoffels, his common-law wife, in to perform, Vermeer set up his easel at home and turned the women into privileged models. The difference between Rembrandt and Vermeer paintings of women with letters is not only a question of narrative – Rembrandt's *Bathsheba* versus a household scene – but also the assumption of different work sites.

Vermeer's achievement as a painter has been linked to the series, made toward the end of his short career, of distinctive representations of solitary women in the household. The women are upright, impressive, self-possessed, and separated from children and from men. What is interesting about them is less what they do (mostly traditional domestic and pictorial activities such as making lace, reading letters, and cooking) than how they are represented. Indeed, the so-called *Young Woman with a Water Jug*

does nothing but pose in the home [fig.10].

In these paintings, Vermeer effectively removes the representation of women from the tensions, as we have seen them, that concerned other artists. (In Vermeer's paintings, mistresses and maids collude with each other openly and frankly rather than focusing the problem of identity, as we saw in Maes.) There is a difference between using family members as one's models and taking the woman in the home as *the* model. While Ter Borch offers us the virtue of a woman spinning, Vermeer offers us the virtue of the woman posing in the home.

Vermeer's pictures have been plumbed for their psychological depth. The nuance with which the absent male painter attends, past the barrier of chair or table and rug, to the self-absorbed woman in view has been remarked on. It has been said that Vermeer overcame his inhibitions to celebrate women and let them simply be. That is to treat them as objects of his generous feeling. But there is another aspect to this: The basis of Vermeer's attention to these women rests on the way he represents the house as his studio and the women in the house as his models.

To paint women in this way took a certain daring. This is registered not only in the extraordinary nuance of Vermeer's invention and execution, which has often been remarked on, but also in their scale. When looking at reproductions, one tends to forget that these pictures are astonishingly small – at forty-centimeters high, the *Young Woman with a Water Jug* is no bigger than Vermeer's life-sized head of the *Woman with the Pearl Earring* (The Hague, Mauritshuis). A condition of the extraordinary presence of these painted women is the reduction in scale from Vermeer's earliest genre paintings. Another condition was the market. We know from recent research that one patron in Delft bought the greater part of Vermeer's small production of paintings. Unlike Rembrandt, Vermeer, it seems, could paint without having to intervene in the marketplace. Vermeer with his single patron was, then, rather in the position of Velázquez and the Spanish king, but his workplace was the household instead of the court. Like Spain, the town of Delft was economically depressed in just these years. So for each painter, there was an element of retreating to a safe harbor mixed with the success of finding patronage.

It was argued in the Netherlands at the time that woman's place should be in the home. Jacob Cats wrote that the husband must be on the street to practice his trade while the wife must stay at home to be in the kitchen. But here, as elsewhere in his writings, Cats appears to have been prescriptive rather than descriptive. Though there is evidence that the Dutch household was conspicuously small compared to those in other places at the time and the servants few, it was not only lived in but also worked in by men as well as women. It had not yet become the female domain it was to become in the nineteenth century. Vermeer, then, is not registering the social fact of domesticity but is producing it in his pictures. This is one reason

Fig.11
Johannes Vermeer
The Lace-Maker 1669–70
Oil on canvas mounted on
wood 24 x 21 cm
Louvre, Paris

that they appear to us to be not only pictorial performances of great skill
but also socially valid. Vermeer's pictures of these women are enabled
by the relationship he establishes between his practice as a painter and
social practice. There is an element of entrapment about the situation –
the condition of female idealization is domesticity. But the artist in the
home-studio is also trapped. As so often occurs in European painting
[. . .], the artist's power is not in his use of but in his identification with the
situation of the women in the studio who are his models.

The proof of this is revealed in the small *Lace-Maker* in the Louvre.
The isolated worker, bending over strands of colored paint and lit
unexpectedly, like the painter, from her left side, is akin to Vermeer [fig.11].

Chapter 11
The metropolitan urban renaissance: London 1660–1760

Elizabeth McKellar

1. John Evelyn
Fumifugium or The Inconvenience of the Aer and Smoak of London Dissipated. Together with some Remedies humbly Proposed

John Evelyn, *Fumifugium or The Inconvenience of the Aer and Smoak of London Dissipated. Together with some Remedies humbly Proposed,* London, 1661, unpaginated, British Library 101.i.15.

John Evelyn (1620–1706) was a gentleman and famous diarist, as well as a Fellow of the Royal Society, the most prestigious scientific academy founded in London in 1660. He was keenly interested in architecture and gardens, stimulated by his travels in Europe during the English Civil War (1642–51) and Oliver Cromwell's Interregnum (1649–60). His pamphlet *Fumifugium* was written just after Evelyn's return from exile in 1659 and the Restoration of Charles II to the throne in 1660. It shows that an interest in 'Publick Works' was well established even before the Great Fire of London in 1666. Evelyn's tract ranges far more widely than simply solutions to the problem of air pollution alone, which becomes a metaphor for the wider regeneration of London that he wishes to see. He provides a vivid description of the overcrowded City of London pre-Fire specifically, rather than Westminster or the suburbs. Some of the solutions to the congestion that he presents, such as a quay along the River Thames to aid the shipping of goods, were to be incorporated into his and Christopher Wren's plans for the rebuilding of the City following the Fire. EMcK

To the Reader

I have, I confesse, been frequently displeased at the small advance
and improvement of *Publick Works* in this Nation, wherein it seems to be
much inferiour to the Countries and Kingdomes which are round about it;
especially, during these late years of our sad Confusions: But now that God
has miraculously restor'd to us our Prince, a Prince of so magnanimous
and Publick a Spirit, we may promise our selves not only a recovery of our
former Splendor; but also whatever any of our Neighbours enjoy of more
universal benefit, for Health or Ornament: In summe, whatever may do
honour to a Nation so perfectly capable of all advantages.

It is in order to this, that I have presumed to offer these few Proposals
for the Meliorating and refining the *Aer* of *London*; being extremely amaz'd,
that where there is so great an affluence of all things which may render
the People of this vast City, the most happy upon Earth; the sordid, and
accursed Avarice of some few Particular Persons, should be suffered to
prejudice the health and felicity of so many: That any Profit (besides what is
of absolute necessity) should render men regardlesse of what chiefly imports
them, when it may be purchased upon so easie conditions, and with so
great advantages: For it is not happiness to possesse Gold, but to enjoy the
Effects of it, and to know how to live cheerfully and in health, *Non est vivere,
sed valere vita*. That men whose very Being is *Aer*, should not breath it freely
when they may; but (as that *Tyrant* us'd his Vassals) condemn themselves
to this misery *& Fumo præfocari*, is strange stupidity: yet thus we see them
walk and converse in *London*, pursu'd and haunted by that infernal Smoake,
and the funest accidents which accompany it wheresoever they retire.

That this Glorious and Antient City, which from Wood might be
rendred Brick and (like another *Rome*) from Brick made Stone and
Marble; which commands the Proud Ocean to the *Indies*, and reaches
to the farthest *Antipodes*, should wrap her stately head in Clowds of
Smoake and Sulphur, so full of Stink and Darknesse, I deplore with just
Indignation. That the *Buildings* should be compos'd of such a Congestion
of mishapen and extravagant Houses; That the *Streets* should be so narrow
and incommodious in the very Center, and busiest places of Intercourse:
That there should be so ill and uneasie a form of *Paving* under foot, so
troublesome and malicious a disposure of the *Spouts* and *Gutters* overhead,
are particulars worthy of Reproof and Reformation; because it is hereby
rendred a *Labyrinth* in its principal passages, and a continual Wet-day
after the Storm is over. Add to this the Deformity of so frequent *Wharfes*
and Magazines of *Wood*, *Coale*, *Boards*, and other course Materials, most of
them imploying the Places of the Noblest aspect for the situation of Palaces
towards the goodly River, when they might with far lesse Disgrace, be
removed to the *Bank-side*, and afterwards disposed with as much facility
where the Consumption of these Commodities lyes; a *Key* in the mean
time so contrived on *London*-side, as might render it lesse sensible of the

Reciprocation of the Waters, for Use and Health infiniteɫy superiour to what it now enjoys. These are the *Desiderata* which this great City labours under, and which we so much deplore. But I see the Dawning of a brighter day approach; We have a Prince who is Resolv'd to be a *Father to his Country*; and a *Parliament* whose Decrees and Resentiments take their Impression from his Majesties great *Genius*, which studies only the Publick Good. It is from them therefore, that we Augure our future happinesse; since there is nothing which will so much perpetuate their Memories, or more justly merit it. *Medails* and *Inscriptions* have heretofore preserv'd the Fame of lesse Publick Benefits, and for the Repairing of a Dilapidated Bridge, a decaid *Aquæduct*, the paving of a Way, or draining a foggy Marsh, their *Elogies* and *Reverses* have out-lasted the Marbles, and been transmitted to future Ages, after so many thousand Revolutions: But this is the least of that which we Decree to our *August CHARLES*, and which is due to his Illustrious *Senators*; because they will live in our Hearts, and in our *Records*, which are more permanent and lasting.

1. May. 1661.
Farewell.

2. Colen Campbell
Vitruvius Britannicus

Colen Campbell, *Vitruvius Britannicus*, London, vol.1, 1715, pp.230–3, British Library 649.b.5; 1717 reprint of 1715 edn.

Colen Campbell (1676–1729) came to prominence with the publication of *Vitruvius Britannicus* (3 vols., 1715–25), having previously worked as a lawyer and then as an architect in Scotland. He used the publication as a means to advertise his own designs as well as providing a new survey of British architecture, following on from William Kip's and Leonard Knyff's *Britannia Illustrata* of 1708. Campbell's introduction makes the case for British architects to stop imitating Baroque architects such as Bernini and Francesco Borromini (1599–1667) and instead follow the more restrained classical approach of Palladio (1508–80) and his English successor Inigo Jones (1573–1652), who was active in the first half of the seventeenth century. The volume became one of the main propaganda vehicles of the new neo-Palladian movement in Britain through its favouring and presentation of Palladian schemes in what purported to be an unbiased presentation of modern British architecture. EMcK

The Introduction

The general Esteem that Travellers have for Things that are Foreign, is in nothing more conspicuous than with Regard to Building. We travel, for the most part, at an Age more apt to be imposed upon by the Ignorance or Partiality of others, than to judge truly of the Merit of Things by the Strength of Reason. It's owing to this Mistake in Education, that so many of the *British* Quality have so mean an Opinion of what is performed in our own Country; tho', perhaps, in most we equal, and in some Things we surpass, our Neighbours.

I have therefore judged, it would not be improper to publish this Collection, which will admit of a fair Comparison with the best of the Moderns. As to the Antiques, they are out of the Question; and, indeed, the Italians themselves have now no better Claim to them than they have to the Purity of the Latin.

We must, in Justice, acknowledge very great Obligations to those Restorers of *Architecture*, which the Fifteenth and Sixteenth *Centurys*

Fig.12
Colen Campbell
'The Banqueting House at Whitehall. By Inigo Jones' from his *Vitruvius Britannicus, or, The British Architect*, London 1715
Engraving
Yale Center for British Art, Paul Mellon Collection

produced in Italy. *Bramante, Barbaro, Sansovino, Sangallo, Michael Angelo, Raphael Urbin, Julio Romano, Serglio* [sic]*, Labaco, Scamozzi*, and many others, who have greatly help'd to raise this Noble Art from the Ruins of Barbarity: But above all, the great *Palladio*, who has exceeded all that were gone before him, and surpas'd his contemporaries, whose ingenious Labours will eclipse many, and rival most of the Ancients. And indeed, this excellent Architect seems to have arrived to a *Ne plus ultra* of his Art. With him the great Manner and exquisite Taste of Building is lost; for the *Italians* can no more now relish the Antique Simplicity, but are entirely employed in capricious Ornament, which must at last end in the *Gothick*.

For Proof of this Assertion, I appeal to the Productions of the *Last Century*: How affected and licentious are the Works of *Bernini* and *Fontana*? How wildly Extravagant are the Designs of *Boromini*, who has endeavoured to debauch Mankind with his odd and chimerical Beauties, where the Parts are without Proportion; Solids without their true Bearing, Heaps of Materials without Strength, excessive Ornament without Grace, and the Whole without Symmetry? And what can be a stronger Argument, that this excellent Art is near lost in that Country, when such Absurdities meet with Applause?

It is then with the renowned *Palladio* that we enter the lists to whom we oppose the famous Inigo Jones: Let the *Banquetting-House* [fig.12], those excellent pieces at *Greenwich*, with many other Things of this great Master, be carefully examined, and I doubt not but an impartial Judge will find in them all the Regularity of the former, with an addition of Beauty and Majesty, in which our *Architect* is esteemed to have out-done all that went before; and when those Designs he gave for *Whitehall*, are published, which I intend in the second Volume, I believe all Mankind will agree with me, that there is no Palace in the World to rival it.

And here I cannot but reflect on the Happiness of the British Nation, that at present abounds with so many learned and ingenious *Gentlemen*, as Sir *Christopher Wren*, Sir *William Bruce*, Sir *John Vanbrugh*, Mr. *Archer*, Mr. *Wren*, Mr. *Wynne*, Mr. *Talman*, Mr. *Hawksmoor*, Mr. *James* &c. who have all greatly contributed to adorn our Island with their curious Labours, and are daily embellishing it more.

I hope, therefore, the Reader will be agreeably entertained in viewing what I have collected with so much Labour. All the Drawings were either taken from the Buildings themselves, or the original Designs of the Architects, who have very much assisted me in advancing this Work; and I can, with great Sincerity, assure the Publick, That I have used the utmost Care to render it acceptable.

3. Jürgen Habermas
Structural Transformation of the Public Sphere

Jürgen Habermas, *Structural Transformation of the Public Sphere: An Inquiry into a Category of Bourgeois Society*, trans. T. Burger with the assistance of F. Lawrence, Cambridge, MA, Massachusetts Institute of Technology, 1989, pp.29–38.

Jürgen Habermas (b.1929) is a Marxist sociologist. His book *Structural Transformation of the Public Sphere* was first published in German in 1962. Since its translation into English in 1989, it has had a huge impact on Anglo-American scholarship in both the humanities and social sciences. In this early section of the work Habermas lays out the 'basic blueprint' for the public sphere in the late seventeenth and eighteenth centuries, a sphere between civil society and the state, as summarised in the diagram. He shows how the development of the public sphere took place at a particular historical moment, as the market economy developed in Europe, and how this created 'culture' as a separate and distinct commodity. EMcK

The bourgeois avant-garde of the educated middle class learned the art of critical-rational public debate through its contact with the 'elegant world.' This courtly-noble society, to the extent that the modern state apparatus became independent from the monarch's personal sphere, naturally separated itself, in turn, more and more from the court and became its counterpoise in the town. The 'town' was the life center of civil society not only economically; in cultural-political contrast to the court, it designated especially an early public sphere in the world of letters whose institutions were the coffee houses, the *salons*, and the *Tischgesellschaften* (table societies). The heirs of the humanistic-aristocratic society, in their encounter with the bourgeois intellectuals (through sociable discussions that quickly developed into public criticism), built a bridge between the remains of a collapsing form of publicity (the courtly one) and the precursor of a new one: the bourgeois public sphere.

With the usual reservations concerning the simplification involved in such illustrations, the blueprint of the bourgeois public sphere in the eighteenth century may be presented graphically as a schema of social realms in the diagram [opposite].

The line between state and society, fundamental in our context, divided the public sphere from the private realm. The public sphere was coextensive with public authority, and we consider the court part of it. Included in the private realm was the authentic 'public sphere,' for it was a public sphere constituted by private people. Within the realm that was the preserve

Private Realm		*Sphere of Public Authority*
Civil society (realm of commodity exchange and social labor)	Public sphere in the political realm Public sphere in the world of letters (clubs, press)	State (realm of the 'police')
Conjugal family's internal space (bourgeois intellectuals)	(market of culture products) 'Town'	Court (courtly-noble society)

of private people we therefore distinguish again between private and public spheres. The private sphere comprised civil society in the narrower sense, that is to say, the realm of commodity exchange and of social labor; imbedded in it was the family with its interior domain (*Intimsphäre*). The public sphere in the political realm evolved from the public sphere in the world of letters; through the vehicle of public opinion it put the state in touch with the needs of society. [. . .]

In Great Britain the Court had never been able to dominate the town as it had in the France of the Sun King. Nevertheless, after the Glorious Revolution a shift in the relationship between court and town can be observed similar to the one that occurred one generation later in the relationship between *cour* and *ville*. Under the Stuarts, up to Charles II, literature and art served the representation of the king. 'But after the Revolution the glory of the Court grew dim. Neither the political position of the Crown, nor the personal temperament of those who wore it was the same as of old. Stern William, invalid Anne, the German Georges, farmer George, domestic Victoria, none of them desired to keep a Court like Queen Elizabeth's. Henceforth the Court was the residence of secluded royalty, pointed out from afar, difficult of access save on formal occasions of proverbial dullness.' The predominance of the 'town' was strengthened by new institutions that, for all their variety, in Great Britain and France took over the same social functions: the coffee houses in their golden age between 1680 and 1730 and the *salons* in the period between regency and revolution. In both countries they were centers of criticism – literary at first, then also political – in which began to emerge, between aristocratic society and bourgeois intellectuals, a certain parity of the educated.

Around the middle of the seventeenth century, after not only tea – first to be popular – but also chocolate and coffee had become the common beverages of at least the well-to-do strata of the population, the coachman of a Levantine merchant opened the first coffee house. By the first decade of the eighteenth century London already had 3,000 of them, each with a core

group of regulars. Just as Dryden, surrounded by the new generation of writers, joined the battle of the 'ancients and moderns' at Will's, Addison and Steele a little later convened their 'little senate' at Button's; so too in the Rotary Club, presided over by Milton's secretary, Marvell and Pepys met with Harrington who here probably presented the republican ideas of his *Oceana*.[i] As in the *salons* where 'intellectuals' met with the aristocracy, literature had to legitimate itself in these coffee houses. In this case, however, the nobility joining the upper bourgeois stratum still possessed the social functions lost by the French; it represented landed and moneyed interests. Thus critical debate ignited by works of literature and art was soon extended to include economic and political disputes, without any guarantee (such as was given in the *salons*) that such discussions would be inconsequential, at least in the immediate context. The fact that only men were admitted to coffee-house society may have had something to do with this, whereas the style of the *salon*, like that of the rococo in general, was essentially shaped by women. Accordingly the women of London society, abandoned every evening, waged a vigorous but vain struggle against the new institution. The coffee house not merely made access to the relevant circles less formal and easier; it embraced the wider strata of the middle class, including craftsmen and shopkeepers. Ned Ward reports that the 'wealthy shopkeeper' visited the coffee house several times a day, this held true for the poor one as well. [. . .]

[D]iscussion within such a public presupposed the problematization of areas that until then had not been questioned. The domain of 'common concern' which was the object of public critical attention remained a preserve in which church and state authorities had the monopoly of interpretation not just from the pulpit but in philosophy, literature, and art, even at a time when, for specific social categories, the development of capitalism already demanded a behavior whose rational orientation required ever more information. To the degree, however, to which philosophical and literary works and works of art in general were produced for the market and distributed through it, these culture products became similar to that type of information: as commodities they became in principle generally accessible. They no longer remained components of the Church's and court's publicity of representation; that is precisely what was meant by the loss of their aura of extraordinariness and by the profaning of their once sacramental character. The private people for whom the cultural product became available as a commodity profaned it inasmuch as they had to determine its meaning on their own (by way of rational communication with one another), verbalize it, and thus state explicitly what precisely in its implicitness for so long could assert its authority.

i. *The Commonwealth of Oceana*, published in 1656 by the English political theorist James Harrington (1611–77).

As Raymond Williams demonstrates, 'art' and 'culture' owe their modern meaning of spheres separate from the reproduction of social life to the eighteenth century.

[. . .] [T]he same process that converted culture into a commodity (and in this fashion constituted it as a culture that could become an object of discussion to begin with) established the public as in principle inclusive. However exclusive the public might be in any given instance, it could never close itself off entirely and become consolidated as a clique; for it always understood and found itself immersed within a more inclusive public of all private people, persons who – insofar as they were propertied and educated – as readers, listeners, and spectators could avail themselves via the market of the objects that were subject to discussion. The issues discussed became 'general' not merely in their significance, but also in their accessibility: everyone had to *be able* to participate. Wherever the public established itself institutionally as a stable group of discussants, it did not equate itself with *the* public but at most claimed to act as its mouthpiece, in its name, perhaps even as its educator – the new form of bourgeois representation. The public of the first generations, even when it constituted itself as a specific circle of persons, was conscious of being part of a larger public. Potentially it was always also a publicist body, as its discussions did not need to remain internal to it but could be directed at the outside world – for this, perhaps, the *Diskurse der Mahlern*, a moral weekly published from 1721 on by Bodmer and Breitinger in Zurich, was one among many examples.

In relation to the mass of the rural population and the common 'people' in the towns, of course, the public 'at large' that was being formed diffusely outside the early institutions of the public was still extremely small. Elementary education, where it existed, was inferior. The proportion of illiterates, at least in Great Britain, even exceeded that of the preceding Elizabethan epoch. Here, at the start of the eighteenth century, more than half of the population lived on the margins of subsistence. The masses were not only largely illiterate but also so pauperized that they could not even pay for literature. They did not have at their disposal the buying power needed for even the most modest participation in the market of cultural goods. Nevertheless, with the emergence of the diffuse public formed in the course of the commercialization of cultural production, a new social category arose.

The court aristocracy of the seventeenth century was not really a reading public. To be sure, it kept men of letters as it kept servants, but literary production based on patronage was more a matter of a kind of conspicuous consumption than of serious reading by an interested public. The latter arose only in the first decades of the eighteenth century, after the publisher replaced the patron as the author's commissioner and organized the commercial distribution of literary works.

Chapter 12
The English landscape garden 1680–1760

Susie West

1. W.J.T. Mitchell
'Imperial Landscapes'

In W.J.T. Mitchell (ed.), *Landscape and Power* (1994), 2nd edn, Chicago and London, University of Chicago Press, 2002, pp.13–15.

William Mitchell teaches across the departments of English and Art History at the University of Chicago. His edited collection of essays, *Landscape and Power*, was first published in 1994 and has become a point of reference for critical enquiry into issues of representation in regard to the landscape. In this extract, he discusses how this seemingly natural feature can be a bearer of meaning. He argues that landscape, even before it is represented in painting, is 'already a symbolic form in its own right', however apparently simple its construction. That is, landscape is already a representation before it is taken up in other media, such as landscape painting. He sets up an intriguing question about the link of landscape painting to practices that naturalise its ties with ownership and imperialism. He proposes that the apparently ordinary nature of landscape conceals its relationship to discourses of power. SW

Thus, the history of landscape painting is often described as a quest, not just for pure, transparent representation of nature, but as a quest for pure *painting*, freed of literary concerns and representation. As [Kenneth] Clark puts it, 'The painting of landscape cannot be considered independently of the trend away from imitation as the *raison d'être* of art.'[1] One end to the story

1. Kenneth Clark, *Landscape into Art*, Boston, Beacon Press, 1963, p.231.

of landscape is thus abstract painting. At the other extreme, the history of landscape painting may be described as a movement from 'conventional formulas' to 'naturalistic transcripts of nature.' Both stories are grail-quests for purity. On the one hand, the goal is nonrepresentational painting, freed of reference, language, and subject matter; on the other hand, pure hyperrepresentational painting, a superlikeness that produces 'natural representations of nature.'

As a pseudohistorical myth, then, the discourse of landscape is a crucial means for enlisting 'Nature' in the legitimation of modernity, the claim that 'we moderns' are somehow different from and essentially superior to everything that preceded us, free of superstition and convention, masters of a unified, natural language epitomized by landscape painting. Benedict Anderson notes that empires have traditionally relied on 'sacred silent languages' like the 'ideograms of Chinese, Latin, or Arabic' to imagine the unity of a 'global community.'[2] He suggests that the effectiveness of these languages is based in the supposed nonarbitrariness of their signs, their status as 'emanations of reality,' not 'fabricated representations of it.' Anderson thinks of the nonarbitrary sign as 'an idea largely foreign to the contemporary Western mind,' but it is, as we have seen, certainly not foreign to Western ideas of landscape painting. Is landscape painting the 'sacred silent language' of Western imperialism, the medium in which it 'emancipates,' 'naturalizes,' and 'unifies' the world for its own purposes?[3] Before we can even pose this question, much less answer it, we need to take a closer look at what it means to think of landscape as a medium, a vast network of cultural codes, rather than as a specialized genre of painting. [. . .]

I have been assuming throughout these pages that landscape is best understood as a medium of cultural expression, not a genre of painting or fine art. It is now time to explain exactly what this means. There certainly is a genre of painting known as landscape, defined very loosely by a certain emphasis on natural objects as subject matter. What we tend to forget, however, is that this 'subject matter' is not simply raw material to be represented in paint but is always already a symbolic form in its own right. The familiar categories that divide the genre of landscape painting into subgenres – notions such as the Ideal, the Heroic, the Pastoral, the Beautiful, the Sublime, and the Picturesque – are all distinctions based, not in ways of putting paint on canvas, but in the kinds of objects and visual spaces that may be represented by paint.

Landscape *painting* is best understood, then, not as the uniquely central medium that gives us access to ways of seeing landscape, but as a representation of something that is already a representation in

2. Benedict Anderson, *Imagined Communities: Reflections on the Origins* *and Spread of Nationalism*, London, Verso, 1983, p.21. 3. Ibid.

its own right. Landscape may be represented by painting, drawing, or engraving; by photography, film, and theatrical scenery; by writing, speech, and presumably even music and other 'sound images.' Before all these secondary representations, however, landscape is itself a physical and multisensory medium (earth, stone, vegetation, water, sky, sound and silence, light and darkness, etc.) in which cultural meanings and values are encoded, whether they are *put* there by the physical transformation of a place in landscape gardening and architecture, or *found* in a place formed, as we say, 'by nature.' The simplest way to summarize this point is to note that it makes Kenneth Clark's title, *Landscape into Art*, quite redundant: landscape is already artifice in the moment of its beholding, long before it becomes the subject of pictorial representation.

Landscape is a medium in the fullest sense of the word. It is a material 'means' (to borrow Aristotle's terminology) like language or paint, embedded in a tradition of cultural signification and communication, a body of symbolic forms capable of being invoked and reshaped to express meanings and values. As a medium for expressing value, it has a semiotic structure rather like that of money, functioning as a special sort of commodity that plays a unique symbolic role in the system of exchange-value. Like money, landscape is good for nothing as a use-value, while serving as a theoretically limitless symbol of value at some other level. At the most basic, vulgar level, the value of landscape expresses itself in a specific price: the added cost of a beautiful view in real estate value; the price of a plane ticket to the Rockies, Hawaii, the Alps, or New Zealand. Landscape is a marketable commodity to be presented and re-presented in 'packaged tours,' an object to be purchased, consumed, and even brought home in the form of souvenirs such as postcards and photo albums. In its double role as commodity and potent cultural symbol, landscape is the object of fetishistic practices involving the limitless repetition of identical photographs taken on identical spots by tourists with interchangeable emotions.

As a fetishized commodity, landscape is what Marx called a 'social hieroglyph,' an emblem of the social relations it conceals. At the same time that it commands a specific price, landscape represents itself as 'beyond price,' a source of pure, inexhaustible spiritual value. 'Landscape,' says Emerson, 'has no owner,' and the pure viewing of landscape for itself is spoiled by economic considerations: 'you cannot *freely* admire a noble landscape, if laborers are digging in the field hard by.'[4] Raymond Williams notes that 'a working country is hardly ever a landscape,' and John Barrell has shown the way laborers are kept in the 'dark side' of English landscape to keep their work from spoiling the philosophical contemplation of

4. Emerson, *Nature* (1836) in *Nature, Adresses and Lectures*, ed. Robert E. Spiller and Alfred R. Ferguson, Cambridge, MA 1971, p.39.

natural beauty.[5] 'Landscape' must represent itself, then, as the antithesis of 'land,' as an 'ideal estate' quite independent of 'real estate,' as a 'poetic' property, in Emerson's phrase, rather than a material one. The land, real property, contains a limited quantity of wealth in minerals, vegetation, water, and dwelling space. Dig out all the gold in a mountainside, and its wealth is exhausted. But how many photographs, postcards, paintings, and awestruck 'sightings' of the Grand Canyon will it take to exhaust its value as landscape? Could we fill up Grand Canyon with its representations? How do we exhaust the value of a medium like landscape?

2. John Bonehill
'Estates'

In John Bonehill and Stephen Daniels (eds.), *Paul Sandby: Picturing Britain. A Bicentenary Exhibition*, London, Royal Academy of Arts, 2009, exhibition catalogue, pp.190–1; 206–7 (no.87).

The watercolourist Paul Sandby (1731–1809) was recently the subject of a major retrospective exhibition that travelled from the Nottingham Castle Museum and Art Gallery to the National Gallery of Scotland, Edinburgh, and finally to London's Royal Academy. A major theme within the exhibition was the representation of the landscape in terms of the political power of the landowning class in Britain. Sandby's work was explored in relation to eighteenth-century theories of landscape design and the issue of national identity. The catalogue entry for the *North West View of Wakefield Lodge in Whittlebury Forest* 1767 in Northamptonshire draws attention to the significance of public exhibitions of the time, which were promoting the new sub-genre of estate portraiture. The exhibition pointed to 'expanded conceptions of estate portraiture and topographic art', in a period when the influence of William Kent (1685–1748) on the design of the English landscape garden had been extended through the design practice of Lancelot 'Capability' Brown (1716–83). SW

In early 1764 Thomas Gainsborough had occasion to decline an invitation from Philip Yorke, 2nd Earl of Hardwicke, to paint on his newly acquired

5. Raymond Williams, *The Country and the City*, London, 1973, p.120; John

Barrell, *The Dark Side [of the Landscape*, 1980.

estates, remarking that 'with regard to *real Views* from Nature in this Country, he had never seen any Place that affords a Subject equal to the poorest imitations of Gaspar or Claude'. He went on to recommend Paul Sandby as 'the only Man of Genius . . . who has employ'd his Pencil that Way'. Clearly Gainsborough considered the taking of '*real Views*' as incompatible with his own professional ambitions, arguing that 'to have anything tolerable of the name of G. the Subject altogether, as well [as] figures & c must be of his own Brain'. Yet, despite this disdain for estate portraiture among artists with academic aspirations, commissioned views of aristocratic seats featured prominently in London's earliest public art exhibitions. Views of the private property of the nation's political and cultural élite sent to these new fashionable spectacles had already confirmed Sandby's 'genius' for such pictures, while the titles of his exhibits also identified him firmly with 'Nature in this Country'.

Country-house and estate portraits of the kind exhibited by Sandby in the 1760s, great oils like that of Nuneham Courtney, the seat of Simon, 1st Earl of Harcourt, not only recorded recent improvements to these houses but also offered extensive views of their estates, whether parkland or farmland, rides or woodland, roads or waterways, as well as natural or man-made features that lay beyond their boundaries, in the form of surrounding hillsides or the landmarks of nearby towns. These were leisured landscapes, comprised of attractive walks and rides, designed with such noble sporting pursuits as hunting or racing in mind, as well as sites of agricultural and industrial production. These features are often framed by, or viewed through, trees, connecting them to, or integrating them with, the surrounding fields and woods, hedges and lanes, villages and farmsteads. Conservative political theorists, alarmed by the fragmentation of a society increasingly driven by commerce, saw connection as an important means of reconciling the moral welfare of a community with the pursuit of profit through improvement. Estate portraiture celebrated prudent management and ownership, social harmony and productivity, in which the resources of the land were employed to stimulate morality as much as prosperity. Good estate management, as many an essayist, novelist or poet noted, offered a metaphor for effective government. Supervision of such a wide extent of variegated land endowed the owner with the independence of means and capacity for generalising thought that were considered essential to participation in government.

Land ownership was the foundation of economic wealth, social status and political authority. In the wake of the constitutional settlement of 1688, which secured a new political dispensation for parliament, landed property and its improvement became the basis of power and influence. Large, consolidated estates enabled landowners to concentrate their political influence over the surrounding countryside and permitted

them to exploit more fully its resources and gain greater control over
the appearance of the landscape. Estates might proclaim an owner's taste
and knowledge or express political ideals, as well as assert his wealth
and power.

Estates, in all their variety, from large royal and aristocratic parks to
domestic and commercial gardens and agricultural and industrial sites,
remained a central theme of Sandby's art beyond the estate portraits of
the 1760s. The antiquities depicted in the previous section were often
encountered by the artist on a tour of a gentleman's property, where
they might not only contrast with improvements recently made but also
symbolise ancestral connections with the landscape. Ancient forts and
strongholds dating from the reigns of Edward I and Edward II feature
prominently alongside images of improvement and industry in Sandby's
XII Views of North Wales, recording the extensive properties of Sir Watkin
Williams Wynn, and include newly built houses, roads and bridges, mills,
forges and towns, raw, mountainous scenery and landscaped parks.

Thomas Sandby had a long-standing interest in the landscaping of
pleasure grounds, as his work as Deputy Ranger of Windsor Great Park
and his lectures to Royal Academy students delivered in his capacity
as that institution's first Professor of Architecture attest.[i] In these
discourses, he argued that:

> To me the talents of ingenious Landskip Painters has always appeared
> the most congenial with the Art of Ornamental Gardening; their
> studies being chiefly directed to such objects as are noble, grand
> and Picturesque: such they endeavour to select, arrange & combine,
> so as to display, on their canvas, the most beautiful forms and effects
> of nature; and would therefore be more likely to succeed in that
> department of Gardening which should produce the most varied
> and agreeable Scenery.

Such a picturesque approach to landscaping had been promoted by
several theorists, not least William Mason. A close friend of Paul Sandby,
the poet-gardener had recently laid out the famous flower garden at
Nuneham 'with Poet's Feeling and with Painter's eye'. In drawings showing
Mason's design, Sandby details the innovative planting of garden and
wild flowers, the classical temples and natural bowers sheltering verse-
inscribed monuments, and animating the scenes with gardeners and
visitors. This was a garden that its patron, William, 2nd Earl of Harcourt,
described in a letter to the artist as one that must be 'perceived and felt'.
When engraved by William Watts for *The Copper-Plate Magazine* in

i. John Bonehill, Stephen Daniels and
Nick Savage, 'The Royal Academy
Lectures of Thomas Sandby', *The*
Walpole Society, 2014 (forthcoming). All
quotes are from this lecture.

1778 these views of Harcourt's planted tribute to the philosophy of Jean-Jacques Rousseau made this sequestered spot visually accessible to those subscribers of the 'middling sort' principally targeted by the publication.

Thomas Sandby observed a peculiar pleasure in viewing someone else's acreage, arguing: 'All the surrounding Country within our View, may be looked on as our own property, when considered with regard to pleasure . . . as if placed there by our own expence'. Such 'pleasure' was surely to be found in the brothers' views of Windsor's parkland and forest, where labourers, groundsmen and gardeners, as well as members of the royal family, attendants and polite visitors, enjoy 'All the surrounding Country'. Excursionists to this historic royal domain were briefly allowed to wander and view the landscape like kings.

Advising his students on matters of situating a property, Thomas recommended that 'there should be a proper quantity of Trees, grown near at hand for shelter and fuel'. Trees and woodland were far more than a material resource, however. They were symbolic of the social order, playing a key role in the political iconography of landscape improvement. A great family's occupancy of a landscape was often symbolised by hardwood trees like beech, elm or oak. Their historic connection with a place through successive generations was naturalised by an imagery of roots and branches. In an island defended by the 'wooden walls' of its navy, timber had long been freighted with patriotic associations. During the long years of war with revolutionary and then Napoleonic France, views of the forests and timber yards of Windsor Great Park had become a favourite Sandby motif, as he exploited patriotic enthusiasm for imagery of the national territory. One of the first British artists to attend to individual species, growth patterns and the roles of trees in the countryside, Sandby produced several spectacular portraits of individual oaks or ancient beeches, as well as wooded landscapes, in his final years, including atmospheric forest scenes. In such pictures he addressed not only an imagery readily associated with loyalism, but also a growing alarm at the scale of national improvements and the threat posed to tradition when the British landscape and the values it was held to represent were so greatly endangered.

Catalogue No. 87
North West View of Wakefield Lodge in Whittlebury Forest, 1767
[. . .] Signed: 'P. Sandby 1767' (l.l.) [. . .] [fig.13]

Wakefield Lodge, in Whittlebury Forest, Northamptonshire, was designed by William Kent for Charles FitzRoy, 2nd Duke of Grafton, and completed by his successor, Augustus Henry FitzRoy. One of Sandby's most important and influential patrons, the 3rd Duke of Grafton was not only instrumental in the artist's appointment to the staff of the Royal Military Academy at

Fig.13
Paul Sandby
*North West View of Wakefield
Lodge in Whittlebury Forest*
1767
Pen, ink, watercolour and
bodycolour over graphite
42.5 × 85.1 cm
Yale Center for British Art,
Paul Mellon Collection

Woolwich but also promised to secure him the post of Surveyor and Keeper of the King's Pictures. He was to be disappointed, however, on the death of the erstwhile incumbent, George Knapton, as Horace Walpole reported to William Mason in January 1778: 'the promise to Sandby is superseded, *de par le roi*, because it dates from the Duke of Grafton.' A politically controversial figure, Grafton was by this time out of favour with George III.

In addition to overseeing the completion of the lodge, Grafton initiated an extensive and profitable programme of improvement, enclosing common land, integrating farms, reforming tenancies and introducing new methods of agriculture and silviculture. The estate had been acquired from the Crown in 1712, thereby extending an existing grant that came with the rangership of the royal forests of Whittlebury and nearby Salcey. However, the making of this modern landscape from the customary forest economy was a complex and contentious process, involving protracted disputes with local people, notably over game and timber. Conflicts with the Crown over Grafton's claims on timber trees brought his estate to national attention in the late 1760s, as they featured in a series of letters to the press, written by the self-styled patriot 'Junius', as examples of tyrannical and corrupt governance.

In Sandby's view of the estate, made in the midst of these local and national controversies, Kent's Lodge is set amid a broad expanse of lawn, belted by trees and shrubs. A lawn was an enclosure for deer, which are depicted grazing peacefully to the right, with the inclusion of horses – which echo a group of *Mares and Foals by a stream* that Grafton had purchased from George Stubbs a couple of years previously – a further allusion to the sport widely associated with the estate, serving as reminders of the famed Wakefield Lawn Races. That this is essentially a leisured landscape is further indicated by the riders and phaeton entering to the extreme left. In one of the artist's characteristic vignettes of comic encounter, in which the polite and the vulgar or the leisured and the labouring collide, the landowner or some well-connected visitors appear to have disturbed a ragged, rustic couple bundling firewood, gathered either from the dead lower branches of the tree or from fallen

boughs nearby. If the richly coloured foliage of this ash-like tree recalls the decorative sidescreens of Claude, heightening pastoral associations of the scene, it also refers, perhaps, to the ornamental planting of the parkland edges that were part of Kent's designs.

Engravings of the house by Michael 'Angelo' Rooker, after two further Sandby drawings, were subsequently issued as part of *A Collection of Landscapes*, published in 1777. Accompanying letterpress, giving 'a description of the place and the adjacent country', celebrated Grafton's improvements, 'where art and nature combine to form a kind of terrestrial Paradise', but also noted the local cost of his enlargement of the estate: 'Many of the neighbouring villages were formerly allowed the use of common in this forest, but they have lately been deprived of that privilege; which has greatly contributed to the depopulating of the adjacent country'. Any anxiety about the social implications of Grafton's improvements was allayed, however, by the prints themselves, with one depicting the lawn as a place of georgic industriousness, complementing the pastoral pleasure of this scene.

On exhibition at the Society of Artists in 1767, Sandby's *North West View of Wakefield Lodge* [fig.13], along with a now untraced companion drawing of the property, joined a number of other pictures depicting named places on noble estates. They ranged widely, geographically as well as in composition and style, and addressed an assortment of sites and estate activities. They included Richard Wilson's *View from Moor Park*, picturing the landscape surrounding the house of Lawrence Dundas, and two paintings set on the property of the Dukes of Portland: George Barret's *A View in Creswell Crags* and George Stubbs's *Two gentlemen going a shooting, with a view of Creswell Crags*. If Wilson's panoramic prospect, looking out towards a neighbouring seat, ranged over a flourishing, improved prospect, Barret's now-untraced picture in contrast showed an elemental landscape, with a rainbow forming above the spray thrown up by a cascade. Stubbs depicted a near-comic scene of sporting activity, but one admired by a rhyming critic as providing 'A perfect Portrait of the copy'd place / Just heighten'd here and there, by taste and grace'. If these pictures illustrate the scope and power of the expanded conceptions of estate portraiture and topographic art that emerged in the period, they also indicate an emergent taste for the scenic delights of native British territory. One critic considered Wilson's painting 'one that may convince the World that the simple Grandeur of an extensive, richly-cultivated, wooded Plain, and the Verdure, almost peculiar to our Island, so much admired in Nature, and so much decried in Imitation, may have extraordinary Beauties in a Picture'.

3. Bianca Maria Rinaldi
The 'Chinese Garden in Good Taste'

Bianca Maria Rinaldi, *The 'Chinese Garden in Good Taste': Jesuits and Europe's Knowledge of Chinese Flora and Art of the Garden in the 17th and 18th Centuries*, Munich, Martin Meidenbauer, 2006, pp.248–9.

Jesuit Catholic missionaries in China from the end of the sixteenth century recorded their acquisition of knowledge about this country in manuscripts and printed works. Their knowledge is said to have found its way into Protestant England where it had some influence on approaches to landscape design, though evidence for this is patchy. Bianca Maria Rinaldi's extensive use of such sources, in her book *The 'Chinese Garden in Good Taste'*, provides a new basis for examining the writings of such commentators on the garden as Sir William Temple (1628–99), Joseph Addison (1672–1719), and later the architect William Chambers (1723–96). Rinaldi is able to identify the unacknowledged use by these authors of Jesuit accounts of Chinese gardens, which reflected a different view of the relationship between nature and culture. The Jesuits' ability to explain how gardens were designed in China – without any reference to the western classical inheritance of Euclidean geometry as manifest in its formal gardens – was essential for European, particularly English, readers' understanding of such gardens. SW

In England, the revolutionary concept of the landscape garden was being elaborated, and China, from which reports of informal and natural gardens were arriving, constituted an interesting reference for that ongoing revolution. The idea of a possible affinity with the art of gardening in that far-off land brought with it, for English intellectuals, the tacit seduction of a relationship with a great empire with an ancient history, and above all with a tradition entirely separated geographically and culturally from that of the despised continental Europe. England was avid for reports on Chinese gardens; but these did suffer from an original sin, namely, their compilation by Catholic missionaries, and worse yet, by Jesuits, Roman papists par excellence. In this Anglican nation, which was proudly claiming its creative originality in architecture, and where a new concept of the garden was coming into being, it seemed simply improper to place, among the points of reference for those changes, the Jesuits' accounts of China. It is therefore not surprising that English authors – excepting William Chambers – did not cite Jesuits as their primary source for knowledge of Chinese gardens, even though they were using their writings

and their multiple descriptions, the only ones resulting from the direct
prolonged observation on the part of persons who had passed their lives in
the east. Persons who were, at the same time, excellent representatives of
a religious faith and a culture that were generally opposed.[1]

The Jesuit missionaries sent to China were true western intellectuals,
which is to say that they were trained in a context which since classical
times had known a sharp separation between the setting made by man,
aesthetically beautiful because it was an expression of his culture, and
nature. Culture in Europe was the product of the artificial environment
of the city, and this origin reverberated in the way a beautiful landscape
was considered such only if it showed signs of the presence of human
beings. In China, this concept of separation did not exist, but, as was
clearly expressed in the gardens, nature herself was considered the bearer
of culture. The Jesuits understood this difference in attitude between
Europe and China slowly; the missionaries' change in view regarding
these matters was explicit in the words of Attiret, who, while explaining
and perhaps justifying his enthusiasm for the imperial gardens, wrote
that 'My eyes and my taste, since I have been in China, have become a
little Chinese'. The Jesuits understood that there was no need to perceive
a declared artificiality of compositional formulae obviously imposed by
man – the architectural forms based on geometry – to perceive the cultural
intention of those green architectures. It was possible to counter this
method with a different approach: imitate in gardens the forms of nature,
but through Art, that is, through a wholly human manner of interpreting
and recomposing aesthetically the matter of nature. It was this novelty, a
concept prior to any specific composition, that the missionaries attempted
to bring out in their presentation of Chinese gardens to Europeans.

1. As a counterpoint to this
nationalistic attitude, it should be
remembered that in the following
century something similar happened,
but on the other side of the Channel and
with the roles reversed. When French
writers too began to write of the new
naturalistic style, they tried to discredit
the fact that its conception had English

origins, on the basis of the Jesuit
descriptions of far older Chinese
gardens. Evoking the gardens of China
enabled the French to speak of and
publicize naturalness in the gardening
art, without referring to English
authors. See, for instance, Honour,
Chinoiserie, 1961, pp. 163–165. In the
introduction to his translation to

Whateley's *Observation*, Latapie wrote
that the English gardens were nothing
more than an imitation of Chinese
gardens. Latapie, *Art*, 1771, pp. VIIJ–IX.
The same remark [was] made [by]
Georges Le Rouge in the introduction to
the first volume of his *Détails de
nouveau jardins à la mode (jardins
anglo-chinois)*.

4. Katherine Myers
'Visual Fields: Theories of Perception and the Landscape Garden'

In Martin Calder (ed.), *Experiencing the Garden in the Eighteenth Century*, Bern, Peter Lang, 2006, pp.13–19.

Eighteenth-century theories of vision were available to a readership beyond the scientific community, as Katherine Myers demonstrates in her essay. At a time when theories of the aesthetic were emerging, Myers shows that vision – as implicated in aesthetic judgement – was also under critical scrutiny. Rather than taking it for granted, she interrogates anew the notion of pictorial effect in a three-dimensional designed landscape. We might characterise Myers's use (after Gombrich) of Gibson's distinction between visual worlds and visual fields as the difference between our daily experience of negotiating a walk down a street and a 'cinematic' approach to revealing the object in view, where the projection screen defines the field and what is revealed on screen is controlled by the filmmaker. Myers suggests that in English garden making, changes observable from the early eighteenth century can be linked to a shift in a theory of vision. As an example, the poet and gardener William Shenstone (1714–63) experimented with ways of controlling how his garden was viewed, and discussed the difference between revealing a set-piece area of the garden to the viewer and guiding the viewer into that area. This awareness of different processes of viewing is considered by Myers to be implicit in the rise of the picturesque as a set of art theory and practices. SW

It is a commonplace that the eighteenth-century English garden was involved with notions of the picturesque, and there has been much discussion about the changing meaning of that term. However, less attention has been paid to the process involved in seeing a landscape or a garden as if it were a picture, which must presuppose a theory of vision that allows for the ability to see the world as if projected on a flat canvas. The origins of the picturesque garden in the early years of the eighteenth century coincided with intense investigations into the nature of the act of seeing, and into the relationship between everyday perception and the special perceptions of the painter. Philosophers were particularly concerned with how we are in fact able to perceive depth, and how our perception of real space is related to the illusion of pictorial space. A difference emerged at this point between French and British theory: Descartes's notion that distance can be perceived through a kind of instinctive three-dimensional geometry was rejected on this side of

the Channel, and what we see came to be thought of as fundamentally depthless, even though it was recognised that the images derived from the pictures on the retina would normally be overlaid with interpretations of the world as consisting of solid three-dimensional objects. The picturesque vision, the act of looking at the world as if it were a painting, could thus constitute an attempt to recover a primal visual sensation. I would argue that the different approaches to gardening in England and France in the early part of the eighteenth century depended in part on differing theories of vision.

If a garden designer wanted to achieve a pictorial effect, he would have to look at his materials as if they were a perspective projection; and in order to appreciate it, so would the garden visitor. This would require an awareness of the visual field rather than the visual world, a distinction made by J.J. Gibson, described by E.H. Gombrich as 'that great student of vision', who in *The Perception of the Visual World* of 1950 investigated the means by which we perceive depth.[1] According to Gibson, the visual world is 'the familiar, ordinary scene of daily life, in which solid objects look solid, square objects look square, horizontal surfaces look horizontal, and the book across the room looks as big as the book lying in front of you'. In order to see the visual field, on the other hand, 'the attitude you should take is that of the perspective draftsman'. The scene comes 'to approximate the appearance of a picture. [. . .] One gets it only by trying to see the visual world in perspective and to see its colours as a painter does'. Parallel lines meet in the visual field, but not in the visual world, where objects retain a constant size, whereas in the visual field apparent size alters with distance. The visual field is roughly oval, and has boundaries (whereas the visual world has none); it has the qualities of a projection, and can be defined by mathematics and optics. However, it is not completely depthless, or lacking in externality, but, says Gibson, 'it has *less* of these qualities than the visual world'. This gives it a somewhat illusory feeling, although it is 'a reasonably close correlate of the retinal image'. It is therefore also private, and represents the 'phenomenal ego', unlike the visual world, which we all share.

Gibson regards the visual field as 'experience-when-we-introspect' and the visual world as 'experience-when-we-do-not', so he maintains that it always takes a special effort to see the visual field, but points out that theorists of vision generally speaking saw it as primary.[2] Thus the philosophers Locke and Berkeley thought that people with untutored eyes (babies or people born blind but recovering from an operation to restore their sight) were not aware of the third dimension, but gradually learned to be so by correlating their visual sensations with their experiences of

1. James J. Gibson, *The Perception of the Visual World*, Cambridge, Mass., 1950; E.H. Gombrich, *The Image and the Eye:* *Further Studies in the Psychology of Pictorial Representation*, London, 1982, p.251.

2. Gibson, pp.26, 27, 33, 35–6, 42, 43.

touch. The painter, according to this view, has to disregard temporarily his acquired knowledge and recover what Ruskin was to call 'the innocence of the eye', so as to be able to trace correctly the projection of three-dimensional forms on a flat surface.[3] The Scottish philosopher Thomas Reid pointed out in 1764 when discussing Berkeley's theory of vision that this was not easy to do, and required a process of learning. He distinguished between appearances and the judgements we make about them, writing:

> I cannot [. . .] entertain the hope of being intelligible to those readers who have not, by pains and practice, acquired the habit of distinguishing the appearance of objects to the eye, from the judgment which we form by sight of their colour, distance, magnitude and figure. The only profession in life wherein it is necessary to make this distinction, is that of painting.[4]

Playing with the ambiguities of projections, however, had been a feature of garden design since the discovery in the Renaissance of single viewpoint perspective, which was instrumental in the development of the geometric garden arranged around a central axis corresponding to the line of sight. In seventeenth-century France the application of perspective geometry to garden design became extremely sophisticated: students of Le Nôtre have shown, for example, how he enlarged the components of his designs the further they receded from the main viewpoint in order to reduce the effects of foreshortening. The perspective projection, or visual field, was juxtaposed to and contrasted with the design on the ground (which could be said to represent the visual world). Since any projection could represent an infinity of actual configurations in space, the exploration of a garden comprised the testing of the picturesque image against the properties of the visual world, discovered by walking over the ground. Allen S. Weiss has written of the opposition in Le Nôtre's gardens between 'pictorial openness and geometric closure, where the ambulatory experience of the garden's depth destroys the illusive pictorialism inherent in the initial viewpoint'.[5] This act of discovery was built into the garden's structure. Thus in the seventeenth-century French garden the vertical projection and the horizontal plan, respectively representing what Gombrich has called the 'mirror' and 'map' methods of delineating three-dimensional space, were both contrasted and linked.[6] The final experience, however, would have

3. John Ruskin, *Elements of Drawing*, in *Three Letters to Beginners*, London, 1857, pp.5–7. Ruskin wrote in a note: 'The perception of solid Form is entirely a matter of experience. We *see* nothing but flat colours. [. . .] The whole technical power of painting depends on our recovery of what may be called the *innocence of the eye*; that is to say, of a sort of childish perception of these flat stains of colour, merely as such, without consciousness of what they signify, as a blind man would see them if suddenly gifted with sight'.

4. Thomas Reid, *An Inquiry into the Human Mind*, Edinburgh, 1764, p.135.
5. Allen S. Weiss, *Unnatural Horizons: Paradox and Contradiction in Landscape Architecture*, New York, 1998, p.54.

been of a shared public world whose social and political meanings were carefully controlled.

This exploration of two different modes of visual experience may also reflect Descartes's belief that we can in a sense 'see', rather than merely infer, the third dimension, at least over relatively short distances. He maintained that the rays of light entering the eye, which he compared to crossed sticks held by a blind man, exert pressures on it, and that we instinctively calculate the distance of objects by measuring the angles formed by the rays through a kind of 'natural geometry', just as the blind man does with his sticks by touch. Indeed, since we have two eyes he could compare this process to the methods by which surveyors ('*arpenteurs*') calculate the distance of inaccessible points by triangulation. As a result, we should be less subject to the illusions of perspective projections: according to Descartes we can intuit the ground plan that lies behind them. In England, however, in the early eighteenth century, his geometric explanation was to be questioned by George Berkeley.[7]

In England the preponderance of bird's-eye views of gardens (approximating to plans) around the turn of the seventeenth and eighteenth centuries suggests that at that time the experience of the shared visual world was thought to represent the fundamental nature of spatial experience. Knyff and Kip's impossibly high viewpoints in the engravings for their *Britannia Illustrata* of 1707, for example, were clearly chosen to reveal the garden plans on the terrain, and these plans more or less followed the axial French model. I would argue that it was, at least in part, Berkeley's theory of vision that finally caused the garden painter, in John Harris's words, to 'come to earth'. He has shown that, by about 1728, bird's-eye views were giving way to perspective projections, just as circumscribed vistas were starting to be eliminated from gardens themselves.[8] The visual field, defined by the secondary quality of colour, was taking over, and the image, rather than accurate information about Locke's primary qualities of extension and figure, was becoming all-important. As Joseph Spence was to say, 'the appearance to the eye is to be followed in gardening rather than the fact'.[9] For this to be the case, however, the principal features of the landscape picture had to be approached indirectly: William Shenstone's maxim that 'when a building, or other object, has been once viewed from its proper point, the foot should never travel to it by the same path which the eye has travelled over before', that you should 'lose the object, and draw nigh, obliquely', precluded the testing of the visual field. Given a roundabout approach the initial picture,

6. E.H. Gombrich, 'Mirror and Map: Theories of Pictorial Representation', in *The Image and the Eye*, pp.172–214.
7. René Descartes, *Discourse on Method, Optics, Geometry and Meteorology*, translated by Paul J. Olscamp, New York, 1965, pp.104–5.
8. John Harris, 'Bird's-Eye Views at Yale', *Country Life*, 164 (30 November 1978), 1820–1823 (p.1822).
9. Joseph Spence, *Observations, Anecdotes, and Characters of Books and Men, Collected from Conversation*, edited by J.M. Osborn, two volumes, Oxford, 1966, §1088 (p.414).

after being presented from a carefully chosen viewpoint, would disappear or be continuously transformed.[10] Questions of size and distance could remain ambiguous, and so could be manipulated for often illusory effect, but the foot had to be taken on a circuitous path to prevent the reality behind the picture being revealed. As a result, the dominant axis of the French garden could give way to the circuit in England from the 1730s and 1740s.

10. William Shenstone, 'Unconnected Thoughts on Gardening', *Works in Verse and Prose*, edited by Robert Dodsley, three volumes, London, 1764–1769, II, p.131.

Part 4 **New worlds of art**

Introduction

Joel Robinson

The following texts apply to art and visual culture during the decades
leading up to and beyond the French Revolution (1789–99). The first
two texts concern the academic circumstances in which the visual arts
were taught, promoted and viewed by the public in eighteenth-century
Britain and France. The training of artists was central to the purpose of
the academy, both in France with the Académie royale de peinture et de
sculpture, established in 1648, and with the founding of the Royal Academy
of Arts in Britain in 1768. Joshua Reynolds, an accomplished painter in the
'grand manner', was the first President of the Royal Academy in London,
and it was in this role that he delivered his *Discourses* between 1769 and
1790. These are effectively lectures on the theory of art, promulgating
similar values to those of the French Academy, even though an increasingly
middle-class patronage in eighteenth-century Britain was by Reynolds's
time encouraging greater flexibility and diversity in the arts.

In the extracts reproduced here, taken from the third and fourth
Discourses, Reynolds upholds the supremacy of classicism and maintains
that painting should not merely copy nature. It should select those
aspects of it that are most beautiful – leaving aside all 'details' and
'particularities' – in an effort to compose a greater perfection, or what his
French counterparts had called 'ideal beauty'. According to Reynolds,
painting required 'invention', but not the kind that would conjure up
new subjects, for these were already 'commonly supplied by the poet or
historian'. At its best, painting was to demonstrate 'grandeur', 'taste', or
'genius' (terms that are suspect nowadays), and the capacity to captivate
the imagination, even improve and warm the hearts of its beholders. He
is conscious here of a new world of spectators, a new kind of audience
that is no longer solely the court or clergy, but the 'public sphere' that
the twentieth-century social philosopher Jürgen Habermas sought to
describe (see pp.170–3, above).

The ostensible broadening of the public audience is the very 'problem' that the art historian Thomas E. Crow addresses in regard to those first exhibitions that can be described as 'modern', and which were mounted by the French Academy from 1737 onwards. Crow's *Painters and Public Life in Eighteenth-Century Paris* (1985) is an example of late twentieth-century critical art history writing. The excerpt included here, which is from the introduction to that book, is indicative of a newfound interest in the study of exhibition culture and the institution of display towards the end of the twentieth century. Here, he discusses the Salons as the first regular and free exhibitions, attracting a mixture of classes and providing one of the greatest public diversions of the day.

With 'high culture' being made available for aesthetic contemplation to a wider segment of society, artists in France and Britain alike found themselves having to appeal to the seemingly conflicting expectations of the academy on the one hand and the public on the other. One of the upshots of this was the birth of new kinds of art writing, mediating between art and its new audiences. In addition to the academic theory penned by men like André Félibien or Reynolds, and the recent emergence of aesthetics as a particular branch of philosophy, there was now the rise of art criticism as a profession in its own right. To be sure, there had always been those who wrote about art, with a view to assessing its merits and shortcomings. However, the writings of more philosophically minded authors like Denis Diderot or William Hazlitt, or even those journalists who reviewed exhibitions for popular gazettes, are to be distinguished from the largely anecdotal commentaries and biographies of the past.

Chapter 14 includes a pair of excerpts from one of Johann Joachim Winckelmann's seminal texts on Greek art, translated from the German in 1765 by the Royal Academician Henry Fuseli. It too represents a new kind of writing about art, one that is much more historically conscious than anything before it. For this reason, it has been seen as one of the founding texts in the discipline of art history, even though it may be difficult to draw a line here between history and criticism. Like Reynolds, Winckelmann celebrates the classical art of antiquity for its attainment to 'ideal beauty', but as a discriminating archaeologist he judges Greek art superior to the Roman. The human figure in Greek sculpture, lightly draped and in natural sinuous motion, possesses what he called 'grace'. This he contrasted with the sculpture of Bernini, whose exaggerated naturalism and histrionic draperies shows up the 'dastardly taste' of the modern age. Winckelmann never formally lectured or advised artists, but with the advent of Neo-classicism toward the end of the century he would nonetheless come to enjoy a pan-European legacy equal to if not surpassing any academician.

Chapter 15 moves away from the German, French and British contexts where neoclassicism was on the horizon. The texts invite a consideration

of the European reception of visual practices that were completely other to
their own, and which were encountered during the voyages to uncharted
areas of the world, such as the South Pacific. Although some of these
texts offer insight into Polynesian visual practices, they are perhaps more
valuable today for what they reveal about the assumptions and prejudices
of Europeans in their encounter with the 'new world'. The extract by the
Scottish historian John Millar, for example, puts forward a theory of the
stages of human society, beginning with the savage (which was cast as
'ignoble', in contrast to the older myth of the 'noble savage'). The 'savage' is
assumed to have unsophisticated forms of government, compared to the
'polished' peoples of Europe, with their ostensibly more complex principles
of commerce and property.

For accounts of visual culture in the South Pacific, one has to look
beyond the usual kinds of art writing, and beyond the discourses of
contemporary academicians whose classical taste would have barred them
from seeing anything more than a 'curiosity' in a decorated adze, canoe
carving or funeral dress. Artists may have joined the voyages, but their
job was mainly to illustrate the flora and fauna, not to write. Hence, the
texts included here are taken from the journals of Captain James Cook and
two scientists who accompanied him on his expeditions, namely William
Wales and William Anderson. Here, much curiosity and admiration is
expressed concerning the performances, tattoos, monuments, statues
and other artefacts they mention, but their descriptions are largely limited
(not surprisingly) to techniques and materials or other basic properties
like shape and measurement, and frequently resort to comparisons with
familiar things from back home. For instance, Cook likens 'the figure of a
man made in basketwork' and representing one of the legion of gods called
Mahuwe to the puppet Punch.

Complementing these primary sources is an extract from the final pages
of an essay by the anthropologist Peter Gathercole. If the texts cited above
are all written from the European perspective, this raises a question barely
considered till more recently, of how indigenous Polynesians themselves
saw the cultural exchanges with Europeans. Here, all we can really do is
put forward 'limited answers', via the 'ethnographic evidence' – that is,
the objects that are extant on account of having been traded by the natives
and collected by visitors like Cook. Even so, one needs to be careful here
because it was a highly 'unpredictable pattern of exchange values' that
decided what entered collections like those of Lord Sandwich (housed at
the University of Cambridge's Museum of Archaeology and Anthropology,
where Gathercole was curator). This text offers a counterpoint to
those cited above, which largely concern the academy's grip on visual
practices of this period. It is also a reminder of how, in the present era, the
boundaries between 'artefacts' and 'works of art' have become so blurred
that many things categorically denied the status of art in the eighteenth

century might now be seen as art (or at least worthy of the attention given to art).

The pair of texts in Chapter 16 returns to the European context, but explores another theme that was beginning to trouble the hegemony of academic theory at this time. Richard Shiff's essay traces three historically specific but often overlapping conceptions of 'originality' operative in western art and culture since the eighteenth century. The first is that of the academics, whose classicism signalled a return to the *original* art of antiquity, and spurned all innovation that was not an improvement on the Greeks. The second is that of certain Romantics or avant-gardes, who defied what they saw as slavish imitation and mute tradition with the idea of *originating* something new, which had not yet been given form precisely because it could not be transmitted and learned, only *felt*, as the German landscape painter Caspar David Friedrich put it.

Shiff's essay provides a helpful context for reading primary sources like Friedrich's musings on painting, and for understanding how what was being called the battle between the 'ancients' and the 'moderns' was coming to a head during the Romantic era. Written from a position outside the stuffy institution of the academy, Friedrich's 'Observations' were very much at odds with Neo-classicism and the 'mundane, dry and leathery men . . . always devising rules'. It asserted the values of inner experience and subjective expression.

However, there was much doubt here, as Shiff reminds us. Such a radical individualism was entirely reliant on a collective public who could perceive it as *original*, and authentically so, rather than something faked or fashionable, commodified newness. This scepticism is said to be latent in the Romantic conception of originality, but 'radicalised' by late twentieth-century critics and artists contemporary to Shiff, thus leading to a third way of conceptualising originality, a 'postmodern variant', which has in turn coloured the way present-day historians like himself approach the study of art.

Chapter 13
Painting for the public

Emma Barker

1. Joshua Reynolds
Discourses

Sir Joshua Reynolds, *Discourses on Art*, ed. Robert R. Wark, New Haven, Yale University Press, 1975, pp.41–5, 49–50 (*Discourse III*, lines 15–146, 265–301); pp.57–9, 70–1 (*Discourse IV*, lines 17–61, 82–94).

Joshua Reynolds (1723–92) was the President of the Royal Academy of Arts from its foundation in 1768 until his death. The first of his fifteen discourses on art was delivered at the opening of the Academy in January 1769; most of the subsequent discourses were delivered in December, initially every year and later every other year, on the anniversary of the academy's foundation. Following the model of academies of art previously founded in continental Europe, the Royal Academy was established to promote the arts of design (that is, painting, sculpture and architecture), thereby raising the professional status of artists in Britain and fostering the development of a national school of British art in accordance with internationally recognised principles and standards. Its two principal activities were the training of young artists and the staging of an annual exhibition.

Reynolds's *Discourses* offer a synthesis of art theory as it had developed in Europe since the Renaissance. However, they are also shaped by their origins as lectures for the benefit of practising artists, including students. They uphold the centrality of the classical tradition to the practice of high art, or what Reynolds calls the 'great style', the fundamental principles of which are outlined in the following extract

from *Discourse III* (delivered in 1770). His key themes here are the pursuit of ideal beauty as opposed to mechanical imitation of nature, the importance of the study of ancient sculpture, and painting's claim to the status of a liberal or intellectual art. In the extract from *Discourse IV* (delivered in 1771), Reynolds outlines the principles of selection and invention to be followed by artists in producing the type of picture known as history painting. EB

Discourse III

Gentlemen,

[. . .] Nature herself is not to be too closely copied. There are excellencies in the art of painting beyond what is commonly called the imitation of nature: and these excellencies I wish to point out. The students who, having passed through the initiatory exercises, are more advanced in the art, and who, sure of their hand, have leisure to exert their understanding, must now be told, that a mere copier of nature can never produce any thing great; can never raise and enlarge the conceptions, or warm the heart of the spectator.

The wish of the genuine painter must be more extensive: instead of endeavouring to amuse mankind with the minute neatness of his imitations, he must endeavour to improve them by the grandeur of his ideas; instead of seeking praise, by deceiving the superficial sense of the spectator, he must strive for fame, by captivating the imagination.

The principle now laid down, that the perfection of this art does not consist in mere imitation, is far from being new or singular. It is, indeed, supported by the general opinion of the enlightened part of mankind. The poets, orators, and rhetoricians of antiquity, are continually enforcing this position; that all the arts receive their perfection from an ideal beauty, superior to what is to be found in individual nature. They are ever referring to the practice of the painters and sculptors of their times, particularly Phidias, (the favourite artist of antiquity,) to illustrate their assertions. As if they could not sufficiently express their admiration of his genius by what they knew, they have recourse to poetical enthusiasm. They call it inspiration; a gift from heaven. The artist is supposed to have ascended the celestial regions, to furnish his mind with this perfect idea of beauty. 'He,' says Proclus,[1] 'who takes for his model such forms as nature produces, and confines himself to an exact imitation of them, will never attain to what is perfectly beautiful. For the works of nature are full of disproportion, and fall very short of the true standard of beauty. So that Phidias, when he formed his Jupiter, did not copy any object ever presented to his sight; but contemplated only that image which he had conceived in his mind

1. Lib. 2, in Timæum Platonis, as cited by Junius de Pictura Veterum.

from Homer's description.' And thus Cicero, speaking of the same Phidias: 'Neither did this artist,' says he, 'when he carved the image of Jupiter or Minerva, set before him any one human figure, as a pattern, which he was to copy; but having a more perfect idea of beauty fixed in his mind, this he steadily contemplated, and to the imitation of this all his skill and labour were directed.'

The Moderns are not less convinced than the Ancients of this superior power existing in the art; nor less sensible of its effects. Every language has adopted terms expressive of this excellence. The *gusto grande* of the Italians, the *beau ideal* of the French, and the *great style*, *genius*, and *taste* among the English, are but different appellations of the same thing. It is this intellectual dignity, they say, that ennobles the painter's art; that lays the line between him and the mere mechanick; and produces those great effects in an instant, which eloquence and poetry, by slow and repeated efforts, are scarcely able to attain. [. . .]

Such is the warmth with which both the Ancients and Moderns speak of this divine principle of the art; but, as I have formerly observed, enthusiastick admiration seldom promotes knowledge. Though a student by such praise may have his attention roused, and a desire excited, of running in this great career; yet it is possible that what has been said to excite, may only serve to deter him. He examines his own mind, and perceives there nothing of that divine inspiration, with which, he is told, so many others have been favoured. He never travelled to heaven to gather new ideas; and he finds himself possessed of no other qualifications than what mere common observation and a plain understanding can confer. Thus he becomes gloomy amidst the splendour of figurative declamation, and thinks it hopeless, to pursue an object which he supposes out of the reach of human industry.

But on this, as upon many other occasions, we ought to distinguish how much is to be given to enthusiasm, and how much to reason. We ought to allow for, and we ought to commend, that strength of vivid expression, which is necessary to convey, in its full force, the highest sense of the most complete effect of art; taking care at the same time, not to lose in terms of vague admiration, that solidity and truth of principle, upon which alone we can reason, and may be enabled to practise.

It is not easy to define in what this great style consists; nor to describe, by words, the proper means of acquiring it, if the mind of the student should be at all capable of such an acquisition. Could we teach taste or genius by rules, they would be no longer taste and genius. But though there neither are, nor can be, any precise invariable rules for the exercise, or the acquisition, of these great qualities, yet we may truly say that they always operate in proportion to our attention in observing the works of nature, to our skill in selecting, and to our care in digesting, methodizing, and comparing our observations. There are many beauties in our art, that

seem, at first, to lie without the reach of precept, and yet may easily be reduced to practical principles. Experience is all in all; but it is not every one who profits by experience; and most people err, not so much from want of capacity to find their object, as from not knowing what object to pursue. This great ideal perfection and beauty are not to be sought in the heavens, but upon the earth. They are about us, and upon every side of us. But the power of discovering what is deformed in nature, or in other words, what is particular and uncommon, can be acquired only by experience; and the whole beauty and grandeur of the art consists, in my opinion, in being able to get above all singular forms, local customs, particularities, and details of every kind.

All the objects which are exhibited to our view by nature, upon close examination will be found to have their blemishes and defects. The most beautiful forms have something about them like weakness, minuteness, or imperfection. But it is not every eye that perceives these blemishes. It must be an eye long used to the contemplation and comparison of these forms; and which, by a long habit of observing what any set of objects of the same kind have in common, has acquired the power of discerning what each wants in particular. This long laborious comparison should be the first study of the painter, who aims at the greatest style. By this means, he acquires a just idea of beautiful forms; he corrects nature by herself, her imperfect state by her more perfect. His eye being enabled to distinguish the accidental deficiencies, excrescences, and deformities of things, from their general figures, he makes out an abstract idea of their forms more perfect than any one original; and what may seem a paradox, he learns to design naturally by drawing his figures unlike to any one object. This idea of the perfect state of nature, which the Artist calls the Ideal Beauty, is the great leading principle, by which works of genius are conducted. By this Phidias acquired his fame. He wrought upon a sober principle, what has so much excited the enthusiasm of the world; and by this method you, who have courage to tread the same path, may acquire equal reputation.

This is the idea which has acquired, and which seems to have a right to the epithet of *divine*; as it may be said to preside, like a supreme judge over all the productions of nature; appearing to be possessed of the will and intention of the Creator, as far as they regard the external form of living beings. When a man once possesses this idea in its perfection, there is no danger, but that he will be sufficiently warmed by it himself, and be able to warm and ravish every one else.

Thus it is from a reiterated experience, and a close comparison of the objects in nature, that an artist becomes possessed of the idea of that central form, if I may so express it, from which every deviation is deformity. But the investigation of this form, I grant, is painful, and I know but of one method of shortening the road; this is, by a careful study of the works of the ancient sculptors; who, being indefatigable in the school of nature,

have left models of that perfect form behind them, which an artist would prefer as supremely beautiful, who had spent his whole life in that single contemplation. But if industry carried them thus far, may not you also hope for the same reward from the same labour? We have the same school opened to us, that was opened to them; for nature denies her instructions to none, who desire to become her pupils. [. . .]

Having gone thus far in our investigation of the great stile in painting; if we now should suppose that the artist has formed the true idea of beauty, which enables him to give his works a correct and perfect design; if we should suppose also, that he has acquired a knowledge of the unadulterated habits of nature, which gives him simplicity; the rest of his task is, perhaps, less than is generally imagined. Beauty and simplicity have so great a share in the composition of a great stile, that he who has acquired them has little else to learn. It must not, indeed, be forgotten, that there is a nobleness of conception, which goes beyond any thing in the mere exhibition even of perfect form; there is an art of animating and dignifying the figures with intellectual grandeur, of impressing the appearance of philosophick wisdom, or heroick virtue. This can only be acquired by him that enlarges the sphere of his understanding by a variety of knowledge, and warms his imagination with the best productions of antient and modern poetry.

A Hand thus exercised, and a mind thus instructed, will bring the art to an higher degree of excellence than, perhaps, it has hitherto attained in this country. Such a student will disdain the humbler walks of painting, which, however profitable, can never assure him a permanent reputation. He will leave the meaner artist servilely to suppose that those are the best pictures, which are most likely to deceive the spectator. He will permit the lower painter, like the florist or collector of shells, to exhibit the minute discriminations, which distinguish one object of the same species from another; while he, like the philosopher, will consider nature in the abstract, and represent in every one of his figures the character of its species.

If deceiving the eye were the only business of the art, there is no doubt, indeed, but the minute painter would be more apt to succeed: but it is not the eye, it is the mind, which the painter of genius desires to address; nor will he waste a moment upon those smaller objects, which only serve to catch the sense, to divide the attention, and to counteract his great design of speaking to the heart.

This is the ambition which I wish to excite in your minds; and the object I have had in my view, throughout this discourse, is that one great idea, which gives to painting its true dignity, which entitles it to the name of a Liberal Art, and ranks it as a sister of poetry.

Discourse IV

Gentlemen,

[. . .] Invention in Painting does not imply the invention of the subject; for that is commonly supplied by the Poet or Historian. With respect to the choice, no subject can be proper that is not generally interesting. It ought to be either some eminent instance of heroick action, or heroick suffering. There must be something either in the action, or in the object, in which men are universally concerned, and which powerfully strikes upon the publick sympathy.

Strictly speaking, indeed, no subject can be of universal, hardly can it be of general, concern; but there are events and characters so popularly known in those countries where our Art is in request, that they may be considered as sufficiently general for all our purposes. Such are the great events of Greek and Roman fable and history, which early education, and the usual course of reading, have made familiar and interesting to all Europe, without being degraded by the vulgarism of ordinary life in any country. Such too are the capital subjects of scripture history, which, besides their general notoriety, become venerable by their connection with our religion.

As it is required that the subject selected should be a general one, it is no less necessary that it should be kept unembarrassed with whatever may any way serve to divide the attention of the spectator. Whenever a story is related, every man forms a picture in his mind of the action and expression of the persons employed. The power of representing this mental picture on canvass is what we call Invention in a Painter. And as in the conception of this ideal picture, the mind does not enter into the minute peculiarities of the dress, furniture, or scene of action; so when the Painter comes to represent it, he contrives those little necessary concomitant circumstances in such a manner, that they shall strike the spectator no more than they did himself in his first conception of the story.

I am very ready to allow that some circumstances of minuteness and particularity frequently tend to give an air of truth to a piece, and to interest the spectator in an extraordinary manner. Such circumstances therefore cannot wholly be rejected: but if there be any thing in the Art which requires peculiar nicety of discernment, it is the disposition of these minute circumstantial parts; which, according to the judgement employed in the choice, become so useful to truth, or so injurious to grandeur.

However, the usual and most dangerous error is on the side of minuteness; and therefore I think caution most necessary where most have failed. The general idea constitutes real excellence. All smaller things, however perfect in their way, are to be sacrificed without mercy to the greater. The Painter will not enquire what things may be admitted without much censure: he will not think it enough to shew that they may be there; he will shew that they must be there; that their absence would render his picture maimed and defective. [. . .]

The great end of the art is to strike the imagination. The Painter is therefore to make no ostentation of the means by which this is done; the spectator is only to feel the result in his bosom. An inferior artist is unwilling that any part of his industry should be lost upon the spectator. He takes as much pains to discover, as the greater artist does to conceal, the marks of his subordinate assiduity. In works of the lower kind, every thing appears studied, and encumbered; it is all boastful art, and open affectation. The ignorant often part from such pictures with wonder in their mouths, and indifference in their hearts.

But it is not enough in Invention that the Artist should restrain and keep under all the inferior parts of his subject; he must sometimes deviate from vulgar and strict historical truth, in pursuing the grandeur of his design. [. . .]

A Portrait-Painter likewise, when he attempts history, unless he is upon his guard, is likely to enter too much into the detail. He too frequently makes his historical heads look like portraits; and this was once the custom amongst those old painters, who revived the art before general ideas were practised or understood. An History-painter paints man in general; a Portrait-Painter, a particular man, and consequently a defective model.

Thus an habitual practice in the lower exercises of the art will prevent many from attaining the greater. But such of us who move in these humbler walks of the profession, are not ignorant that, as the natural dignity of the subject is less, the more all the little ornamental helps are necessary to its embellishment. It would be ridiculous for a painter of domestick scenes, of portraits, landscapes, animals, or of still life, to say that he despised those qualities which has made the subordinate schools so famous. The art of colouring, and the skilful management of light and shadow, are essential requisites in his confined labours. If we descend still lower, what is the painter of fruit and flowers without the utmost art in colouring, and what the painters call handling; that is, a lightness of pencil that implies great practice, and gives the appearance of being done with ease? Some here, I believe, must remember a flower-painter whose boast it was, that he scorned to paint for the *million*: no, he professed to paint in the true Italian taste; and despising the crowd, called strenuously upon the *few* to admire him. His idea of the Italian taste was to paint as black and dirty as he could, and to leave all clearness and brilliancy of colouring to those who were fonder of money than of immortality. The consequence was such as might be expected. For these petty excellencies are here essential beauties; and without this merit the artist's work will be more short-lived than the objects of his imitation.

2. Thomas E. Crow
Painters and Public Life in Eighteenth-Century Paris

Thomas E. Crow, *Painters and Public Life in Eighteenth-Century Paris*, New Haven, Yale University Press, 1985, pp.1–17.

Thomas E. Crow (b.1948) is Rosalie Solow Professor of Modern Art at the Institute of Fine Arts, New York University. He is the author of two books on eighteenth-century French art and has also written extensively on art of the later twentieth century. *Painters and Public Life in Eighteenth-Century Paris* (1985) was widely acclaimed as a major contribution to art history when it was first published and has been highly influential on subsequent scholarship on eighteenth-century French art. It explores the ways in which the practice of art was shaped by the public exhibition known as the Salon, which took place regularly from 1737 onwards, paying particular attention to the art criticism of the period. Crow shows that, from the first, the Salon critics' assertion of their right to publish their comments on the grounds that they represented public opinion had an oppositional character and that public discourse on art never achieved uncontested legitimacy prior to the French Revolution (1789). In the following extract, Crow examines the complex relationship between the Salon audience and the idea of the 'public'. EB

Ambitious painting most conspicuously entered the lives of eighteenth-century Parisians in the Salon exhibitions mounted by the Academy of Painting and Sculpture. These had begun as regular events in 1737; held in odd-numbered years, except for a brief early spell of annual exhibitions, they opened on the feast-day of St. Louis (25 August) and lasted from three to six weeks. During its run, the Salon was the dominant public entertainment in the city.[1] As visual spectacle, it was dazzling: the *Salon carré* of the Louvre – the vast box of a room which gave the exhibition its name – packed with pictures from eye-level to the distant ceiling, the overflow of still-life and genre pictures spilling down the stairwells that led to the gallery; an acre of color, gleaming varnish, and teeming imagery in the midst of the tumble-down capital (the dilapidation of the

1. Eighteenth-century estimates of total Salon attendance vary from c. 20,000 to 100,000 or more; see Richard Wrigley, 'Censorship and Anonymity in Eighteenth-Century Art Criticism', *Oxford Art Journal*, VI, no. 2, p. 25 and note, for a discussion of these estimates. For a compact, useful survey of the history of the exhibitions, see J. J. Guiffrey, *Notes et documents inédits sur les expositions du XVIIIe siècle*, Paris, 1886. A more recent account can be found in Georg Friedrich Koch, *Die Kunstausstellung*, Berlin, 1967, pp. 124–83. For a brief, well-documented discussion of the Salons between 1759 and 1781, see Udo van de Sandt, 'Le Salon de l'Académie de 1759 à 1781', in Marie-Catherine Sahut and Nathalie Volle, *Diderot et l'art de Boucher à David*, Paris, 1984, pp. 79–84.

Louvre itself was the subject of much contemporary complaint). 'Ceaseless waves' of spectators filled the room, so the contemporary accounts tell us,[2] the crush at times blocking the door and making movement inside impossible. The Salon brought together a broad mix of classes and social types, many of whom were unused to sharing the same leisure-time diversions. Their awkward, jostling encounters provided constant material for satirical commentary.

The success of the Salon as a central Parisian institution, however, had been many decades in the making. Its actual origins lay in the later seventeenth century, but these had not been particularly auspicious. The Academy's initial efforts at public exhibition had been limited to a few cramped and irregular displays of pictures, first in its own meeting rooms and later in the open arcades of the adjoining Palais Royal. The disadvantage of the latter practice, according to an early account, was that the artists 'had the constant worry of damage to the paintings by the weather, which pressed them often to withdraw the pictures before the curiosity of the public had been satisfied.'[3] By 1699 the Salon was more comfortably installed inside the Louvre, and Parisians were spared the sight of academicians hustling their canvases out of the rain. By all accounts, that exhibition was a popular success, but it was almost forty years before the Salon became a permanent fixture of French cultural life.

After 1737, however, its status was never in question, and its effects on the artistic life of Paris were immediate and dramatic. Painters found themselves being exhorted in the press and in art-critical tracts to address the needs and desires of the exhibition 'public'; the journalists and critics who voiced this demand claimed to speak with the backing of this public; state officials responsible for the arts hastened to assert that their decisions had been taken in the public's interest; and collectors began to ask, rather ominously for the artists, which pictures had received the stamp of the public's approval. All those with a vested interest in the Salon exhibitions were thus faced with the task of defining what sort of public it had brought into being.

This proved to be no easy matter, for any of those involved. The Salon exhibition presented them with a collective space that was markedly different from those in which painting and sculpture had served a public function in the past. Visual art had of course always figured in the public life of the community that produced it: civic processions up the Athenian Acropolis, the massing of Easter penitents before the portal of Chartres

2. Louis-Sebastien Mercier, 'Le Sallon (*sic*) de Peinture,' *Le Tableau de Paris*, Amsterdam, IV, 1782–8, pp. 203–6; anonymous, 'Entretiens sur les tableaux exposés au Salon en 1783,' n.p., 1783, pp. 6, 12.
3. Note extraite du Mercure de France',

Deloynes Collection, Cabinet des Estampes, Bibliothéque Nationale, Paris, no. 3, pp. 28–9. For this and all further references to texts and documents contained in this collection, consult Georges Duplessis, *Catalogue de la collection de pièces sur les*

beaux-arts imprimées et manuscrites recueillie par Pierre-Jean Mariette, Charles-Nicolas Cochin et M. Deloynes, auditeur des comptes, et acquise récemment par le départment des Estampes de la Bibliothèque nationale, Paris, 1881.

cathedral, the assembly of Florentine patriots around Michelangelo's
David – these would just begin the list of occasions in which art of the
highest quality entered the life of the ordinary European citizen and
did so in a vivid and compelling way. But prior to the eighteenth century,
the popular experience of high art, however important and moving it
may have been to the mass of people viewing it, was openly determined
and administered from above. Artists operating at the highest levels of
aesthetic ambition did not address their wider audience directly; they
had first to satisfy, or at least resolve, the more immediate demands of elite
individuals and groups. Whatever factors we might name which bear on
the character of the art object, these were always refracted through the
direct relationship between artists and patrons, that is, between artists
and a circumscribed, privileged minority.

The broad public for painting and sculpture would thus have been
defined in terms other than those of interest in the arts for their own sake.
In the pre-eighteenth-century examples cited above, it was more or less
identical with the ritualized assembly of the political and/or religious
community as a whole – and it could be identified as such. The eighteenth-
century Salon, however, marked a removal of art from the ritual
hierarchies of earlier communal life. There the ordinary man or woman
was encouraged to rehearse before works of art the kinds of pleasure and
discrimination that once had been the exclusive prerogative of the patron
and his intimates. There had been precedents for this kind of exhibition,
of course, in France and elsewhere in Europe: displays of paintings often
accompanied the festival of Corpus Christi, for example, and there were
moves under way in many places to make royal and noble collections
available to a wider audience.[4] But the Salon was the first regularly
repeated, open, and free display of contemporary art in Europe to be
offered in a completely secular setting and for the purpose of encouraging
a primarily aesthetic response in large numbers of people.

There was in this arrangement, however, an inherent tension between
the part and the whole: the institution was collective in character, yet
the experience it was meant to foster was an intimate and private one.
In the modern public exhibition, starting with the Salon, the audience is
assumed to share in some community of interest, but what significant
commonality may actually exist has been a far more elusive question.
What was an aesthetic response when divorced from the small community
of erudition, connoisseurship, and aristocratic culture that had heretofore
given it meaning? To call the Salon audience a 'public' implies some
meaningful degree of coherence in attitudes and expectations: could the
crowd in the Louvre be described as anything more than a temporary

4. For a survey of the process by which
some state and aristocratic collections
were opened to public view in this
period, see Niels von Holst, *Creators,
Collectors, and Connoisseurs*, B.
Battershaw, trans., London, 1967,
pp.169–214.

collection of hopelessly heterogeneous individuals? We can and shall
arrive at empirical knowledge concerning the Salon *audience*, because an
audience is by definition an additive phenomenon: we identify, and count if
possible, the individuals and groups recorded as making it up; no one who
was present can be disqualified from membership. But what transforms
that audience into a public, that is, a commonality with a legitimate role
to play in justifying artistic practice and setting value on the products of
that practice? The audience is the concrete manifestation of the public but
never identical with it. In empirical terms, we are confronted only with
the gross totality of the audience and its positively identifiable constituent
parts: individuals and group categories defined by sex, age, occupation,
wealth, residence, etc. The public, on the other hand, is the entity which
mediates between the two, a representation of the *significant* totality by
and for someone. A public appears, with a shape and a will, via the various
claims made to represent it; and when sufficient numbers of an audience
come to believe in one or another of these representations, the public can
become an important art-historical actor.

It follows from this that the role of the new public space in the history
of eighteenth-century French painting will be bound up with a struggle
over representation, over language and symbols and who had the right to
use them. The issue was never whether that problematic entity, the public,
should be consulted in artistic matters, but who could be legitimately
included in it, who spoke for its interests, and which or how many of the
contending directions in artistic practice could claim its support. [. . .]

But we need to entertain the possibility [. . .] that the Salon audience of
eighteenth-century Paris was so fragmented, distracted, and incoherent
that it did not deserve the title of 'public'. This is to say that it could present
no useful demands or criteria to which an artist could respond. It certainly
enjoyed no 'natural' affinity with much of the work on display. Through
the first several decades of Salons, there were almost no pictures produced
primarily to be shown there; they were works of art meant for other places
and other onlookers. There were pieces of Rococo confection looking
naked in the cavernous space, rows of interchangeable portraits, and high
above, the large history paintings, their life-size figures reduced by the
distance to the scale of miniatures. Though ostensibly the most 'public'
in their purpose, these last were not only physically remote from the
Salon visitor, but difficult to decipher once seen. A literate Parisian would
have had a certain degree of familiarity with the motifs and narratives of
classical literature, more than is usually recognized today, but academic
artists tended to choose subjects few viewers would have understood
adequately. [. . .] The recondite character of this sort of literary subject
matter, its meaning often carried in details and stylistic nuances nearly
invisible from the gallery floor, plainly communicated the ambivalence
of the Academy toward the business of public exhibition. There was an

inevitable gap in comprehension which distinguished the secondary from the primary consumers of art.

The placement of pictures on the walls of the Salon was, of course, partly the result of practical necessity: the lower sections were packed with small pictures so they could be seen. The elevated placement of history painting in the Salon did not represent a willful withdrawal of access, but it did unavoidably express the contradictory character of the public exhibition under the Old Regime. What, after all, would ambitious painting be like if it were not learned and difficult, artificial and self-referential in style, aspiring to the sophistication of literary classicism and the audience that all this implied? It would have been difficult to find some available point of reference by which a care-worn merchant or apprentice clerk could genuinely participate in that culture. Everyday life, its physical imprint on the body, its costume, texture, and grit: include more than a hint of that and you have fatally compromised the desired nobility of the form. This is a period, we need to remind ourselves, when individuals and spheres of human life were rigorously distinguished and ranked on a scale of intrinsic value. The hierarchy of genres was, for the eighteenth century, a translation into cultural terms of the division of persons between *noblesse* [nobility] and *roture* [commoners]. Here, for example, is one eighteenth-century art critic defending that hierarchy and then moving on to maintain that even the physical constitutions of noble persons (the overriding figural concern of history painting) were different from those of the non-noble:

> The sublimity of a simple tale is not that of an epic. The good family father, the return of the nurse, the village bride, all make charming scenes. But should you transform these humble actors into Consuls or Roman matrons, or in place of the invalid grandfather suppose a dying Emperor, you will see that the malady of a hero and that of a man of the people are in no way the same, anymore than are their healthy constitutions. The majesty of a Caesar demands a character which should make itself felt in every form and movement of the body and soul.[5]

This is, to be sure, a distinction present in poetics since antiquity and in art theory since the Renaissance at least. It is telling, however, that the source of this passage is an anonymous pamphlet by a popular critic. This writer's position in cultural politics was one of liberal opposition to what he and others of his type regarded as the mendacity and sterile despotism of the academic hierarchy. Yet such critics found it difficult or impossible to imagine a democratic painting, that is, an art which did not make

5. Anonymous, *Dialogues sur la peinture, seconde édition, enrichie de notes*, Paris, 1773, pp. 42–3.

implicit distinctions among spectators in terms of social class. As it stood, history painting would speak through a repertoire of signs over which the typical Salon-goer would have little command.

Chapter 14
Canova, Neo-classicism and the sculpted body

Linda Walsh

1. Johann Joachim Winckelmann
'On the Imitation of the Painting and Sculpture of the Greeks' and 'On Grace'

Johann Joachim Winckelmann, *Reflections on the Painting and Sculpture of the Greeks: With Instructions for the Connoisseur* (German edition 1755)*, and an Essay on Grace in Works of Art* (German edition 1759), trans. Henry Fusseli, London, A. Millar, 1765 (reprinted in London, Routledge, 2000), pp.1–20, 273–87.

Johann Joachim Winckelmann (1717–68) is considered by many to have pioneered archaeology and art history in their modern forms. His *Reflections on the Painting and Sculpture of the Greeks* was published in German in 1755. The text went through several editions and was translated into French, Italian and English. In this work Winckelmann argues that ancient Greek art provided a model that 'modern' artists of his own time should follow. The book influenced thinking about art and aesthetics throughout the late eighteenth and early nineteenth centuries. In the extracts below Winckelmann outlines two concepts that were to lie at the heart of his later writings and of his judgements about art. The first is that of 'ideal beauty', a perfected and idealised representation of natural forms, including the human body, appropriate to the grandeur that should be sought in the highest genres of painting and sculpture. Related to this is the concept of grace, an essay on which was included in the first edition of Fuseli's 1765 translation of *Reflections*. Grace, Winckelmann argues, is a particular kind of idealised representation of the poses, expressions, movements and dress of the human form. In each case Winckelmann praises subtlety,

understatement and refinement over the crude naturalism he ascribes to Dutch realist and Italian Baroque art. LW

On the Imitation of the Painting and Sculpture of the Greeks
I. Nature

To the Greek climate we owe the production of Taste, and from thence it spread at length over all the politer world. Every invention, communicated by foreigners to that nation, was but the seed of what it became afterwards, changing both its nature and size in a country, chosen, as *Plato* says, by Minerva, to be inhabited by the Greeks, as productive of every kind of genius.

But this Taste was not only original among the Greeks, but seemed also quite peculiar to their country: it seldom went abroad without loss; and was long ere it imparted its kind influences to more distant climes. It was, doubtless, a stranger to the northern zones, when Painting and Sculpture, those offsprings of Greece, were despised there to such a degree, that the most valuable pieces of *Corregio* served only for blinds to the windows of the royal stables at Stockholm.

There is but one way for the moderns to become great, and perhaps unequalled; I mean, by imitating the antients. And what we are told of *Homer*, that whoever understands him well, admires him, we find no less true in matters concerning the antient, especially the Greek arts. But then we must be as familiar with them as with a friend, to find Laocoon[i] as inimitable as *Homer*. [. . .]

With such eyes *Michael Angelo, Raphael*, and *Poussin*, considered the performances of the antients. They imbibed taste at its source; and Raphael particularly in its native country. We know, that he sent young artists to Greece, to copy there, for his use, the remains of antiquity. [. . .]

It is not only *Nature* which the votaries of the Greeks find in their works, but still more, something superior to nature; ideal beauties, brain-born images, as *Proclus* says.

The most beautiful body of ours would perhaps be as much inferior to the most beautiful Greek one, as Iphicles was to his brother Hercules. The forms of the Greeks, prepared to beauty, by the influence of the mildest and purest sky, became perfectly elegant by their early exercises. Take a Spartan youth, sprung from heroes, undistorted by swaddling-cloths; whose bed, from his seventh year, was the earth, familiar with wrestling and swimming from his infancy; and compare him with one of our young Sybarits, and then decide which of the two would be deemed worthy, by an artist, to serve for the model of a Theseus, an Achilles, or

i. First-century AD copy, probably of a Greek bronze original of the second century BCE attributed to Polydoros, Agesander and Athenodoros of Rhodes.

The sculpture shows Laocoon, priest of Poseidon at Troy, and his two sons, in the coils of two snakes. The snakes had been sent by Athena as punishment for

Laocoon's intervention in the Trojan War.

even a Bacchus. The latter would produce a Theseus fed on roses, the former a Theseus fed on flesh [. . .].

The grand games were always a very strong incentive for every Greek youth to exercise himself. Whoever aspired to the honours of these was obliged, by the laws, to submit to a trial of ten months at Elis, the general rendezvous; and there the first rewards were commonly won by youths [. . .].

Behold the swift Indian outstripping in pursuit the hart: how briskly his juices circulate! how flexible, how elastic his nerves and muscles! how easy his whole frame! Thus *Homer* draws his heroes, and his Achilles he eminently marks for 'being swift of foot.'

By these exercises the bodies of the Greeks got the great and manly Contour observed in their statues, without any bloated corpulency. The young Spartans were bound to appear every tenth day naked before the Ephori, who, when they perceived any inclinable to fatness, ordered them a scantier diet; nay, it was one of *Pythagoras*'s precepts, to beware of growing too corpulent; and, perhaps for the same reason, youths aspiring to wrestling-games were, in the remoter ages of Greece, during their trial, confined to a milk diet.

They were particularly cautious in avoiding every deforming custom; and *Alcibiades*, when a boy, refusing to learn to play on the flute, for fear of its discomposing his features, was followed by all the youth of Athens.

In their dress they were professed followers of nature. No modern stiffening habit, no squeezing stays hindered Nature from forming easy beauty; the fair knew no anxiety about their attire [. . .].

From their fine complexion, which, though mingled with a vast deal of foreign blood, is still preserved in most of the Greek islands, and from the still enticing beauty of the fair sex, especially at Chios; we may easily form an idea of the beauty of the former inhabitants, who boasted of being Aborigines, nay, more antient than the moon. [. . .]

Those diseases which are destructive of beauty, were moreover unknown to the Greeks. There is not the least hint of the small-pox, in the writings of their physicians; and *Homer*, whose portraits are always so truly drawn, mentions not one pitted face. Venereal plagues, and their daughter the English malady,[ii] had not yet names.

And must we not then, considering every advantage which nature bestows, or art teaches, for forming, preserving, and improving beauty, enjoyed and applied by the Grecians; must we not then confess, there is the strongest probability that the beauty of their persons excelled all we can have an idea of?

Art claims liberty: in vain would nature produce her noblest offsprings, in a country where rigid laws would choak her progressive growth, as in

ii. Syphilis.

Egypt, that pretended parent of sciences and arts: but in Greece, where, from their earliest youth, the happy inhabitants were devoted to mirth and pleasure, where narrow-spirited formality never restrained the liberty of manners, the artist enjoyed nature without a veil.

The Gymnasies, where, sheltered by public modesty, the youths exercised themselves naked, were the schools of art. These the philosopher frequented, as well as the artist. [. . .] Here beautiful nakedness appeared with such a liveliness of expression, such truth and variety of situations, such a noble air of the body, as it would be ridiculous to look for in any hired model of our academies.

Truth springs from the feelings of the heart. What shadow of it therefore can the modern artist hope for, by relying upon a vile model, whose soul is either too base to feel, or too stupid to express the passions, the sentiment his object claims? unhappy he! if experience and fancy fail him.

The beginning of many of *Plato*'s dialogues, supposed to have been held in the Gymnasies, cannot raise our admiration of the generous souls of the Athenian youth, without giving us, at the same time, a strong presumption of a suitable nobleness in their outward carriage and bodily exercises.

The fairest youths danced undressed on the theatre; and *Sophocles*, the great *Sophocles*, when young, was the first who dared to entertain his fellow-citizens in this manner. *Phryne* went to bathe at the Eleusinian games, exposed to the eyes of all Greece, and rising from the water became the model of Venus Anadyomene. During certain solemnities the young Spartan maidens danced naked before the young men: strange this may seem, but will appear more probable, when we consider that the christians of the primitive church, both men and women, were dipped together in the same font.

Then every solemnity, every festival, afforded the artist opportunity to familiarize himself with all the beauties of Nature. [. . .]

These frequent occasions of observing Nature, taught the Greeks to go on still farther. They began to form certain general ideas of beauty, with regard to the proportions of the inferiour parts, as well as of the whole frame: these they raised above the reach of mortality, according to the superiour model of some ideal nature. [. . .]

According to those ideas, exalted above the pitch of material models, the Greeks formed their gods and heroes: the profile of the brow and nose of gods and goddesses is almost a streight line. The same they gave on their coins to queens, &c. but without indulging their fancy too much. Perhaps this profile was as peculiar to the antient Greeks, as flat noses and little eyes to the Calmucks and Chinese; a supposition which receives some strength from the large eyes of all the heads on Greek coins and gems. [. . .]

We observe, nevertheless, that the Greek artists in general, submitted to the law prescribed by the Thebans: 'To do, under a penalty, their best in imitating Nature.' For, where they could not possibly apply their easy

profile, without endangering the resemblance, they followed Nature, as we see instanced in the beauteous head of Julia, the daughter of Titus, done by *Euodus*.

But to form a 'just resemblance, and, at the same time, a handsomer one,' being always the chief rule they observed, and which *Polygnotus* constantly went by; they must, of necessity, be supposed to have had in view a more beauteous and more perfect Nature. [. . .] Sensual beauty furnished the painter with all that nature could give; ideal beauty with the awful and sublime; from that he took the *Humane*, from this the *Divine*.

Let any one, sagacious enough to pierce into the depths of art, compare the whole system of the Greek figures with that of the moderns, by which, as they say, nature alone is imitated; good heaven! what a number of neglected beauties will he not discover!

For instance, in most of the modern figures, if the skin happens to be any where pressed, you see there several little smart wrinkles: when, on the contrary, the same parts, pressed in the same manner on Greek statues, by their soft undulations, form at last but one noble pressure. These masterpieces never shew us the skin forcibly stretched, but softly embracing the firm flesh, which fills it up without any tumid expansion, and harmoniously follows its direction. There the skin never, as on modern bodies, appears in plaits distinct from the flesh.

Modern works are likewise distinguished from the antient by parts; a crowd of small touches and dimples too sensibly drawn. In antient works you find these distributed with sparing sagacity, and, as relative to a completer and more perfect Nature, offered but as hints, nay, often perceived only by the learned.

The probability still increases, that the bodies of the Greeks, as well as the works of their artists, were framed with more unity of system, a nobler harmony of parts, and a completeness of the whole, above our lean tensions and hollow wrinkles.

Probability, 'tis true, is all we can pretend to: but it deserves the attention of our artists and connoisseurs the rather, as the veneration professed for the antient monuments is commonly imputed to prejudice, and not to their excellence; as if the numerous ages, during which they have mouldered, were the only motive for bestowing on them exalted praises, and setting them up for the standards of imitation.

Such as would fain deny to the Greeks the advantages both of a more perfect Nature and of ideal Beauties, boast of the famous *Bernini*, as their great champion. He was of opinion, besides, that Nature was possessed of every requisite beauty: the only skill being to discover that. He boasted of having got rid of a prejudice concerning the Medicean Venus,[iii]

iii. Venus de'Medici, a Roman copy of one of the most canonical Greek sculptures of Venus (the Roman name for the ancient Greek goddess of love, Aphrodite), made c. second century BCE, formerly housed in Rome's Villa Medici, but now in Florence in the Uffizi Gallery.

whose charms he at first thought peculiar ones; but, after many careful researches, discovered them now and then in Nature.

He was taught then, by the Venus, to discover beauties in common Nature, which he had formerly thought peculiar to that statue, and but for it, never would have searched for them. Follows it not from thence, that the beauties of the Greek statues being discovered with less difficulty than those of Nature, are of course more affecting; not so diffused, but more harmoniously united? and if this be true, the pointing out of Nature as chiefly imitable, is leading us into a more tedious and bewildered road to the knowledge of perfect beauty, than setting up the ancients for that purpose: consequently *Bernini*, by adhering too strictly to Nature, acted against his own principles, as well as obstructed the progress of his disciples.

The imitation of beauty is either reduced to a single object, and is *individual*, or, gathering observations from single ones, *composes of these one whole*. The former we call copying, drawing a portrait; 'tis the straight way to Dutch forms and figures; whereas the other leads to general beauty, and its ideal images, and is the way the Greeks took. But there is still this difference between them and us: they enjoying daily occasions of seeing beauty, (suppose even not superior to ours,) acquired those ideal riches with less toil than we, confined as we are to a few and often fruitless opportunities, ever can hope for. It would be no easy matter, I fancy, for our nature, to produce a frame equal in beauty to that of Antinous; and surely no idea can soar above the more than human proportions of a deity, in the Apollo of the Vatican,[iv] which is a compound of the united force of Nature, Genius, and Art.

Their imitation discovering in the one every beauty diffused through Nature, shewing in the other the pitch to which the most perfect Nature can elevate herself, when soaring above the senses, will quicken the genius of the artist, and shorten his discipleship: he will learn to think and draw with confidence, seeing here the fixed limits of human and divine beauty.

Building on this ground, his hand and senses directed by the Greek rule of beauty, the modern artist goes on the surest way to the imitation of Nature. The ideas of unity and perfection, which he acquired in meditating on antiquity, will help him to combine, and to ennoble the more scattered and weaker beauties of our Nature. Thus he will improve every beauty he discovers in it, and by comparing the beauties of nature with the ideal, form rules for himself.

iv. The Apollo Belvedere (currently in the Vatican, Rome); in Winckelmann's time this sculpture was considered to represent archetypal beauty. It is a Roman copy of a fourth-century BCE Greek original.

iv. The Apollo Belvedere (currently in the Vatican, Rome); in Winckelmann's time this sculpture was considered to represent archetypal beauty. It is a Roman copy of a fourth-century BCE Greek original.

On Grace

Grace is the harmony of agent and action. It is a general idea: for whatever reasonably pleases in things and actions is gracious. Grace is a gift of heaven; though not like beauty, which must be born with the possessor: whereas nature gives only the dawn, the capability of this. Education and reflection form it by degrees, and custom may give it the sanction of nature. [. . .]

Grace is perfect when most simple, when freest from finery, constraint, and affected wit. Yet always to trace nature through the vast realms of pleasure, or through all the windings of characters, and circumstances infinitely various, seems to require too pure and candid a taste for this age, cloyed with pleasure, in its judgments either partial, local, capricious, or incompetent. Then let it suffice to say, that Grace can never live where the passions rave; that beauty and tranquillity of soul are the centre of its powers. By this Cleopatra subdued Cæsar [. . .] but Michael Angelo was blind to it; though all the remains of ancient art, even those of but middling merit, might have satisfied him, that Grace alone places them above the reach of modern skill. [. . .]

Grace, in works of art, concerns the human figure only; it modifies the *attitude* and *countenance, dress* and *drapery.* And here I must observe, that the following remarks do not extend to the comic part of art.

The attitude and gestures of antique figures are such as those have, who, conscious of merit, claim attention as their due, when appearing among men of sense. Their motions always shew the motive; clear, pure blood, and settled spirits; nor does it signify whether they stand, sit, or lie; the attitudes of Bacchanals only are violent, and ought to be so.

In quiet situations, when one leg alone supports the other which is free, this recedes only as far as nature requires for putting the figure out of its perpendicular. Nay, in the *Fauni*, the foot has been observed to have an inflected direction, as a token of savage, regardless nature. To the modern artists a quiet attitude seemed insipid and spiritless, and therefore they drag the leg at rest forwards, and, to make the attitude ideal, remove part of the body's weight from the supporting leg, wring the trunk out of its centre, and turn the head, like that of a person suddenly dazzled with lightning. Those to whom this is not clear, may please to recollect some stage-knight, or a conceited young Frenchman. Where room allowed not of such an attitude, they, lest unhappily the leg that has nothing to do might be unemployed, put something elevated under its foot, as if it were like that of a man who could not speak without setting his foot on a stool, or stand without having a stone purposely put under it. The ancients took such care of appearances, that you will hardly find a figure with crossed legs, if not a Bacchus, Paris, or Nireus; and in these they mean to express effeminate indolence.

In the countenances of antique figures, joy bursts not into laughter; 'tis only the representation of inward pleasure. Through the face of a Bacchanal peeps only the dawn of luxury. In sorrow and anguish they resemble the sea, whose bottom is calm, whilst the surface raves. Even in the utmost pangs of nature, Niobe continues still the heroine, who disdained yielding to Latona. The ancients seem to have taken advantage of that situation of the soul, in which, struck dumb by an immensity of pains, she borders upon insensibility; to express, as it were, characters, independent of particular actions; and to avoid scenes too terrifying, too passionate, sometimes to paint the dignity of minds subduing grief.

Those of the moderns, that either were ignorant of antiquity, or neglected to enquire into Grace in nature, have expressed, not only what nature feels, but likewise what she feels not. [. . .] A *Carita* of *Bernini*, on one of the papal monuments in St. Peter's, ought, you'll think, to look upon her children with benevolence and maternal fondness; but her face is all a contradiction to this: for the artist, instead of real graces, applied to her his nostrum, dimples, by which her fondness becomes a perfect sneer. As for the expression of modern sorrow, every one knows it, who has seen cuts, hair torn, garments rent, quite the reverse of the antique, which, like Hamlet's,

> – *hath that within, which passeth shew:*
> *These, but the trappings, and the suits of woe.*[v]

[. . .] Grace, in the accidental parts of antiques, consists, like that of the essential ones, in what becomes nature. The drapery of the most ancient works is easy and slight: hence it was natural to give the folds beneath the girdle an almost perpendicular direction. – Variety indeed was sought, in proportion to the increase of art; but drapery still remained a thin floating texture, with folds gathered up, not lumped together, or indiscreetly scattered. That these were the chief principles of ancient drapery, you may convince yourself from the beautiful Flora in the Campidoglio,[vi] a work of Hadrian's times. Bacchanals and dancing figures had, indeed, even if statues, more waving garments, such as played upon the air; such a one is in the Palazzo Riccardi at Florence; but even then the artists did not neglect appearances, nor exceed the nature of the materials. Gods and heroes are represented as the inhabitants of sacred places, the dwellings of silent awe, not like a sport for the winds [. . .].

v. Lines from Shakespeare's *Hamlet,* Act I, Scene II.
vi. Flora is the goddess of flowers and spring. The reference is to the *Capitoline Flora* currently in the Capitoline Museums, Rome, located at the Piazza di Campidoglio.

Grace extends to garments, as such were given to the Graces by the ancients. How would you wish to see the Graces dressed? Certainly not in birth-day robes; but rather like a beauty you loved, still warm from the bed, in an easy negligee.

The moderns, since the epoch of *Raphael* and his school, seem to have forgot that drapery participates of Grace, by their giving the preference to heavy garments, which might not improperly be called the wrappers of ignorance in beauty: for a thick large-folded drapery may spare the artists the pains of tracing the Contour under it, as the ancients did. Some of the modern figures seem to be made only for lasting. *Bernini* and *Peter* of *Cortona* introduced this drapery. For ourselves, we choose light easy dresses; why do we grudge our figures the same advantage?

He that would give a History of Grace, after the revolution of the arts, would perhaps find himself almost reduced to negatives, especially in sculpture.

In sculpture, the imitation of one great man, of *Michael Angelo*, has debauched the artists from Grace. He, who valued himself upon his being 'a pure intelligence' despised all that could please humanity; his exalted learning disdained to stoop to tender feelings and lovely grace.

There are poems of his published, and in manuscript, that abound in meditations on sublime beauty: but you look in vain for it in his works. – Beauty, even the beauty of a God, wants Grace, and Moses, without it, from awful as he was, becomes only terrible. Immoderately fond of all that was extraordinary and difficult, he soon broke through the bounds of antiquity, grace, and nature; and as he panted for occasions of displaying skill only, he grew extravagant. His lying statues, on the ducal tombs of St. Lorenzo at Florence,[vii] have attitudes, which life, undistorted, cannot imitate: so careless was he, provided he might dazzle you with his mazy learning, of that decency, which nature and the place required [. . .].

He was blindly imitated by his disciples, and in them the want of Grace shocks you still more: for as they were far his inferiors in science, you have no equivalent at all. [. . .]

At last *Lorenzo Bernini* appeared, a man of spirit and superior talents, but whom Grace had never visited even in dreams. He aimed at encyclopædy in art; painter, architect, statuary, he struggled, chiefly as such, to become original. In his eighteenth year he produced his Apollo and Daphne;[viii] a work miraculous for those years, and promising that sculpture by him should attain perfection. Soon after he made his David, which fell short of Apollo.[ix] Proud of general applause, and sensible of his impotency, either to equal or to offuscate the antiques; he seems, encouraged by the dastardly taste of that age, to have formed the project of becoming a

vii. Michelangelo's monuments for the chapel of the powerful Medici family in the Basilica di San Lorenzo, Florence.

viii. This sculpture is in the Galleria Borghese, Rome.

ix. Also in the Galleria Borghese.

legislator in art, for all ensuing ages, and he carried his point. From that time the Graces entirely forsook him: how could they abide with a man who begun his career from the end opposite to the ancients? His forms he compiled from common nature, and his ideas from the inhabitants of climates unknown to him; for in Italy's happiest parts nature differs from his figures. He was worshipped as the genius of art, and universally imitated; for, in our days, statues being erected to piety only, none to wisdom, a statue *à la Bernini* is likelier to make the kitchen prosper than a Laocoon. [. . .]

At Athens the Graces stood eastward, in a sacred place. Our artists should place them over their work-houses; wear them in their rings; seal with them; sacrifice to them; and, court their sovereign charms to their last breath.

Chapter 15
The other side of the world

Paul Wood

1. John Millar
From a lecture on the 'Four Stages' of human society

Ronald L. Meek, *Social Science and the Ignoble Savage*, Cambridge, Cambridge University Press, 1976, n.143, pp.165–6.

John Millar (1735–1801) was a prominent figure in the Scottish Enlightenment of the late eighteenth century. His *Observations Concerning the Distinction of Ranks in Society* was published in 1771, reaching its definitive form in a third edition of 1779. He lectured on Government at Glasgow University in the 1760s and 1770s and several sets of his lecture notes have survived. Part of one of these, originally headed 'State of Government among *Savages*', is reprinted verbatim by the sociologist Ronald L. Meek (1917–78) in his study of Millar's theory of four developmental stages that have marked the evolution of human society. PW

Having examined the general principles of Government, we shall consider in what manner these have been combined, so as to produce different forms of Government in different Ages.

The first object of mankind is to produce subsistence. To obtain the necessaries, the comforts, the conveniencies of life. Their next aim is to defend their persons and their acquisitions against the attacks of one another.

It is evident, therefore, that the more inconsiderable the possessions of any people, their political regulations will be the more simple. And the more opulent a nation becomes its government ought to be the more complicated.

Property is at the same time the principal source of authority, so that

the opulence of a people, not only makes them stand in need of much regulation, but enables them to establish it.

By tracing the progress of wealth we may thus expect to discover the progress of Government. I shall take notice of *4 great stages* in the acquisition of property.

1. Hunters and Fishers, or mere Savages.
 – Indians of America.
 – Some inhabitants of northern and eastern parts of Tartary.
 – Of the Terra Australis.
 – Of southern coast of Africa.
2. Shepherds.
 – Greater part of Tartars. Arabs.
 – Nations on southern coast of Africa.
 – Ancient Germans.
3. Husbandmen.
 – Several tribes on the southern coast of Africa.
 –In East Indies.
 – Towns and villages in ancient Greece and Italy.
 – Gothic nations after their settlement in the Roman Empire.
4. Commercial people.
 – All polished nations.

2. James Cook, William Wales and William Anderson
Aspects of Polynesian art and culture

Captain James Cook, William Wales and William Anderson, various observations on Polynesian art and culture, from *The Journals of Captain James Cook on his Voyages of Discovery*, 3 vols., ed. J.C. Beaglehole, Cambridge, Cambridge University Press, 1955–67. 2i) vol.1, *The Voyage of the Endeavour 1768–1771*, 1955, reprinted with addenda and corrigenda, 1968, pp.111–13. 2ii) ibid. pp.135–6. 2iii) vol.2, *The Voyage of the* Resolution *and the* Adventure *1772–1775*, 1961, reprinted with addenda and corrigenda, 1969, pp.804–5. 2iv) ibid. pp.825–6. 2v a) vol.1, 1968, p.125; b) ibid. pp.278–9; c) vol.3, *The Voyage of the* Resolution *and the* Discovery *1776–1780*, 1967, p.930.

During his three voyages of Pacific exploration between 1768 and 1779, Captain James Cook (1728–79) and several other officers kept extensive journals. These included descriptions of objects and practices that are now regarded as examples of Polynesian art or culture, but which in the late eighteenth century were noted as 'curiosities'. (Eighteenth-century spelling and punctuation is retained.) PW

2i. James Cook
Account of two marae, or temple precincts, in Tahiti, 1769

In his account of a journey round the island of Tahiti in June 1769, Cook describes two temple precincts, one including a figure representing the trickster god Maui ('Mahuwe' in the extract) the other consisting of a large pyramidal structure standing in a walled area. PW

We landed upon the first Whennua in Opooreonoo where we found several of our old acquaintances, what we saw here remarkable was a Morie paved and adorned with [a] pyramid about five feet high of the fruits of Cratova [or] Palm nuts, on the pave'd floor near this were three skulls of men laid in a row & nigh them a little shade covering a very rough image of stone about 18 Inches high; near to the Morie stood an Altar under which lay the Skull bones of 26 Hogs and 6 Dogs. From hence we proceeded farther and met with a very extraordinary curiosity call'd Mahuwe[1] and said by the Natives to be used in their Heiva's or publick entertainments, probably as punch is in a Puppet Show. It was the figure of a man made in basket work 7½ feet high and every [other] way large in proportion, the head was ornamented with four nobs resembling stumps of horns three stood in front and one behind, the whole of this figure was cover'd with feathers, white for the ground upon which [black] imitating hair and the Marks of tattou, it had on a maro or cloth about its loins, under which were proofs of its being intended for the figure of a man. From hence we proceeded to Papara the seat of our friend Oborea where we meant to sleep [. . .] Near this place stands the Morie of Oamo or Obarea, a wonderfull peice of Indian Architecture and far exceeds every thing of its kind upon the whole Island, it is a long square of stone work built Pyramidically, the base is 267 feet by 87, the breadth and length at top is 177 feet by 7, it riseth by large steps all round, like those leading up to a sun dial, there are 11 of those each 4 feet high which makes the whole height 44 feet; the foundation is of squared rockstone of a redish Colour one Corner Stone of which measured $4^F 7^I$ by 2 ft 4 In. its thickness 15 Inches; every step was composed of one row of

1. Tupia informs [us] that this is a representation of one of the Second rank of Eatua's or Gods called *Mauwe* who inhabited the Earth before the Creation of Man, he is represented as an immence Giant who had Seven heads & was indueed with immence strength & Abilities many Absurd stories are told of his Feats by Tupia.

Coral rock very neatly squared the rest of round Stones like large pebbles which seem'd to have been worked by their uniformness in size and Shape. Of the Coral Stones some were large (3½ feet by 2½). On the middle of the top stood the figure of a bird carved in wood and near it lay the broken one of a fish carved in stone: there was no hollow or cavity in the inside the whole being fill'd up with stone. The whole was inclosed in a Spacious Area part of one side of which it made, the Size of this Area was 360 feet by 354 f. incompass'd by a wall of stone, in it were several Etoa trees, or what I call Cypress, and Plantains.

2ii. James Cook
Description of the 'Chief Mourner', in Tahiti, 1769

In July 1769 Cook described witnessing a high-ranking funeral in Tahiti, in which the naturalist Joseph Banks (1743–1820) took part. Cook mentions the intricate costume of the 'Chief Mourner'. Similar examples of the costume were subsequently taken back to Europe on the second voyage (though not on this occasion, when Banks was unable to purchase it). The costume was also the subject of a remarkable drawing by the Raiatean priest Tupaia, who accompanied the Europeans on their travels until his death in Batavia in December 1770. PW

Some time before we left the Island an old woman an relation of *Tooboura Temidu* happend to die and was entar'd in the usual manner, for several successive evenings after one of her relations dress'd himself in a very odd dress which I cannot tell how to describe or to convey a better Idea of it than to suppose a man dress with Plumes of feathers something in the same manner as those worn by Coaches hearses, horses &ca at the funerals in London; it was very neatly made up of black or brown and white cloth black and white feathers and pearl oysteres shells, it coverd the head face and body as low as the Calf of the leg or lower and not only looked grand but awfull likewise. The man thus equip'd and attended by two or three more men or women with their faces and bodies besmeared with soot and a club in their hands would about sunset take a compass of near a mile runing here and there, and where ever they came the people would fly from them as tho they had been so many hobgoblins not one daring to come in their way.

2iii. William Wales
Account of dancing in Tahiti, 1773

William Wales (1734–98) was the astronomer on Cook's second voyage. In his journal for September 1773 he gives an extensive account of the acting and dancing with which the navigators were entertained in Tahiti, noting similarities and differences with European dancing. Wales later taught mathematics at Christ's Hospital school in London. Although it cannot be proved, many believe that his stories of sailing in the southern ocean planted the seed of an idea for the poem *The Rime of the Ancient Mariner* (1798) in the mind of his pupil, Samuel Taylor Coleridge. PW

This Afternoon went with some of the Officers to the House of the Aree of the district where the Ships lay, and who is Brother to the Principal King, or Aree of the Whole Island; where we were entertained with what they call a *Heava*; that is an entertainment of Music and Dancing. The Music was performed on three Drums of different Tones, arrising from their different magnitudes & form. The Base, or deepest toned one, was about 12 or 14 Inches high, and perhaps as much in diameter: The Middle one was about 2½ feet high and about 10 Inches diameter; and that which had the highest tone, might be near 3½ feet high and about 7 or 8 Inches Diameter. Their Heads were made of Shark's Skin and braced much in the same Manner as ours are, only without the slides which ours have for bracing and unbracing; and they beat them with their fingers. The Dancing, as we called it, was performed by two Girls, one of whom is the daughter of the Aree, and accounted a capital Performer, under the direction of an old Man, who travills from place to place for that purpose, and is said to have made great improvement to this divirsion, on which account he is held in great Esteem. The Dress of the Performers is extraordinary and very grand on these Occasions. It consists of a great quantity of their cloth of different Colours bound very tight around the Waist with Cords, and disposed so as to stand off sideways from the Hips in a vast number of plaits or folds, to the extent of a fine Lady's Hoop-Peticoat when in a full Dress. To this is attached a parcel of Coats below, and a sort of Waist coat without sleeves above. Round the Head is wound a great quantity of plaited Hair in such Manner as to stand up like a Coronet, and this is stuck full of small floures of various colours which renders the Head-Dress, in My opinion, truly elegant. The Dexterity of the Performers does not lie in the Motion of the feet; but in that of the Hips, Arms, Fingers and Mouth: all which they keep in motion together, and ye principal skill of the performer seems to lie in contriving to have these several motions as opposite & contrary to one another as possible. These Motions they perform in all attitudes viz standing sitting kneeling Lying, as also with their face in all directions as

East, west &c. all which is directed by the above mentioned old Man who not only gives the word, but sets the example also. In this part of the *Heava*, although the principal with them, there is little very entertaining to an European Eye. The wriggling of their Hips, especially as set off with such a quantity of Furbeloes, is too Ludicrous to be pleasing, and the distortion of their mouths is realy disagreeable, although it is for this the young Princess is chiefly admired. Her face is naturally one of the most beautiful on the Island; but in these performances she twists it in such a manner that a stranger would some times realy question whether her right Eye, Mouth & left Ear did not form one great Gash passing in an oblique direction across her face.

It may be supposed this Exercise is too violent to last long at a time, especially in this climate and under such a load of dress: accordingly the dancing seldom lasts longer than about 5 or 6 Minutes at a time, and in the intervals we were entertained with the performances of 5 or 6 men which sometimes consisted in a sort of figure Dance, wherein they were very carefull that their feet kept exact time to the Drums; at others in the action of short Interludes, which were in my opinion by far the best parts of the Performance, and realy diverting. The subjects of these were sometimes tricks which they are supposed to put on one another either through cunning, or under cover of a dark night; but oftener turn on intimaces between the Sexes, which at times they carry great lengths. These Parts were performed exceeding well, the command which they have over their Features and Countinance is extraordinary, and I am not certain that I ever saw Mr Garrick perform with more propriety than one Man did most of his parts. Their Stage, if I may be allowed the Expression, is under a Shed, open in the Front, and at one end is their dressing Room; into, and out of which they make their *exits*, and enterances as occasion requires; & the floor is spread with very curious Mats: In short, it may be said without exaggeration, that the Drama is advanced in these Islands, very far beyond the Age of Thespis.

2iv. William Wales
Description of the statues of Easter Island, 1774

In March 1774 the HMS *Resolution* called at Easter Island, the most distant of the Polynesian islands. The large stone statues there were described by Cook, Wales and others, and drawn by the voyage artist William Hodges (1744–97). They were as mystified by the statues as by other aspects of Polynesian culture they had encountered, but also in this case were unsurprisingly overawed by their scale. PW

This side of the Island is full of those Colossean Statues which I have mentioned so often, some placed in Groups on platforms of Masonry others single and without any being fixed only in the Earth, and that not deep; these latter are in general much larger than the others. I measured one which was fallen down & found it very near 27 feet long & upwards of 8 feet over the breast, or shoulders and yet this appeared considerably short of the size of one which we dined near: its shade at a little past 2 oClock being sufficient to shelter all our party, consisting of near 30 persons from the Rays of the sun.

The Workmanship of these stupendous Figures, although rude is not bad, nor the features of the Face ill formed: their Noses and Chins, in particular, are exceeding well executed. They are as near as I guess about half length ending in a sort of Stump at the Bottom on Which they stand. [. . .]

It appears very surprizing to me how they could bring and raise those prodigeous Masses of Stone, and still more how they could place the large Cylindric Stones which has been mentioned on the Heads of them afterwards: if indeed the former are factitious they might have been put together on the place and in the position they now stand, and I know not or have heard of any probable Means which could have been used to effect the latter unless a sort of Mount or scaffolding of Stones or Earth has been raised in shelving form equal to the hight of the Statue up which they may have rolled the Cylinder, and even then it would have been found no easy matter to have placed it on its head without throwing it down: This it must be owned must have been a work of immense Time Labour and Patience, and therefore no wonder it seems now to have been long discontinued for not one that we saw has the least appearance of being modern; however if it be a reason for discontinnuing the errecting of them it could be none to the taking care of those which were already set up, in which point there seems to be as great a difficency amongst the present Natives as in the former, and there is some reason to believe that in a few years there will be few or none standing.

2v. Captain James Cook and William Anderson
Accounts of the practice of tattooing in Polynesia

**The cultural practice that attracted the most consistent attention from
the voyagers, and which was evident throughout Polynesia in different
forms, was tattooing. Some of the sailors, including Joseph Banks on
the first voyage, had themselves tattooed. The naturalist William
Anderson (1750–78) was the ship's surgeon on the third voyage,
1776–79/80. PW**

a) Cook in Tahiti, 1769

Both sexes paint their bodys *Tattow* as it is called in their language, this is
done by inlaying the Colour of black under their skins in such a manner
as to be indelible. Some have ill design'd figures of men birds or dogs, the
women generaly have this figure Z simply on ever[y] joint of their fingures
and toes, the men have it like wise and both have other defferent figures
such as circles crescents &ca which they have on their Arms and legs. In
short they are so various in the application of these figures that both the
quantity and situation of them seem to depend intirely upon the humour
of each individual, yet all agree in having all their buttocks cover'd with a
deep black, over this most have arches drawn one over a[n]other as high
as their short ribs which are near a quarter of an Inch broad; these arches
seem to be their great pride as both men and women show them with great
pleasure. Their method of Tattowing I shall now describe. The Coulour they
use is lamp black prepared from the smook of a kind of Oily nutt used by
them instead of Candles; the Instruments for pricking it under the skin is
made of very thin flat pieces of [b]one or shell, from a quarter of an Inch to
an Inch and a half broad according to the purpose it is to be use'd for and
about an inch and a half long, one end is cut into sharp teeth and the other
fasten'd to a handle; the teeth are diped into the black liquor and then
drove by quick sharp blows struck upon the handle with a stick for that
purpose into the skin so deep that every stroke is followed [with] a small
quantity of blood, the part so marked remains sore for some days before it
heals. As this is a painfull operation especially the tattowing thier buttocks
it is perform'd but once in their life time, it is never done untill they are 12
or 14 years of age.

b) Cook in New Zealand, 1770

The Natives of this Country are a strong raw boned well made Active people
rather above than under the common size especially the men, they are all
of a very dark brown Colour with black hair, thin black beards and white
teeth and such as do not disfigure their faces by tattowing &ca have in
general very good features. The men generaly wear their hair long coombd
up and tied upon the crown of their heads, some of the women wear it

long and loose upon their Shoulders, old women especialy, others again wear it crop'd short: their coombs are some made of bone and others of wood, they sometimes wear them as an ornament stuck upright in thier hair. They seem to injoy a good state of hilth and many of them live to a good old age. Many of the old and some of the middle aged men have thier faces mark'd or tattow'd with black and some few we have seen who have had their buttocks thighs and other parts of their bodies mark'd but this is less common. The figures they mostly use are spirals drawn and connected together with great nicety and judgement; they are so exact in the application of these figures that no difference can be found between the one side of the face and the other if the whole is mark'd, for some have only one side and some a little on both sides, hardly any but the old men have the whole tattowd. From this I conclude that it takes up some time perhaps years to finish the operation which all who have begun may not have perseverance enough to go through, as the manner in which it must be done must certainly cause intolerable pain and may be the reason why so few are mark'd att all, at least I know no other. The women inlay the colour of black under the skins of their lips and both sexes paint their faces and bodies at times more or less with red oker mix'd with fish oyle.

c) Anderson in Tonga, 1777

The men are staind from about the middle of the belly to about half way down the thighs with a deep blue colour. This is done by what we might call puncturation or ingraining with a little flat bone instrument cut full of fine teeth & fix'd in a handle. It is dipt into the staining mixture, which is prepard from the soot of the Dooedooe and struck into the skin with a bit of stick until the blood sometimes follows, and by that means leaves such indelible marks that time cannot efface them. They trace in this manner the various lines & figures that fancy suggests which in some are very elegant either from their variety or disposition, but as the practice is quite universal it does not appear whether it is intended as an ornament, or merely a compliance with one of those old customs for whose institution no satisfactory reason can be given in after times.

3. Peter Gathercole
'Lord Sandwich's Collection of Polynesian Artefacts'

In Margarette Lincoln (ed.), *Science and Exploration in the Pacific: European Voyages to the Southern Oceans in the Eighteenth Century*, Woodbridge and London, Boydell Press in association with the National Maritime Museum, 1998, pp.113–15.

This extract is a modern account of the difficulties of interpreting Polynesian historical material. The anthropologist and curator Peter Gathercole (1929–2010) discusses the problem of knowing what the Polynesian perspective might have been of their eighteenth-century cultural encounter with the Europeans on Cook's voyages, and what their reasoning may have been behind some of the exchanges. He concludes by discussing modern revisions to traditional ideas about those historical exchanges. PW

As Dening has remarked concerning the attitudes of Tahitians towards Europeans in 1767, 'How the natives saw the Strangers is, by any standard of objective discourse, nothing more than informed guess.'[1] The journals, paintings and drawings resulting from the Europeans' Pacific voyages in the 1770s provide accounts and interpretations of the actions of exotic *Strangers* often difficult to understand. Of course, this does not mean that every European account is inevitably tagged with an irredeemable discount. It is rather that questions asked about Polynesian attitudes are likely to receive only limited answers. Thus, when the question is asked why Tahitians and Maoris parted with artefacts in exchange for nails and beads, the response is unlikely to be much more than that they seemed to value the latter more than the former. Not very helpful. In the 1770s indigenous Polynesian voices lacked direct expression. Secondly, and somewhat paradoxically, it can be argued that, because they are literally 'mute', to a limited degree artefacts can speak for themselves. For example, given that a stone adze could have had meanings for a 1770s Maori beyond functional and cross-culturally recognisable ones, it is possible from ethnographic evidence to suggest what some of those meanings might have been. More prosaically, if comparisons are made between those artefacts available for acquisition, and what were acquired, inferences might be made about the nature of the relationships between the parties involved.

1. G. Dening, *Performances* (Chicago, 1996), p.137.

Thus an assessment of the indigenous significance of the objects that became the Sandwich collection is hedged with provisos. The visitors had certain needs, particularly food. If we start from this fact, and also that Polynesians were prepared to part with certain objects in return for what the Europeans were able to offer and Polynesians accept, we then have to recognise other limiting factors. There were, especially at the beginning of contact, severe language and cultural misunderstandings, with negotiations prejudiced by violence or its threat (all liable to be played down in the sailors' journal accounts). Contacts were limited to where the Europeans were able, or were allowed by the Polynesians, to go. In addition, regarding at least the Maori objects, and I suspect also those from Tahiti, it is impossible to determine precisely from where, and so from whom, they were obtained.

It is helpful, when considering these factors influencing possible Polynesian attitudes to parting with their artefacts in 1769–70, to compare exchange patterns on Cook's first and second voyages. The most remarkable artefacts seen at Tahiti in 1769 were mourning dresses but none were obtained. This situation was reversed during the second voyage, when, in 1774, parts of at least ten changed hands, in exchange particularly for red feathers the voyagers had obtained from the Tongans. In 1769, the rarest artefact obtained from the Tahitians to become part of the Sandwich collection was the ethnographically unique canoe carving originally from Oheteroa. Less unusual but visually dramatic is the breast gorget. Appearances may be deceptive, however. Kaeppler lists no less than twenty of them derived from Cook's voyages, of which this alone can be localised to the first one, suggesting that what to us appear exotic in contrast to the 'mundane' qualities of fish hooks, adzes or even head rests may have been regarded by Tahitians by other criteria. This was unlikely to be the case for several of the Maori objects not commonly dispensed with. There is a finely made cloak with an unusual taniko border; the possible canoe prow ornament; two paddles; and the two horns from the Hinchingbrooke collections. The quality and rarity of these objects, alongside others less unusual, indicate that the arrival of Europeans in 1769 presented Tahitians and Maoris, individual by individual, with a sudden, rapidly changing, and unpredictable pattern of possible exchange values, which they exploited as time and chance allowed. This pattern was reflected, with a degree of effectiveness we can only guess at, in the material goods they were prepared to part with. It is these material goods which are now shadowly represented in museum collections.

Finally, what about attitudes today among Tahitians and Maoris towards the artefacts collected during the 1770s? They are unlikely to rest on the judgements of western history. These artefacts are an important part of the peoples' cultural heritage, especially those obtained in 1769. Often no comparable objects now exist in the Pacific, people knowing

of them, if at all, only from illustrations or reproductions. Compared to attitudes of earlier generations, who often regarded such material records of their past as of secondary importance compared to more immediate needs, there is now, especially among younger Polynesians, a widespread and growing view that many artefacts should be held no longer in museums or similar institutions, or in the hands of private collectors, outside the Pacific. A less trenchant attitude accepts that some collections or individual items can act as effective cultural ambassadors overseas, demonstrating the splendours of the Polynesian cultural past. In this respect certain overseas museums could have an important role in the furthering of international understanding.

Chapter 16
Inventing the Romantic artist

Emma Barker

1. Caspar David Friedrich
'Observations on Viewing a Collection of Paintings Largely by Living or Recently Deceased Artists'

C. Harrison, P. Wood and J. Gaiger (eds.), *Art in Theory 1815–1900*, Oxford, Blackwell, 1998, pp.48–54, trans. J. Gaiger

Caspar David Friedrich (1774–1840) was the most important German landscape painter of the early nineteenth century. Born in Greifswald near the Baltic Coast, he trained in Copenhagen and spent his working life in Dresden. His 'Observations', written around 1830 but not published until 1841, have as their point of departure his experience of viewing an exhibition of paintings by contemporary artists, none of whom have been identified. The following extracts concentrate on those of his remarks that offer insights into Friedrich's own artistic concerns and commitments. Many of the views that he expresses, his rejection of rules and emphasis on feeling, for example, are characteristic of Romanticism. EB

The artist's feeling is his law. Pure sensibility can never be contrary to nature but is always in accord with it. However, we should never allow the feeling of another to be imposed on us as a law. Spiritual affinity results in similar work, but this affinity is far removed from crude imitation. No matter what may be said about the paintings by XXX and how similar they are to the paintings of Y, he has produced them from out of himself and they are his own.

Who wishes to know what is to be adjudged beautiful and who can teach it? And who can set limits and impose rules on what is spiritual? You mundane, dry and leathery men are always devising rules. The majority will praise you for the crutches you offer them, but whoever is conscious of their own powers will ridicule you.

Those who sit in judgement on works of art are no longer satisfied with our German sun, moon and stars, with our rocks, trees and plants, with our plains, lakes and rivers. Everything must be Italian if it is to raise a claim to greatness and beauty. [. . .]

How numerous are those who call themselves artists without realizing that this also involves something quite different from mere technical skill.

Some hold it mere folly that art must develop from within and that it is dependent on the ethical and religious worth of the individual. Yet just as only a pure, unmarked mirror can return a pure reflection, so a true work of art can only come forth from a pure soul.

What pleases us most in the pictures of the Old Masters is their pious simplicity. However, we should not seek to become simple, as many have done, and so imitate their faults, but rather to become pious and imitate their virtues.

The noble person (a painter) recognizes God in everything, the common person (also a painter) perceives only the form, but not the spirit.

Art is to be likened to a child, science to an adult.

The only true source of art is our heart, the language of a pure, childlike spirit. A picture which does not spring from this source is nothing but affectation. Every genuine work of art is conceived in consecrated hours and born in joyous ones from an inner compulsion of the heart of which the artist himself often remains unconscious.

Close your bodily eyes in order that you may first see your painting with your spiritual eye. Then bring to the light of day what you have seen in the darkness so that it can affect others, penetrating inwards from without.

Painters train themselves in invention, or as they term it, composition. Does this not mean, otherwise expressed, that they train themselves in patching and mending? A painting should not be invented [*erfunden*] but felt [*empfunden*].

If you want to know what beauty is, ask those who theorize about aesthetics. It may be useful to you at the coffee table, but not before the easel. There you need to feel what is beautiful.

Not everything can be taught and not everything can be learnt or achieved through mere dead practice at something; for that art which may genuinely be said to possess a pure spiritual nature transcends the narrow limits of manual craft. Hence it is a complete misunderstanding of what can be termed higher art when young painters form into groups in order to practise so-called composition [*Komponieren*]. The ability to express one's feelings and responses through shape and colour is something which

can neither be learnt nor acquired through mere dexterity of the hand. What can and must be practised, craft, is of a more undeveloped nature, but in my opinion this, too, should be taught with more caution and with more consideration for the particular character of the student than it is, unfortunately, at present; for the treatment of a subject stands in a much closer relation to the object represented than is commonly believed – as does the object to the manner in which it is represented.

It may be a great honour to have a large public for one's works. But the honour is certainly greater to have a small but discriminating public. [. . .]

It is indeed difficult to do justice to others and not to overestimate oneself, and this is true both as regards other historical periods and particular individuals. Every age bears its own character. And every person has his own way of being. The more someone's deeds and actions are in tune with nature or humanity, the more they deserve to be respected and imitated. But the onward march of time results in permanent war, for wherever something new wishes to take shape, no matter how true and beautiful it might be, what is old and already in existence will fight against it; only through struggle and conflict can the new make room for itself, until it, in turn, is displaced by what is new. However, not every displacement of the old by the new should necessarily be seen as contributing towards an increase in our knowledge and insight. If, today, we consider this in relation to the visual arts, we may well ask whether the new school of landscape painting represents progress over what came before. I do not believe that landscape painting has ever been treated with as much honour as it properly deserves. [. . .] Contemporary artists have deliberately avoided the task of capturing the landscape as it actually appears, but they have also failed to do justice to its various individual parts, even though at first glance they may appear to have done so [. . .] Ultimately, these paintings create an adverse impression on me because they seem never to present nature in its simple nobility and grandeur – as it actually is when one has the sensibility, character and feeling to grasp it and recognize it as such. Instead I see everywhere the tiresome attempt to imitate Old Master paintings and engravings. Oh holy Nature! How oft must you yield to fashion and subject yourself to human rules? [. . .]

These men *know* what art is and what it *ought* to be; but you do not feel it and have never been penetrated by it in a living way; for this reason your knowledge is dead and your sorry efforts do not speak to the heart. If you plain and sober men had once truly felt something, your paintings would not resemble corpses without sensibility or feeling, without warmth. [. . .]

The artist should not only paint what he sees before him, but also what he sees within him. If he does not see anything within him, he should give up painting what he sees before him. [. . .]

2. Richard Shiff
'Originality'

In Robert Nelson and Richard Shiff (eds.), *Critical Terms for Art History*, 2nd edn, Chicago, University of Chicago Press, 2003, pp.145–51.

Richard Shiff is Effie Marie Cain Regents Chair in Art and Director of the Center for the Study of Modernism at the University of Texas at Austin. Best known for his book *Cézanne and the End of Impressionism* (1984), he has written on a wide range of topics in the field of modern art. The following extract is the opening section of an essay taken from a volume that he co-edited with Robert Nelson, in which each contributor explores a key concept in the current practice of art history. In 'Originality', Shiff explores the Romantic or modern conception of artistic originality that had crystallised in western culture by the early nineteenth century, distinguishing it from the classical attitude towards the origin of works of art that preceded it. EB

How did our world – everything – originate? Here are two classic Western accounts, one pagan, the other Judeo-Christian. In the *Timaeus*, Plato's creator gives preexisting form to preexisting matter, setting time in motion and instituting change. In the *Confessions*, Augustine's God performs a more radical act, creating 'something, and out of nothing.' For the historian these narratives serve much the same inaugural purpose, because history cannot proceed without both time and a 'something,' a material substance that grows or decays into everything we know and which, if unmoved or unanimated, might as well be 'nothing.'

We motivate and narrate history as if to imply it once had a beginning. Where do artists fit into this history? They enter rather than originate. In 1822, advising fellow painters to build upon the creativity of predecessors – that is, to start at some established point and with something in hand – Ingres uttered what was for him a simple truth: 'You don't get anything from nothing.' As latecomers, artists can play neither pagan prime mover nor Christian God (Prime Innovator). Beginning with what has already been created (the something), they enter into historical traditions, their language of form having already been spoken.

Originality implies some sense of coming first or doing first, a priority or lack of precedent; it therefore cannot be divorced from considerations of chronology and historical sequence. It is also linked to issues of class, a kind of social priority or lineage (one inherits class status and property, just as one does an artistic tradition). If artists must use what has already been shaped, how can they and their artworks attain originality? Perhaps

originality is transmissible (the artist as inheritor and bearer of original first principles, a set of universal truths). And perhaps originality is manifested when one alters existing directions or forces (the artist as countercultural deviator of a tradition or as social deviant).

Our problem is not that the question of artistic originality has no reasonable answer, but that reasonable opinion divides. The concept of artistic originality becomes subject to the same irony that characterizes other central cultural constructs: because different positions on the topic prevail in different eras, originality may lack an essence or fixed center, having instead an irregular history. So we can ask not only what might be the historical origin of a particular practice or tradition, but also what might be the origin of or motivation for a particular sense of originality. There exists no single correct solution to the problem of originality; investigating it, we distinguish a 'modern' attitude from its 'classical' counterpart, and perhaps also a 'postmodern' variant. Such categories have historical foundation, yet do not correspond to a natural evolution with a definitive chronological sequence. The modern does not follow necessarily from the classical, nor is the classical forever superseded; expressions of the classical position can be found in our present.

The question of originality becomes a matter of what people at a given time believe, why they believe it, and how they express their belief. By the early nineteenth century Western culture appears to have shifted from a predominantly classical attitude to a predominantly modern one, if only because European romantics proclaimed this momentous event, arrogating originality as their own (the self-conceived romantic or modern artist as original deviator, forever beginning anew). Given their stress on individual experience, romantics regarded classicism as a thing of the past for two reasons, one related to its normative values, the other to its communal identity. In its first capacity, as the bearer of order and hierarchy, classicism tended to regularize and restrain. It thus interfered with precisely those forces that constituted modernity and its particular originality – the private citizen's free movement and personal growth (furthered by the vicissitudes of individual experience) and the open-ended social evolution fostered by an emerging industrial economy. In its second capacity as a marker of community, classicism promoted the spiritual and social harmony so difficult to maintain in the wake of modernity's transformations of the social order. In this respect, the loss of classicism was mourned as much as celebrated by nineteenth-century theorists.

Historians have connected the shift from classic to romantic-modern with changes in class structure, including a decline of aristocratic social hierarchies and an accompanying rise of the bourgeoisie. In the social realm, a 'classic' society – agrarian, rural, oligarchical – gradually yields to a 'modern' society – industrial, urban, democratic. Exemplary members of oligarchical society are those who inherit and embody

traditions of knowledge appropriate to their privileged class. Exemplary members of democratic society are those who educate themselves through individualized experience, which is different for each person but available to all.

Because classical values and methods tended to be codified (assuming textbook form, as it were), champions of modernity often called their more classicist colleagues 'academic.' The term suggested an artistic practice founded on rote learning rather than expressive idiosyncrasy and diversity; it also alluded to the professional recognition offered by institutions such as state academies of fine arts that, whether admitting to it or not, promoted standardization. So when nineteenth-century art critics advised painters and sculptors to find their model in nature (the 'original' source they were to imitate), a political argument was implicit: artists, as well as anyone else, would prosper in the absence of authoritative, aristocratic antecedents in matters of culture or in any other aspect of political life. Facing nature freely and relying on their own experience, they would find all they needed. Their compositions would be ready-made, with the picture – as critic Théophile Thoré argued in 1847 – already 'complete' in nature and superior to any academic reduction or recombination. For Thoré, nature would do what art did for Ingres, providing the 'something' from which to work. Yet this modernist claim to nature had a serious rival. Some argued that when classicists turned to Greek art for inspiration this, too, was to work from nature, since the ancients (as the first artists) had themselves no classical model to follow; they used nature directly, capturing its truth for the first time. Nature's originality could be adequately transmitted to the moderns through these ancient sources, whose style of representation had no precedent and therefore nothing from which to deviate.

Obviously, classical and modern variants of originality conflict. A number of antiessentialist and decentering perspectives have cast suspicion on both of them. Let me group such positions together under the rubric 'poststructuralist' – here in preference to 'postmodernist' – to signal the influence of such theorists as Jacques Derrida (his critique of the 'origin' of language) and Jacques Lacan (his analysis of the construction of the self in language). Poststructuralists argue that belief in originality as conceived in the Western tradition entails isolating a central origin; this is to privilege one term above all others from within what must be a continuously reconfigured matrix of language and representation, a system without a center. When the center is not evident, both classicists and modernists assume it nevertheless exists, but is hidden or has been 'lost.' It therefore becomes the object of an artistic search. For classicists, the center, origin, or privileged representational term might be God, nature, community, or truth; for modernists, it might be true feeling, unmediated experience, individuality, or the essential self.

We can leave poststructuralist doubt aside for the moment (it will quickly return) as we attempt to picture history with a center. Imagine (like a classicist, a modernist, or nearly anyone conducting his or her everyday life) that the history of human endeavor has a unique point of origin, and that history expands from this point like a big bang universe. History might therefore assume the form of a sphere with the original moment of creation at its center. Or better, a cone, since the position of the vertex will imply movement outward in one direction only, say, from left to right in a delimited pictorial field (like time moving forward). But already it is tempting to conclude – along with poststructuralists and others preceding them who questioned the absolute integrity of any discourse, medium, or mentality – that modes of representation prefigure what can be imagined. For without the frame being used to picture it, why should the cone have any particular orientation? Features of the preexisting representational or linguistic context give an image a sense of direction, a range of meaning toward which the image will tend.

The framed conical figure encourages us to conceive time as linear; yet this figure also accommodates spatial and generational expansion (a widening of the cone), corresponding to our notion that events proliferate as they move ahead in sequence. Now, if history is a cone, do artists attain originality by referring to or rediscovering its vertex, the singular point of origin, as if to follow the stream of history backwards, narrowing back to its central source? Or does originality appear only when artists innovate, as if to move outside of, or to the margins of, or to divert, history's conical flow? If the latter, where is the source, the origin? And is it somehow transformed?

Before nineteenth-century romantics complicated the matter, classically minded art theorists had no difficulty distinguishing two modes of transformation: 'imitations' of sources and 'copies' of the same. With imitation they associated a certain originality. They argued that imitation is an interpretive act involving a degree of difference between the model (the 'original') and its copy, whereas copying is an attempt at mechanistic replication. Both procedures amount to the creation of a form analogous to that of its original. In the case of copying, the principle of transformation can be described in terms of a geometric or mathematical algorithm. An artist might 'copy' either a natural scene or a painting by applying a grid and reducing all measurements to one half or one quarter the original, allowing no exceptions. Or an artist might systematically convert all hues to a set of ten or perhaps only three grays. Photography does something of the sort, often applying a systematic reduction of both size and color according to the specifications of the lens and film – hence the modernist charge that this medium inhibits the free exercise of originality. In the case of 'imitation,' however, the principle of transformation is free and irregular; it is as if new, potentially radical, interpretive decisions are made at every moment in the process. The source of such idiosyncrasy is

an artist who follows no codified rule but responds at every moment to changes in his or her environmental and psychological situation. If the artist's practice follows a law, it is internalized and invisible: spontaneous rule by person rather than predictable rule by system. With 'imitation,' the individual artist becomes as much of a center as the model, perhaps seeking something hidden or lost within.

Does this mean that the originality to be associated with 'imitation' must be the province of modernists? Not necessarily. Consider the classical position as presented in two related commentaries on the Renaissance master Raphael, commentaries by two citizens of early modern society; the authors in question are Sir Joshua Reynolds and A.-C. Quatremère de Quincy (friend and admirer of Ingres), both of whom presided over modern academies for which they composed 'classical' theory. According to Reynolds (1774), Raphael took 'so many models, that he became himself a model for all succeeding painters, always imitating, and always original.' Reynolds's 'imitation' verges on a composite 'copying.' His logic may seem obscure to those immersed in late modernist forms of creation: How can such imitation end in a fundamental originality? Reynolds appears to condone eclecticism and repetition, perhaps even plagiarism, at the expense of authenticity and innovation. An element of Quatremère's praise of Raphael helps to resolve this apparent contradiction: 'Once a beautiful thought has been struck with the mark of genius, there is also genius in refraining from giving it a new imprint.' Repetition, it seems, is not necessarily the enemy of genius. An artist can exercise creativity by acknowledging what ought to be reiterated.

But where does this leave originality? Given Quatremère's position, Raphael's choice of features worthy of the effort of his imitation makes him original in two senses. First, he creates particularly effective combinations, actually enriching the standard imagery with new, albeit hybrid forms derived from his multiple sources; classicists had a special term for this, calling it 'invention.' Second, Raphael imitates only the very best of all discernible qualities. If we presume that Raphael's antecedents did the same – indeed, in their commentaries both Reynolds and Quatremère invoke the precedent of Masaccio, and before him the precedent of the ancients – then we understand that at least some element of the earliest artistic form necessarily passes into Raphael's art through a timeless process of genius recognizing, emulating, and re-creating genius. What results is an expression of Western culture as a set of collective, anonymous values. There is further implication: the principle of classical anonymity entails that predecessors resemble followers as much as followers resemble predecessors; thus, classical originality has little to do with one's position in a sequence of 'geniuses' but depends instead on whether one participates in transmitting a culture's primordial values. Priority becomes a matter of rediscovering and disseminating first principles which (it must be

concluded) have no independent alternatives. Classical artists work not to innovate but to preserve established priorities. Their originality entails a certain sameness.

That, at least, is the classical position in the eyes of 'modernist' artists. They assume the role of revolutionaries either by introducing change, returning to values long lost from the classical hierarchy, or representing truths in personalized, perhaps deviant, expressive form. It might be argued that in Italian Renaissance art the form had already become identified with its individual creator and was therefore 'modern.' Nineteenth-century romantics nevertheless adopted this position as their own, as if it were their exclusive property. Modernists have a certain hubris. Often arguing that they lack true precedent, they conceive of *themselves* (not their principles) as original and seek originality by realizing their inner feelings, thoughts, and character. Manet once represented his aesthetic by stating that he 'sought simply to be himself, and not another.' Accordingly, romantics and modernists associate artistic authenticity with an expressive manner so autonomous that it must also appear innovative, in opposition to the value a classicist might locate in selective repetition. Delacroix, for example, claimed that because he had achieved mastery, others would copy him; but he would feel no need to imitate anything himself. His contemporary Thoré characterized original artists as 'sons of no one' who 'proceed from their own innateness.' Another critic of the time argued that the 'true originality' of those like Delacroix would never be imitated successfully, being too idiosyncratic to be transmitted to pupils; whereas Ingres's classical style possessed a regularity that allowed his students to 'simulat[e] any work whatever of [their] professor.' This accessibility rendered the master unoriginal by modernist standards. The lesson is this: classics repeat; moderns should not, except when reiterating what belongs to each one of them alone, their personal style.

Because a borrowed or preexisting form has already served as another's expression, priority for the modern artist becomes a matter of establishing a new principle in a new form, that is to say, an idiosyncratic manner of working. Originality is becoming the first of oneself: 'I am the primitive of my own way,' Cézanne was reported to say. The precise words are probably not the painter's, but the sentiment is quintessentially modernist; and that is why this mythogenic statement has so often been quoted by art historians and critics despite the questionableness of its witness. Modernist originality is marked by difference at the source ('my own way'). The source is the self, and mastery becomes self-mastery.

To seek originality by stressing one's deviation from others has consequences in the social realm; it encourages a certain personal competition that in turn has economic implications. Artists sell their unique difference, but not always easily. Modernists saw the irony of struggling for market recognition in a world ruled by fashion, which itself

follows a principle of uniqueness of a peculiar kind: fashion is novelty produced in multiple and multiauthored edition. 'Nobody wants my work because it is different from that of others,' wrote Gauguin to his dealer. He added immediately: 'Strange, illogical public which demands the greatest possible originality from a painter and yet will not accept him unless he resembles all the others – [but] I do resemble those who resemble me, that is, those who imitate me.' Thus Gauguin as modernist understood not only the conflict between innovation and fashion, but also one of the classical truths of originality – its commutability, the fact that the first in line might seem indistinguishable from the last, given successful acts of mediating imitation. Such imitation need not 'copy' (that is, reproduce every detail) but need only preserve elements of particular interest and value to the society. 'Original' artists themselves become commodities, subject to reproduction with respect to each one's originality factor, the point of interest. Sometimes that factor can be marketed more effectively by those who borrow it than by those who create it.

Gauguin knew that although artists might strive to express an inborn originality, they were attributed originality only if others saw the signs of it in their person, in their work, or in their identifiable following. So originality appeared as an attribute that might pass or be passed, like a sign or signifier, from one artist to another. Attributes or signs are communal entities, not private property; they can be appropriated by anyone with access to and authority to use the artistic language. Just as nineteenth-century artists and critics focused on the cultural value of expressing originality, so they doubted the entire enterprise because the general signs of originality and authenticity, like the more specific signs of individual identity and authorship, could be faked: 'For those who aspire to truth . . . what temptation to imitate instead of creating, and to fall into the intentional and regulated naiveté that can only be a mannerism like the academic formulas.'

The preceding critical commentary dates from 1841 and is hardly unusual; it indicates a general awareness that representation forever threatens to displace, or even to rule over and determine, original and authentic truth. But such fear was not enough to prevent artists from acting on their desire for originality and self-expression as they created one modernist innovation after another, or at least what passed for innovation. It was left to the critic to question the sincerity and effectiveness of each artistic manner. During the past two decades artists have internalized the critic's anxiety more than ever before to the detriment of claims to originality. If, among many contemporary artists, originality and other modernist values now seem discredited, it is because artists have radicalized old suspicions, adopting poststructuralist theory to make their case.

Part 5 Art and modernity

Introduction

Pamela Bracewell-Homer

The first three texts in this section include extracts from the writings of two poets and an artist. Between them, they offer a polarised sense of the preoccupations of artists and writers as they engaged with an increasingly industrialised modern world that was changing rapidly. For the French poet Charles Baudelaire, modern painting in the mid-nineteenth century was indicative of a new form of anti-classical beauty that was rooted in the 'heroism of everyday life'. By this he meant street life, prostitution and criminality as well as 'the eternal and the immutable' half of art that is artistic form and expression – the 'absolute' and the 'particular'. Baudelaire thoroughly rejected conventional Salon art, insisting that each age has its own unique brand of modernity, and must thereby develop art forms that respond creatively to the distinctiveness of the age, not to the past. A generation later, the French painter Paul Gauguin was led to reject European 'modernity' altogether in his quest for an authentically 'modern art'. First between 1891 and 1893, and then for a second time in 1895, he journeyed to the South Pacific in search of something he felt was lacking in modern bourgeois civilisation. The selection from his book *Noa Noa* (published posthumously in 1919) was written prior to his second departure; he died on the Marquesas Islands in French Polynesia in 1903. To read the extract is to be transported to a world of 'otherness', superstition and a pantheistic fusion of man, woman and nature to the extent that 'difference' of whatever kind is extinguished: 'there is something virile in the women and something feminine in the men'. Moving on from Gauguin's escape from what he called the 'corruption of an entire civilization' to a 'healthy simplicity' in Polynesia, the style and content of Filippo Tommaso Marinetti's 'The Founding and Manifesto of Futurism' (1909) provides a stark contrast. The aggressive language and imagery, replete with hammering allusions to metal, fire, locomotives, trams, speed and anthropomorphised cars, frame demands to embrace

the pain of death and injury, to glorify war, referred to as 'the world's only hygiene' and to emphatically reject the classical, outmoded past. The manifesto's pledge to 'destroy museums' and to 'fight moralism and feminism' was immensely influential on European and British avant-garde groups before the First World War. Marinetti's determination to sweep away tradition and convention speaks of the power of the crowd, of riot and revolution. When a roaring car is hailed as 'more beautiful than the *Victory of Samothrace*',[1] there is no place for the contemplative life or the art of the past; an aesthetics of the *machine* was to take its place.

The next group of three texts are variously grounded in a condemnation of the physical and psychological situation of the individual, living and working in highly urbanised contexts. They examine the reality and effect of town and city dwelling upon work, art and leisure, and the threat to well-being of an industrialised capitalist society. For John Ruskin and William Morris, writing respectively in the mid- and later nineteenth century, the relationship between the worker, machine-based industry and an increasing division of labour was highly problematical and damaging to the spirit, the intellect, leisure and social life. Ruskin's uncompromising medievalism stressed the importance of craftsmanship, 'healthy and ennobling labour' and in this extract he condemns the dehumanisation of man resulting from the demands of the processes of mass production. When the love of wealth in such a society is seen as the only source of pleasure, for Ruskin, 'we manufacture everything . . . except men'. Alongside Ruskin's elaborately biblical prose, the extract from William Morris's 'Useful Work *versus* Useless Toil' (1884) is straightforwardly pragmatic and direct in its mission to set the worker free from the capitalist 'tyranny' of 'profit-grinding' and 'commercialism'. Resolutely but not conventionally socialist in character, Morris sets out a blueprint for a 'new order of things', requiring labour to be useful and varied, brief, 'attractive' and 'endurable'. 'Popular Art' or simple craftsmanship that once was a valuable source of pleasure and happiness for the labourer had been 'killed by commercialism' and the 'useless toil' of capitalistic gain. In identifying how life in the city induces a psychological state of indifference to people, surroundings and social life that he calls the 'blasé attitude', the extract from Georg Simmel's essay 'The Metropolis and Mental Life' (1903) explores an irreversibly negative mental condition that makes strangers from individuals and inhibits any sense of 'belonging' or community, with no will for change. Simmel's extremely bleak characterisation of city life at the beginning of the twentieth century is without hope or redress, unlike the distinctly proselytising proposals for change laid down by Ruskin and Morris.

1. *The Winged Victory of Samothrace,* Greek marble sculpture representing the goddess Nike (Victory) dated to c.190 BCE, presently housed in the Louvre, Paris.

Returning to a focus on France, and specifically Paris, David Cottington's *Cubism and its Histories* (2004) offers at this point an example of a key secondary text. This succinctly represents the major historical and critical contexts surrounding the development of probably the most influential movement in modern art history. The breakdown of conventional systems of representation based on likeness, linear perspective techniques, surface appearances and illusionism that had sustained art forms for over four hundred years was decisive. We can trace how this rupture was already foreshadowed in the rejection of the Salon and academies in the mid-nineteenth century and the ways in which photography had intervened in the quest for likeness and documentation. The Cubism of Picasso and Braque, while remaining tied to the visual motif, had nevertheless paved the way for an art that was fully and uncompromisingly abstract, relying upon its own formal means – colour, composition, texture and construction – for its effects and significance.

The last four texts in this section are concerned with modern architecture and design during the period between the wars. There are two related themes here that have already been addressed in different ways by earlier writers. First, Baudelaire's characterisation of *modernité* in all its guises and his emphasis on the 'distinctiveness' of each age prefigured claims for a 'New Spirit' or *Zeitgeist* in the first decades of the twentieth century. Secondly, ways of living and how *not* to live in order to lessen the pressures of modern life and enhance the enjoyment of 'pure' form common to all art comes under scrutiny in the context of the modern movement in architecture. Architecture defined as 'a function of light . . . volumes in light' is the concern of Le Corbusier in his article 'Notes à la suite' (1926). Light is fundamental to existence, thought, all the 'animal' senses and the joy of life itself, without which we would simply be asleep, in the *dark*. It is clear that now the modern world and modernity, dubbed the ultimate evil by so many, with its culpable roots in nineteenth-century industrialisation, seemingly provides from within itself an antidote to the darkness and degradation identified as endemic to a capitalist society fixated on the accumulation of wealth. In Le Corbusier's words, this panacea is oddly incongruous, but strangely compelling: 'With technology we have conquered *the fundamental basis of architectural sensation: light.*'

In the first of two extracts from the Swiss architectural historian Sigfried Giedion, he reflects on the 'impossibility' of achieving architectural innovation and creativity in the design and building of private houses, which he attributes to prevailing traditionalism, resistance to new ideas, and a lack of standardised manufacture. His call is to simplify and completely revolutionise the way houses are built and designed in order to offer wide open spaces, light and transparency, with seamless connections between inside and outside in an 'unbroken sequence of

interconnections and spatial bridges'. Le Corbusier's La Roche house is
hailed as an exemplar of the new approach to domestic architecture:
uncluttered, minimal, open, light, representing the 'successful leap from
understanding to creation'. While Le Corbusier stressed the function of
light in designing architecture, in Giedion's second text, the emphasis
is on *air* and how distinctions between interior and exterior are broken
down in a 'single, indivisible space'. It is also interesting to note his
preoccupation with the making of analogies between architecture and
painting and the purist principles Le Corbusier explored as a painter
using his real name – Charles-Édouard Jeanneret– a theme that is
extended in the analysis offered in the fourth text in this section. Steen
Eiler Rasmussen's exploration of how buildings may be perceptually
experienced and understood, in response to the 'new architecture' of
Le Corbusier, offers an insight about precisely what was *different* about
his work when compared to conventional buildings. He contrasts two
types of imagination that may not be experienced together at the same
time, but which offer an understanding of either solidity (the 'plastic'), or
space or spatial relationships. Explaining that Le Corbusier's buildings
need to be approached in terms of outlines rather than spaces and solid
shapes, Rasmussen explicitly draws a parallel between the techniques
used in purist painting, citing an example by Amédée Ozenfant, and in
architecture. The most uncompromising rationality of Le Corbusier's work,
both as architect and painter, is nonetheless a profound expression of
soaring spirit and optimism.

Chapter 17
Avant-garde and modern world: some aspects of art in Paris and beyond c.1850–1914

Paul Wood

1. Charles Baudelaire
'On the Heroism of Modern Life' (from *The Salon of 1846*) and 'Modernity' (from 'The Painter of Modern Life')

Trans. Jonathan Mayne in Jonathan Mayne (ed.), *Art in Paris: 1845–1862. Salons and Other Exhibitions, Reviewed by Baudelaire*, London, Phaidon, 1964, reprinted in Charles Harrison, Paul Wood and Jason Gaiger (eds.), *Art in Theory 1815–1900*, Oxford, Blackwell, 1998, pp.302–4, 497–8.

The French poet Charles Baudelaire (1821–67) is best known today for his volume of poems *Les Fleurs du Mal*, first published in 1857. However, he was also a prolific writer of art and literary criticism, and is now widely regarded as the key theorist of modernity as it emerged in Paris in the mid-nineteenth century. In his lifetime he was a supporter of Édouard Manet (1832–83), now generally seen as the first 'modern' artist. The following extracts are taken from Baudelaire's *Salon of 1846* (1846) and from his essay 'The Painter of Modern Life', written in the late 1850s but not published until 1863. PW

On the Heroism of Modern Life (from *The Salon of 1846*)
Many people will attribute the present decadence in painting to our decadence in behaviour. This dogma of the studios, which has gained currency among the public, is a poor excuse of the artists. For they had a vested interest in ceaselessly depicting the past; it is an easier task, and

one that could be turned to good account by the lazy.

It is true that the great tradition has been lost, and that the new one is not yet established.

But what *was* this great tradition, if not a habitual, everyday idealization of ancient life – a robust and martial form of life, a state of readiness on the part of each individual, which gave him a habit of gravity in his movements, and of majesty, or violence, in his attitudes? To this should be added a public splendour which found its reflection in private life. Ancient life was a great *parade*. It ministered above all to the pleasure of the eye, and this day-to-day paganism has marvellously served the arts.

Before trying to distinguish the epic side of modern life, and before bringing examples to prove that our age is no less fertile in sublime themes than past ages, we may assert that since all centuries and all peoples have had their own form of beauty, so inevitably we have ours. That is in the order of things.

All forms of beauty, like all possible phenomena, contain an element of the eternal and an element of the transitory – of the absolute and of the particular. Absolute and eternal beauty does not exist, or rather it is only an abstraction skimmed from the general surface of different beauties. The particular element in each manifestation comes from the emotions: and just as we have our own particular emotions, so we have our own beauty. [. . .]

But to return to our principal and essential problem, which is to discover whether we possess a specific beauty, intrinsic to our new emotions, I observe that the majority of artists who have attacked modern life have contented themselves with public and official subjects – with our victories and our political heroism. Even so, they do it with an ill grace, and only because they are commissioned by the government which pays them. However there are private subjects which are very much more heroic than these.

The pageant of fashionable life and the thousands of floating existences – criminals and kept women – which drift about in the underworld of a great city; the *Gazette des Tribunaux* and the *Moniteur* all prove to us that we have only to open our eyes to recognize our heroism. [. . .]

The life of our city is rich in poetic and marvellous subjects. We are enveloped and steeped as though in an atmosphere of the marvellous; but we do not notice it.

Modernity (from 'The Painter of Modern Life')
Casting an eye over our exhibitions of modern pictures, we are struck by a general tendency among artists to dress all their subjects in the garments of the past. Almost all of them make use of the costumes and furnishings of the Renaissance, just as David employed the costumes and furnishings of Rome. There is however this difference, that David,

by choosing subjects which were specifically Greek or Roman, had no alternative but to dress them in antique garb, whereas the painters of today, though choosing subjects of a general nature and applicable to all ages, nevertheless persist in rigging them out in the costumes of the Middle Ages, the Renaissance or the Orient. This is clearly symptomatic of a great degree of laziness; for it is much easier to decide outright that everything about the garb of an age is absolutely ugly than to devote oneself to the task of distilling from it the mysterious element of beauty that it may contain, however slight or minimal that element may be. By 'modernity' I mean the ephemeral, the fugitive, the contingent, the half of art whose other half is the eternal and the immutable. Every old master has had his own modernity; the great majority of fine portraits that have come down to us from former generations are clothed in the costume of their own period. They are perfectly harmonious, because everything – from costume and coiffure down to gesture, glance and smile (for each age has a deportment, a glance and a smile of its own) – everything, I say, combines to form a completely viable whole. This transitory, fugitive element, whose metamorphoses are so rapid, must on no account be despised or dispensed with. By neglecting it, you cannot fail to tumble into the abyss of an abstract and indeterminate beauty [. . .]

It is doubtless an excellent thing to study the old masters in order to learn how to paint; but it can be no more than a waste of labour if your aim is to understand the special nature of present-day beauty. The draperies of Rubens or Veronese will in no way teach you how to depict *moire antique, satin à la reine* or any other fabric of modern manufacture, which we see supported and hung over crinoline or starched muslin petticoat. In texture and weave these are quite different from the fabrics of ancient Venice or those worn at the court of Catherine.[i] Furthermore the cut of skirt and bodice is by no means similar; the pleats are arranged according to a new system. Finally the gesture and the bearing of the woman of today give to her dress a life and a special character which are not those of the woman of the past. In short, for any 'modernity' to be worthy of one day taking its place as 'antiquity', it is necessary for the mysterious beauty which human life accidentally puts into it to be distilled from it. [. . .]

I have remarked that every age had its own gait, glance and gesture. The easiest way to verify this proposition would be to betake oneself to some vast portrait-gallery, such as the one at Versailles. But it has an even wider application. Within that unity which we call a Nation, the various professions and classes and the passing centuries all introduce variety, not only in manners and gesture, but even in the actual form of the face. Certain types of nose, mouth and brow will be found to dominate

i. Generally accepted as a reference to Catherine II, also know as Catherine the Great (1729–96), Empress of Russia.

the scene for a period whose extent I have no intention of attempting to determine here, but which could certainly be subjected to a form of calculation. Considerations of this kind are not sufficiently familiar to our portrait-painters; the great failing of M. Ingres, in particular, is that he seeks to impose upon every type of sitter a more or less complete, by which I mean a more or less despotic, form of perfection, borrowed from the repertory of classical ideas.

In a matter of this kind it would be easy, and indeed legitimate, to argue *a priori*. The perpetual correlation between what is called the 'soul' and what is called the 'body' explains quite clearly how everything that is 'material', or in other words an emanation of the 'spiritual', mirrors, and will always mirror, the spiritual reality from which it derives. If a painstaking, scrupulous, but feebly imaginative artist has to paint a courtesan of today and takes his 'inspiration' (that is the accepted word) from a courtesan by Titian or Raphael, it is only too likely that he will produce a work which is false, ambiguous and obscure. From the study of a masterpiece of that time and type he will learn nothing of the bearing, the glance, the smile or the living 'style' of one of those creatures whom the dictionary of fashion has successively classified under the coarse or playful titles of 'doxies', 'kept women', *lorettes*, or *biches*.

The same criticism may be strictly applied to the study of the military man and the dandy, and even to that of animals, whether horses or dogs; in short, of everything that goes to make up the external life of this age. Woe to him who studies the antique for anything else but pure art, logic and general method! By steeping himself too thoroughly in it, he will lose all memory of the present; he will renounce the rights and privileges offered by circumstance – for almost all our originality comes from the seal which Time imprints on our sensations.

2. Paul Gauguin
Noa Noa

Paul Gauguin, *Noa Noa: The Tahiti Journal of Paul Gauguin*, trans.
O.F. Theis, originally published New York, 1919; reprinted in the
'Océanie' edition, San Francisco, Chronicle Books, 1994, pp.40–8.

**The French artist Paul Gauguin (1848–1903) composed his book *Noa
Noa* in Paris in the mid-1890s, between his two stays in the South
Pacific, the first from 1891–3, the second from 1895 to his death in 1903.
It represents a prose accompaniment to his visual art, by turns
expressing both a criticism of the European civilisation he had rejected
and a mythologised account of his experiences in Tahiti. In this extract
he describes a kind of epiphany in which he feels himself reborn as
a 'Maori'. It should be noted that although the Maori of New Zealand
were descended from the inhabitants of central Polynesia, Gauguin's
identification of Tahitians as 'Maori' is idiosyncratic. PW**

It happened once that I had need of rosewood for my carving. I wanted a
large strong trunk, and I consulted Totefa.

'We have to go into the mountains,' he told me. 'I know a certain spot
where there are several beautiful trees. If you wish it I will lead you. We
can then fell the tree which pleases you and together carry it here.'

We set out early in the morning.

The footpaths in Tahiti are rather difficult for a European, and 'to go into
the mountains' demands even of the natives a degree of effort which they
do not care to undertake unnecessarily.

Between two mountains, two high and steep walls of basalt, which it
is impossible to ascend, there yawns a fissure in which the water winds
among rocks. These blocks have been loosened from the flank of the
mountain by infiltrations in order to form a passageway for a spring.
The spring grew into a brook, which has thrust at them and jolted them,
and then moved them a little further. Later the brook when it became a
torrent took them up, rolled them over and over, and carried them even
to the sea. On each side of this brook, frequently interrupted by cascades,
there is a sort of path. It leads through a confusion of trees – breadfruit,
ironwood, pandanus, bouraos, cocoanut, hibiscus, guava, giant-ferns. It
is a mad vegetation, growing always wilder, more entangled, denser, until,
as we ascend toward the center of the island, it has become an almost
impenetrable thicket.

Both of us went naked, the white and blue *paréo* around the loins,
hatchet in hand. Countless times we crossed the brook for the sake of a
short-cut. My guide seemed to follow the trail by smell rather than by

sight, for the ground was covered by a splendid confusion of plants, leaves, and flowers which wholly took possession of space.

The silence was absolute but for the plaintive wailing of the water among the rocks. It was a monotonous wail, a plaint so soft and low that it seemed an accompaniment of the silence.

And in this forest, this solitude, this silence were we two – he, a very young man, and I, almost an old man from whose soul many illusions had fallen and whose body was tired from countless efforts, upon whom lay the long and fatal heritage of the vices of a morally and physically corrupt society.

With the suppleness of an animal and the graceful litheness of an androgyne he walked a few paces in advance of me. And it seemed to me that I saw incarnated in him, palpitating and living, all the magnificent plant-life which surrounded us. From in him, through him there became disengaged and emanated a powerful perfume of beauty.

Was it really a human being walking there ahead of me? Was it the naive friend by whose combined simplicity and complexity I had been so attracted? Was it not rather the Forest itself, the living Forest, without sex – and yet alluring?

Among peoples that go naked, as among animals, the difference between the sexes is less accentuated than in our climates. Thanks to our cinctures and corsets we have succeeded in making an artificial being out of woman. She is an anomaly, and Nature herself, obedient to the laws of heredity, aids us in complicating and enervating her. We carefully keep her in a state of nervous weakness and muscular inferiority, and in guarding her from fatigue, we take away from her possibilities of development. Thus modeled on a bizarre ideal of slenderness to which, strangely enough, we continue to adhere, our women having nothing in common with us, and this, perhaps, may not be without grave moral and social disadvantages.

On Tahiti the breezes from forest and sea strengthen the lungs, they broaden the shoulders and hips. Neither men nor women are sheltered from the rays of the sun nor the pebbles of the sea-shore. Together they engage in the same tasks with the same activity or the same indolence. There is something virile in the women and something feminine in the men.

This similarity of the sexes makes their relations the easier. Their continual state of nakedness has kept their minds free from the dangerous pre-occupation with the 'mystery' and from the excessive stress which among civilized people is laid upon the 'happy accident' and the clandestine and sadistic colors of love. It has given their manners a natural innocence, a perfect purity. Man and woman are comrades, friends rather than lovers, dwelling together almost without cease, in pain as in pleasure, and even the very idea of vice is unknown to them.

In spite of all this lessening in sexual differences, why was it that there suddenly rose in the soul of a member of an old civilization, a horrible

thought? Why, in all this drunkenness of lights and perfumes with its enchantment of newness and unknown mystery?

The fever throbbed in my temples and my knees shook.

But we were at the end of the trail. In order to cross the brook my companion turned, and in this movement showed himself full-face. The androgyne had disappeared. It was an actual young man walking ahead of me. His calm eyes had the limpid clearness of waters.

Peace forthwith fell upon me again.

We made a moment's halt. I felt an infinite joy, a joy of the spirit rather than of the senses, as I plunged into the fresh water of the brook.

'*Toë, toë* (it is cold),' said Jotefa.

'Oh, no!' I replied.

This exclamation seemed to me also a fitting conclusion to the struggle which I had just fought out within myself against the corruption of an entire civilization. It was the end in the battle of a soul that had chosen between truth and untruth. It awakened loud echoes in the forest. And I said to myself that Nature had seen me struggle, had heard me, and understood me, for now she replied with her clear voice to my cry of victory that she was willing after the ordeal to receive me as one of her children.

We took up our way again. I plunged eagerly and passionately into the wilderness, as if in the hope of thus penetrating into the very heart of this Nature, powerful and maternal, there to blend with her living elements.

With tranquil eyes and ever uniform pace my companion went on. He was wholly without suspicion; I alone was bearing the burden of an evil conscience.

We arrived at our destination.

The steep sides of the mountain had by degrees spread out, and behind a dense curtain of trees, there extended a sort of plateau, well-concealed. Jotefa, however, knew the place, and with astonishing sureness led me thither. A dozen rosewood trees extended their vast branches. We attacked the finest of these with the ax. We had to sacrifice the entire tree to obtain a branch suitable for my project.

I struck out with joy. My hands became stained with blood in my wild rage, my intense joy of satiating within me, I know not what divine brutality. It was not the tree I was striking, it was not it which I sought to overcome. And yet gladly would I have heard the sound of my ax against other trunks when this one was already lying on the ground.

And here is what my ax seemed to say to me in the cadence of its sounding blows:

Strike down to the root the forest entire!
Destroy all the forest of evil,
Whose seeds were once sowed within thee by the breathings of death!
Destroy in thee all love of the self!

Destroy and tear out all evil, as in the autumn we cut with the hand the flower of the lotus.

Yes, wholly destroyed, finished, dead, is from now on the old civilization within me. I was reborn; or rather another man, purer and stronger, came to life within me.

This cruel assault was the supreme farewell to civilization, to evil. This last evidence of the depraved instincts which sleep at the bottom of all decadent souls, by very contrast exalted the healthy simplicity of the life at which I had already made a beginning into a feeling of inexpressible happiness. By the trial within my soul mastery had been won. Avidly I inhaled the splendid purity of the light. I was, indeed, a new man; from now on I was a true savage, a real Maori.

3. Filippo Tommaso Marinetti
'The Founding and Manifesto of Futurism'

Trans. R.W. Flint in Flint, *Marinetti's Selected Writings*, London 1971; reprinted in Charles Harrison and Paul Wood (eds.), *Art in Theory 1900–2000*, Oxford, Blackwell, 2003, pp.146–9.

Filippo Tommaso Marinetti (1876–1944) was an Italian Symbolist poet who became the founder and leading intellectual figure of futurism, the avant-garde movement spanning literature and music as well as the visual arts, which became enormously influential across Europe in the five years before the First World War. The Manifesto was published in the Parisian newspaper *Le Figaro* on 20 February 1909. Its ideas of dynamism and simultaneity, and a sense of art having to face up to twentieth-century modernity in general and the machine age in particular, had a resonance that went far beyond the right-wing nationalism espoused by Marinetti himself. PW

We had stayed up all night, my friends and I, under hanging mosque lamps with domes of filigreed brass, domes starred like our spirits, shining like them with the prisoned radiance of electric hearts. For hours we had trampled our atavistic ennui into rich oriental rugs, arguing up to the last confines of logic and blackening many reams of paper with our frenzied scribbling.

An immense pride was buoying us up, because we felt ourselves alone at that hour, alone, awake, and on our feet, like proud beacons or

forward sentries against an army of hostile stars glaring down at us from their celestial encampments. Alone with stokers feeding the hellish fires of great ships, alone with the black spectres who grope in the red-hot bellies of locomotives launched down their crazy courses, alone with drunkards reeling like wounded birds along the city walls.

Suddenly we jumped, hearing the mighty noise of the huge double-decker trams that rumbled by outside, ablaze with coloured lights, like villages on holiday suddenly struck and uprooted by the flooding Po and dragged over falls and through gorges to the sea.

Then the silence deepened. But, as we listened to the old canal muttering its feeble prayers and the creaking bones of sickly palaces above their damp green beards, under the windows we suddenly heard the famished roar of automobiles.

'Let's go!' I said. 'Friends, away! Let's go! Mythology and the Mystic Ideal are defeated at last. We're about to see the Centaur's birth and, soon after, the first flight of Angels! . . . We must shake the gates of life, test the bolts and hinges. Let's go! Look there, on the earth, the very first dawn! There's nothing to match the splendour of the sun's red sword, slashing for the first time through our millennial gloom!'

We went up to the three snorting beasts, to lay amorous hands on their torrid breasts. I stretched out on my car like a corpse on its bier, but revived at once under the steering wheel, a guillotine blade that threatened my stomach.

The raging broom of madness swept us out of ourselves and drove us through streets as rough and deep as the beds of torrents. Here and there, sick lamplight through window glass taught us to distrust the deceitful mathematics of our perishing eyes.

I cried, 'The scent, the scent alone is enough for our beasts.'

And like young lions we ran after Death, its dark pelt blotched with pale crosses as it escaped down the vast violet living and throbbing sky.

But we had no ideal Mistress raising her divine form to the clouds, nor any cruel Queen to whom to offer our bodies, twisted like Byzantine rings! There was nothing to make us wish for death, unless the wish to be free at last from the weight of our courage!

And on we raced, hurling watchdogs against doorsteps, curling them under our burning tyres like collars under a flatiron. Death, domesticated, met me at every turn, gracefully holding out a paw, or once in a while hunkering down, making velvety caressing eyes at me from every puddle.

'Let's break out of the horrible shell of wisdom and throw ourselves like pride-ripened fruit into the wide, contorted mouth of the wind! Let's give ourselves utterly to the Unknown, not in desperation but only to replenish the deep wells of the Absurd!'

The words were scarcely out of my mouth when I spun my car around with the frenzy of a dog trying to bite its tail, and there, suddenly, were two

cyclists coming towards me, shaking their fists, wobbling like two equally convincing but nevertheless contradictory arguments. Their stupid dilemma was blocking my way – Damn! Ouch! . . . I stopped short and to my disgust rolled over into a ditch with my wheels in the air. . . .

O maternal ditch, almost full of muddy water! Fair factory drain! I gulped down your nourishing sludge; and I remembered the blessed black breast of my Sudanese nurse . . . When I came up – torn, filthy, and stinking – from under the capsized car, I felt the white-hot iron of joy deliciously pass through my heart!

A crowd of fishermen with handlines and gouty naturalists were already swarming around the prodigy. With patient, loving care those people rigged a tall derrick and iron grapnels to fish out my car, like a big beached shark. Up it came from the ditch, slowly, leaving in the bottom, like scales, its heavy framework of good sense and its soft upholstery of comfort.

They thought it was dead, my beautiful shark, but a caress from me was enough to revive it; and there it was, alive again, running on its powerful fins!

And so, faces smeared with good factory muck – plastered with metallic waste, with senseless sweat, with celestial soot – we, bruised, our arms in slings, but unafraid, declared our high intentions to all the *living* of the earth:

MANIFESTO OF FUTURISM

1. We intend to sing the love of danger, the habit of energy and fearlessness.
2. Courage, audacity, and revolt will be essential elements of our poetry.
3. Up to now literature has exalted a pensive immobility, ecstasy, and sleep. We intend to exalt aggressive action, a feverish insomnia, the racer's stride, the mortal leap, the punch and the slap.
4. We affirm that the world's magnificence has been enriched by a new beauty: the beauty of speed. A racing car whose hood is adorned with great pipes, like serpents of explosive breath – a roaring car that seems to ride on grapeshot is more beautiful than the *Victory of Samothrace*.
5. We want to hymn the man at the wheel, who hurls the lance of his spirit across the Earth, along the circle of its orbit.
6. The poet must spend himself with ardour, splendour, and generosity, to swell the enthusiastic fervour of the primordial elements.
7. Except in struggle, there is no more beauty. No work without an aggressive character can be a masterpiece. Poetry must be conceived as a violent attack on unknown forces, to reduce and prostrate them before man.
8. We stand on the last promontory of the centuries! . . . Why should we look back, when what we want is to break down the mysterious doors

of the Impossible? Time and Space died yesterday. We already live in the absolute, because we have created eternal, omnipresent speed.

9. We will glorify war – the world's only hygiene – militarism, patriotism, the destructive gesture of freedom-bringers, beautiful ideas worth dying for, and scorn for woman.

10. We will destroy the museums, libraries, academies of every kind, will fight moralism, feminism, every opportunistic or utilitarian cowardice.

11. We will sing of great crowds excited by work, by pleasure, and by riot; we will sing of the multicoloured, polyphonic tides of revolution in the modern capitals; we will sing of the vibrant nightly fervour of arsenals and shipyards blazing with violent electric moons; greedy railway stations that devour smoke-plumed serpents; factories hung on clouds by the crooked lines of their smoke; bridges that stride the rivers like giant gymnasts, flashing in the sun with a glitter of knives; adventurous steamers that sniff the horizon; deep-chested locomotives whose wheels paw the tracks like the hooves of enormous steel horses bridled by tubing; and the sleek flight of planes whose propellers chatter in the wind like banners and seem to cheer like an enthusiastic crowd.

Chapter 18
Victorian Britain: from images of modernity to the modernity of images

Steve Edwards

1. John Ruskin
'The Nature of Gothic'

In John Ruskin, *The Stones of Venice,* vol.2, E.T. Cook and Alexander Wedderburn (eds.), *The Works of John Ruskin*, London, George Allen, 1903–12, vol.10, pp.191–6.

John Ruskin (1819–1900) was one of the most influential English art critics of the nineteenth century. He was an advocate of the close study of nature and supporter of J.M.W. Turner and the Pre-Raphaelite Brotherhood, and his writings also made an impact on a range of social thinkers. In this account of Venetian Gothic architecture, which comes from his chapter 'The Nature of Gothic' in volume 2 of his three-volume treatise *The Stones of Venice* (1851–3), he sees modern labour in a dim light when compared with the decorative work of the medieval artisans. In this section he suggests that the English worker is more degraded than African or ancient Greek slaves. In an earlier part of the chapter this claim is clearly linked to his belief in the authentic Christianity of medieval society, which he represents as superior to these other societies or to his own. The original notes have been revised. SE

Understand this clearly: You can teach a man to draw a straight line, and to cut one; to strike a curved line, and to carve it; and to copy and carve any number of given lines or forms, with admirable speed and perfect precision; and you find his work perfect of its kind: but if you ask him to think about any of those forms, to consider if he cannot find any better in his own head, he stops; his execution becomes hesitating; he thinks, and ten to one he thinks wrong; ten to one he makes a mistake in the first touch

he gives to his work as a thinking being. But you have made a man of him for all that. He was only a machine before, an animated tool.

And observe, you are put to stern choice in this matter. You must either make a tool of the creature, or a man of him. You cannot make both. Men were not intended to work with the accuracy of tools, to be precise and perfect in all their actions. If you will have that precision out of them, and make their fingers measure degrees like cog-wheels, and their arms strike curves like compasses, you must unhumanize them. All the energy of their spirits must be given to make cogs and compasses of themselves. All their attention and strength must go to the accomplishment of the mean act. The eye of the soul must be bent upon the finger-point, and the soul's force must fill all the invisible nerves that guide it, ten hours a day, that it may not err from its steely precision, and so soul and sight be worn away, and the whole human being be lost at last – a heap of sawdust, so far as its intellectual work in this world is concerned: saved only by its Heart, which cannot go into the form of cogs and compasses, but expands, after the ten hours are over, into fireside humanity. On the other hand, if you will make a man of the working creature, you cannot make a tool. Let him but begin to imagine, to think, to try to do anything worth doing; and the engine-turned precision is lost at once. Out come all his roughness, all his dulness, all his incapability; shame upon shame, failure upon failure, pause after pause: but out comes the whole majesty of him also; and we know the height of it only when we see the clouds settling upon him. And, whether the clouds be bright or dark, there will be transfiguration behind and within them.

And now, reader, look round this English room of yours, about which you have been proud so often, because the work of it was so good and strong, and the ornaments of it so finished. Examine again all those accurate mouldings, and perfect polishings, and unerring adjustments of the seasoned wood and tempered steel. Many a time you have exulted over them, and thought how great England was, because her slightest work was done so thoroughly. Alas! if read rightly, these perfectnesses are signs of a slavery in our England a thousand times more bitter and more degrading than that of the scourged African, or helot Greek. Men may be beaten, chained, tormented, yoked like cattle, slaughtered like summer flies, and yet remain in one sense, and the best sense, free. But to smother their souls within them, to blight and hew into rotting pollards the suckling branches of their human intelligence, to make the flesh and skin which, after the worm's work on it, is to see God,[i] into leathern thongs to yoke machinery with, – this it is to be slave-masters indeed; and there might be more freedom in England, though her feudal lords' lightest words were worth men's lives, and though the blood of the vexed husbandman

i. An allusion to Job 19:26.

dropped in the furrows of her fields, than there is while the animation of her multitudes is sent like fuel to feed the factory smoke, and the strength of them is given daily to be wasted into the fineness of a web, or racked into the exactness of a line.

And, on the other hand, go forth again to gaze upon the old cathedral front, where you have smiled so often at the fantastic ignorance of the old sculptors: examine once more those ugly goblins, and formless monsters, and stern statues, anatomiless and rigid; but do not mock at them, for they are signs of the life and liberty of every workman who struck the stone; a freedom of thought, and rank in scale of being, such as no laws, no charters, no charities can secure; but which it must be the first aim of all Europe at this day to regain for her children.

Let me not be thought to speak wildly or extravagantly. It is verily this degradation of the operative into a machine, which, more than any other evil of the times, is leading the mass of the nations everywhere into vain, incoherent, destructive struggling for a freedom of which they cannot explain the nature to themselves. Their universal outcry against wealth, and against nobility, is not forced from them either by the pressure of famine, or the sting of mortified pride. These do much, and have done much in all ages; but the foundations of society were never yet shaken as they are at this day. It is not that men are ill fed, but that they have no pleasure in the work by which they make their bread, and therefore look to wealth as the only means of pleasure. It is not that men are pained by the scorn of the upper classes, but they cannot endure their own; for they feel that the kind of labour to which they are condemned is verily a degrading one, and makes them less than men. Never had the upper classes so much sympathy with the lower, or charity for them, as they have at this day, and yet never were they so much hated by them: for, of old, the separation between the noble and the poor was merely a wall built by law; now it is a veritable difference in level of standing, a precipice between upper and lower grounds in the field of humanity and there is pestilential air at the bottom of it. I know not if a day is ever to come when the nature of right freedom will be understood, and when men will see that to obey another man, to labour for him, yield reverence to him or to his place, is not slavery. It is often the best kind of liberty, – liberty from care. The man who says to one, Go, and he goeth, and to another, Come, and he cometh,[ii] has, in most cases, more sense of restraint and difficulty than the man who obeys him. The movements of the one are hindered by the burden on his shoulder; of the other, by the bridle on his lips: there is no way by which the burden may be lightened; but we need not suffer from the bridle if we do not champ at it. To yield reverence to another, to hold ourselves and our lives at his disposal, is not slavery; often, it is the noblest state in which a man can

ii. Matthew 8:9.

live in this world. There is, indeed, a reverence which is servile, that is to say, irrational or selfish: but there is also noble reverence, that is to say, reasonable and loving; and a man is never so noble as when he is reverent in this kind; nay, even if the feeling pass the bounds of mere reason, so that it be loving, a man is raised by it. Which had, in reality, most of the serf nature in him, – the Irish peasant who was lying in wait yesterday for his landlord, with his musket muzzle thrust through the ragged hedge; or that old mountain servant, who, 200 years ago, at Inverkeithing, gave up his own life and the lives of his seven sons for his chief? – and as each fell, calling forth his brother to the death, 'Another for Hector!'[iii] And therefore, in all ages and all countries, reverence has been paid and sacrifice made by men to each other, not only without complaint, but rejoicingly; and famine, and peril, and sword, and all evil, and all shame, have been borne willingly in the causes of masters and kings; for all these gifts of the heart ennobled the men who gave, not less than the men who received them, and nature prompted, and God rewarded the sacrifice. But to feel their souls withering within them, unthanked, to find their whole being sunk into an unrecognized abyss, to be counted off into a heap of mechanism, numbered with its wheels, and weighed with its hammer strokes; – this, nature bade not, – this, God blesses not, – this, humanity for no long time is able to endure.

We have much studied and much perfected, of late, the great civilized invention of the division of labour; only we give it a false name. It is not, truly speaking, the labour that is divided; but the men: – Divided into mere segments of men – broken into small fragments and crumbs of life; so that all the little piece of intelligence that is left in a man is not enough to make a pin, or a nail, but exhausts itself in making the point of a pin or the head of a nail. Now it is a good and desirable thing, truly, to make many pins in a day; but if we could only see with what crystal sand their points were polished, – sand of human soul, much to be magnified before it can be discerned for what it is – we should think there might be some loss in it also. And the great cry that rises from all our manufacturing cities, louder than their furnace blast, is all in very deed for this, – that we manufacture everything there except men; we blanch cotton, and strengthen steel, and refine sugar, and shape pottery; but to brighten, to strengthen, to refine, or to form a single living spirit, never enters into our estimate of advantages. And all the evil to which that cry is urging our myriads can be met only in one way: not by teaching nor preaching, for to teach them is but to show them their misery, and to preach to them, if we do nothing more than preach, is to mock at it. It can be met only by a right understanding,

iii. The Irish peasant refers to political disturbances and repression in mid-nineteenth-century Ireland. In Sir Walter Scott's *The Fair Maid of Perth*, in the Civil War battle at Inverkeithing in the Scottish region of Fife, seven brothers died fighting for their clan chief Sir Hector Maclean who participated on the Royalist side. They called out 'Another for Sir Hector!' The novel is set in the fourteenth century, but Scott refers to these later events.

on the part of all classes, of what kinds of labour are good for men, raising them, and making them happy; by a determined sacrifice of such convenience, or beauty, or cheapness as is to be got only by the degradation of the workman; and by equally determined demand for the products and results of healthy and ennobling labour.

2. William Morris
'Useful Work *versus* Useless Toil'

A.L. Morton (ed.), *Political Writings of William Morris*, London, Lawrence and Wishart, 1984, pp.100–4.

William Morris (1834–96) was a renowned English writer, artist and designer. In 1883 he became an active socialist, lecturing and writing about capitalist degradation and the possible socialist alternative, and was editor of the Socialist League newspaper, *Commonweal*. The piece from which this extract was taken was originally presented as a talk for the Hampstead Liberal Club in 1884 and published the following year as a Socialist League pamphlet. Building on the work of Ruskin, Morris contrasts the debasement of work, and particularly decorative or ornamental art, under capitalism with his vision for art and work in the socialist future. SE

I say once more that, in my belief, the first thing which we shall think so necessary as to be worth sacrificing some idle time for, will be the attractiveness of labour. No very heavy sacrifice will be required for attaining this object, but some *will* be required. For we may hope that men who have just waded through a period of strife and revolution will be the last to put up long with a life of mere utilitarianism, though Socialists are sometimes accused by ignorant persons of aiming at such a life. On the other hand, the ornamental part of modern life is already rotten to the core, and must be utterly swept away before the new order of things is realized. There is nothing of it – there is nothing which could come of it that could satisfy the aspirations of men set free from the tyranny of commercialism.

We must begin to build up the ornamental part of life – its pleasure, bodily and mental, scientific and artistic, social and individual – on the basis of work undertaken willingly and cheerfully, with the consciousness of benefiting ourselves and our neighbours by it. Such absolutely necessary work as we should have to do would in the first place take up but a small

part of each day, and so far would not be burdensome; but it would be a task of daily recurrence, and therefore would spoil our day's pleasure unless it were made at least endurable while it lasted. In other words, all labour, even the commonest, must be made attractive.

How can this be done? – is the question the answer to which will take up the rest of this paper. In giving some hints on this question, I know that, while all Socialists will agree with many of the suggestions made, some of them may seem to some strange and venturesome. These must be considered as being given without any intention of dogmatizing, and as merely expressing my own personal opinion.

From all that has been said already it follows that labour, to be attractive, must be directed towards some obviously useful end, unless in cases where it is undertaken voluntarily by each individual as a pastime. This element of obvious usefulness is all the more to be counted on in sweetening tasks otherwise irksome, since social morality, the responsibility of man towards the life of man, will, in the new order of things, take the place of theological morality, or the responsibility of man to some abstract idea. Next, the day's work will be short. This need not be insisted on. It is clear that with work unwasted it *can* be short. It is clear also that much work which is now a torment, would be easily endurable if it were much shortened.

Variety of work is the next point, and a most important one. To compel a man to do day after day the same task, without any hope of escape or change, means nothing short of turning his life into a prison-torment. Nothing but the tyranny of profit-grinding makes this necessary. A man might easily learn and practise at least three crafts, varying sedentary occupation with outdoor – occupation calling for the exercise of strong bodily energy for work in which the mind had more to do. There are few men, for instance, who would not wish to spend part of their lives in the most necessary and pleasantest of all work – cultivating the earth. One thing which will make this variety of employment possible will be the form that education will take in a socially ordered community. At present all education is directed towards the end of fitting people to take their places in the hierarchy of commerce – these as masters, those as workmen. The education of the masters is more ornamental than that of the workmen, but it is commercial still; and even at the ancient universities learning is but little regarded, unless it can in the long run be made *to pay*. Due education is a totally different thing from this, and concerns itself in finding out what different people are fit for, and helping them along the road which they are inclined to take. In a duly ordered society, therefore, young people would be taught such handicrafts as they had a turn for as a part of their education, the discipline of their minds and bodies; and adults would also have opportunities of learning in the same schools, for the development of individual capacities would be of all things chiefly aimed

at by education, instead, as now, the subordination of all capacities to the great end of 'money-making' for oneself – or one's master. The amount of talent, and even genius, which the present system crushes, and which would be drawn out by such a system, would make our daily work easy and interesting.

Under this head of variety I will note one product of industry which has suffered so much from commercialism that it can scarcely be said to exist, and is, indeed, so foreign from our epoch that I fear there are some who will find it difficult to understand what I have to say on the subject, which I nevertheless must say, since it is really a most important one. I mean that side of art which is, or ought to be, done by the ordinary workman while he is about his ordinary work, and which has got to be called, very properly, Popular Art. This art, I repeat, no longer exists now, having been killed by commercialism. But from the beginning of man's contest with Nature till the rise of the present capitalistic system, it was alive, and generally flourished. While it lasted, everything that was made by man was adorned by man, just as everything made by Nature is adorned by her. The craftsman, as he fashioned the thing he had under his hand, ornamented it so naturally and so entirely without conscious effort, that it is often difficult to distinguish where the mere utilitarian part of his work ended and the ornamental began. Now the origin of this art was the necessity that the workman felt for variety in his work, and though the beauty produced by this desire was a great gift to the world, yet the obtaining variety and pleasure in the work by the workman was a matter of more importance still, for it stamped all labour with the impress of pleasure. All this has now quite disappeared from the work of civilization. If you wish to have ornament, you must pay specially for it, and the workman is compelled to produce ornament, as he is to produce other wares. He is compelled to pretend happiness in his work, so that the beauty produced by man's hand, which was once a solace to his labour, has now become an extra burden to him, and ornament is now but one of the follies of useless toil, and perhaps not the least irksome of its fetters.

Besides the short duration of labour, its conscious usefulness, and the variety which should go with it, there is another thing needed to make it attractive, and that is pleasant surroundings. The misery and squalor which we people of civilization bear with so much complacency as a necessary part of the manufacturing system, is just as necessary to the community at large as a proportionate amount of filth would be in the house of a private rich man. If such a man were to allow the cinders to be raked all over his drawing-room, and a privy to be established in each corner of his dining-room, if he habitually made a dust and refuse heap of his once beautiful garden, never washed his sheets or changed his tablecloth, and made his family sleep five in a bed, he would surely find himself in the claws of a commission *de lunatico*. But such acts of miserly

folly are just what our present society is doing daily under the compulsion of a supposed necessity, which is nothing short of madness. I beg you to bring your commission of lunacy against civilization without more delay.

For all our crowded towns and bewildering factories are simply the outcome of the profit system. Capitalistic manufacture, capitalistic land-owning, and capitalistic exchange force men into big cities in order to manipulate them in the interests of capital; the same tyranny contracts the due space of the factory so much that (for instance) the interior of a great weaving-shed is almost as ridiculous a spectacle as it is a horrible one. There is no other necessity for all this, save the necessity for grinding profits out of men's lives, and of producing cheap goods for the use (and subjection) of the slaves who grind. All labour is not yet driven into factories; often where it is there is no necessity for it, save again the profit-tyranny. People engaged in all such labour need by no means be compelled to pig together in close city quarters. There is no reason why they should not follow their occupations in quiet country homes, in industrial colleges, in small towns, or, in short, where they find it happiest for them to live.

As to that part of labour which must be associated on a large scale, this very factory system, under a reasonable order of things (though to my mind there might still be drawbacks to it), would at least offer opportunities for a full and eager social life surrounded by many pleasures. The factories might be centres of intellectual activity also, and work in them might well be varied very much: the tending of the necessary machinery might to each individual be but a short part of the day's work. The other work might vary from raising food from the surrounding country to the study and practice of art and science. It is a matter of course that people engaged in such work, and being the masters of their own lives, would not allow any hurry or want of foresight to force them into enduring dirt, disorder, or want of room. Science duly applied would enable them to get rid of refuse, to minimize, if not wholly to destroy, all the inconveniences which at present attend the use of elaborate machinery, such as smoke, stench, and noise; nor would they endure that the buildings in which they worked or lived should be ugly blots on the fair face of the earth. Beginning by making their factories, buildings, and sheds decent and convenient like their homes, they would infallibly go on to make them not merely negatively good, inoffensive merely, but even beautiful, so that the glorious art of architecture, now for some time slain by commercial greed, would be born again and flourish.

3. Georg Simmel
'The Metropolis and Mental Life'

Trans. Kurt H. Wolff 1950, in D. Frisby and M. Featherstone (eds.), *Simmel on Culture*, London, California and New Delhi, Sage Publications, 1997, pp.178–80.

Georg Simmel (1858–1918) was a German social theorist whose attention to new forms of experience have had a profound impact on subsequent discussions of modernity. In this extract from his essay 'The Metropolis and Mental Life', published in 1903, Simmel considers the over-stimulation of the nerves in the modern city and the effects on the personality. He claims that the mental shocks caused by city living produce a distinctive form of mental response that he characterises as 'the blasé attitude' or 'reserve'. This is a defensive attitude, which protects the individual against numerous psychic and social conflicts, but it simultaneously involves a flattening of subjective experience and distance from social engagement. SE

There is perhaps no psychic phenomenon which has been so unconditionally reserved to the metropolis as has the blasé attitude. The blasé attitude results first from the rapidly changing and closely compressed contrasting stimulations of the nerves. From this, the enhancement of the metropolitan intellectuality, also, seems originally to stem. Therefore, stupid people who are not intellectually alive in the first place usually are not exactly blasé. A life in boundless pursuit of pleasure makes one blasé because it agitates the nerves to their strongest reactivity for such a long time that they finally cease to react at all. In the same way, through the rapidity and contradictoriness of their changes, more harmless impressions force such violent responses, tearing the nerves so brutally hither and thither that their last reserves of strength are spent; and if one remains in the same milieu they have no time to gather new strength. An incapacity thus emerges to react to new sensations with the appropriate energy. This constitutes that blasé attitude which, in fact, every metropolitan child shows when compared with children of quieter and less changeable milieus.

This physiological source of the metropolitan blasé attitude is joined by another source which flows from the money economy. The essence of the blasé attitude consists in the blunting of discrimination. This does not mean that the objects are not perceived, as is the case with the half-wit, but rather that the meaning and differing values of things, and thereby the things themselves, are experienced as insubstantial. They appear to the blasé person in an evenly flat and gray tone; no one object deserves

preference over any other. This mood is the faithful subjective reflection of the completely internalized money economy. By being the equivalent to all the manifold things in one and the same way, money becomes the most frightful leveller. For money expresses all qualitative differences of things in terms of 'how much?' Money, with all its colorlessness and indifference, becomes the common denominator of all values; irreparably it hollows out the core of things, their individuality, their specific value, and their incomparability. All things float with equal specific gravity in the constantly moving stream of money. All things lie on the same level and differ from one another only in the size of the area which they cover. In the individual case this coloration, or rather discoloration, of things through their money equivalence may be unnoticeably minute. However, through the relations of the rich to the objects to be had for money, perhaps even through the total character which the mentality of the contemporary public everywhere imparts to these objects, the exclusively pecuniary evaluation of objects has become quite considerable. The large cities, the main seats of the money exchange, bring the purchasability of things to the fore much more impressively than do smaller localities. That is why cities are also the genuine locale of the blasé attitude. In the blasé attitude the concentration of men and things stimulate the nervous system of the individual to its highest achievement so that it attains its peak. Through the mere quantitative intensification of the same conditioning factors this achievement is transformed into its opposite and appears in the peculiar adjustment of the blasé attitude. In this phenomenon the nerves find in the refusal to react to their stimulation the last possibility of accommodating to the contents and forms of metropolitan life. The self-preservation of certain personalities is bought at the price of devaluating the whole objective world, a devaluation which in the end unavoidably drags one's own personality down into a feeling of the same worthlessness.

Whereas the subject of this form of existence has to come to terms with it entirely for himself, his self-preservation in the face of the large city demands from him a no less negative behavior of a social nature. This mental attitude of metropolitans toward one another we may designate, from a formal point of view, as reserve. If so many inner reactions were responses to the continuous external contacts with innumerable people as are those in the small town, where one knows almost everybody one meets and where one has a positive relation to almost everyone, one would be completely atomized internally and come to an unimaginable psychic state. Partly this psychological fact, partly the right to distrust which men have in the face of the touch-and-go elements of metropolitan life, necessitates our reserve. As a result of this reserve we frequently do not even know by sight those who have been our neighbors for years. And it is this reserve which in the eyes of the small-town people makes us appear to be cold and heartless. Indeed, if I do not deceive myself,

the inner aspect of this outer reserve is not only indifference but, more often than we are aware, it is a slight aversion, a mutual strangeness and repulsion, which will break into hatred and fight at the moment of a closer contact, however caused. The whole inner organization of such an extensive communicative life rests upon an extremely varied hierarchy of sympathies, indifferences, and aversions of the briefest as well as of the most permanent nature. The sphere of indifference in this hierarchy is not as large as might appear on the surface. Our psychic activity still responds to almost every impression of somebody else with a somewhat distinct feeling. The unconscious, fluid and changing character of this impression seems to result in a state of indifference. Actually this indifference would be just as unnatural as the diffusion of indiscriminate mutual suggestion would be unbearable. From both these typical dangers of the metropolis, indifference and indiscriminate suggestibility, antipathy protects us. A latent antipathy and the preparatory stage of practical antagonism effect the distances and aversions without which this mode of life could not at all be led. The extent and the mixture of this style of life, the rhythm of its emergence and disappearance, the forms in which it is satisfied – all these, with the unifying motives in the narrower sense, form the inseparable whole of the metropolitan style of life. What appears in the metropolitan style of life directly as dissociation is in reality only one of its elemental forms of socialization.

This reserve with its overtone of hidden aversion appears in turn as the form or the cloak of a more general mental phenomenon of the metropolis: it grants to the individual a kind and an amount of personal freedom which has no analogy whatsoever under other conditions.

Chapter 19
Cubism and Abstract Art revisited

Paul Wood

1. David Cottington
A.H. Barr and Clement Greenberg on Cubism and abstract art

David Cottington, *Cubism and its Histories*, Manchester and New York, Manchester University Press, 2004, pp.181–90, pp.278–80.

David Cottington's book *Cubism and its Histories* (2004) performs two tasks: a historical contextualisation of the Cubist movement in pre-First World War Paris, and a study of the evolution of the theories by which it has been interpreted. In the present extract, Cottington discusses the emergence of the modernist understanding of Cubism and its relation to abstraction as articulated by the curator Alfred H. Barr (1902–81) and the critic Clement Greenberg (1909–94) in America during the 1930s, 1940s and 1950s. For the most part, the extract is self-explanatory, but at points Cottington refers to discussions elsewhere in the book. These include reference to the two 'wings' of the Cubist movement in pre-First World War Paris: the 'Salon' Cubist group, which exhibited publicly and included artists such as Henri Le Fauconnier (1881–1946), Albert Gleizes (1881–1953), Jean Metzinger (1883–1956) and Robert Delaunay (1885–1941); and the 'Gallery' Cubists, Georges Braque (1882–1963) and Pablo Picasso (1881–1973), who were contracted to the dealer Daniel-Henry Kahnweiler (1884–1979). Cottington also refers to Kahnweiler's earlier theory of two phases of Cubism, 'analytic' and 'synthetic', which was adapted and changed by Barr. Whereas Barr treated the two phases as part of a stylistic evolution in line with his overall formalist approach to art, Kahnweiler had drawn on idealist philosophy, particularly the distinction between a 'phenomenal', perceptual world and a

supposedly more profound conceptual reality. Cottington also glancingly refers to an interest in 'durational continuity' on the part of the Salon Cubists, by which he means their interest in the theories of the French philosopher Henri Bergson (1859–1941) about time and memory, which were widely influential among the pre-war avant-garde. Finally, he mentions Greenberg's Trotskyism. This is a reference to his position in the circle of anti-Stalinist American Marxists active before the Second World War around the journal *Partisan Review*. Greenberg subsequently distanced himself from his earlier political radicalism in the context of the Cold War. PW

The Museum of Modern Art (MoMA) was opened in New York in 1929, an initiative that represented the consolidation of the authority of a key group of collectors and patrons of modernist art, at the centre of which was the Rockefeller family and its fortune, at a crucial moment in the critical debate over that art which was being conducted in the USA.[1] Alfred Barr was appointed as its first director, a young art history graduate of Princeton and Harvard whose methodological grounding was in formalism and connoisseurship; his Harvard professor, Paul J. Sachs, was a close friend of Bernard Berenson who brought to his seminars the systematic, rational yet subjective determination of quality that Berenson espoused, and Barr seems to have been the first to adapt this method of connoisseurship to modern art.[2] His appointment at MoMA thus extended into the modern field, and into the contemporary art arena, a methodology that constructed the history of art around a narrative of stylistic change, driven by an internal logic that was independent of social, political and personal pressures and accessible only to those with the discernment to make qualitative judgements about individual works. [. . .] [I]t was a methodology consistent with the values and functioning of that dealer–collector–critic system then establishing its ascendancy in the modern art market over the increasingly cumbersome and sclerotic apparatus of salons and state patronage, and Barr worked to consolidate both with the establishment of an ambitious programme of thematic exhibitions at MoMA designed to map the sprawling field of modern and contemporary art according to the coordinates they provided. [. . .]

 Unlike most US critics, however, he had spent several months in 1927–28 in Europe, meeting not only 'most of the major figures in German contemporary art, such as the Bauhaus group, the Neue Sachlichkeit, and the dealers and critics that supported them',[3] but also visiting Russia

1. Sybil Gordon Kantor, *Alfred H. Barr, Jr., and the Intellectual Origins of the Museum of Modern Art*, Cambridge, MA: MIT Press, 2002.
2. Susan Noyes Platt, 'Modernism, formalism and politics: the "Cubism and Abstract Art" exhibition of 1936 at the Museum of Modern Art', *Art Journal*, 47, no. 4 (winter 1988), 286.

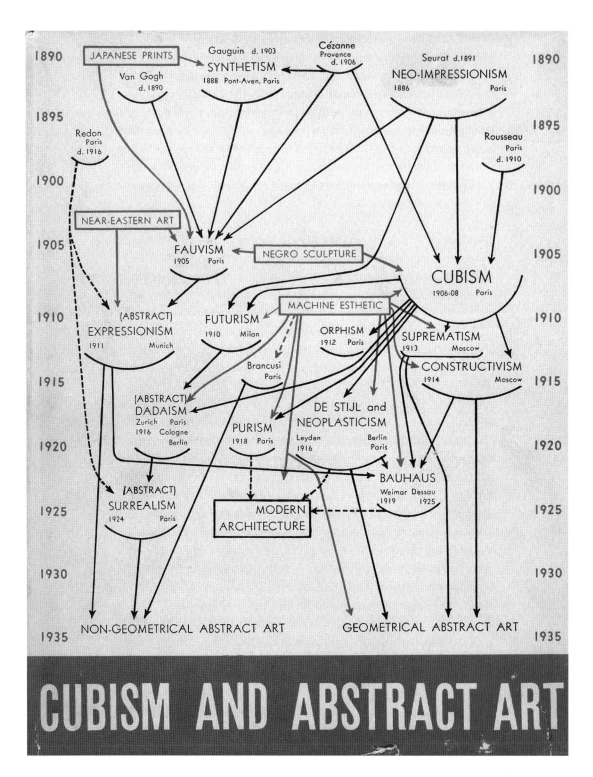

Fig.14
Alfred H. Barr
The Development of Abstract Art 1936
Cover of *Cubism and Abstract Art*,
exhibition catalogue, Museum
of Modern Art, New York 1936. Printed
in colour 26 x 29 cm

and meeting the members of the avant-garde there. As a result, he had an awareness of the vitality and range of abstract as well as representational art in those countries, which deepened into strong sympathy during a second stay in Europe in 1932–33. There he lived for a time in Stuttgart, where he seems to have experienced the growth of a Nazi-led intolerance towards modernism and an enthusiasm for Hitler that raised his awareness both of the threat this development posed for avant-garde artists and of the political ramifications of a rejection of abstraction in favour of traditional realism. [. . .]

This was the institutional and personal context of the 1936 'Cubism and Abstract Art' exhibition, in which Barr brought together his didactic inclinations, formalist method, connoisseur's acuity and personal awareness of the precarious position of avant-garde art into a display and explanation of what he saw as the main currents of modernism, whose influence on Western, and in particular Anglo-American, scholarly and critical understanding of that modernism has not since been matched.[4] The mix of these qualities yielded something of a paradox: although Barr remarked in his catalogue essay that it and the exhibition 'might well be dedicated to those painters of squares and circles (and the architects influenced by them) who have suffered at the hands of philistines with political power',[5] and preceded this dedication with a cogent two-page summary of the worsening relations between abstract artists and the nascent states of the Soviet Union and Nazi Germany, he stepped lightly over the aesthetic dimension of the politics of abstraction, simply distinguishing 'art in the narrow sense of the word' from 'typography, photography, posters, movies, engineering, stage design, carpentry – anything but painting or sculpture',[6] and this was the first and last encroachment of questions of politics – for all the inseparability of these from the aesthetics of many of its participants – into a project the interpretive framework of which was rigorously formalist. The map that Barr provided of the field it displayed – the 'chart of modern art' (fig.14) which has since become notorious as a metonym for that formalism – was prominently posted throughout the exhibition and on the catalogue dust-jacket, the framework within which Barr elaborated a set of analytical concepts and procedures, and proceeded with these to sketch out his modernist edifice. The keystone of this was cubism, and specifically the analytic–synthetic pairing, around which its history was, following Kahnweiler, Gris and the now-established convention of 1920s' interpretation, seen to turn. As Daniel Robbins notes, however, Barr's application of these terms 'neutralised' the philosophical idealism fundamental to them, replacing it with a narrative

3. A(lfred) H. B(arr), Jr, 'Foreword', in *Painting in Paris from American Collections*, exh. cat., New York: Museum of Modern Art, 1930, 11, quoted in Platt, 'Modernism, formalism and politics', 287.

4. Barr's exhibition catalogue – *Cubism and Abstract Art*, New York: Museum of Modern Art, 1936 – has since been reprinted three times: in 1966, 1974 and 1986.

5 *Ibid.*, 18.

6. *Ibid.*, 17.

274 Part 5 Art and modernity

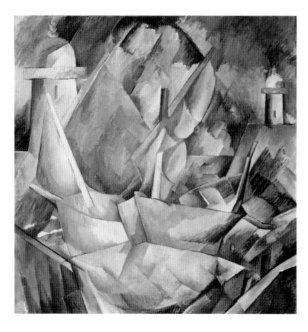

Fig.15
Georges Braque
Harbour in Normandy 1909
Oil on canvas 81.1 x 80.5 cm
Art Institute, Chicago

of formalist progression grounded in a discussion of the work of Picasso and Braque, unprecedented in its specificity of reference to particular paintings and devices, and to a chronology.[7] Thus Barr defined analytic cubism not in terms of any conceptualising of essential or primary qualities, or of durational continuity, in its subject matter, but in those of a 'progressive tearing apart or disintegrating of natural forms', in which 'the disintegrated image of the natural object gradually took on a more and more abstract shape'.[8] 'The Cubists seem to have had little conscious interest in subject matter', he observed. 'They used traditional subjects for the most part, figures, portraits, landscapes, still life, all serving as material for Cubist analysis.'[9]

In this analysis – Barr used the term loosely and metaphorically, and as already current ('The development of Cubism during its first six years from 1906 to 1912 has been called analytical'[10]) – the painters' subject matter was first 'systematically broken down into facets like a cut diamond' (Barr cited Picasso's *Head of a Woman* of 1908–9[11] and Braque's *Harbour in Normandy* (fig.15) of early 1909 as examples). In a second phase later in 1909 these facets were allowed to 'slip, causing further deformation' (he cited Picasso's *Portrait of Braque*[12]), which led to a 'third stage of

7. Daniel Robbins, 'Abbreviated historiography of cubism', *Art Journal*, 47, no. 4 (winter 1988), 282. See also Christopher Green, *Art in France 1900–1940*, New Haven and London: Yale University Press, 2000.
8. Barr, *Cubism and Abstract Art*, 78.
9. *Ibid.*, 15; Barr did, however, add a footnote to this observation, acknowledging and discussing a possibility which Meyer Schapiro had suggested in 'an interesting theory', namely that 'consciously or unconsciously the Cubists through their subject matter reveal significant preoccupation with the bohemian and artistic life'; hedging his bets, Barr concluded that 'the iconography of Cubism should not be ignored'.
10. *Ibid.*,78.
11. Pierre Daix and Joan Rosselet, *Picasso: The Cubist Years, 1907–1916*, London: Thames & Hudson, 1979, cat. 291.

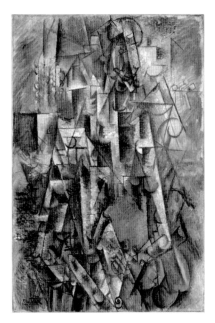

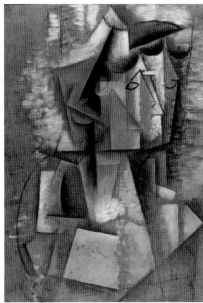

Fig.16
Pablo Picasso
The Poet 1911
Oil on linen 131.2 x 89.5 cm
The Solomon R.
Guggenheim Foundation,
Peggy Guggenheim
Collection, Venice

Fig.17
Pablo Picasso
Arlésienne 1912
Oil on canvas 73 x 54 cm
Private collection, courtesy
Thomas Amman Fine Art,
Zurich

disintegration' (as in Picasso's 1911 *The Poet* – fig.16) which Barr did
not summarise; thence to a fourth in which, as in Picasso's *Arlésienne*
(fig.17), the head was 'made up of flat, overlapping, transparent planes,
almost rectangular in shape'. Acknowledging that the superimposition
in this painting of frontal and profile views illustrated 'the principle of
"simultaneity" – the simultaneous presentation of different views of an
object in the same picture' – Barr however showed no interest in pursuing
that principle or its implications (this indeed was his only reference to it in
the essay), instead moving straight on to the fifth stage, which marked 'the
end of "Analytical" Cubism and the beginning of "Synthetic" Cubism', and
was characterised by 'two-dimensional, flat, linear form, so abstract as to
seem nearer geometry than representation'.[13]

The capitalising of the initial letter of the twin terms is emblematic of
Barr's reworking of them to function not as philosophical concepts but
as stylistic and periodising markers, clearly distinguishing and dating
(if allowing some overlap between) cubism's cardinal moments and their
characteristic features. His precise and detailed chronologies for each
located the 'apogee of Analytical Cubism' in 1912, and the 'transition to
Synthetic Cubism' in the following year.[14] This was a further significant
departure from the model provided by Kahnweiler, whose *Weg zum
Kubismus* had suggested Cadaqués as the transitional moment; while
[. . .] his observations on the role played by *papier-collé* and collage in the
development of gallery cubism, though provocative, were undeveloped:

12. *Ibid.*, cat. 330.
13. All but the first quotation in this
paragraph: Barr, *Cubism and Abstract*

Art, 31.
14 *Ibid.*, 29 and 77.

Picasso and Braque introduced new materials into their canvases in
order to 'eliminate the use of colour as *chiaroscuro*, which had still
persisted to some extent in their painting, by amalgamating painting
and sculpture';[15] that was all. Barr, by contrast, saw in such new media
'an emphasis not upon the reality of the represented objects but upon the
reality of the painted surface'; their use, together with the construction
of those objects out of 'geometrical shapes [that] are so remotely related
to the original form of the object that they seem almost to have been
invented rather than derived', effectively replaced a process of 'breaking
down or analysis' with one of 'building up or synthesis'.[16] His claim
recapitulated the 'autonomy thesis' on which the Kahnweiler-Gris
definition of 'synthetic' had been based, but placed this on the firmer and
more specific foundations of *papier-collé* and collage – and Barr showed
no interest in the 'conceptual reality' thesis by which that definition had
been coloured; synthetic cubism was, fundamentally, a matter of texture,
'a logical culmination of the interest in simulating textures' that Braque
and Picasso had earlier shown.[17]

 Barr's conception of synthetic cubism was integral to his overall
thesis, that cubism was a key phase of the development of 'the impulse
towards abstract art during the past fifty years', the 'widening stream'
through which the more important of the two currents by which this
impulse was manifested found its way from 'its sources in the art and
theories of Cézanne and Seurat' to 'its delta in the various geometrical
and constructivist movements that developed in Russia and Holland
during the [First World] War and have since spread throughout the
world'.[18] Although it led him to underplay the degree of the gallery cubists'
engagement with the materiality of the things they painted, and to ignore
(despite his qualification, noted above) their iconographic implications,
it underpinned a formalist reading of their work that for the first time, as
Daniel Robbins notes, accounted for its method, followed that method in
detail across stages and embedded it in the history of modern art.[19] This
is perhaps one reason why *Cubism and Abstract Art* provided a paradigm
that, developing and replacing Kahnweiler's, shaped the historiography
of cubism for more than a generation, and why his reworking of the
analytic-synthetic pairing he inherited from the latter became a
universally accepted descriptive code.

 It is not, however, the only reason. In the light of the ascendancy
of gallery cubism, and its consequences, as I have traced them, there is
unintentional irony in Robbins's assertion that this exhibition catalogue

15. D.-H. Kahnweiler, *Der Weg zum
Kubismus*, Munich: Delphin, 1920;
English edition, *The Rise of Cubism*,
trans. Henry Aronson, New York:
Wittenborn Schultz, 1949, 15.

16. Barr, *Cubism and Abstract Art*, 78.
17. *Ibid.*
18. *Ibid.*, 19. The second current, Barr
wrote, 'has its principal source in the
art and theories of Gauguin and his

circle, flows through the Fauvisme
of Matisse to the . . . pre-war paintings
of Kandinsky': *ibid*.
19. Robbins, 'Abbreviated
historiography of cubism', 280.

'could only have been written by an American, moreover one who was a
trained historian, who sought objective truth [and] was not partisan to
the currents and counter movements of European, especially Parisian
art politics'.[20] There is nevertheless substance in his implication that
it was a product not only of its time and place, in the ways I have
outlined, but of a broader dynamic: one in which an influential fraction
of the dominant class in the USA would over the next three decades
institutionalise modernism, separating its aesthetics from the domain
of the social and harnessing the 'impulse towards abstraction' identified
and fostered by Barr to preserve it from contamination by commercial
culture. MoMA was itself a crucial vehicle for this dynamic; its well-
resourced promotion of 'Cubism and Abstract Art' ensured widespread
coverage, and the didactic clarity of both the exhibition and its catalogue
provided educational resources for contemporary artists, while the
purchase in 1939 of *Les Demoiselles d'Avignon*, a painting that Barr had
placed at the start of his narrative of cubism but had been unable to
include in the exhibition, reinforced that narrative's immediacy. The
'European art politics' was not so easily disengaged from it, however; not
only had it been formed in part by these, as I have shown, but as the Nazi
and Stalinist regimes drove increasing numbers of avant-garde artists
out of Germany and the Soviet Union from the mid-1930s they, and their
politics, followed their art to New York,[21] and out of this heterogeneous
population, alongside MoMA and in part a product of its activities (or at
least a leading beneficiary of them), there developed over the next decade
an increasingly informed, sophisticated and politicised discourse of
contemporary art criticism.

One of its key participants appeared in print in 1939 for only the
second time with an essay that has since been recognised as the first
articulation of what was to become the dominant interpretation of
modernism of the second half of the twentieth century.[22] Clement
Greenberg's 'Avant-garde and kitsch', published in *Partisan Review*
that autumn, picked up Barr's autonomy thesis and the formalism that
underpinned it, developing the political ramifications that these had
marginalised in a direction influenced by the socialist vanguardism
of Trotsky. Greenberg sketched a history of an avant-garde formation
driven, since its emergence in the mid-nineteenth century, by resistance

20. *Ibid.*, 278.
21. On this dynamic, and its
consequences for art in New York, see
Clement Greenberg, 'The late thirties in
New York', in *Art and Culture: Critical
Essays*, Boston, MA: Beacon Press, 1961;
Serge Guilbaut, *How New York Stole the
Idea of Modern Art*, Chicago, IL:
University of Chicago Press, 1983;

Dickran Tashjian, *A Boatload of
Madmen: Surrealism and the American
Avant-Garde, 1920–1950*, London and
New York: Thames & Hudson, 2002.
22. Clement Greenberg, 'Avant-garde
and kitsch', *Partisan Review* (fall 1939);
reprinted in Clement Greenberg, *The
Collected Essays and Criticism*, vol. 1:
Perceptions and Judgements, 1939–1944,

ed. John O'Brian, Chicago, IL, and
London: University of Chicago Press,
1986; on this article see the essays by T.J.
Clark, Thomas Crow and Michael Fried
in Francis Frascina (ed.), *Pollock and
After: The Critcal Debate*, London: Paul
Chapman, 1985.

to and critique of the culture of advanced capitalism, inwards into specialisation around the unique propertiers of its respective arts:

> Picasso, Braque, Mondrian, Miró, Kandinsky, Brancusi, even Klee, Matisse and Cézanne, derive their chief inspiration from the medium they work in. The excitement of their art seems to lie most of all in its pure preoccupation with the invention and arrangement of spaces, surfaces, shapes, colours, etc., to the exclusion of whatever is not implicated in these factors.[23]

Greenberg saw in the popular commercial culture of capitalism a mortal threat to this 'formal culture': 'Capitalism in decline finds that whatever of quality it is still capable of producing becomes almost invariably a threat to its own existence.' Moreover: 'Advances in culture, no less than advances in science and industry, corrode the very society under whose aegis they are made possible.'[24] Arguing – seemingly with a keener sense of dialectics than of irony – that no culture can develop without a social base and a stable source of income, he noted that the ruling-class elite which provided these for the avant-garde was 'rapidly shrinking', and warned: 'Since the avant-garde forms the only living culture we now have, the survival in the near future of culture in general is thus threatened.'[25]

Greenberg made no mention of cubism in this essay, and there is only a passing reference in another keynote article of the following year, 'Towards a newer Laocoön', in which he fleshed out his thesis,[26] but it quickly became apparent both that it was a touchstone for this and that Barr's formalist history and autonomist emphasis provided the model for his understanding of it, although one from which he was to depart in significant respects. Following Barr (and, via him, Kahnweiler), cubism – which 'defined and isolated' the 'basic tendencies of recent western painting' – for Greenberg was gallery cubism, and primarily that of Picasso and Braque.[27] It held the highest value for him: the 'cubist mission and its hope, coincident with that of Marxism and the whole matured tradition of Enlightenment' was that of 'humanising the world'; 'cubism remains', he declared, 'the epoch-making feat of twentieth-century art, a style that has changed and determined the complexion of western art as radically as Renaissance naturalism once did'.[28] Originating not only from the art that preceded it but from the optimism, self-confidence and scientific outlook of 'the highest stage of industrial capitalism',

23. Greenberg, *Perceptions and Judgements*, 9.
24. *Ibid.*, 22.
25. *Ibid.*, 10–11.
26. *Partisan Review*, 7, no. 4 (July–August 1940), reprinted in Greenberg, *Perceptions and Judgements*.
27. Obituary of Mondrian, *The Nation*, 4 March 1944, Greenberg, *Perceptions and Judgements*, 187.
28. 'The decline of cubism', *Partisan Review* (March 1948), reprinted in Clement Greenberg, *The Collected Essays and Criticism*, vol. 2: *Arrogant Purpose, 1945–1949*, ed. John O'Brian, Chicago, IL, and London: University of Chicago Press, 1986, 212.

cubism, by its rejection of illusionist effects in painting or sculpture and its insistence on the physical nature of the two-dimensional picture plane . . . expressed the positivist or empirical state of mind with its refusal to refer to anything outside the concrete experience of the particular discipline, field or medium in which one worked; and it also expressed the empiricist's faith in the supreme reality of concrete experience.[29]

This was a clear departure from Kahnweiler's idealism – if not from Barr's formalism – for Greenberg developed the latter's identification of 'flatness' as a cardinal feature of synthetic cubism into cubism's single governing principle, and made (what he saw as) Braque's and particularly Picasso's determination to strip painting of every quality that contravened it into the motor that drove painting from analytic to synthetic cubism and beyond into abstraction:

> It was of the essence of cubism after its initial stage to situate the image or rather the pictorial complex, *ambiguously*, leaving the eye to doubt whether it came forward or receded. But the ambiguity itself was weighted, and its inherent, irrevocable (and historical) tendency was to drive the picture plane forward so that it became identical with the physical surface of the canvas itself . . . It belongs to the importance of cubism, to that which makes it the most epochal school of painting since the Renaissance, that it conclusively liquidated the illusion of the third dimension. It did not have to wait for Malevich or Mondrian to do that. Pre-figuring the furthest extremes of abstract art in our time, Picasso as a cubist already contained everything that abstract art has since made obvious.[30]

From the end of 1948 Greenberg's distinctive interpretation of cubism, and its differences now from that of Barr as well, became clearer as he addressed its formal developments more specifically. Reviewing an exhibition of collages by Picasso, Braque, Arp and Schwitters at MoMA that November, he tacitly disagreed with Barr's account of the introduction of new materials by Braque and Picasso in 1912, arguing that it was not a matter of 'more varied texture', as Barr had inferred, but of an insistence on 'the physical reality of the work of art'; *papier-collé* and collage 'made that reality the same as the art'. The collage medium was thus 'the most succinct and direct single clue to the aesthetic of genuinely modern art'.[31] Returning to this article ten years later, cannibalising and amending

29 *Ibid.*, 213–14.
30. 'Reply to George L. K. Morris',
Partisan Review (June 1948); reprinted
in Greenberg, *Arrogant Purpose*, 244–5.

31. *The Nation*, 27 November 1948;
reprinted in Greenberg, *Arrogant
Purpose*, 260, 259.

its phrasing for a more extended essay on the same subject, he went further. Directly challenging the inference, by then conventional in the Kahnweiler-Barr interpretive lineage, of a realistic intention in Braque's and Picasso's turn to *papier-collé* and collage,[32] Greenberg extended his insistence on flatness as the guiding concept back into Picasso's and Braque's cubism of 1909–11, reading the innovations of 1912–14 as necessitated by an inexorable logic: 'there seemed no direction left in which to escape from the literal flatness of the surface – except into the non-pictorial, real space in front of the picture'; this 'seems quite apparent by now – so apparent that one wonders why those who write on collage continue to find its origin in nothing more than the Cubists' need for renewed contact with "reality"'.[33]

The pugilistic tone of this was a product of more than confidence in his own aesthetic judgement. For between the two versions of his assessment of collage, Greenberg's political views had undergone an about-face from his earlier Trotskyist allegiance to an active anti-communism (he was a founder-member in 1950 of the American Committee for Cultural Freedom, established for that purpose, with headquarters in Paris),[34] and his writing on art changed accordingly. In the mid-1940s his commitment to the importance of cubism rested on the general foundations of his argument in 'Avant-garde and kitsch', that the autonomy of avant-garde art from, and its implicit resistance to, the banalities of commercial-capitalised culture was vital; even if the sense of conscious resistance by the avant-garde to that culture had weakened since the 1939 essay, a sense of its detachment remained. An essay of 1947, 'The present prospects of American painting and sculpture', in *Horizon* suggested that in France, industrialisation was not so complete that it did not still permit the individual 'a little confidence in his own private solution, a modicum of space in which personal detachment could survive and work up its own proper interestingness'. As a result, 'in the preserves of Bohemia, the impressionists, fauvists and cubists could still indulge in a contemplation that was as sincere and bold as it was largely unconscious'.[35] In the USA, by contrast, there were no such spaces; there the industrialisation and rationalisation of culture was more comprehensive. While the fear Greenberg had earlier expressed over the threat posed by kitsch had

32. Barr, *Cubism and Abstract Art*, 78. Of course, Kahnweiler's understanding of this realism as conceptual needs to be distinguished, within this convention, from Barr's understanding of it as material.
33. 'The pasted paper revolution', *Art News* (September 1958); reprinted in Clement Greenberg, *The Collected Essays and Criticism*, vol. 4: *Modernism with a Vengeance, 1957–1969*, ed. John O'Brian, Chicago, IL, and London; University of Chicago Press, 1993, 64, 61. For a recent assessment of this essay and its relation to Greenberg's other writings on collage see Lisa Florman, 'The flattening of "collage"', *October*, 102 (autumn 2002), 59–86.
34. John O'Brian, 'Introduction', in Clement Greenberg, *The Collected Essays and Criticism*, vol. 3: *Affirmations and Refusals, 1950–1956*, ed. John O'Brian, Chicago, IL, and London: University of Chicago Press, 1993, xxvii.
35. 'The present prospects of American painting and sculpture', *Horizon* (October 1947); reprinted in Grenberg, *Arrogant Purpose*, 165.

receded, it had been replaced by that of 'general middlebrow taste', the very improvement of which – as a result of that rationalisation – was 'itself a danger':

> Whereas high art used to remain untempted, simply because it had no chance whatsoever of complying with the market demand, today the new mass cultural market created by industrialism is seducing writers and artists into rationalising and packaging for mass distribution even the most pretentious products.[36]

In consequence:

> High culture – which in the civilised past has always functioned on the basis of sharp class distinctions, is endangered – at least for the time being – by this sweeping process which, wiping out the social distinctions between the more and the less cultivated, renders standards of art and thought provisional . . . At the same time that the average college graduate becomes more literate the average intellectual becomes more banal, both in personal life and professional activity.[37]

Yet for all the continued perception of a high culture under threat, the politics that informed it had shifted decisively; indeed Greenberg's readiness to replace his former Marxist beliefs with such clear nostalgia for class distinctions is almost shocking. More than this: the qualification 'at least for the time being' presaged a further shift around 1950, as – like many of the New York intellectuals with whom he associated – Greenberg became a cold warrior who equated American capitalism with democracy and supported it as a bulwark against totalitarianism. As John O'Brian observes, in his long 1953 essay 'The plight of our culture', Greenberg's disdain for middlebrow culture gave way to an optimism that the rising wealth of the new managerial class in America would transform it into high culture, producing, 'for the first time in history, high urban culture on a "mass" basis'.[38] O'Brian notes:

> The central paradox of modernism, high art's attachment to and estrangement from the arrangements of capitalism, was therefore stripped of its former political cogency. What remained was modern art's self-reflexivity, its fixation on its own field of competence, its absorption with questions of delimitation and of medium.[39]

36. *Ibid.*, 162.
37. *Ibid.*, 163.
38. 'The plight of our culture',

Commentary (June–July 1953); reprinted in Greenberg, *Affirmations and Refusals*, 140.

39. O'Brian, Introduction', *ibid.*, xxx.

Hence Greenberg's insistent narrowing down, in 'The pasted paper revolution', of the terms of the narrative of cubism's development to the single criterion of flatness, and his rejection of any idea that an engagement with 'reality' had anything to do with it. Reductive almost to the point of caricature, this reading became the cornerstone of an understanding of modernism and a broader narrative of its history since Manet which Greenberg put in place over the next decade; most notably in his essay 'Modernist painting' and his collection of heavily revised articles from the 1950s, *Art and Culture*, both published in 1961. Reiterated like a catechism by countless proselytisers for 1960s' 'post-painterly abstraction' and its successors, elaborated and enriched by critic-historians such as Michael Fried, Greenbergian modernism and the genealogy it offered enjoyed a hegemony over an entire generation of historical writing on twentieth-century art and contemporary criticism.

Chapter 20
Modernism in architecture and design: function and aesthetic

Tim Benton

1. Le Corbusier
'Notes à la suite'

Cahiers d'Art, 1 March 1926, pp.46–52 (trans. Tim Benton).

The art journal *Cahiers d'Art* was founded in 1926 by Christian Zervos (1889–1970) to promote an interest in modern art. The piece by the Swiss modernist architect Le Corbusier (1887–1965)[1] in the first issue was partly aimed at promoting his latest projects but also at making a case for architecture as visual art. The emphasis is therefore on light and the visual sensations it can produce. The argument runs counter to the emphasis on structure and function that dominated much discussion of the evolving modern movement in architecture, including some of Le Corbusier's own writings. In the light of the other texts included in this chapter, it is notable how little Le Corbusier stresses transparency or the practical or social aspects of the houses.

The staccato style of Le Corbusier's writing, which took the form of categorical statements and slogans (including deliberate repetition), was already in evidence in the first articles he wrote for *L'Esprit Nouveau* magazine in 1920–1; he later collected together these pieces in the book *Vers une architecture* (1923).[2] TB

1. Le Corbusier was the pseudonym adopted by Charles Édouard Jeanneret in the early 1920s, but his work as a painter was carried out under his birth name until 1928.
2. Le Corbusier, *Vers une architecture*, Paris, G.Crès et cie, 1924. This second edition, a revised version of the original 1923 edition, has been reprinted many times. The first English language edition was published as Le Corbusier, *Towards a New Architecture*, New York, Payson & Clarke, 1927, but see also a new and more accurate translation by John Goodman, Le Corbusier, J.-L. Cohen et al., *Toward an Architecture*, Los Angeles, Getty Research Institute, 2007.

First some definitions:

Construction: holding things together

Arrangement: resolving the practical problems of comfort

Architecture: to claim an emotional reaction

I

Architecture is a function of light; it is a matter of volumes in light. Without light, you cannot see anything. Without sight, there is no feeling. No architectural emotion without light.

This is how the architectural phenomenon is rooted even more fundamentally in the fact of light: we wake up with the light, we see, discriminate, act, work, think. Without light, we go to sleep; we stop having feelings, we stop thinking (apart from our subconscious). The bird sings at sunrise; he becomes silent and sleeps at night. In recent times we can prolong the day into night time thanks to artificial light. When the light goes out, we sleep.

Modern artificial light is intense, acute; it throws sharp rays, like the sun. We love to dance, to drink, to sing under artificial light because the working day is over and the bright light stimulates us and incites us to action. It makes us happy and we dance.

Shops that want to sell things are brilliantly lit. Their call (for it is a call) is joyous. We look, we enter, we buy. Light puts us at ease.

We love it when the sun comes into the house, for we live a sedentary life in the big city. We cannot go and look for the sun in the countryside. [. . .]

II

Windows bring sunshine into our home.

For centuries, man has struggled with the technical difficulties of windows that can bring in a lot of sunlight.

Suddenly, reinforced concrete has unlocked the treasures of sunlight.

III

What does the sun do in the house? It illuminates.

What does it illuminate? The floors, ceilings and walls.

A room has four walls. When you open a window in one of the walls, the facing wall is partly illuminated, the two side walls are gloomy and the window wall is in deep shadow.

The room is sad because the walls are insufficiently lit by a single square or vertical window framed in a wall.

Under Louis XV, XVI and Haussmann, the tall windows were progressively brought closer together until they occupied almost the whole wall surface with two or three windows [. . .] With reinforced concrete, *there is no need for a framing wall. The window can run from wall to wall and illuminate them all over* [fig.18].

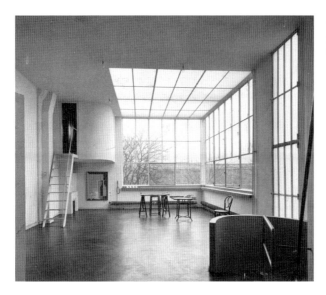

Fig.18
Le Corbusier and Pierre
Jeanneret
Ozenfant Studio, 1922–3
Courtesy Fondation Le
Corbusier, Paris

Now the room is full of light because the walls are illuminated. There are no walls in shadow or half-light. Our senses are enchanted; our animal being is delighted. We have the sun in our room. *It is bright in our house.*

And we say: *Our house is cheerful.*

It's a synonym for us.

With technology we have conquered *the fundamental basis of architectural sensation: light.*

I repeat: the fundamental basis of sensation [. . .] Because it is a question of the *senses*. Where is the wooden panelling and plaster decoration now? It doesn't matter for the moment; it is a question of sensation; of responding to the sunlight, the joy of light, *with our senses*, just as you smell a perfume or taste a dish. [. . .]

To live happily in a home, you must make the light come in, give the inhabitant illuminated walls. This is the starting point for the architectural sensation.

<p style="text-align:center">IV</p>

These illuminated walls, you perceive them in their precise proportions. What is this proportion, is it harmonious, is it full of character? Or is it shapeless and lacking in seduction? Watch out, your walls are going to speak to you! According to whether they are long or tall, depending on whether they are disposed symmetrically to left and right when you enter the room, or unevenly, or whether one wall creates a kind of façade and the others a kind of corridor, or whether they are smooth and unbroken or pockmarked with holes or reliefs, the architectural language will vary and so will your sensations. You will feel crushed, or circumscribed, or liberated, etc. This is what architectural eloquence is made of.

Where then are the wooden panelling, the plaster decoration and the style dictionaries?

V

Depending on the orientation of the walls to north, south or west, and their dimensions in width and height, the light will give your walls a different impact.

Now let us consider that these white plaster walls can sometimes speak a more incisive language than that of their geometric measurements alone. Once again, our senses may be stirred by the colour red, irritated by yellow, calmed by blue, and so on. How should these colours, delivering precise and specific effects, be distributed? Research has been carried out about colour; there is an optics of colour: red should be fully illuminated (if it is to look red); blue is best in shade (to be a proper blue), etc. [. . .]

The supple modern plan with its constant interpenetration of spaces,[i] cannot be coloured in the same way as the traditional house, with its red dining room, blue bedroom etc.

The wall of one room also forms part of the next room. So?

For many years I thought that the polychromy of the domestic interior should be determined by the luminosity of the wall. And this following the classic principles: hot tones in sunlight, cold tones in shade. I have experimented animating the interior with counterpoints and fugues of colour, following the modulations of lighting. In this way I am still celebrating the phenomenon of light.

VI

And what happens in the evening, with electric light? The light sources here are different, the light levels are not the same.

Yes.

This is a quite new problem that is not going to find a solution in a day since, to start with, we have not begun to solve the problem of lighting the house in the evening. [. . .][ii]

I have tried to light two houses in Auteuil[iii] without any ceiling lights; it wasn't convincing.

I go so far as to say that when you begin to pluck this lyre (for light is lyrical), we are placing in the hands of our clients a subtle instrument that can either hit the right note or a false one. You must play with your light and play right: it's a matter of relationships, intensity, situation etc. [. . .] Your walls can be lit well or badly, can be joyous or serene, or they can be brutal, vacant or gloomy. [. . .]

i. Translator's note: 'enjambements' literally translates as strides, but the meaning here refers to the extension of one space into another.
ii. Le Corbusier launches here into a digression about the continuing production of chandeliers.
iii. The La Roche and Jeanneret-Raaf houses.

IX

But the house is made to live in, to sleep and to act.

To act.

You walk, you sit down, you lie down.

You walk: I have already said that doors are placed exactly where, when opened, they reveal the orchestrated presentation of an architectural spectacle.

You sit down to work, or to relax. To work, you sit at a table.

Do the chairs exist that meet these functions?

Yes. For office workers – and their bosses – the calibre[iv] of convenient chairs evolved thirty years ago. They can be bought. Are we able to introduce them into the home?

It seems to me that if these useful, *standard*, chairs fit with our architecture it is because the latter is stripped of arbitrary and inconsequential details which, if present, would have presented an obstacle to the introduction of these *furniture-servants*.[v]

Furniture servants! Have I committed *lèse-majesté*? (I am reassured, their majesties *sat on chairs* to rule.)

To relax: to talk or gaze at spiders on the ceiling.

I was told that Adolf Loos has just said, in a recent lecture, that modern man sits lower than Louis XV.

This is the recognition of an established state of affairs.

Club armchairs, deckchairs, car seats, etc. We are no longer worried about stretching our legs: the women will forgive us; they do the same. Codes of politeness have changed. Thus, women today show us their legs and we have been happy to accept it; they have cut their hair[vi] [. . .]. There are good reasons for all this. The chairs produced in the 'Faubourg'[vii] are high and still 'Grand Roy'.[viii] In the end we will go elsewhere for our furniture, to the office supplier or the sports manufacturer.

Then there are the tables.

To eat: the simple fact of displacing the four table legs to the centre is a serious stylistic reform.

But do we always eat at the same dining-room table? What if I didn't have a dining room in my house? Some days, there are two of us round

iv. Translator's note: Le Corbusier uses a surprising word here: 'calibre'. In French this means much the same as the technical definition in English, suggesting tubular steel, or at least an industrial process.

v. This strange expression, 'meuble-serviteur', is glossed in Le Corbusier's book *L'Art decorative d'aujourd'hui,* where he describes pieces of furniture as extensions to our limbs: 'The human limb-object [i.e. furniture] is a docile servant. A good servant is discreet and effaces himself, to allow his master freedom' (Le Corbusier, *L'art décoratif d'aujourd'hui*, Paris, G.Crès et cie, 1926, p.79; Eng. trans. Le Corbusier, *The Decorative Art of Today*, Cambridge, MA, MIT Press, 1987).

vi. This is an extremely condensed version of an argument that he would develop in his lecture in Buenos Aires in October 1929 (published as Le Corbusier, *Précisions sur un état présent de l'architecture et de l'urbanisme*, Paris [1930], 1969, pp.106–7), in which he claimed that women, with their bobbed hair and simplified clothing, were more 'modern' than men.

vii. The Faubourg St Antoine, to the east of the Bastille, in Paris, was the traditional furniture-making district of Paris.

viii. 'Grand Roy' is a seventeenth-century expression for the monarchy.

the table, tomorrow there will be five of us and on Sunday twelve. Here's a problem worth solving. Although we are usually only two at dinner, I install a huge dining table for the occasions when I invite six or a dozen guests. It's a nonsense.

Standardising the dimensions of my tables I could put together two tomorrow, and on Sunday four, and I could place them wherever I wanted in my house.

So where are the historic styles, the canons of furniture?

2. Sigfried Giedion
The new house

Sigfried Giedion, 'Das neue Haus; Bemerkungen zu Le Corbusiers (P. Jeanneret) Haus Laroche in Auteuil 1925' [The new house: notes on the La Roche house in Auteuil by Le Corbusier and Pierre Jeanneret], in *Das Kunstblatt*, vol.10, no.4, 1926, pp.153–7 (trans. Tim Benton).

Sigfried Giedion (1888–1968) was a Swiss architectural historian and critic who became a highly influential theoretician and apologist for the modern movement in architecture. Studying under Heinrich Wölfflin (1864–1945) at Munich, his first interest was German Baroque architecture, which he interpreted in the light of Hegelian idealism. Giedion believed that artistic and architectural styles reflected a Zeitgeist that changed to reflect material conditions. He attempted in all his writing to find a relationship between the economic, technical, social and imaginative spheres, arguing that a unity between these domains in the eighteenth century had been shattered by the industrialisation and urbanisation of Europe in the nineteenth century.

From 1924 he became a fervent supporter of modern architecture and design, contributing a number of critical and theoretical articles in Swiss, German and French magazines and writing a highly influential book, *Bauen in Frankreich, Eisen, Eisenbeton*,[1] in 1928, which was translated into English as *Building in France, Building in Iron, Building in Ferro-Concrete* in 1995 (following extract). In the same year he became the Secretary General of CIAM (Congrès Internationaux d'Architecture Moderne), founded at the Château de la Sarraz in Switzerland that year.

1. S. Giedion, *Bauen in Frankreich; Eisen Eisenbeton*, Berlin, Leipzig, 1928 (English language edition, *Building in France, Building in Iron, Building in Ferro-Concrete*, Santa Monica, CA, Getty Center for the History of Art and the Humanities, 1995).

In this article, written in 1926, he coins the term *Durchdringung* (interpenetration), which became a feature of the theory put forward in *Bauen in Frankreich*. The term signifies not only the transparency produced by large expanses of glass and the spatial effects produced by steel and concrete structures, but also a social transparency, reducing the hierarchies of traditional society. He interpreted the interpenetration of space in the La Roche house as a socially radical innovation, prefiguring a new way of living. Applied, as it was, to the house of a wealthy bachelor and art collector, this is a bizarre conclusion. It is surprising that Giedion, whose approach stressed the importance of transparency and structural lightness, should admire Le Corbusier as much as he did. The fact that Le Corbusier and Giedion, both Swiss, formed a tight working relationship in their campaigns to publicise modern architecture – and in particular the campaign for the prize-winning but unsuccessful design of Le Corbusier and his cousin Pierre Jeanneret (1896–1967) for the League of Nations building in Geneva in 1927 – may be one reason for this. TB

The context: If it is possible to build factories today, houses are impossible. Principally for two reasons. The house is weighed down by tradition and prejudice, both of which impose a certain constraint on architectural creativity, to which is added the resistance of the client. Secondly, the technical and social conditions required by the really serious architect of today do not yet exist. Architectural genius can always be identified by the breadth and strength of its creative vision and it will have to soar today if it is to design the new dwellings from precise materials.

The technical conditions have not been discovered because – with the possible exception of steel houses in England – there are as yet no factories producing windows, doors and walls for the architects to use. But the knowledge exists to standardise any type of manufacture.

The social conditions are not yet ready because the contemporary client – the wealthy bourgeois – has complicated and individualistic requirements demanding elaborate furnishing and a sequence of separate rooms. By contrast, the architect of the future seeks simplification and standardisation.

The laboratories of the 'New Spirit' across the world will have a job on their hands if, in the next ten years, they are to find a way to transform today's cumbersome and costly houses into practical tools ('as the car has become a tool').[i] This means factory prefabrication with dry assembly on site!

At any rate, the task will be made easier by the will to discover the style of the day.[ii]

i. Translator's note: In French in the original German text ('Comme l'auto devient un outil'), paraphrasing Le Corbusier's description of the house as a machine for living in (Le Corbusier, *Vers une architecture*, Paris, G.Crès et cie., 1924, p.200).
ii. Translator's note: 'Stilwille' translates literally as 'will to style'. Giedion could assume that contemporary readers would understand this term, which refers to the Hegelian (Hegel in glossary) notion of the Zeitgeist, the spirit of the era, which always tries to find a style to match the conditions of the day.

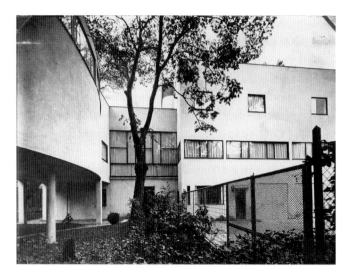

Fig.19
Le Corbusier and Pierre
Jeanneret
La Roche House, the gallery
is on the left, the hall straight
ahead
Courtesy Fondation Le
Corbusier, Paris

The new house is as gaunt as possible. As empty as possible. The new house will be sociable. But certainly not ostentatious! Translated into form, this means that all new houses will revolve around a single large space, surrounded by the other rooms, often without dividing walls. Apart from the one big space, all the other rooms – dining room, bedrooms, study – will be calculated like ship's cabins. Even the dining room will be small because people no longer require great feasts of gastronomic delights. The house interior will be as simple as possible – a few partition walls, a few doors, some carpets, some furniture (as far as possible built in), a few paintings, some curtains, recessed lighting, minimal sized lighting fixtures – the greatest possible liberation of space from clutter! The most precise resolution of every detail. Avoidance of unused spaces; instead of a pitched roof, a flat roof that can be put to good use. Economy, concision. Construction!

The immediate sources are ships, railway coaches and airplane cabins (fig.20).

Why? Because in all these cases it is the structural skeleton that is load-bearing, not the walls; because in all these cases the thin wall surfaces provide only insulation. We want lightweight walls because the new house is free-floating, supported by a few thin columns inside. This also has an impact on the external appearance. That's why the newly fashionable and gesturing cube-like houses – as solid as frozen lumps of dough – are the most disgusting of all. Lightness!

Summary: The new house is no longer an enclosed fortress. Both inside and outside. Just as today the whole foundation of the family has been penetrated, as if by anonymous X-rays, and must extend itself or be completely superseded, so the new house must be open inside and outside.

Structural consequences: The requirement now is for letting in as much light as possible from the outside: studio-like illumination. Just as in

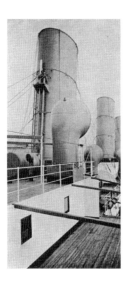

Fig.20
Deck of a Canadian Pacific
Liner
Courtesy Fondation Le
Corbusier, Paris

earlier times when no garden was complete without its ivy- and vine-lined bower, which created a new enclosure within the whole, the new house demands a roof garden where the sky can be framed by an architectural setting and one can live among the tree-tops.

In the interior, too, the aim is to get rid of partition walls as much as possible (figs.21, 22). Just as in America, where the gardens are not separated by hedges or barriers, a process has begun to avoid separating individual spaces with walls and doors and instead to indicate their purpose by the intelligent placement of furniture. At the same time that the Germans were going through the third or fourth Rococo revival – in the nineteenth century! – Frank Lloyd Wright in America was formulating the classic solutions for the new houses. This is the starting point for the new architecture. It has several consequences, leading to the intensive blending together of the main space with the others, not only horizontally but vertically as well.

We were all brought up in separate rooms. Many of us require seclusion, in order to soothe our nerves or concentrate on work. This will perhaps amaze the next generation. The new architecture is already taking account of this. In one word, the meaning of the new architecture is: interpenetration! Interpenetration from outside to inside, from inside to outside, from top to bottom.

This is the context for Le Corbusier's house for the art collector La Roche in the Parisian suburb of Auteuil. In fact it is a double house, with the La Roche house occupying the left wing. This is the first time that we have seen not only the posing of the problem of the new house, but also its resolution with architectural flair, for here the cool concrete walls are so divided, cut up and disposed – as if alive – as to make tangible a whole series of spatial volumes, in a way that we have only seen – in a wholly different realm – in certain Baroque chapels.

Step into the 'Hall' (fig.21) and you find yourself immediately in touch with every part of the house. Cut into the wall on the right is a black staircase. A second staircase is in the left-hand wall, with its landing projecting into space. On the right-hand side are the living quarters; to the left is the art collection. As you climb the stairs, the penetrating views evolve, with an unbroken sequence of interconnections and spatial bridges. Instead of demonstrating the new structural systems with cantilevered concrete slabs, they are given form here through a spatial vision alone. [. . .]

In the La Roche house, the library is stretched out like the bridge of a ship (fig.21) with views in all directions. It is precisely this interconnectedness of the spaces in the vertical dimension, this merging together of the floor planes, which allows the Franco-Swiss Le Corbusier to push past the discoveries of Frank Lloyd Wright into new territory.

The exterior of the houses in Auteuil are also a high point in Le Corbusier's creative practice to date (fig.19). Conspicuously still, without publicity, like his books. One day Le Corbusier will be considered one of the main exponents of the modern movement. The row of windows

Fig.21 [opposite]
Le Corbusier and Pierre
Jeanneret
La Roche House, hall and
library, 1923–5
Courtesy Fondation Le
Corbusier, Paris

Fig.22
Le Corbusier and Pierre
Jeanneret
La Roche House, hall, 1923–5
Courtesy Fondation Le
Corbusier, Paris

below recalls the discipline of a railway train, while the unframed windows
above could be compared with those of the upper deck of a Canadian
Pacific ocean liner (fig.20), illustrated in one of Le Corbusier's books.[iii]
Floating on thin concrete piers, the curving volume of the gallery space juts
out at right angles.

The La Roche house represents the successful leap from understanding
to creation.

iii. Le Corbusier, *L'Art décoratif*
d'aujourd'hui, Paris, G.Crès et cie, 1925,
p.187.

3. Sigfried Giedion
Building in France, Building in Iron, Building in Ferro-Concrete

First published in Germany as *Bauen in Frankreich, Eisen, Eisenbeton*, Berlin, Leipzig (1928), trans. J. Duncan Barry, Santa Monica, CA, Getty Center for the History of Art and the Humanities, 1995, pp.167, 168, 179–80, 186.

See the introduction to the previous extract for a discussion of this text.

Le Corbusier, the French Swiss from La Chaux-de-Fonds (born 1887), gets credit for having placed the housing problem, the notably most underdeveloped aspect of French architecture, unequivocally in the centre of his theoretical and practical activity. [. . .]

Like no one before him, Corbusier had the ability to make resonate the ferroconcrete skeleton that had been presented by science. We do not mean his designs. We mean the skill with which he knows how to translate construction, the frame, into the new housing function. Out of the possibility of hanging the whole weight of a building on a few ferroconcrete pillars, of omitting the enclosing wall wherever one so desires, Corbusier created the eternally open house. [. . .]

Corbusier's houses are neither spatial nor plastic; air flows through them! Air becomes a constituent factor! Neither space nor plastic form counts, only RELATION and INTERPENETRATION! There is only a single, indivisible space. The shells fall away between interior and exterior.

Yes, Corbusier's houses appear as thin as paper. They remind us, if you will, of the fragile wall paintings of Pompeii.[i] What they express in reality, however, coincides completely with the will expressed in all abstract painting. We should not compare them to paper and to Pompeii but point to Cubist paintings, in which things are seen in a floating transparency, and to the Purist painter [Charles-Édouard] Jeanneret himself, who as architect has assumed the name Le Corbusier. In his *La Peinture Moderne*[ii] he likes to assure us that he has deliberately chosen only the most ordinary bottles and glasses, that is, the most uninteresting objects, for his pictures so as not to detract attention from the painting. But the historian does not see this choice as accidental. For him the significance of this choice lies in the preference for floating, transparent objects whose contours flow weightlessly into each other. He points from the pictures to the architecture. [. . .]

i. Giedion is referring to the architectural settings of some Pompeian frescoes, which are constructed of spindly columns and open balconies.
ii. A. Ozenfant and Jeanneret, *La Peinture moderne*, Paris, Tours, G.Crès et Cie, 1925.

From the beginning, the will of the age[iii] requires a strong interpenetration and interrelationship of all parts and connection to the outside [. . .][iv] The spheres of the stories interpenetrate one another. Just as [Frank] Lloyd Wright – twenty years earlier – fused the rooms of the house horizontally, so Corbusier primarily does it vertically.[v] It is good to peel the skin off the house and to expose in the naked skeleton itself how the structural parts flow seamlessly into one another. Spaces and light, interior and exterior stream together. In an unexpected spot in the ceiling (above the wall-less library of the second story) is cut a square skylight, through whose clear glass one sees the sky (fig.21). Even the ceilings are light. No burdensome closure. [. . .]

What is Corbusier's achievement? He has grasped the house with the sensitivity of a seismograph and released it from traditional weight. [. . .] Corbusier has ventured pioneering work like no one else in our time. He attempts to translate into the housing form that suspended equilibrium, that lightness and openness that iron constructions of the nineteenth century expressed abstractly. He has shown us how one must mould the house throughout – below, above, on the sides – in order to relieve its weight. [. . .]

Le Corbusier's houses can be attacked on several points. He has been reproached for his romanticism, as when he – for instance, when he started out – takes over a whole series of formal motifs from shipbuilding. There is also a certain danger of a strong, aesthetic emphasis, which today's architects understandably fear. Architecture today – like nineteenth century construction – proceeds gradually, for it must lay down foundations for a long time to come.

Others may appear who will purify Corbusier's work. What is laid down nevertheless stays, for it is controlled by an architectural vision, and its roots are torn from the flesh of the age!

iii. Giedion refers again to the 'will of the epoch' or Zeitgeist. This is like saying: 'people today feel the need for a strong interpenetration.'

iv. Giedion refers here to his article in *das Kunstblatt* (see previous extract).
v. Giedon's original text was annotated: 'The elements of the open, two-story

plan are found in many [artists'] studios in France. Corbusier has elaborated what was rudimentarily available.'

4. Steen Eiler Rasmussen
'Le Corbusier: The Architecture of Tomorrow'

Steen Eiler Rasmussen, 'Le Corbusier die kommender Baukunst', *Wasmuths Monatshefte für Baukunst,* Berlin, 1926, pp.378–93, (trans. Imke Klein, edited by Tim Benton).

The Danish architect and town planner Steen Eiler Rasmussen (1898–1990) became a member of the Danish Royal Academy of Fine Arts at the age of twenty-four and embarked on an extensive series of travels in search of different systems of urban planning and domestic architecture. The article he wrote on Le Corbusier was partly devoted to the estate of fifty-one houses built by Le Corbusier and Pierre Jeanneret at Pessac near Bordeaux, which Rasmussen visited and photographed at its inauguration in June 1926. The first part of the essay, however, is of particular interest, since in it Rasmussen tries to grapple with the unfamiliar and shocking spatial and volumetric effects of the La Roche house. His emphasis on figure/ground ambiguity, and the difficulty he describes in seeing spatial relationships and formal relationships at the same time, was taken up by Bruno Reichlin (b.1941) in an important article, in which he discusses this as evidence of the influence of the De Stijl exhibition that opened in Paris in October 1923.[1] The drawings and models by Theo van Doesburg (1883–1931) and Cornelis van Eesteren (1897–1988) shown at this exhibition reduced architecture to a series of interconnecting planes, coloured in red, blue and yellow. Rasmussen, however, makes a comparison between the techniques of the purist art of Amédée Ozenfant (1886–1966) and Le Corbusier's methods of architectural design. He identified in both a progression from the realistic representation of objects or, in the case of architecture, a rational matching of form and function, towards a more abstract flowing together of forms, where identifiable representations of everyday objects become lost in a play of colour and form. TB

Whilst experiencing a building, an idea is formed in the mind of an overall relationship between volume and space.[i] An internal figurative image is created by combining all the separate perceptions available. In this way the observer obtains an understanding of the inside and outside of the

1. Bruno Reichlin, 'Le Corbusier vs de Stijl', in Yve-Alain Bois and B. Reichlin, *De Stijl et l'architecture en France*, Brussels, Pierre Mardaga, 1985, pp.91–108.
i. In the original German, Rasmussen repeatedly uses two words, 'Raum' (room or space) and 'Plastik' (three-dimensional solids or sculptural), which are difficult to translate because they are ambiguous. 'Raum' can refer both to negative space (the interval between solids) or a sensation of space as a positive quality, as when one talks about 'spatial qualities'. 'Plastik' means three-dimensional form, but it can refer to volumes, which have no mass, or to solids, which do. These rather subtle differences are crucial in Rasmussen's text.

Fig.23
Illustration of the figure /
ground phenomenon: black
vase or two white faces

building in a way that can never be achieved from a single viewpoint. When the observer attempts to form his overall perception, it is a similar process as that of the artist creating a form from his materials. [. . .]

Should the viewer by contrast experience a concave cavity, without any protruding surface, their imagination is led to think in spatial terms: the space itself becomes the object of aesthetic experience.

These things will possibly become clearer with reference to two-dimensional compositions, which can be illustrated by images.

The drawing [fig.23] above can be viewed as a picture of a black vase, but it also can be perceived as two white faces that are facing each other in front of a black background. However, it is not possible to see the vase and the faces simultaneously. Nor is it possible to think spatially and sculpturally at the same time. By a complete change of perception one can recognise either one or the other. There is a wealth of such examples of figures that are arranged in a way that allows the observer to choose what to perceive as the positive. However, in most cases we do not have a choice; the objects more or less force us into one or other perception. [. . .]

Thus, the terms 'plastic' or 'space' evolve from an analysis of how we are able to perceive the world; I am aware that artistic research, through which these terms first evolved, went in different directions; Schmarsow for example, links the feeling of space with the human body itself. He sees the symmetrical church as a continuation of the symmetrical organisation of the human physique itself. From this you might be led to conclude that a crippled architect would build misshapen churches. Modern romanticism has brought us such churches. In reality it was the spirit, not the architect's body that was crippled. The symmetrical forms of all objects that travel in a straight line do not require an aesthetic explanation. Imagine an asymmetrical flying machine.

Fig.24
Diagram of the same shape as volume
(left: gothic pier) and space (right:
circular room)

A coincidence of spatial and plastic imagination is therefore impossible. This does not mean that a single building may not trigger plastic and spatial perceptions one after the other. On the contrary. There are indeed for example few buildings that can only be perceived as space, apart from rock caves, where all shapes are hollowed out.

However all convex shapes, such as gothic compound piers (on left in fig.24) impose a plastic reading, whereas centralised rooms with alcoves (on right in fig.24) have to be inevitably understood as spatial. But such borderline cases are few and far between. [. . .]

If an architect wants to work only with shapes that evoke no association (as, for example, Frank Lloyd Wright or J.J.P. Oud try to do) his architectural means will be limited to the contrast between plastic form – emphasis – and space – counter-emphasis. And yet an architecture is evolving that does work only with plastic form and space. In a true sense, this is 'new architecture'.

We are looking at the entrance hall of the house in Auteuil [fig.21 on p.292, above], which was built by Le Corbusier and Pierre Jeanneret. We notice that they neither thought in plastic nor even less in spatial terms. Rather, we are made aware of the dominance of lines and surfaces that delimit the spaces and volumes.

Le Corbusier explained to me how he created this space: 'For me the window is the most important element, which is why I continued its line as the top edge of the balustrade.' It is evident in the illustration that only the contours that outline the surfaces have been continued: the window transforms into a wall surface. In traditional space-plastic-architecture[ii]

ii. Rasmussen is referring here to
buildings in which there is no
ambiguity between what is solid and
the space in between.

Fig.25
Amédée Ozenfant
Still Life with Bottles 1922
Oil on canvas 130.3 x 97 cm
Los Angeles County Museum of Art

this would be a mistake, whereas here it is not a mistake but expresses a fundamental attitude which is, I believe, not derived from architecture but rather belongs to modern painting.

We find the same configuration, for example, in a painting by Ozenfant. The painting was chosen as it is a good example, but I could have just as well chosen a painting by Le Corbusier himself, who is also a painter.

A bottle-shaped object is apparent in fig.25, in which a black area is aligned with a grey one to construct the shape of a bottle by the use of the outline alone. Further on the left, other white and grey areas are observable that are identified only by line. Thus the areas appear antithetic in tone and colour and only the outline holds them together as an entity. Equally the windows and wall surfaces are only connected through their boundaries in the entrance hall of the house in Auteuil (fig.21). No spatial or plastic image dominates in Le Corbusier's architecture because the various surfaces are perceived as abstract objects.

The optical impression loses perspective and relief in Ozenfant's painting in the same way; the lines merely become boundaries of areas which themselves do not form objects.

How a concept of architecture can arise at all under these circumstances, is probably easiest explained with reference to fig.23. Apart from the two possibilities already mentioned – perceiving a black vase or two white faces in this illustration – there is a third possibility. We can perceive the outline itself. To eliminate the memory of the vase and faces, turn the image around, then imagine the black outline drawing as the cartographic image of an island. Following the outline one can walk step by step along the coast. This offers a third and wholly new concept of the object. A cartographer would perceive the shoreline in something like this manner, whereas the owner of the island would imagine it as a surface area. In a similar manner, in a three-dimensional space one can perceive the surfaces which frame the space or instead look at the solid masses, and the artist may arrange the composition in such a way that either a spatial or a sculptural perception will be possible.

To support this, the following means are available. Firstly, as mentioned above, continuous lines may be used that link together hollow spaces and plastic forms. Thereby all surfaces become equal, their solidity loses all meaning and only the lines outlining the surfaces remain significant. As explained earlier, the sculptural effect may be strengthened by explicit solidity in relief and in the emphasis on the treatment of the corners. By contrast, when these elements are missing, the sculptural effect diminishes. Looking at Le Corbusier's buildings, we find that he increasingly abstains from these aids.

Whereas his earlier buildings still showed an indication of the cornice, his newest houses do not have any cornices; the walls appear to be made from paper. They are, as the figures clearly illustrate, dispossessed of their solidity. [. . .]

The spatial perception can also be extenuated. A hollow space is perceived by identifying its corners. As the room illustrated in fig.21 confirms, since the corners are barely detectable, one does not have a strong perception of the space. Rooms normally have vertical windows with corners that remain dark, which emphasise the shape of the room. Le Corbusier prefers to let the windows extend to the side walls.

Part 6 **From modernism
to globalisation**

Introduction

Pamela Bracewell-Homer

A complex range of debates and issues about the mode of existence of a work of art, the changing status of the artist and the role of the spectator is a defining feature of art theory and practice from the mid-twentieth century onwards. It is this very complexity that apparently renders contemporary art inaccessible and unapproachable, while at the same time we witness the rise of the art museum as a place of mass entertainment and embodied performance rather than thoughtful, disembodied intellectual contemplation.[1] The 'white cube' of minimal display and silence is challenged by interactive experience, bustle, crowds and *noise*. London's Tate Modern gallery opened to the public in 2000 and by the end of the first year had attracted four million visitors, ensuring its status as one of the most popular modern art collections in the world. It is also during this period that the 'work of art' decisively exits the confines of gallery spaces and moves out into urban, rural and geographical contexts, and when art as *idea* or concept, rather than a physical object, becomes a reality.

It is important to approach art in this period with some openness to its complexity and the shifting grounds of theoretical debate. Along with the lack of neatly defined conceptual or linguistic frameworks to anchor our experiences, it is necessary to work carefully from specifics and particulars in order to keep a foothold on some kind of manageable and justifiable point of view. The extracts in this section appropriately begin with the individual: an exploration of the nature of the artistic personality and its impact on the art that is produced. This is a highly compelling subject in the writing of an art history, and the first two texts serve a dual function in prominently displaying the characteristic

1. See N. Prior, 'Having One's Tate and Eating It: Transformations of the Museum in a Hypermodern Era', in A. McClellan (ed.), *Art and its Publics: Museum Studies at the Millennium*, Oxford, Blackwell, 2003, pp.51–74.

interests and preoccupations of both writer and artist. Jean-Paul Sartre's encounter with Alberto Giacometti offers a distinctive philosophical lens through which to approach the artist and his oeuvre, opening up a rich seam of imaginative and intellectual possibilities in the sheer act of engagement. 'An exhibition by Giacometti,' he observes, 'is a whole people', but it is a people who do not connect, living in a void of uncertainty. His probing of the tensions between something and nothing, being and non-being via Giacometti's work is characteristic of the existentialist enterprise that seeks to interrogate and explore the human condition. By contrast, casting a robust critical eye on Pablo Picasso's work and reputation, John Berger's assessment is forthright and openly contentious. This is an account that does not hesitate to air the questions barely contemplated by others. Running in direct opposition to popular belief, he insists that Picasso is not a great draughtsman at all, but that his greatness lies in the personality of the man himself and his restless, probing and inventive spirit.

It may seem that an artist writing about his or her own work is the ultimate authority, and the most direct guide to 'correct' or 'accurate' meanings and interpretations. This kind of material can be illuminating testimony, but it can also be a trap for the uncritical enquirer. Jackson Pollock's description of his 'drip-painting' techniques in the next short statement is certainly an insight into his practice. His stress on how a painting just emerges or 'come[s] through' from the unconscious does nevertheless reveal potential contradictions between expression and conscious control: 'It is only when I lose contact with a painting that the result is a mess.' Typically, this statement stands as a marker of the different ways in which Pollock's work and that of his contemporaries has been evaluated in critical terms. Debates about what is 'good' art, the nature and source of an aesthetic and how the relationship between artist and work is to be assessed are situated between the lines of Pollock's apparent contradictions. The extracts from Clement Greenberg's essay 'American-Type Painting' and Harold Rosenberg's 'The American Action Painters' reflect the deep divide between competing 'modernisms' as well as the fierce critical and personal rivalry between the two men. These texts frame questions about how the new modern American art was to be represented to a post-war world in which Europe had lost its artistic momentum.[2] The influx of refugee artists from Europe, including Piet Mondrian and the Surrealist Max Ernst, had handed that momentum squarely to America with the development of Abstract Expressionism, or alternatively for Rosenberg, 'Action Painting'.

2. See H. Rosenberg, 'The Fall of Paris', originally published in *Partisan Review*, 1940; reprinted and revised version in Charles Harrison and Paul Wood (eds.), *Art in Theory 1900–2000: An Anthology of Changing Ideas*, Oxford, Blackwell, 2003, pp.549–53.

For Allan Kaprow, the death of Pollock in 1956 symbolically signalled a parallel loss for art itself and a hugely significant turning point for practice: 'He created some magnificent paintings. But he also *destroyed* painting.' In mourning for Pollock, Kaprow recognises that the triumphs of painting in the guise of America's 'New Art' – Abstract Expressionism – had become either 'dull and repetitious' or backward looking. In either case, 'the jig was up' and it was time to move on. Reminiscent of Baudelaire's stress on *modernité* in the previous century (see pp.248–51 above), Kaprow predicts the transformation from 'painter' to 'artist' in the 1960s. The new artists will be immersed in, and 'dazzled' by 'everyday life,' but crucially, unlike 'the painter of modern life', they will not bounded by medium, body, materials, thought or action: *everything* could, and would be, the province of an artwork. Kaprow's prophetic account marks another critical moment in the development of twentieth-century art, and it is appropriate to see the texts that follow as examples of underlying trends that break away from the medium specificity of formalist modernism and the distinctiveness previously associated with the individual arts of painting, sculpture and architecture.

Accounts of modernism and what followed, symbolically associated with the death of Pollock, spawn innumerable debates about the character and meaning of the concept 'postmodern' and its well-earned attendant scare-quotes. It is a term that can apparently be avoided or sidestepped by substituting others that stress different concerns and practices, such as the 'expanded field',[3] 'happenings', 'pop art', 'site-specificity', 'conceptual art', 'conceptualism', 'post-conceptualism', 'globalisation' and so on. Yet none of these terms will substitute adequately enough to be sufficiently generalist or meaningful, so the term postmodern persists as a shorthand route to indicate, at least, a *refusal* of medium-specificity and modernism as a formalist preoccupation, if nothing else. It is clear that the only way forward again is to embrace the particular, and the extracts that follow provide a sample of key concerns and critical issues that emerge from a common point of rupture.

As 'painter' gives way to 'artist', the status of a work of art as a physical *object* or *practice* of some kind now becomes eroded. Lucy Lippard's and John Chandler's essay considers the point at which art becomes 'idea', a matter of thought, thinking processes and intellect, not of *making* or execution. The viewer becomes a reader and active participant, not a passive consumer of sumptuous form and colour. The development of conceptual art profoundly challenges the hegemony of the *visual* that is art's historical legacy. Lawrence Weiner's 'Statements' provide an example of the process by which language renders the making of physical objects

3. R. Krauss, 'Sculpture in the Expanded Field', *October,* vol.8, Spring 1979, pp.30–44.

redundant or unnecessary. Declaring that he does not 'mind' objects, but simply does not 'care to make them', the statements read as a set of instructions and descriptive actions. The mode of engagement with the 'work' is left entirely to the reader's imagination to construct, or conceptualise.[4]

'Conceptual art,' like 'postmodernism', is a generalist term that admits of a wide and complex range of understandings and experimental practices. Lucy Lippard's early involvement in recognising the trends that were emerging in the late 1960s is paralleled here with an extract from her much later publication concerning notions of place and identity and what these signify in relation to the making of artworks and ideas about its character. Read in conjunction with Miwon Kwon's analysis of 'site-specific' work, these two extracts testify to other strands of development such as land, environmental and public art. Issuing broadly out of conceptual art practices that questioned the nature of art as object, these practices held in common a wholesale rejection of the traditional role of galleries and institutions as the places where art should be situated: 'pure idealist space . . . was radically displaced by the materiality of the natural landscape or the impure and ordinary space of the everyday.' The 'space of art' now becomes a 'real place', and art and life are no longer held apart.

The last set of texts complete this collection of extracts 'documenting' moments of art historical, critical and visual culture. De-formed, de-objectified and projected out of the gallery into place and space, Kaprow's post-Pollock cry of 'what now?' for art is revisited in globalised terms. The success of Documenta, staged every five years in Kassel, Germany, as a celebrated showcase for contemporary art has proved that the art exhibition is by no means otiose or irrelevant. It did, however, have to change and adjust and even pander to a media-dominated world; the focus is now on the invited curatorial personalities and their individual vision of content, display and selected themes. These reviews give a flavour of political, social and cultural issues and concerns after the September 2001 attacks on the United States and at the beginning of a twenty-first century when the function and purpose of art again comes under intense scrutiny.

Kim Levin's assessment of Okwui Enwezor's ostensibly politicised Documenta 11 as the 'proclamation of a state of emergency' from which there is no escape route is an indictment of art's 'ultimate inadequacy within the socio-cultural-political-historical-context', despite the proliferation of hard-hitting photojournalistic and documentary exhibits and displays. Conversely, reading the exhibition as an aggressive attack on global capitalism as represented by America, the 'Evil Empire', at its centre, Blake Gopnik, a *Washington Post* staff writer, completely dismisses

4. In 'Statements', Weiner elaborates: '1. The artist may construct the work 2. The work may be fabricated 3. The work need not be built'; reprinted in Harrison and Wood 2003, p.894.

both Documenta's focus on non-American suffering and the value of most of the works on show. Despite this, in claiming that 'most of its works of art will stand or fall according to the sum of their own virtues and vices', this highly negative response still testifies to a pressing need to distinguish what is 'good' from 'bad', even at a remote historical distance from Greenberg's bullish modernism of the 1960s. Linda Nochlin, concentrating on the exhibition's 'documentary mode' and its hybridity, hails it as a success for new media and techniques and celebrates this 'diverse range of often stimulating and original works' that can operate on 'the level of the political unconscious, as well as that of conscious realization of justice'. Matthew Higgs' review is rather less enthusiastic; describing a 'sober and at times tetchy exhibition', and irritated by its 'hectoring tone', he reflects that the pessimism of the collection may be at least an 'honest reflection of our times', and that there is little that art can do to change anything for the better, echoing Levin's view.

Finally, the role of the curator and what is seen to be the 'best' art are key topics that frame matters for James Meyer. In no doubt about the 'outstanding' characteristics of Steve McQueen's film *Western Deep* (2002), for Meyer the resonating balance between its documentary reality effect and its 'microscopic attention to form' produces an 'aesthetic encounter' that he sees as an 'unlikely combination'.[5] In wondering whether Documenta should simply present what is 'outstanding' in contemporary art, or if the curator's vision should determine the works chosen for display, irrespective of perceived quality, Meyer highlights a continuing dilemma about the criteria by which the 'best' works are to be genuinely distinguished from the 'worst' or the merely mediocre. On this point, all five reviews indicate some interest in art as a powerful and relevant activity that has, or at least *should* have, some kind of continuing value that enables its survival and worth in both artistic and human terms.

5. This is not such an 'unlikely combination' as it appears. Links between aesthetic (formal) efficacy and political commitment in the arts have been widely debated. Especially memorable is Walter Benjamin's claim, speaking of literature, in his essay 'The Author as Producer' (1934), that 'political correctness' can only be achieved if a work is 'correct in the literary sense', by which is meant formal and artistic means and aims: 'this and nothing else makes up the quality of a work'; reprinted in Harrison and Wood 2003, pp.494–5.

Chapter 21
Modernism and figuration

Brendan Prenderville

1. Jean-Paul Sartre
'Giacometti in Search of Space'

Jean-Paul Sartre, 'Les Peintures de Giacometti', in *Derriére le miroir*, no.65, May 1954, trans. as 'Giacometti in Search of Space', *Art News*, vol.54, no.5, September 1955, pp.26–9, 63–5, trans. Lionel Abel.

In his 1954 article 'Giacometti in Search of Space', Jean-Paul Sartre (1905–80) focuses on themes somewhat different from those that concerned him in 'Search for the Absolute', his catalogue essay for Alberto Giacometti's exhibition at the Pierre Matisse Gallery, New York, in 1948. In that earlier text, he concentrated on a search for the essence of 'things' rather than culturally inflected, received expression. Here, discussing both sculpture and painting, he explores notions of the void (*le vide*, emptiness), and ends by introducing the theme of the imaginary, which had been addressed in his book *L'Imagination* (1936). BP / PJBH

His friend the Existentialist philosopher describes the painting and sculpture of this prolific artist who has just been given large exhibitions simultaneously in New York and London

'Several nude women, seen at *Le Sphinx*, and I, seated at the far end of the room. The distance separating us (the shining parquet floor which seemed impassable in spite of my desire to cross it) moved me as much as did the women' [from a letter by Giacometti to Pierre Matisse]. The result: four inaccessible figurines balanced on a deep swell, which is really only a vertical parquet floor. He made them as he saw them: distant. Here we have

four attenuated girls, present to an overwhelming degree, who surge from
the ground and, with one movement, threaten to fall upon him like the lid
of a trunk. 'I saw them often, above all one evening, in a little room, rue de
l'Echaudé, very near and menacing.' To his eyes, distance, far from being
an accident, is part of the intimate nature of an object. These prostitutes at
twenty meters – twenty impassable meters – he has forever frozen in the
awareness of his hopeless desire.

His studio is an archipelago, a disorder of various remotenesses. Against
the wall, the Mother-Goddess looms as inescapable as an obsession: if I
recoil, she advances; she is nearest when I am farthest. This statuette at
my feet is a passer-by seen in the rear-view mirror of a car, on the verge
of fading from sight; I approach in vain; he keeps his distance. [. . .] But
after all, it was man who created distance, which has meaning only in the
context of human space: it separates Hero from Leander and Marathon
from Athens, but not one pebble from another.

I understood distance one evening in April 1941: I had spent two months
in a prisoner-of-war camp – in other words, in a sardine box – and I had
experienced the most total proximity. The boundary of my personal life-
space had been my skin; day and night I had felt against me the warmth
of another shoulder, another thigh. This proximity, however, had not been
disturbing: others became simply an extension of myself. But that first
evening out, unknown in my native town, having not yet rediscovered my
former friends, I pushed past the door of a café. At once I was afraid – it
was almost terror. The few patrons there seemed more distant than the
stars. And my sudden agoraphobia was a confession of dim regret for the
intimate life from which I had just been forever weaned.

So with Giacometti: distance for him is not voluntary isolation, nor
is it recoil: it is requirement, ceremony, an understanding of difficulties.
It is the product – as he himself has said – of powers of attraction and
forces of repulsion. If he could not cross the few meters of shining parquet
separating him from the naked girls, it was because timidity or poverty
had nailed him to his chair; but if he felt their inviolability so strongly, he
must have wanted to touch their expensive bodies. He rejects promiscuity,
good-neighbor relationships, but only because he longs for friendship, love.
He does not dare take because he is afraid of being taken. His figurines
are solitary; but if you put them together, in no matter what order, their
solitude unites them; they instantly form a little magical society. 'Looking
at the figures which, in clearing the table, I had set on the ground at
random, I noted that they formed two groups which seemed to correspond
to what I was seeking. I mounted the two groups on bases without
changing their order in the least . . .'

An exhibition by Giacometti is a whole people. He has sculptured men
crossing a square without seeing one another; they criss-cross irrevocably
alone, and yet they are *together*; they are about to lose each other forever,

but would not be lost if they had not first sought each other out. Giacometti defined his universe better than I could when he wrote of one of his groups that it recalled to him 'a corner of a forest seen over a number of years where the trees, with bare and lashing trunks, . . . always seemed like personages immobilized in their step and conversing.'

And just what is that enclosing distance – which only the word can cross – if not the idea of the negative, the void? Ironical, defiant, ceremonious and tender, Giacometti sees the void everywhere. But not everywhere, it will be said. For there are objects which touch one another. But here is the point: Giacometti is not sure of anything, not even that objects really touch. For weeks at a time he is fascinated by the legs of a chair: they do *not* touch the ground. Between things, between men, connections have been cut; emptiness filters through everywhere; each creature secretes his own void. Giacometti became a sculptor because he is obsessed with the void. [. . .]

But can sculpture suffice? Kneading the plaster, he creates the void *from a starting point of the solid*. Once the figure has left his fingers it is 'at ten paces,' 'at twenty paces,' and in spite of everything remains there. It is the statue itself which decides the distance from which it must be seen, just as court etiquette determines the correct distance from which it is permitted to address the king. The real engenders the no-man's land which surrounds it. A figure by Giacometti is Giacometti himself producing his small local nothingness.

But all these delicate absences, which belong to us as do our names and shadows, do not suffice to make a world. There is also the void itself, that universal distance of everything from everything. The street is empty, in the sun; and *in this emptiness* a personage suddenly appears. Sculpture *starting with the solid* created the void; can it show the solid surging from a prior emptiness? Giacometti has tried a hundred times to answer this question. His composition, *The Cage*, corresponds to 'the desire to abolish the base and to have a *limited* space in which to realize a head and a figure.' For the whole problem is there: empty space can pre-exist the beings that fill it can be immemorially before them,[i] if first one encloses it between walls. This 'cage' is 'a room I saw; I even saw the curtains behind the woman . . .' Another time he makes 'a figurine in a box between two boxes which are houses.' In short, he frames his figures; they keep an imaginary distance with respect to us, but they live in a closed space which imposes on them its own distances, in a prefabricated void which they do not succeed in filling and which they submit to rather than create.

And what is this filled, framed void if not a painting? Lyrical when he is a sculptor, Giacometti becomes objective when he paints. He tries to catch

i. Punctuation error in the original. This should read 'empty space can pre-exist the beings that fill it, can be immemorially before them' ('le vide sera antérieur aux êtrei qui le peuplent immémorial').

the features of his wife Annette or of his brother Diego as they appear to
him in an empty room, in his barren studio. I tried to show elsewhere that
he approaches sculpture like a painter in that he treats a plaster figurine
like a character in a painting: he confers on his statuettes an imaginary
and fixed distance. Conversely, I can say that he approaches painting like
a sculptor, for he would like us to take for a *true* void the imaginary space
which the frame limits. He would like us to see the seated woman he has
just painted through layers of emptiness; he would like the canvas to be like
still water, and his personages to be seen *within* the picture, as Rimbaud
saw a salon in a lake, through transparency. Sculping as others paint,
painting as others sculp, is he a painter or a sculptor? Neither one nor the
other; and both. [. . .] In any case, these two activities are inseparable and
complementary: they enable him to treat the problem of his relations with
others in all its aspects, according to whether their isolation springs from
themselves, from him, or from the universe.

How paint the void? [. . .] Again it is necessary to distinguish the
personage from what surrounds him. Ordinarily one does this by
emphasizing the contours. But a line is formed by the interaction of two
surfaces, and the void cannot be represented as a surface, still less as a
volume. A line separates the container from the contained, but the void
is not a container. Shall one say that Diego stands out 'in relief' from
this wall behind him? No; the relation of 'form-background' exists only
for relatively flat surfaces; unless he leans against it, this far-off wall
cannot serve as a background for Diego; his only contact with it is that
the man and the object are in the same painting, they must bear certain
practical relationships to each other (tones, values, proportions) which
bring unity to the canvas. But these correspondences are at the same
time canceled out by the nothingness which interposes itself between
them. No, Diego does not stand out against the grey background of a
wall; he is there, and the wall is there, that is all. Nothing enfolds him,
nothing supports him, nothing contains him: he *appears*, isolated in the
immense frame of the void. With each one of his pictures, Giacometti
leads us back to the moment of creation *ex nihilo*, each one of them poses
again the old metaphysical question: why is there something rather than
nothing? And still, there is something: there is this stubborn apparition,
unjustifiable and superfluous. The painted personage is hallucinatory,
for he presents himself in the form of a *questioning apparition*.

But how fix him on the canvas without drawing his outline? Will he
not explode in the void like a deep-sea fish dredged to the water's surface?
Precisely no, for the drawn line expresses an arrested flight, it represents
an equilibrium between the internal and the external [. . .] One day when
he had undertaken to draw me, Giacometti burst out astonished, 'What
density,' he said, 'what lines of force!' I was more astonished than he, for
I think my face rather flabby, like everyone's. But the fact is that he saw

every line in it as a centripetal force. Seen that way, the face turns back on itself like a loop which closes in on itself. Turn around it; you will never see a contour; nothing but a solid. The line is the beginning of a negation, the passage from being to non-being. [. . .]

These extraordinary figures, so completely immaterial that they often become transparent, so totally and fully real that they affirm themselves like a blow of the fist and are unforgettable, are they appearances or disappearances? Both at once. They seem sometimes so diaphanous that one no longer dreams of asking questions about their expression, one pinches oneself to be sure that they really exist. If one obstinately continues to watch them the whole picture becomes alive, a somber sea rolls over and submerges them, nothing remains but a surface daubed with soot; and then the wave subsides and one sees them again, nude and white, shining beneath the waters. But when they reappear, it is to affirm themselves violently.

They are entirely in action, and sinister, too, because of the void which surrounds them. These creatures of nothingness attain the fullness of existence because they elude and mystify us.

A magician has three hundred helpers every evening: the spectators themselves, and their second natures. He attaches a wooden arm in a fine red sleeve to his shoulders. The public demands two arms in sleeves of the same material; it sees two arms, two sleeves, and is content. And all the time a real arm, wrapped in a black invisible material is at work seeking a rabbit, a playing card, an exploding cigarette. The art of Giacometti is related to that of the magician: we are his dupes and accomplices. Without our avidity, our heedless precipitation, the traditional errors of our senses, and the contradictions of our perceptions, he could not succeed in making his portraits live. He works by guesswork in accordance with what he sees, but above all in accordance with what he thinks we shall see. His aim is not to present us with an image, but to produce simulacra, which, while standing for what they actually are, excite in us the feelings and attitudes which ordinarily follow from an encounter with real men.

At the Musée Grévin, one becomes irritated or frightened on recognizing one of the guards as a waxwork. This theme immediately suggests the most exquisite jokes. But Giacometti does not particularly like jokes. Excepting one – the single practical joke to which he has devoted his life. He understood long ago that artists work in the imaginary and that we can only create by means of *trompe-l'oeil*; he knows that the 'monsters imitated by art' will never elicit from the spectators anything but fictive terrors. However he does not lose hope; one day he will show us a portrait of Diego apparently just like the others. We will be warned, we will know that it is only a phantom, a vain illusion, the prisoner of its frame. Yet, nonetheless, on that day we will feel before the mute canvas a shock, a tiny shock, of the very kind that we feel when we come home late and find a

stranger advancing toward us in the dark. Then Giacometti will know that
he has awakened by his pictures a real emotion, and that his simulacra,
without ceasing to be illusory, have had for a few moments *real* powers. I
wish him success very soon in this memorable trick. If he does not achieve
it no one can. No one, in any case, can go further than he has.

2. John Berger
'Why Picasso?'

New Statesman, 15 May 1954, reprinted in Berger, *Permanent Red:
Essays in Seeing*, London, Methuen, 1960, pp.126–32.

**The texts in the book *Permanent Red* (1960) by the English art critic,
novelist and painter John Berger (b.1926) were originally published as
current art criticism, and some of the views he expresses seem harsh, if
also lucid and challenging. In the following extract, originally published
as an article in the *New Statesman* in 1954, Berger outlines his criticism
of Pablo Picasso by analysing his art and comparing him to other artists.
He focuses on Picasso's *Guernica* (1937), one of the iconic works of art of
the twentieth century, in an attempt to unravel Picasso's popularity and
appeal to the public. Berger was to develop his critique of Picasso in his
1965 book *The Success and Failure of Picasso*. BP / AL**

Picasso suffers from being taken too seriously. He recognizes this himself
and it is one of the ironical themes of some of his drawings. The indignant
take him too seriously because they attach too much importance to the
mad prices his works fetch and so assume that he – instead of his
hangers-on – is a racketeer. The ostentatiously tolerant take him too
seriously because they forgive him his excesses on the ground that, when
he wants to be, he is a great draughtsman. In fact this is untrue. His best
drawings if compared to those of Géricault, Daumier or Goya appear
brilliant but not profound. Picasso's future reputation as a great artist
would not, as is so often said, be guaranteed by his realistic works alone.
The enthusiastic take him too seriously because they believe that every
mark he has made, the date on which he made it and the address he
happened to be living at, are of sacred significance. The critical minority
in the Communist Party take him too seriously because they consider him
capable of being a great socialist artist and assume that his political
allegiance is the result of dialectical thinking rather than of a
revolutionary instinct.

In front of Picasso's work one pays tribute above all to his personal spirit. The old argument about his political opinions on one hand and his art on the other is quite false. As Picasso himself admits, he has, as an artist, discovered nothing. What makes him great are not his individual works, but his existence, his personality. That may sound obscure and perverse, but less so, I think, if one inquires further into the nature of his personality.

Picasso is essentially an improviser. And if the word improvisation conjures up, amongst other things, associations of the clown and the mimic – they also apply. Living through a period of colossal confusion in which so many values both human and cultural have disintegrated, Picasso has seized upon the bits, the fragments, the smithereens, and with magnificent defiance and vitality made something of them to amuse us, shock us, but primarily to demonstrate to us by the example of his spirit that within the confusion, out of the debris, new ideas, new values, new ways of looking at the world can and will develop. His achievement is not that he himself has developed these things, but that he has always been irrepressible, has never been at a loss. [. . .]

Obviously, this shorthand view of Picasso oversimplifies, but it does, I think, go some way to explaining other facts about him: the element of caricature in all his work; the extraordinary confidence behind every mark he makes – it is the confidence of the born performer; the failure of all his disciples – if he were a profoundly constructive artist this would not be so; the amazing multiplicity of his styles; the sense that, by comparison with any other great artist, any single work by Picasso seems unfinished; the truth behind many of his enigmatic statements: 'In my opinion, to search means nothing in painting. To find is the thing.' 'To me there is no past or future in art. If a work of art cannot live always in the present it must not be considered at all.' Or, 'When I have found something to express, I have done it without thinking of the past or the future.'

The tragedy of Picasso is that he has worked at a time when a few live by art alone and the vast majority live without art at all. Such a state of affairs is of course tragic for all artists – but not to the same extent. Certain painters – such as Cézanne, Degas, Gris – can work for the sake of research. They work to extend painting's conquest over nature. Picasso is not such an artist; it is significant, for instance, that for over forty years he has scarcely ever worked directly from a model. Other painters – such as Corot, Dufy, Matisse – work to communicate a quintessence of pleasure and are comparatively satisfied if this pleasure is shared even by a few. Again, Picasso is not such an artist. There is a violence in everything he has done which points to a moral, didactic conviction that cannot be satisfied simply by an awareness of pleasure. Picasso is, as Rodin was in a different way, naturally a popular dramatic artist, terribly handicapped by a lack of constant popular themes.

What makes a work by Picasso immediately recognizable? It is not only his familiar formalizations but his unique form of conviction, of utter singlemindedness in any one canvas. Possibly that sounds a vague quality. Yet if one goes into a Romanesque church and sees side by side a twelfth- and an eighteenth-century fresco, it is this quality of singlemindedness which distinguishes them, when all the other obvious differences have been allowed for. The twelfth-century painter, if a local one, was usually clumsy, unoriginal and entirely ignorant of theoretical pictorial principles. The eighteenth-century painter was often sensitive, highly skilful in rendering an unlimited variety of poses and steeped in valid pictorial theory. What then explains the force of the twelfth-century artist's composition, the expressiveness of his drawing, the clarity of his narrative, and the comparative feebleness in all these respects of the later work? It is surely the earlier artist's singlemindedness – a singlemindedness which in terms of religion was impossible in the eighteenth century. Because the earlier artist knew exactly what he wanted to say – and it was something quite simple – it did not occur to him to think of anything else. This reduced observation to a minimum but it gave his work the strength of seeming absolutely inevitable. It is precisely the same quality which distinguishes Picasso's work from that of his contemporaries and disciples; [. . .]

Look at the drawing of the hands and feet in *Guernica*. They are based on no more penetrating observation than those in the work of an efficient cartoonist. They represent no more than the *idea* of hands and feet. But – and this is why *Guernica* can still strike our hearts until we are forced to make resolutions – the ideas of hands, feet, a horse's head, a naked electric light bulb, a mother and ravaged child, are all equally, heartrendingly and entirely dominated by the *idea* of the painting: the idea of horror at human brutality.

I believe that in almost every work of Picasso's a single idea has dominated in this way and so created a similar sense of inevitability. If the idea is, for example, that of sexual beauty, it demands more subtle forms: the girl's back will be made to twist very sensitively: but the principle remains the same and rests on the same ability of the artist to forgo all questioning and to yield completely to his one purpose. Forms become like letters in an alphabet whose significance solely depends upon the word they spell. And that brings us back to the tragedy of Picasso. Obviously in the case of an artist such as I have described, his development within himself and his impact on others depend exclusively on his ideas, on his themes. Picasso could not have painted *Guernica* had it only been a personal nightmare. And equally, if the picture which now exists had always been called *Nightmare* and we knew nothing of its connection with Spain, it would not move us as it does. All aesthetes will object to that. But *Guernica* has deservedly become the one legendary painting of this

century, and although works of art can perpetuate legends, they do not create them. If they could Picasso's problem would have been solved, for his tragedy is that most of his life he has failed to find themes to do himself justice. He has produced *Guernica, War* and *Peace*, some miraculous Cubist studies, some beautiful lyrical drawings, but in hundreds of works he has, as a result of his singlemindedness, sacrificed everything to ideas which are not worthy of the sacrifice. Many of his paintings are jokes, either bitter or gay; but they are the jokes of a man who does not know what else to do except laugh, who improvises with fragments because he can find nothing else to build upon.

It would be foolish to imagine that Picasso could have developed differently. His genius is wilful and instinctive. He had to take what was at hand and the unity of popular feeling essential to sustain the themes of a dramatic artist such as he is, has often been lacking or beyond his horizon. He then faced the choice of either abandoning his energy or expending it on something trivial and so creating parodies.

I am sure he is aware of this. He is obsessed by the question of whether art, which as we understand it today is so conscious an affair, can ever be born of happiness and abundance instead of lack and loss. The immortal incomplete artist beside the mortal complete man – this is one of his recurring themes. The sculptor chisels instead of enjoying his model. The poet-lovers search for images in one another's eyes instead of each other. A woman's head is drawn in a dozen different ways, is almost endlessly improvised upon, because no single representation can do her living justice. And then at other times, and particularly in the second half of his life, Picasso reverses his comment and comparison, and contrasts the artist's always new, fresh imagination with his ageing body.

Chapter 22
From Abstract Expressionism to Conceptual Art: a survey of New York art 1940–1970

Michael Corris

1. Jackson Pollock
'My Painting'

Possibilities I, 1947–8; reprinted in Charles Harrison and Paul Wood (eds.), *Art in Theory 1900–2000: An Anthology of Changing Ideas*, Oxford, Blackwell, 2003, p.571.

This is one of the few public statements that Jackson Pollock (1912–56) published on his art. It appeared in the New York journal *Possibilities I* in the winter of 1947–8. *Possibilities* was a specialist art journal with a small circulation and a readership limited to art experts, edited by the art critic and artist Robert Motherwell (1915–91), the art critic and poet Harold Rosenberg (1906–78), the musician John Cage (1912–92) and the architect Pierre Chareau (1883–1950). The final paragraph, although included in Pollock's draft, was omitted from the original article in *Possibilities I*, but was reinstated in Harrison's and Wood's anthology of 2003. Pollock's statement summarises his most recent preoccupations and methods of painting; however, none of his breakthrough drip paintings, which he began in the early 1940s, had yet been photographed for reproduction. This left readers puzzling over the relation between his text and the artworks – drawn between 1944 and 1946 – chosen to illustrate it. MC

My painting does not come from the easel. I hardly ever stretch my canvas before painting. I prefer to tack the unstretched canvas to the hard wall or the floor. I need the resistance of a hard surface. On the floor I am more at ease. I feel nearer, more a part of the painting, since this way I can walk around it, work from the four sides and literally be *in* the painting.

This is akin to the method of the Indian sand painters of the West.

I continue to get further away from the usual painter's tools such as easel, palette, brushes, etc. I prefer sticks, trowels, knives and dripping fluid paint or a heavy impasto with sand, broken glass and other foreign matter added.

When I am *in* my painting, I'm not aware of what I'm doing. It is only after a sort of 'get acquainted' period that I see what I have been about. I have no fears about making changes, destroying the image, etc., because the painting has a life of its own. I try to let it come through. It is only when I lose contact with the painting that the result is a mess. Otherwise there is pure harmony, an easy give and take, and the painting comes out well.

The source of my painting is the unconscious. I approach painting the same way I approach drawing. That is direct – with no preliminary studies. The drawings I do are relative to my painting but not for it.

2. Clement Greenberg '"American-Type" Painting'

Partisan Review, 1955; revised and reprinted in Clement Greenberg, *Art and Culture: Critical Essays*, Boston, Beacon Press, 1961, pp.208–10, 228

In this essay, originally published in the New York cultural magazine *Partisan Review* in 1955 and extensively reworked for subsequent publication in his collected essays, the art critic Clement Greenberg (1909–94) clears the ground for a theoretically informed reception of abstract expressionism. The text is highly polemical and was intended to explain the origins and originality of Abstract Expressionism while establishing the case for the international pre-eminence of the new American avant-garde in painting and sculpture. Greenberg describes the work of those artists whom he considers to be leading figures of this movement. In doing so, he deftly teases out their aesthetic positions and frames them with his sweeping theory of formalist Modernism in relation to Cubism, abstraction and the work of artists such as Franz Kline, Clyfford Still, Mark Rothko, Barnett Newman and Jackson Pollock. MC

Advanced painting continues to create scandal when little new in
literature or music does (sculpture is a different question). This would
be enough of itself to indicate that painting is the most alive of the avant-
garde arts at the present moment, for only a substantial and meaningful
newness can upset right-thinking people. But why should painting
monopolize this kind of newness? Among a variety of reasons, I single out
one that I feel to be most to the point: namely, the relative slowness, despite
all appearances to the contrary, of painting's evolution as a modernist art.

Though it may have started toward modernism earlier than the other
arts, painting has turned out to have a greater number of *expendable*
conventions imbedded in it, or at least a greater number of conventions
that are difficult to isolate in order to expend. It seems to be a law of
modernism – thus one that applies to almost all art that remains truly
alive in our time – that the conventions not essential to the viability of a
medium be discarded as soon as they are recognized. [. . .]

Painting continues, then, to work out its modernism with unchecked
momentum because it still has a relatively long way to go before being
reduced to its viable essence. Perhaps it is another symptom of this same
state of affairs that Paris should be losing its monopoly on the fate of
painting. By no one, in recent years, have that art's expendable conventions
been attacked more directly or more sustainedly than by a group of artists
who came to notice in New York during and shortly after the war. Labeled
variously as 'abstract expressionism,' 'action painting' and even 'abstract
impressionism,' their works constitute the first manifestation of American
art to draw a standing protest at home as well as serious attention from
Europe, where, though deplored more often than praised, they have
already influenced an important part of the avant-garde.

These American painters did not set out to be advanced. They set out to
paint good pictures that they could sign with their own names, and they
have 'advanced' in search of qualities analogous with those they admired
in the art of the past. They form no movement or school in any accepted
sense. They come from different stylistic directions, and if these converge
it is thanks largely to a common vitality and a common ambition and
inventiveness in relation to a given time, place and tradition. Their work
evinces uniform stylistic traits only when compared on the broadest terms
with that of artists who work, or worked, in other times, places or relations.
The pictures of some of these Americans startle because they seem to
rely on ungoverned spontaneity and haphazard effects; or because, at the
other extreme, they present surfaces which appear to be largely devoid
of pictorial incident. All this is very much seeming. There is good and bad
in this art, and when one is able to tell the difference between them he
begins to realize that the art in question is subject to a discipline as strict
as any that art obeyed in the past. What puzzles one initially – as it puzzled
one initially in every new phase of modernism in the past – is the fact

that 'abstract expressionism' makes explicit certain constant factors of pictorial art that the past left implicit, and leaves implicit on the other hand, certain other such factors that the past made explicit. [. . .] 'abstract expressionism' makes no more of a break with the past than anything before it in modernist art has. [. . .]

When they started out, the 'abstract expressionists' had had the traditional diffidence of American artists. They were very much aware of the provincial fate lurking all around them. This country had not yet made a single contribution to the mainstream of painting or sculpture. What united the 'abstract expressionists' more than anything else was their resolve to break out of this situation. By now, most of them (along with the sculptor, David Smith) have done so, whether in success or failure. Whatever else may remain doubtful, the 'centrality,' the resonance, of the work of these artists is assured.

3. Harold Rosenberg
'The American Action Painters'

Art News, vol.51, no.8, December 1952; reprinted in Harold Rosenberg, *The Tradition of the New* (1959), London, Thames and Hudson, 1962, pp.35–47.

Harold Rosenberg (1906–78) was one of the most active supporters of the new painting that emerged in New York during the late 1940s. He coined the term 'action painting' to refer to a particular type of gestural abstraction. Rosenberg's term has entered the lexicon of art and, for better or worse, represents a relatively accessible entry point into the aesthetic positions of artists as diverse as Jackson Pollock, Franz Kline (1910–62) and Willem de Kooning (1904–97). While critics such as Clement Greenberg focused on the *object* of painting, Rosenberg in this article draws our attention to the *act* of painting. This emphasis was influential on the next generation of American avant-garde artists. Like many other art critics of his time, Rosenberg was keen to elevate American painting over and above that being produced in Paris. MC

At a certain moment the canvas began to appear to one American painter after another as an arena in which to act – rather than as a space in which to reproduce, redesign, analyze or 'express' an object, actual or imagined. What was to go on the canvas was not a picture but an event.

The painter no longer approached his easel with an image in his mind; he went up to it with material in his hand to do something to that other piece of material in front of him. The image would be the result of this encounter.

It is pointless to argue that Rembrandt or Michelangelo worked in the same way. You don't get Lucrece with a dagger out of staining a piece of cloth or spontaneously putting forms into motion upon it.[i] She had to exist some place else before she got on the canvas, and the paint was Rembrandt's means for bringing her here. Now, everything must have been in the tubes, in the painter's muscles and in the cream-colored sea into which he dives. If Lucrece should come out she will be among us for the first time – a surprise. To the painter, she *must* be a surprise. In this mood there is no point in an act if you already know what it contains. [. . .]

Call this painting 'abstract' or 'Expressionist' or 'Abstract-Expressionist,' what counts is its special motive for extinguishing the object, which is not the same as in other abstract or Expressionist phases of modern art.

The new American painting is not 'pure art,' since the extrusion of the object was not for the sake of the aesthetic. The apples weren't brushed off the table in order to make room for perfect relations of space and color. They had to go so that nothing would get in the way of the act of painting. In this gesturing with materials the aesthetic, too, has been subordinated. Form, color, composition, drawing, are auxiliaries, any one of which – or practically all, as has been attempted, logically, with unpainted canvases – can be dispensed with. What matters always is the revelation contained in the act. It is to be taken for granted that in the final effect, the image, whatever be or be not in it, will be a *tension*.

A painting that is an act is inseparable from the biography of the artist. The painting itself is a 'moment' in the adulterated mixture of his life – whether 'moment' means, in one case, the actual minutes taken up with spotting the canvas or, in another, the entire duration of a lucid drama conducted in sign language. The act-painting is of the same metaphysical substance as the artist's existence. The new painting has broken down every distinction between art and life.

i. Lucretia (Lucrece) was raped by Sextus Tarquinus, son of the King of Rome, in 509 BCE and as a result she committed suicide.

4. Allan Kaprow
'The Legacy of Jackson Pollock'

Art News, October 1958, reprinted in Kaprow, *Essays on the Blurring of Art and Life*, Berkeley, University of California Press, 1993, pp.84–9.

This article by artist Allan Kaprow (1927–2006) was originally commissioned as an obituary for Jackson Pollock, who died in a car crash in August 1956, but *Art News* delayed publication by two years. It eventually appeared in October 1958. In the meantime, Kaprow presented his first 'happening' and began to clarify his ideas on this form of performance art that depended entirely on audience participation for its completion. Kaprow's early experience as a painting student with Hans Hofmann (1880–1966) in New York in 1947 provided him with a strong appreciation of 'action painting'. A later encounter with the musician John Cage and the presence of a favourable artistic milieu at Rutgers University, New Jersey, where Kaprow taught during the mid-1950s, laid the foundation for the artist's reflections on the future direction of art. MC

The tragic news of Pollock's death two summers ago was profoundly depressing to many of us. We felt not only a sadness over the death of a great figure, but in some deeper way that something of ourselves had died too. We were a piece of him: he was, perhaps, the embodiment of our ambition for absolute liberation and a secretly cherished wish to overturn old tables of crockery and flat champagne. We saw in his example the possibility of an astounding freshness, a sort of ecstatic blindness.

But, in addition, there was a morbid side to his meaningfulness. To 'die at the top' for being his kind of modern artist was, to many, I think, implicit in the work before he died. It was this bizarre consequence that was so moving. We remembered Van Gogh and Rimbaud. But here it was in our time, in a man some of us knew. This ultimate, sacrificial aspect of being an artist, while not a new idea, seemed, the way Pollock did it, terribly modern, and in him the statement and the ritual were so grand, so authoritative and all-encompassing in its scale and daring, that whatever our private convictions, we could not fail to be affected by its spirit.

It was probably this latter side of Pollock that lay at the root of our depression. Pollock's tragedy was more subtle than his death: for he did not die at the top. One could not avoid the fact that during the last five years of his life his strength had weakened, and during the last three, he hardly worked at all. Though everyone knew, in the light of reason, that the man was very ill (and his death was perhaps a respite from almost certain

future suffering), and that, in point of fact, he did not die as Stravinsky's fertility maidens did, in the very moment of creation/annihilation –we still could not escape the disturbing itch (metaphysical in nature) that this death was in some direct way connected with art. And the connection, rather than being climactic, was, in a way, inglorious. If the end had to come, it came at the wrong time.

Was it not perfectly clear that modern art in general was slipping? Either it had become dull and repetitive qua the 'advanced' style, or large numbers of formerly committed contemporary painters were defecting to earlier forms. America was celebrating a 'sanity in art' movement, and the flags were out. Thus, we reasoned, Pollock was the center in a great failure: the New Art. His heroic stand had been futile. Rather than releasing a freedom, which it at first promised, it caused him not only a loss of power and possible disillusionment, but a widespread admission that the jig was up. And those of us still resistant to this truth would end the same way, hardly at the top. Such were our thoughts in August, 1956.

But over two years have passed. What we felt then was genuine enough, but it was a limited tribute, if it was that at all. It was surely a manifestly human reaction on the part of those of us who were devoted to the most advanced of artists around us and who felt the shock of being thrown out on our own. But it did not actually seem that Pollock had indeed accomplished something, both by his attitude and by his very real gifts, which went beyond even those values recognized and acknowledged by sensitive artists and critics. The 'Act of Painting,' the new space, the personal mark that builds its own form and meaning, the endless tangle, the great scale, the new materials, etc. are by now clichés of college art departments. The innovations are accepted. They are becoming part of text books.

But some of the implications inherent in these new values are not at all as futile as we all began to believe; this kind of painting need not be called the 'tragic' style. Not all the roads of this modern art lead to ideas of finality. I hazard the guess that Pollock may have vaguely sensed this, but was unable, because of illness or otherwise, to do anything about it.

He created some magnificent paintings. But he also *destroyed painting*. [. . .]

What we have then, is a type of art which tends to lose itself out of bounds, tends to fill our world with itself, an art which, in meaning, looks, impulse, seems to break fairly sharply with the traditions of painters back to at least the Greeks. Pollock's near destruction of this tradition may well be a return to the point where art was more actively involved in ritual, magic and life than we have known it in our recent past. If so, it is an exceedingly important step, and in its superior way, offers a solution to the complaints of those who would have us put a bit of life into art. But what do we do now?

There are two alternatives. One is to continue in this vein. Probably many good 'near-paintings' can be done varying this esthetic of Pollock's

without departing from it or going further. The other is to give up the making of paintings entirely, I mean the single, flat rectangle or oval as we know it. [. . .]

Pollock, as I see him, left us at the point where we must become preoccupied with and even dazzled by the space and objects of our everyday life, either our bodies, clothes, rooms, or, if need be, the vastness of Forty-Second Street. Not satisfied with the *suggestion* through paint of our other senses, we shall utilize the specific substances of sight, sound, movements, people, odors, touch. Objects of every sort are materials for the new art: paint, chairs, food, electric and neon lights, smoke, water, old socks, a dog, movies, a thousand other things which will be discovered by the present generation of artists. Not only will these bold creators show us, as if for the first time, the world we have always had about us, but ignored, but they will disclose entirely unheard of happenings and events, found in garbage cans, police files, hotel lobbies, seen in store windows and on the streets, and sensed in dreams and horrible accidents. An odor of crushed strawberries, a letter from a friend or a billboard selling Draino; three taps on the front door, a scratch, a sigh or a voice lecturing endlessly, a blinding staccato flash, a bowler hat – all will become materials for this new concrete art.

The young artist of today need no longer say 'I am a painter' or 'a dancer.' He is simply an 'artist.' All of life will be open to him. He will discover out of ordinary things the meaning of ordinariness. He will not try to make them extraordinary. Only their real meaning will be stated. But out of nothing he will devise the extraordinary and then maybe nothingness as well. People will be delighted or horrified, critics will be confused or amused, but these, I am sure, will be the alchemies of the 1960s.

5. Lucy R. Lippard and John Chandler 'The Dematerialization of Art'

Art International, February 1968, pp.31–6.

Lucy Lippard (b.1937) is an independent academic, writer and political activist who had already established herself during the mid-1960s as an important commentator on minimal art and a champion of the abstract painter Ad Reinhardt (1913–67). In this extract from an article published in the journal *Art International*, Lippard – in collaboration with the artist and writer John Chandler – maps out the territory of what would come to be known as conceptual art. The article is one of the most widely cited texts in the literature of that tendency in art, and Lippard was perhaps the first critic to emphasise a connection between conceptual art and a range of earlier avant-garde art practices in performance, painting, sculpture and film. For Lippard and Chandler, the common threads that bind the avant-garde of the late 1960s are an interest in seriality, performance and above all an extreme reduction of the art object to the point of its 'dematerialization'. MC

During the 1960's, the anti-intellectual, emotional/intuitive processes of art-making characteristic of the last two decades have begun to give way to an ultra-conceptual art that emphasizes the thinking process almost exclusively. As more and more work is designed in the studio but executed elsewhere by professional craftsmen, as the object becomes merely the end product, a number of artists are losing interest in the physical evolution of the work of art. The studio is again becoming a study. Such a trend appears to be provoking a profound dematerialization of art, especially of art as object, and if it continues to prevail, it may result in the object's becoming wholly obsolete.

The visual arts at the moment seem to hover at a crossroad which may well turn out to be two roads to one place, though they appear to have come from two sources: art as idea and art as action. In the first case, matter is denied, as sensation has been converted into concept; in the second case, matter has been transformed into energy and time-motion. If the completely conceptual work of art in which the object is simply an epilogue to the fully evolved concept seems to exclude the *objet d'art*, so does the primitivizing strain of sensuous identification and envelopment in a work so expanded that it is inseparable from its non-art surroundings. Thus the extremely cool and rejective projects of Judd, LeWitt and others have a good deal in common with the less evolved but perhaps eventually more fertile synesthetic ambitions of Robert Whitman, Robert Rauschenberg and Michael Kirby, or the dance of Yvonne Rainer and

Alex Hay, among others. This fact is most clearly illustrated by the work of Robert Morris, who has dealt with idea as idea, idea as object, and idea as performance. In fact, the performance media are becoming a no man's or everyman's land in which visual artists whose styles may be completely at variance can meet and even agree. As the time element becomes a focal point for so many experiments in the visual arts, aspects of dance, film and music become likely adjuncts to painting and sculpture, which in turn are likely to be absorbed in unexpected ways by the performing arts. [...]

A highly conceptual art, like an extremely rejective art or an apparently random art, upsets detractors because there is 'not enough to look at', or rather not enough of what they are accustomed to looking *for*. Monotonal or extremely simple-looking painting and totally 'dumb' objects exist in time as well as in space because of two aspects of the viewing experience. First, they demand more participation by the viewer, despite their apparent hostility (which is not hostility so much as aloofness and self-containment). More time must be spent in immediate experience of a detail-less work, for the viewer is used to focusing on details and absorbing an impression of the piece with the help of these details. Secondly, the time spent looking at an 'empty' work, or one with a minimum of action, seems infinitely longer than action-and-detail-filled time. This time element is, of course, psychological, but it allows the artist an alternative to or extension of the serial method. Painter-sculptor Michael Snow's film *Wavelength*, for instance, is tortuously extended within its 45-minute span. By the time the camera, zeroing in very slowly from the back of a large loft, reaches a series of windows and finally a photograph of water surface, or waves, between two of them, and by the time that photograph gradually fills the screen, the viewer is aware of an almost unbearable anticipation that seems the result of an equally unbearable length of time stretched out at a less than normal rate of looking; the intensity is re-enforced by the sound, which during most of the film is monotonal, moving up in pitch and up in volume until at the end it is a shrill hum, both exciting and painful. [...]

The medium need not be the message, and some ultra-conceptual art seems to declare that the conventional art media are no longer adequate as media to be messages in themselves. [...]

Much recent conceptual art is illustration in a sense, in the form of drawings or models for nearly impossible projects that will probably never be realized, or in many cases, *need* no further development. According to Joseph Kosuth: 'All I make are models. The actual works of art are ideas. Rather than "ideals", the models are a visual approximation of a particular art object I have in mind.'[1] [...]

1. *Non-Anthropomorphic Art by Four Young Artists: Four Statements*, Lannis Gallery, Feb. 1967.

Idea art has been seen as art about criticism rather than art-as-art
or even art about art. On the contrary, the dematerialization of the object
might eventually lead to the disintegration of criticism as it is known
today. The pedantic or didactic or dogmatic basis insisted on by many
of these artists is incorporated in the art. It bypasses criticism as such.
Judgment of ideas is less interesting than following the ideas through. In
the process, one might discover that something is either a good idea, that
is, fertile and open enough to suggest infinite possibilities, or a mediocre
idea, that is, exhaustible, or a bad idea, that is, already exhausted or with
so little substance that it can be taken no further. (The same can be applied
to style in the formal sense, and style except as an individual trademark
tends to disappear in the path of novelty.) If the object becomes obsolete,
objective distance becomes obsolete. Sometime in the near future it
may be necessary for the writer to be an artist as well as for the artist
to be a writer. There will still be scholars and historians of art, but the
contemporary critic may have to choose between a creative originality
and explanatory historicism.

6. Lawrence Weiner
'Statements'

Lawrence Weiner, *Statements* (1968), reprinted in *Art-Language: The Journal of Conceptual Art*, vol.1, no.1, Coventry, May 1969, p.17.

The conceptual artist Lawrence Weiner (b.1942) has remarked that he is interested in the relationship between materials and human beings. During the late 1960s, Weiner began to compose situations that demonstrated the properties of a variety of material substances. Reading like scripts for performances, it remained unclear whether the work of art was the action described or the instructions themselves. Indeed, Weiner states that the performance of the action is at the discretion of the owner of the work. Weiner's 'Statements', which were divided into general and specific types, were printed as an artist's book in 1968. Some of them were then reprinted in the conceptual art journal *Art-Language* in 1969. Those reproduced here are taken from that source. MC

General Statements

1. A field cratered by structured simultaneous TNT explosions.
2. A removal of an amount of earth from the ground. The intrusion into this hole of a standard processed material.
3. One sheet of plywood secured to the floor or wall.
4. One regular rectangular object placed across an international boundary allowed to rest then turned to and turned upon to intrude the portion of one country into the other.
5. A removal to the lathing or support wall of plaster or wall board from a wall.
6. One standard dye marker thrown into the sea.
7. A piece of masonite painted allowed to dry. Sanded for a certain time elapsure with a standard flat finishing sander. And secured to the wall or floor.
8. One sheet of transparent plastic secured to the floor or wall.
9. A rectangular canvas and stretcher support with a rectangular removal from one of the four corners sprayed with paint for a time elapsure.
10. Common steel nails driven into the floor at points designated at time of installation.
11. An amount of paint poured directly upon the floor and allowed to dry.
12. A series of stakes set in the ground at regular intervals to form a rectangle. Twine strung from stake to stake to demark a grid.

Chapter 23
Border crossings: installations, locations and travelling artists

Gill Perry

1. Lucy R. Lippard
'Being in Place'

Lucy R. Lippard, *The Lure of the Local: Senses of Place in a Multicentered Society*, New York and London, The New Press, 1997, pp.33–8.

Lucy Lippard (b.1937) is an influential art critic, writer and curator, who was active in the anti-modernist avant-garde of the 1960s and 1970s. The extract reproduced here, published in 1997, explores our various senses of place, and the ways in which these can inform artworks. Going beyond the limits of the art world, she explores ideas of community, nature and how we produce landscape. She considers the meanings of the term 'a sense of place' and its relationship with a controversial notion of 'regionalism'. She argues that regional concerns can emerge even within our modern, homogenised, electronic culture, and charts some of the ways in which recent art practices have been associated with, or rejected, regionalism. GP

> *The land is important to me, but even more important is the idea that it becomes a 'place' because someone has been there*
> – Marlene Creates

Much has been written in the last twenty years or so about 'the sense of place,' which is symbiotically related to a sense of displacement. I am ambivalent about this phrase even as I am touched by it. 'A sense of place' has become not just a cliché but a kind of intellectual property, a way for nonbelongers to belong, momentarily. At the same time, senses of place,

a serial sensitivity to place, are invaluable social and cultural tools, providing much-needed connections to what we call 'nature' and, sometimes, to cultures not our own. Such motives should be neither discouraged nor disparaged.

All places exist somewhere between the inside and the outside views of them, the ways in which they compare to, and contrast with, other places. A sense of place is a virtual immersion that depends on lived experience and a topographical intimacy that is rare today both in ordinary life and in traditional educational fields. From the writer's viewpoint, it demands extensive visual and historical research, a great deal of walking 'in the field,' contact with oral tradition, and an intensive knowledge of both local multiculturalism and the broader context of multicenteredness. On one hand, there is 'the ability to know a new place quickly and well, and to adapt to its circumstance,' a source of mapping in indigenous societies. This is still a survival technique, a kind of scanning known to citydwellers as well as to woodsmen. On the other hand, memory is stratified. If we have seen a place through many years, each view, no matter how banal, is a palimpsest. Yi-fu Tuan says that the terrain of late childhood seems to penetrate our lives and memories most intensely. In Georgetown, driving on an almost-two-lane tarred road, I can call up its predecessors: the one-lane hard-top, the gravel, the dirt with the tall grasses growing up between the ruts, stained with oil from under the cars, the straightened curve now lying forgotten over there in the puckerbrush. I can imagine even further back. The old road seen in photographs, described in recollections, is now woods, its ruts the faintest trace. Even as a newcomer, in New Mexico, once I know that *Avenida Vieja* (the old road) ran northeast-southwest before the highways came in and the adobe ruin next door might have been a stage stop, I can call it up along with the noisy carts and carriages that bumped over it. Memory is part first-person, part collective.

The sense of place, as the phrase suggests, does indeed emerge from the senses. The land, and even the spirit of the place, can be experienced kinctically, or kinesthetically, as well as visually. If one has been raised in a place, its textures and sensations, its smells and sounds, are recalled as they felt to a child's, adolescent's, adult's body. Even if one's history there is short, a place can still be felt as an extension of the body, especially the walking body, passing through and becoming part of the landscape. Michael Martone is eloquent about his sensuous identification with the Midwest:

The Midwest is too big to be seen [as the Heartland] . . . I think of it more as a web of tissue, a membrane, a skin. And the way I feel about the Midwest is the way my skin feels and the way I feel about my own skin . . . the Midwest is hide, an organ of sense and not power, delicate and coarse at the same time . . .

Kent Ryden isolates the sense of place as a specific genre of regional folklore, offering four 'layers of meaning' familiar to local residents but invisible to visitors, cartographers, and even scholars: local and material lore including local names for flora, fauna, and topography; handed-down history, much of it intimate, some of it apocryphal; group identity and place-based individual identity; and the emotions or affective bonds attached to place, which Yi-fu Tuan calls 'topophilia.'

Place is most often examined from the subjective viewpoint of individual or community, while 'region' has traditionally been more of an objective geographic term, later kidnapped by folklorists. In the fifties, a region was academically defined as a geographic center surrounded by 'an area where nature acts in a roughly uniform manner.' Today a region is generally understood not as a politically or geographically delimited space but one determined by stories, loyalties, group identity, common experiences and histories (often unrecorded), a state of mind rather than a place on a map. Perhaps the most accurate definition of a region, although the loosest, is Michael Steiner's; 'the largest unit of territory about which a person can grasp "the concrete realities of the land," or which can be contained in a person's genuine sense of place.'

'Regionalism' – named and practiced as either a generalized, idealized 'all-Americanism' or a progressive social realism – was most popular in the thirties when, thanks to hard times, Americans moved voluntarily around the country less than they had in the twenties or would in the fifties. During the Great Depression, the faces and voices of 'ordinary people' became visible and audible, through art, photographs, and journalism, and had a profound effect on New Deal government policy. John Dewey and other scholars recognized that local life became all the more intense as the nation's identity became more confusingly diverse and harder to grasp. (Allen Tate called America 'that all-destroying abstraction.') The preoccupation with regionalism was a 'search for the primal spatial structure of the country . . . [for] the true underlying fault lines of American culture.'

Bioregionalism seems to me the most sensible, if least attainable, way of looking at the world. Rejecting the artificial boundaries that complicate lives and divide ecosystems, it combines changing human populations and distinct physical territories determined by land and life forms. But most significantly, a region, like a community, is subjectively defined, delineated by those who live there, not by those who study it, as in Wendell Berry's description of regionalism as 'local life aware of itself.'

In April, 1996, the town of Fairfield, California, for instance, inspired by a coalition of local public artists and administrators, asked itself, 'Where is Fairfield?' A local high school designed chairs as symbols of places in the community; grade schoolers designed postcards; t-shirts, supermarket bags, banners, local media, and oral history projects all asked the question.

A year later, responses are still coming in as the formerly agricultural, now-urban, town continues the process of struggling to identify itself and its disparate parts.

In the art world, the conservative fifties saw regionalism denigrated and dismissed, in part because of its political associations with the radical thirties, in part because its narrative optimism, didactic oversimplification and populist accessibility was incompatible with the Cold War and out of sync with the sophisticated, individualist Abstract Expressionist movement, just then being discovered as the tool with which to wrench modern art away from Parisian dominance. Today the term *regionalism*, most often applied to conventional mediums such as painting and printmaking, continues to be used pejoratively, to mean corny backwater art flowing from the tributaries that might eventually reach the mainstream but is currently stagnating out there in the boondocks.

In fact, though, all art is regional, including that made in our 'art capital,' New York City. In itself extremely provincial, New York's artworld is rarely considered 'regional' because it directly receives and transmits international influences. The difference between New York and 'local' art scenes is that other places know what New York is up to but New York remains divinely oblivious to what's happening off the market and reviewing map. Yet, paradoxically, when the most sophisticated visitors from the coasts come to 'the sticks,' they often prefer local folk art and 'naive' artists to warmed-over syntheses of current big-time styles. (Ad Reinhardt, the ultimate avant-gardist, 'last painter' of apparently solid black canvases, once gave a jury prize to an elderly woman's leaf collages, infuriating his local imitators, who thought they had the inside track.)

Instead of getting angry, defensive, or discouraged, it might be a good idea for local artists to scrutinize their situation. Why *does* this very local art often speak so much more directly to those who look at a lot of art all over the place? What many of us find interesting and energetic in the 'regions' is a certain 'foreignness' (a variation on the Exotic Other) that, on further scrutiny, may really be an unexpected familiarity, emerging from half-forgotten sources in our own local popular cultures. Perhaps it is condescending to say that a regional art is often at its best when it is not reacting to current marketplace trends but simply acting on its own instincts; the word 'innocent' is often used. But it can also be a matter of self-determination. Artists are stronger when they control their own destinies and respond to what they know best – which is not necessarily related to place. Sometimes significant work is done by those who have never (or rarely) budged from their place, who are satisfied with their lives, and work out from there, looking around with added intensity and depth because they are already familiar with the surface. These artists may seem marginal even to their local artworld, but not to their own audiences and communities.

It has been argued that there is no such thing as regionalism in our homogenized, peripatetic, electronic culture, where all citizens have theoretically equal access to the public library's copy of *Art in America* if not to the Museum of Modern Art (which costs as much as a movie). On another level altogether, middle-class museum-goers living out of the centers do become placeless as they try to improve and appreciate, and in the process learn to distrust their own locally aquired tastes. They are usually unaware that mainstream art in fact borrows incessantly from locally rooted imagery as well as from the much-maligned mass cultures – from Navajo blankets to Roman Catholic icons[i] to Elvis to Disney.

Everybody comes from someplace, and the places we come from – cherished or rejected – inevitably affect our work. Most artists today come from a lot of places. Some are confused by this situation and turn to the international styles that claim to transcend it; others make the most of their multicenteredness. Some of the best regional art is made by transients who bring fresh eyes to the place where they have landed. They may be only in temporary exile from the centers (usually through a teaching job), but they tend not to waste their time bewailing their present location or getting away whenever possible. They are challenged by new surroundings and new cultures and bring new material into their art. As Ellen Dissanayake has observed, the function of art is to 'make special'; as such, it can raise the 'special' qualities of place embedded in everyday life, restoring them to those who created them. Yet modernist and some postmodernist art, skeptical of 'authenticity,' prides itself on departing from the original voices. The sources of landbased art and aesthetics remain opaque to those who only study them.

In all discussions of place, it is a question of abstraction and specifics. If art is defined as 'universal,' and form is routinely favored over content, then artists are encouraged to transcend their immediate locales. But if content is considered the prime component of art, and lived experience is seen as a prime material, then regionalism is not a limitation but an advantage, a welcome base that need not exclude outside influences but sifts them through a local filter. Good regional art has both roots and reach.

i. Strictly speaking there are no Roman Catholic icons. The word 'icon' in the sense of religious image is exclusively associated with the Orthodox Church. [AL]

2. Miwon Kwon
One Place after Another

Miwon Kwon, 'Introduction' and 'Genealogy of Site Specificity', *October*, no.80, Spring 1997, pp.85–96, revised version in *One Place after Another: Site-Specific Art and Locational Identity* (2002), Cambridge, MA, and London, MIT Press, 2004, pp.1–3, 11–13, 168–70.

Miwon Kwon (b.1961) teaches art history at the University of California, Los Angeles. These extracts were published in the Introduction and Chapter 1 ('Genealogy of Site Specificity') of her book *One Place after Another* (2002), although an earlier version of the essay was published in the journal *October* in 1997. Her book is a critical exploration of the emergence of site-specific art from the late 1960s to the 1990s. She sees some early examples of this genre as a radical reaction to prevailing ideas of artworks as autonomous and universal, somehow independent of location, concerned with the positioning of art in terms of a spatial-political dynamic. GP

Introduction

Site-determined, site-oriented, site-referenced, site-conscious, site-responsive, site-related. These are some new terms that have emerged in recent years among many artists and critics to account for the various permutations of site-specific art in the present. On the one hand, this phenomenon indicates a return of sorts: an attempt to rehabilitate the criticality associated with the anti-idealist, anticommercial site-specific practices of the late 1960s and early 1970s, which incorporated the physical conditions of a particular location as integral to the production, presentation, and reception of art. On the other hand, it signals a desire to *distinguish* current practices from those of the past – to mark a difference from artistic precedents of site specificity whose dominant positivist formulations (the most well-known being Richard Serra's) are deemed to have reached a point of aesthetic and political exhaustion.

This concern to reassess the relationship between the art work and its site is largely provoked by the ways in which the term 'site-specific' has been uncritically adopted as another genre category by mainstream art institutions and discourses. The term is indeed conspicuous in a diverse range of catalogue essays, press releases, grant applications, magazine reviews, and artist statements today; it is applied rather indiscriminately to art works, museum exhibitions, public art projects, city arts festivals, architectural installations; and it is embraced as an automatic signifier of 'criticality' or 'progressivity' by artists, architects, dealers, curators, critics, arts administrators, and funding organizations.[1] For those who

adhere to cooptation as the most viable explanation of the relationship between advanced art, the culture industry, and the political economy throughout the twentieth century, the unspecific (mis)uses of the term 'site-specific' are yet another instance of how vanguardist, socially conscious, and politically committed art practices always become domesticated by their assimilation into the dominant culture. And this argument would insist that if the aesthetic and political efficacy of site-specific art has become insignificant or innocuous in recent years, it is because it has been weakened and redirected by institutional and market forces.

But the current efforts to redefine the art-site relationship are also inspired by a recognition that if site-specific art seems no longer viable – because its critical edges have dulled, its pressures been absorbed – this is partly due to the conceptual limitations of existing models of site specificity itself. In response, many artists, critics, historians, and curators, whose practices are engaged in problematizing received notions of site specificity, have offered alternative formulations, such as context-specific, debate-specific, audience-specific, community-specific, project-based.[2] These terms, which tend to slide into one another at different times, collectively signal an attempt to forge more complex and fluid possibilities for the art-site relationship while simultaneously registering the extent to which the very concept of the site has become destabilized in the past three decades or more.

Yet despite these efforts to rethink site specificity, and despite the rise in interest in the artistic developments of the 1960s and 1970s in general, contemporary art discourse still lacks a substantive account of the historical and theoretical 'grounds' of site specificity. Consequently, the framework within which we might discuss the artistic merit and/ or political efficacy of the various formulations of site specificity, old and new, remains inconclusive.[3] Most importantly, what remain

1. The two concurrent exhibitions organized in conjunction with the 1996 Olympic Games in Atlanta, Georgia, are good examples of the confusing uses of the term 'site specificity' in contemporary art discourse. The exhibitions were 'Rings,' a thematic show structured around the 'five universal emotions symbolically related to the number of the Olympic rings,' and 'Picturing the South: 1860 to the Present,' a photography exhibition with a regional focus on the history and culture of the American South, especially Atlanta. In the press release for the exhibitions, Ned Rifkin, Director of the High Museum of Art in Atlanta, promoted the former rather than the

latter as a site-specific exhibition. In this case, despite the universalizing theme of 'Rings,' its temporal coordination with the Olympic Games would seem to trump the geographical specificity of 'Picturing the South.'
2. These terms are used rather loosely and interchangeably in current art discourse. The concept of debate specificity, however, was coined in the 1970s by Mary Kelly to describe her move away from the prevailing dominance of concerns for medium specificity in art discourse. See her comments in her interview with Douglas Crimp in *Mary Kelly* (London: Phaidon Press, 1997), 15. Kelly's debate specificity corresponds to the notion of

discursive sites that I develop in chapter 1.
3. In addition to a few articles, three recent books begin to address this problem: Julie H. Reiss, *From Margin to Center: The Spaces of Installation Art* (Cambridge: MIT Press, 1999); Nick Kaye, *Site-Specific Art; Performance, Place, and Documentation* (London: Routledge, 2000); and Erika Suderburg, ed., *Space, Site, Intervention: Situating Installation Art* (Minneapolis: University of Minnesota Press, 2000). Much work remains, however, in historicizing and theorizing site-specific art, as distinct from installation art

unrecognized, and thus unanalyzed, are the ways in which the very term 'site specificity' has itself become a site of struggle, where competing positions concerning the nature of the site, as well as the 'proper' relationship of art and artists to it, are being contested. [. . .]

Genealogy of Site Specificity

Site specificity used to imply something grounded, bound to the laws of physics. Often playing with gravity, site-specific works used to be obstinate about 'presence,' even if they were materially ephemeral, and adamant about immobility, even in the face of disappearance or destruction. Whether inside the white cube or out in the Nevada desert, whether architectural or landscape-oriented, site-specific art initially took the site as an actual location, a tangible reality, its identity composed of a unique combination of physical elements: length, depth, height, texture, and shape of walls and rooms; scale and proportion of plazas, buildings, or parks; existing conditions of lighting, ventilation, traffic patterns; distinctive topographical features, and so forth. If modernist sculpture absorbed its pedestal/base to sever its connection to or express its indifference to the site, rendering itself more autonomous and self-referential, thus transportable, placeless, and nomadic, then site-specific works, as they first emerged in the wake of minimalism in the late 1960s and early 1970s, forced a dramatic reversal of this modernist paradigm.[4] Antithetical to the claim, 'If you have to change a sculpture for a site there is something wrong with the sculpture,'[5] site-specific art, whether interruptive or assimilative,[6] gave itself up to its environmental context, being formally determined or directed by it.

In turn, the uncontaminated and pure idealist space of dominant modernisms was radically displaced by the materiality of the natural landscape or the impure and ordinary space of the everyday. And the space of art was no longer perceived as a blank slate, a tabula rasa, but a real place. The art object or event in this context was to be singularly and multiply experienced in the here and now through the bodily presence

4. Douglas Crimp has written: 'The idealism of modernist art, in which the art object *in and of itself* was seen to have a fixed and transhistorical meaning, determined the object's placelessness, its belonging in no particular place, a no-place that was in reality the museum . . . Site specificity opposed that idealism – and unveiled the material system it obscured – by its refusal of circulatory mobility, its belongingness to a *specific* site.' Douglas Crimp, *On the Museum's Ruins* (Cambridge: MIT Press, 1993), 17. See also Rosalind Krauss, 'Sculpture in the Expanded Field' (1979), in Hal Foster, ed., *The Anti-Aesthetic: Essays on Postmodern Culture* (Port Townsend, Wash.: Bay Press, 1983), 31–42.
5. William Turner, British sculptor, as quoted by Mary Miss in 'From Autocracy to integration: Redefining the Objectives of Public Art,' in Stacy Paleologos Harris, ed., *Insights/On Sites: Perspectives on Art in Public Places* (Washington, D.C.: Partners for Livable Places, 1984), 62.
6. Rosalyn Deutsche has made an important distinction between an assimilative model of site specificity – in which the art work is geared toward *integration* into the existing environment, producing a unified, 'harmonious' space of wholeness and cohesion – and an interruptive model in which the art work functions as a critical *intervention* in the existing order of a site through some sort of disruption. See her essays 'Tilted Arc and the Uses of Public Space,' *Design Book Review* 23 (Winter 1992): 22–27; and 'Uneven Development: Public Art in New York City,' *October* 47 (Winter 1988): 3–52.

of each viewing subject, in a sensory immediacy of spatial extension
and temporal duration (what Michael Fried derisively characterized as
theatricality),[7] rather than instantaneously perceived in a visual epiphany
by a disembodied eye. Site-specific work in its earliest formation, then,
focused on establishing an inextricable, indivisible relationship between
the work and its site, and demanded the physical presence of the viewer
for the work's completion. The (neo-avant-gardist) aesthetic aspiration to
exceed the limitations of traditional media, like painting and sculpture,
as well as their institutional setting; the epistemological challenge to
relocate meaning from within the art object to the contingencies of its
context; the radical restructuring of the subject from an old Cartesian
model to a phenomenological one of lived bodily experience; and the
self-conscious desire to resist the forces of the capitalist market economy,
which circulates art works as transportable and exchangeable commodity
goods – all these imperatives came together in art's new attachment to
the actuality of the site.

In this frame of mind, Robert Barry declared in a 1969 interview that
each of his wire installations was 'made to suit the place in which it was
installed. They cannot be moved without being destroyed.'[8] Similarly,
Richard Serra wrote fifteen years later in a letter to the director of the
Art-in-Architecture Program of the General Services Administration in
Washington, D.C., that his 120-foot, Cor-Ten steel sculpture *Tilted Arc*
was 'commissioned and designed for one particular site: Federal Plaza.
It is a site-specific work and as such not to be relocated. To remove the
work is to destroy the work.'[9] He further elaborated his position in 1989:

> As I pointed out, *Tilted Arc* was conceived from the start as a
> site-specific sculpture and was not meant to be 'site-adjusted'
> or . . . 'relocated.' Site-specific works deal with the environmental
> components of given places. The scale, size, and location of site-specific
> works are determined by the topography of the site, whether it be
> urban or landscape or architectural enclosure. The works become
> part of the site and restructure both conceptually and perceptually
> the organization of the site.[10]

Barry and Serra echo one another here. But whereas Barry's comment
announces what was in the late 1960s a new radicality in vanguardist
sculptural practice, marking an early stage in the aesthetic experiments

7. Michael Fried, 'Art and Objecthood'
(1967), in Gregory Battcock, ed.,
Minimal Art: A Critical Anthology (New
York: Dutton, 1968), 116–147.
8. Robert Barry in Arthur R, Rose
(pseud.), 'Four Interviews with Barry,

Huebler, Kosuth, Weiner', *Arts Magazine*
(February 1969): 22.
9. Richard Serra, letter to Donald
Thalacker dated January 1, 1985, as
published in Clara Weyergraf-Serra and
Martha Buskirk, eds., *The Destruction of*

Tilted Arc: Documents (Cambridge: MIT
Press, 1991), 38.
10. Richard Serra, '*Tilted Arc* Destroyed,'
Art in America 77, no. 5 (May 1989):
34–47.

that were to follow through the 1970s (land/earth art, process art, installation art, conceptual art, performance/body art, and various forms of institutional critique), Serra's statement, spoken twenty years later within the context of public art, is an indignant defense, signaling a crisis point for site specificity – at least for a version that would prioritize the *physical* inseparability between a work and its site of installation.[11]

Informed by the contextual thinking of minimalism, various forms of institutional critique and conceptual art developed a different model of site specificity that implicitly challenged the 'innocence' of space and the accompanying presumption of a universal viewing subject (albeit one in possession of a corporeal body) as espoused in the phenomenological model. Artists such as Michael Asher, Marcel Broodthaers, Daniel Buren, Hans Haacke, and Robert Smithson, as well as many women artists including Mierle Laderman Ukeles, have variously conceived the site not only in physical and spatial terms but as a *cultural* framework defined by the institutions of art. If minimalism returned to the viewing subject a physical body, institutional critique insisted on the social matrix of the class, race, gender, and sexuality of the viewing subject.[12] Moreover, while minimalism challenged the idealist hermeticism of the autonomous art object by deflecting its meaning to the space of its presentation, institutional critique further complicated this displacement by highlighting the idealist hermeticism of the space of presentation itself. The modern gallery/museum space, for instance, with its stark white walls, artificial lighting (no windows), controlled climate, and pristine architectonics, was perceived not solely in terms of basic dimensions and proportion but as an institutional disguise, a normative exhibition convention serving an ideological function. The seemingly benign architectural features of a gallery/museum, in other words, were deemed to be coded mechanisms that *actively* disassociate the space of art from the outer world, furthering the institution's idealist imperative of rendering itself and its values 'objective,' 'disinterested,' and 'true.'

11. The controversy over *Tilted Arc* obviously involved other issues besides the status of site specificity, but, in the end, site specificity was the term upon which Serra hung his entire defense. Despite his defeat, the legal definition of site specificity still remains unresolved and continues to be grounds for many juridical conflicts. For a discussion concerning legal questions in the *Tilted Arc* case, see Barbara Hoffman, 'Law for Art's Sake in the Public Realm,' in W.J.T. Mitchell, ed., *Art in the Public Sphere* (Chicago: University of Chicago Press, 1991), 113–146. Thanks to James Marcovitz for discussions concerning the legality of site specificity.
12. See Hal Foster's seminal essay 'The Crux of Minimalism,' in Howard Singerman, ed., *Individuals: A Selected History of Contemporary Art 1945–1986* (Los Angeles: Museum of Contemporary Art, 1986), 162–183. See also Craig Owens, 'From Work to Frame, or, Is There Life After "The Death of the Author"?,' in Scott Bryson et al., eds., *Beyond Recognition: Representation, Power, and Culture* (Berkeley: University of California Press, 1992), 122–139.

Chapter 24
Global dissensus: art and contemporary capitalism

Steve Edwards and Gail Day

This chapter includes extracts from five reviews of the exhibition Documenta 11, which was held in 2002. Documenta is, perhaps, the biggest and certainly one of the most prestigious exhibitions of contemporary art. First held in 1955 to 'document' a wide range of modern art repressed under Nazism, it is now presented every five years in the German city of Kassel and organised by an invited curator. The eleventh such event was put together by Okwui Enwezor (the first African curator to spearhead the event) with a team of collaborators.[1] Documenta 11 caused a certain amount of controversy, both for its commitment to engaging with the current post-colonial world order and its heavy reliance on documentary.

The selected texts represent a range of opinions and responses to the exhibition. Two are taken from US newspapers and three from the US magazine *Artforum International* (Linda Nochlin and James Meyer are art historians and Matthew Higgs is a curator). The reviews are significant as they reflect the immediate response from critics to a huge event made up of numerous artworks. In these reviews we see the writers trying to make sense of contemporary art, and in the process of doing so their individual perspectives and assumptions rise to the surface. We have not supplied biographical notes in the glossary on the numerous artists, curators and critics referred to in these reviews. SE

1. The other members of the curatorial team were: Carlos Basualdo, Ute Meta Bauer, Susanne Ghee, Sarat Maharaj, Mark Nash and Octavio Zaya.

1. Kim Levin
'The CNN Documenta'

Village Voice, New York, 2 July 2002, p.57.

The first Documenta of what artistic director Okwui Enwezor calls 'an already less than promising century' is elegant, intelligent, and sleekly installed. The curatorial vision is generous, complex, and remarkably coherent. The art is relevant and political, exactly as the eloquent Enwezor had promised.

Updating the founder's original intent, which was to bring to post-war Germany the latest developments in modern art from the rest of Europe, Documenta 11 (which continues through September 15) brings to Europe the latest developments from the rest of the struggling, globalizing, postcolonial world. Jan Hoet's Documenta IX missed its historic chance to bring new art from the former Soviet empire into the fold in 1992. Catherine David's Documenta X in 1997 talked the talk about inclusion, but flubbed it with exclusionist hauteur. Enwezor, with a team of six co-curators, delivers on his promise.

He delivers all too well. The advance list, studded with big-name artists, provoked expectations of a safe, low-risk show. The exhibition, however, stuns viewers into silence. With curatorial intelligence, it connects a plethora of unanticipated dots. It succeeds in bringing issues of genocide, poverty, political incarceration, industrial pollution, earthquake wreckage, strip-mine devastation, and news of fresh disasters into the inviolable white cube. With 415 works by 180 artists from five continents, a large percentage commissioned for the occasion, the show alludes to hostages, captives, witnesses, perpetrators, illegal immigrants, and truth commissions. It explores the representation of border disputes, contested territories (such as Pakistan/India or Palestine/Israel), and collapsing urban space. Nasty metal bed frames, used every which way, are a leitmotiv in an exhibition in which the most effective aesthetic strategy is often the use of photojournalistic and documentary formats. And before you fault certain works for rampant exoticism, consider that the local color signifies, as Enwezor has noted, 'not an elsewhere but a deep entanglement.' As Sarat Maharaj, one of the co-curators, puts it, this Documenta negotiates 'the tension between the foreign and the familiar in the xenographic space that is Europe today.' [. . .]

Of course the international artworlders swarming through Kassel didn't remain silent for long. By the third preview day, petty complaints began to surface. 'It's political, it's gutsy, it's the kind of show you want to like,' waffled an art dealer. 'It's got no humor. Nothing made me laugh or even smile,' complained a critic from Central Europe. 'As an Asian

woman I am completely excluded,' griped a museum board member from Taipei, accusing Nigerian-born and -bred Enwezor of being part of the Westernized elite. 'I just wish,' said a collector plaintively, 'that the art world would stop being CNN.'

Political correctness? Not exactly. The first works that confront you in the Fridericianum, formerly the main exhibition space, are Leon Golub's menacing canvases about abuse of power, uneasily sharing a gallery with Doris Salcedo's brutalized chairs. Across the hall is an overwhelming installation of brutally blackened crates, bundles, trunks, jars, and racks of rolled drawings – capable of vanquishing perennial Documenta ghost Joseph Beuys – by the late Chohreh Feyzdjou, an Iranian-born Jew.

But this Documenta's decentralized heart is the vast old Binding Brewery, which houses the newest, largest, and sometimes most gratuitous works, including Simparch's skateboard pit. Louise Bourgeois's crumpled rag dolls in cells are sadly upstaged by Annette Messager's overblown installation of kinetic stuffed body parts, which drags one inert beast endlessly around its periphery. Mark Manders's anti-Eden of android Adams, lab rats, and crematorium apparatus is portentous and pretentious. Fabian Marcaccio's vast virtual mural – swarming with panicky urbanity, bloody brush strokes, and other ropy mutations of the painterly, the photographic, and the digital – wins hands down for raw acreage as well as excess of garbled global relevance. Yinka Shonibare's grand-tour tableau, an orgy of fornicating imperialists, may be blatant but it gets the essential question of this Documenta right: Who's screwing whom?

The vast show has more than its share of visual and conceptual excellence, including Feng Mengbo's shooting-gallery computer game, Mona Hatoum's electrified room installation, Jeff Wall's Ralph Ellison-inspired lightbulb-bedecked lightbox image, Alfredo Jaar's *Lament of the Images* (with three glowing texts about withheld images and a blindingly bright blank screen), and David Small's interactive virtual book. There are powerful works by the Atlas Group, among whose archival conceits is an inventory of car bombs (make, model, and color) exploded in Beirut during the Lebanese wars; by Raqs Media Collective, which delineates the dispossession of urban space in New Delhi; and by Multiplicity, whose *ID: Journey Through a Solid Sea* exposes the Italian cover-up of a shipwreck of immigrants.

There are outdoor diversions: Cildo Meireles's ice popsicle vendors (*Disappearing Element*), Chinese performance artists in Maoist uniforms staging a long march through Kassel, John Bock's sporadic events in a riverside encampment. And, secreted in the courtyard of an immigrant housing complex, Thomas Hirschhorn's scrappy monument to Bataille, a user-friendly gesture of community inclusion. For the more affluent,

Hirschhorn's oversize gold-foil CNN locket, in the Documenta Halle with other artists' editions, is buyable as well as emblematic.

But it's Tania Bruguera's brutal and thrilling installation that provides the ultimate visceral summation of this Documenta. Blinded by the lights, stunned by a barrage of stomping jackboots and hair-trigger clicks, it takes a minute for you to realize that the sounds issue from a live sentry pacing back and forth on a catwalk overhead, endlessly reloading his gun. Recasting the viewer as a potential target, this Cuban artist brings us full circle back to Golub's ancestral thugs. By the third preview day, the installation was temporarily closed; the performer had a sore thumb.

Documenta 11 reflects not only on 'the postcolonial aftermath of globalization and the terrible nearness of distant places' (in Enwezor's words), but on art's ultimate inadequacy within the socio-cultural-political-historical context. Refusing to fall into the trap of grand narratives and neat conclusions, Enwezor would have us realize that this vast art show is merely one-fifth of a decentralizing project: The first four 'platforms' were scholarly conferences about burning issues on different continents. Bringing news of the woes of the world to Europe, this Documenta tells a sorry tale of globalization and its discontents. It has an agenda, as a fellow critic complained. But what exhibition doesn't?

At the press conference in Kassel, Enwezor insisted that Documenta 11 is 'diagnostic' rather than 'prognostic.' And that seems to be the main complaint: Describing the crisis, it shows no way out. Yet it's a measure of the power of Enwezor's chilling vision that you never notice the near-total absence of works by artists exploring strategic naughtiness, dreamy adolescence, cinematic byplay, or their own navels – all ubiquitous on the gallery circuits lately. So let's receive this Documenta as the proclamation of a state of emergency. It's going to be a hard act to follow. And given the current events transpiring on our planet, it's really not fair to blame the messenger for the dire news.

2. Blake Gopnik
'The Coarse Art of Repudiation'

Blake Gopnik, 'The Coarse Art of Repudiation: Waging War on a Wicked West', Sunday Arts' supplement, *Washington Post*, 16 June 2002, p.G01.

A visit to Documenta 11, the latest edition of Germany's twice-a-decade exhibition of contemporary art – or even just a quick leaf through the catalogue for this ultra-prestigious show – serves as a useful reminder of the deep loathing that the farther reaches of the global left can have for our country. Behaviors taken for granted here – churchgoing, gun-owning, stock-buying, lethal-injecting – can look odd, even positively baleful, out in the wider world. For some leaders in the international art world, the Evil Empire is us.

The new global order, with the United States at its center, is 'materializing, hegemonizing and attempting to regulate all forms of social relations and cultural exchanges' according to an essay by Okwui Enwezor, the New York-based Nigerian who is artistic director of this latest Documenta. His exhibition, he says, is more than anything about rallying the arts to help oppose 'that sphere of global totality that manifests itself through the political, social, economic, cultural, juridical and spiritual integration achieved via institutions devised and maintained solely to perpetuate the influence of European and North American modes of being.'

The first culprit Enwezor cites for all this oppression is, of course, global capitalism. And some of the art he brings to bear does an eloquent, poetic job of pointing to the depredations and inequities that an unregulated market can lead to. (Though no one makes art about the nastiness, brutishness and simple shortness of most people's lives before constructive capital came on the scene. Not to mention that medieval barons were not, I think, in the habit of funding lavish exhibitions of artworks intent on tearing down the feudal system. This Documenta doesn't simply bite the hand that feeds it; it wants to chew and swallow, arm and all.)

The second culprit in America's global domination may come as more of a surprise: it seems another vehicle that helps effect worldwide oppression is 'the perpetual interpretation of what a just society ought to be, pursued through the secular vision of democracy as the dominant principle of political participation.' Faced with such a potent tool of the 'neo-liberal globalist onslaught' as democracy, Enwezor finds only one force up to the job of mounting a 'counter-hegemonic opposition' to it: radical Islam.

'September 11,' argues Enwezor, 'should perhaps be framed as the instance of the full emergence of the margin to the center.' The Ground

Zero that it created, he goes on, could then become a metaphor for 'the founding instant of the reckoning to come with Westernism after colonialism,' a 'ground-clearing gesture of tabula rasa' that is 'a beginning in the ethics and politics of constituting a new order of global society.'

Luckily for Documenta visitors, Enwezor wasn't really able to find much art in support of his position, and what he did find is never quite as bad as his own text. Art can be dumb, but just by virtue of its relative opacity it can never be as idiotic as a full-blown half-baked argument in words. At worst, a visitor to the exhibition has to deal with – or ignore – an installation or two that clumsily address the Middle Eastern situation.

In the most notable example, a Stuttgart-based American called Fareed Armaly, working with Palestinian filmmaker Rashid Masharawi, has generated a schematic pseudo-map of the Palestinian territory – it's actually derived from the digitized surface of a random stone as a symbol 'for the world, for architecture and for weapons' (don't ask me) – and then rendered it as a web of intersecting white lines on the gallery floor, with the names of Palestinian population centers printed wherever the lines cross. The one virtue of this work is that it is so easy to step over it on your way to someone else's better art. On the walls nearby, Armaly sticks up picture postcards and other archival material from the region, in an oversimplified effort to portray the psychic oppression of the Palestinian people at the hands of their Israeli neighbors.

Contrast that with the real metaphoric subtlety of Seifollah Samadian's nine-minute film of a chador-clad woman caught in a freak Tehran snowstorm, and you get to see the difference between a work that simply illustrates a limited didactic point and a truly political work of art that has something to say for itself. The chador worn in the snow evokes ideas about social dysfunction; the dot of black-clad woman on a field of white speaks about isolation; the woman waiting in the mounting snow (she doesn't take a bus that stops in front of her) becomes a sign of fortitude – while all along the whole thing is also just a gorgeous scene captured from daily life. Rather than being just a visual paraphrase of some spelled-out proposition, Samadian's work is itself so rich it can't be paraphrased.

Strangely, about the only piece in Documenta directly addressing the events of last September is more likely to be read as a stale lamentation for the victims of the New York attack than as a celebration of the tabula rasa wrought by its perpetrators. Touhami Ennadre, a Moroccan-born artist now based in Paris, provides a series of frankly sentimental black-and-whites of the now-standard 9/11 images – mourners at the World Trade Center, still-hopeful seekers after lost loved ones, vigils for those acknowledged dead – that are not much worse, but certainly no better, than the tens of thousands of snapshots that other witnesses have taken.

Which leads to what may be the most important take-home message of this Documenta: no matter how bad the curating can be, and how

exasperating the texts that it produces, most of its works of art will stand or fall according to the sum of their own virtues and vices.

Even the most hegemonic curators never quite manage to hegemon as thoroughly as they might like.

3. Linda Nochlin
'Documented Success'

Artforum International, vol.41, issue 1, September 2002, pp.161–3.

The most striking aspect of Documenta 11 is the predominance of the documentary mode, for want of a better word. The work of Bernd and Hilla Becher occupies a central place in the genealogy of this sensibility – and in the space of the Kulturbahnhof itself. Their photographs constitute some of the earliest 'documentation' (*pace* August Sander, the father of them all) that aspires to something beyond or different from conventional documentary, something which inevitably calls forth the idiom of art, conceptual or otherwise. In a recent *Art in America* interview with the Bechers, the crucial question of the relation of art to documentary is explicitly raised. The interviewer, Ulf Erdmann Ziegler, cites a text by Rudi Fuchs in which the author declares that 'the question of whether Bernd and Hilla Becher's work is a work of art is not so very interesting'; nevertheless, Ziegler points out that ' "only in art could they find the motivation" for their gigantic task.' He concludes that the Bechers 'work precisely as artists do, since they rigidly limit their interest to a few chosen subjects and refuse to let themselves be distracted.'

Endless art. What is art? What is documentary? Shows like Documenta 11 ultimately redefine the parameters of the 'artistic.' But while everyone is surely bored by the 'Is it art or something else?' question, one does crave, amid all the exempla of the documentary mode at this exhibition, works that are less problematic in their genre typology, works full of sensuousness and color. Or one wants the definitely nondocumentary, imaginative, sexually focused yet politically charged sculptural installations of, say, Yinka Shonibare, in which headless bodies – gorgeously garbed in costumes *dix-huitième siècle* in cut but African in decoratively patterned fabric – fuck, suck, and bugger with an elegance at once postcolonial and bitterly ironic. Or Annette Messager's endlessly, fantastically mobile installation combining animal form and human desire, stuffed figures with deep roots in childish nightmares and grown-up perversity. Or the wacky, tacky slapstick (better filmed than live) of John Bock. Or the lacerating,

retro humanity of William Kentridge's opera *Confessions of Zeno*, 2002, which resituates Italo Svevo's 1923 novel from pre-World War I Trieste to '80s Johannesburg.

But there is a return to humanity beyond the strictly documentary in much of the work in the exhibition, and this is certainly among the curatorial successes. Construed in its largest possible sense, the notion of the documentary mode includes installations and archives (another cornerstone typology) as well as photography, film, and video. Film and video are most apposite in exploring the nature of documentary sensibility and its relation to more conventional notions of art. Certainly the most interesting films here are not 'documentary' in the traditional sense. Instead these works deliberately foreground the apparatus, defamiliarizing and dwelling on details and fragments, focusing with stop action on meaningful or meaningless images. Some, such as Steve McQueen's coruscating *Western Deep*, 2002, leave us literally in the dark as to the precise nature of what is going on yet fully certain that the experience presented is sinister and literally toxic.

Many of these works function in the documentary mode but transform and expand it, making it into a kind of hybrid that appeals not merely to curiosity, a quest for specific information about some topic, but to imagination, political consciousness, and unconscious fears and desires. In *A Season Outside*, 1997, Amar Kanwar, an independent documentary filmmaker from New Delhi, goes back and forth between pursuing a conventional documentary mode – recording the enactment of national identities on the India-Pakistan border crossing at Wagah in terms of crowd movement, the transfer of goods, and the military ritual of opening and closing the border – and constantly interrupting that mode by foregrounding the telling detail. There are hypnotically repetitive close-ups of the bare feet of the Indians and Pakistanis exchanging their burdens of merchandise over that thin white line, emphasizing the arbitrariness of all such activities taking place across contested national boundaries. Or his odd, sometimes focused, sometimes oblique attention to the strange military border routine, a kind of stiff, macho dance of repetitive hostility, punctuated by sharp turns and arrogant kicks, which his camera constructs as occurring within an increasingly claustrophobic space. [. . .]

One film that is not in any traditional sense 'documentary' but certainly can take its place within the more flexible parameters of the mode is Eija-Liisa Ahtila's *The House*, 2002, which can be simply described as the story of a woman who begins to hear voices. But there is nothing simple about the film or its construction. Here, using a triptych format, a multiple-screen strategy effectively deployed by several filmmakers in the show (Isaac Julien used three screens and Fiona Tan four), Ahtila visually demonstrates the subject's increasing loss of a sense of inside and outside, self and other, a disturbing permeability to the myriad sights

and sounds around her. Indeed, the installation – with its simultaneous
and ever-changing left, right, and center views of the subject's movement
through space – envelops the viewer in this experience of dissolution. One
striking sequence demonstrates the subject's loss of the most basic sense
of bodily rootedness – that of the gravitational pull of the earth – as the
young woman floats uneasily into the air above her house. The house stands
for, and is, the subject herself and her increasing inability to maintain a
sense of psychic wholeness as the outside world – cars, cows, people – begins
to impinge on her being, infest her four walls. In a film that is both highly
poetic and nitty-gritty realist, madness is visually demonstrated as both
terrifying and somehow just the way things really are.

I believe that all art-looking is a dialogic activity, enormously enhanced
by interchange with a companion or two at one's side (or, that lacking, an
invisible one inside one's head). That said, the Documenta experience was
salutary. Never have I encountered so many people from so many parts of
my life all assembled to look at and comment on a diverse range of often
stimulating and original works. More particularly, I must admit that
on first viewing I disliked *The House*, finding it at once pretentious and
simple-minded. But my companion found it powerful in both formal and
narrative terms, so I went to see it again. I realized I had been disturbed
by the vividness of Ahtila's visual inscription of total loss of self/other
discrimination and that I had tried to belittle her achievement in defending
my own selfhood, as it were. The moral of this story is that one should see
works with another person, who can sometimes shine a different light
shared on things that you yourself are incapable of seeing. (Incidentally, my
penchant for shared viewing and thinking fits perfectly with an exhibition
in which the number of works by collaborative teams is notable.)

Finally, the previously mentioned *Western Deep* takes us on an infernal
vertical journey into one of the deepest gold mines in South Africa. Because
we are located experientially *inside* the mine, not watching it from the
outside, the trip is almost unbearable – but irresistible in its force. It is not
just that we are submerged in almost total, otherworldly darkness for what
seems an interminable length of time but that there is a stomach-churning
gravitational velocity to our plunge. Nor is this visceral descent tied to
a continuous comprehensible narrative that might help us 'make sense'
of our experience. On the contrary, narrative continuity is continually
disrupted – by infernal drilling noises, by momentary visions of individual
heads, by the sudden and unexplained appearance of a thermometer
between the lips of a desperately tired and ill-looking miner, and, most
pointedly, by the unprecedented dancelike steps of rows of half-nude
miners undergoing some sort of robotic physical test as inhuman and
repressive as this descent into hell itself. McQueen explains nothing; it
is simply there, the filmic equivalent of relentless suffering, colonial
co-optation, and the prospect of nothing better – nothing but death.

It is perhaps beside the point to speak of McQueen's brilliance as a filmmaker, and a highly political one. But his politics are totally imbricated with an original formal project. His work draws us in, suffocates us, makes us psychically permeable and guilty on the level of the political unconscious, as well as that of conscious realization of injustice. If Documenta 11 engages seriously with the documentary mode, *Western Deep* is one of its most moving, thought-provoking, and convincing achievements.

4. Matthew Higgs
'Same Old Same Old'

Artforum International, vol.41, issue 1, September 2002, pp.166–7.

The Friedrich-Wöhler housing estate is a fairly typical working-class enclave located on the fringes of Kassel's town center. Patronizingly described as a 'marginalized local community' in the exhibition's accompanying guide, it is, for the duration of Documenta 11, temporarily home to Thomas Hirschhorn's extraordinary *Bataille Monument*, 2002, the highlight of an otherwise sober and at times tetchy exhibition.

The third in Hirschhorn's ongoing series of ad hoc 'anti-monuments' dedicated to some of our most troubling and original thinkers – the previous incumbents being Baruch Spinoza and Gilles Deleuze – the *Bataille Monument* is a series of five interconnected structures that occupy the public spaces between the extant residential buildings. Built and maintained by the artist with the assistance and support of the local residents, the piece is inextricably implicated in the daily life of its neighbors and surroundings.

The *Bataille Monument* comprises a café, a library of books and videos that relate to the recurring themes in Bataille's oeuvre, an exhibition dedicated to his life and works, a public sculpture in the form of an oversize tree trunk fabricated from scrap materials and mummified in brown packing tape, and a television studio-*cum*-lecture hall. Constructed in Hirschhorn's now signature and somewhat precarious manner, the *Bataille Monument* is a complex provocation that seeks to test the potential of art as a discursive, socially liberating force. (On my second visit, during the final stages of the World Cup, the television studio had been temporarily commandeered to screen the third-place match between South Korea and Turkey. The crowd was a good-natured mix of 'marginalized' Turkish and German locals drinking beer and cracking jokes. I'm sure Bataille would have approved.) [. . .]

While rightly skeptical of the self-referential and self-satisfied autonomy of much recent art, Documenta 11 is paradoxically an often simplistic and curiously prescriptive affair. The informal, open-ended possibilities offered by works such as Hirschhorn's and Adéagbo's are nearly drowned out by the hectoring tone of the many others that seek to represent – often with the subtlety of an amateur dramatics production – the plight of the world's downtrodden and oppressed.

Works such as Chantal Akerman's *From the Other Side*, 2002, an overwrought rumination on the nocturnal economic migration across the border that separates Mexico from the United States; Mona Hatoum's lumpen riff on domesticity, *Homebound*, 2000; and Tania Bruguera and Luis Camnitzer's ham-fisted theatrical installations appear at once naive and condescending, if not exploitative, of the estranged circumstances of others.

Writing elsewhere on documentary photography, British artist Liam Gillick has described the kind of work that seeks meaning in the apparent profundity of its subject matter in lieu of offering a 'constructed critique' as a 'stunned mirror.' Emblematic of this condition are Kendell Geers's smug photographs of the attempts by paranoid postapartheid white South Africans to defend their homes; Lisl Ponger's banal photojournalistic account of the traces of the 2001 protests against the G8 summit in Genoa, Italy; and Touhami Ennadre's frankly opportunistic images of New Yorkers, taken in the aftermath of September 11.

Elsewhere Documenta 11 is peppered with clichéd and often sentimental pictures of the effects of social and economic deprivation, environmental neglect, natural disasters, military repression, and suspect ideologies. Unable or unwilling to go beyond meekly acknowledging the persistent presence of global traumas, these 'stunned mirrors' – like images in *Time* or *Newsweek* – appear mute. Operating as political ballast, their ineffectualness is contrasted with the more pertinent inclusion of documentary films created by grassroots collectives such as Canada's Inuit Igloolik Isuma Productions, the Democratic Republic of Congo's Le Groupe Amos, and Britain's now defunct Black Audio Film Collective. Created out of direct need or to counter stereotypical misrepresentations in the mainstream media, these essentially activist works elect not to sit on the fence, preferring instead a more precise engagement with the immediate concerns of their respective constituents, communities, and audiences.

In many ways, like Catherine David's pervasively influential 1997 Documenta X, Documenta 11 sought sanctuary in the ivory towers of the academy and its nostalgia for the unrealized union of the postwar political and artistic avant-gardes. Historical curiosities such as the unrealizable urban projects of Yona Friedman and the former Situationist Constant were wheeled out as being somehow exemplary. Similarly, academically inclined late-'60s and early-'70s Conceptual art –

including the oblique notations of Hanne Darboven and the emotionally stunted photographs of Bernd and Hilla Becher – is privileged center-stage over and above the more troublesome and contemporaneous propositions of, say, Sturtevant or Gustav Metzger.

With some notable exceptions, including Kutlug Ataman's gently subversive (and strangely suggestive) video installation *The Four Seasons of Veronica Read*, 2002, this is a curiously prim, somewhat repressed exhibition. Documenta 11's almost total disavowal of any practices, old or new, that might have invoked the continuing presence of more complex socially (and sexually) transgressive narratives – Jack Smith, General Idea, Valie Export, Pierre Molinier, San Francisco's Cockettes, the Viennese Actionists, Nayland Blake, Sarah Lucas, Elke Krystufek, Tom Burr, Bruce LaBruce, Ugo Rondinone, Lukas Duwenhögger – appears at times censorious.

While the expectations for any Documenta are undoubtedly high, this is a curiously conservative exhibition that mirrors its predecessor in more ways than its organizers might care to admit. A decidedly mature exhibition – a cursory glance at the statistics reveals that the average age of its participants approaches fifty – Documenta 11 seems wary, if not downright suspicious, of the potential and optimism that remain a privilege of youth. However, given the permanent turmoil that describes our global condition, maybe Documenta 11's pessimism is an honest reflection of our times after all. If so its subtext seems to suggest that, basically, we're all fucked, and there's not a lot we – or art, for that matter – can do about it.

5. James Meyer
'Tunnel Visions'

Artforum International, vol.41, issue 1, September 2002, pp.168–9.

Documenta presents its organizer with a dilemma. Should the outstanding exhibition of contemporary art – a show that surpasses all others in ambition, financing, and planning – simply present the best work, regardless of form and theme? Or should the curator impose strict parameters and choose art that fits his or her concept?

Recent directors have differed in their response. Jan Hoet's Documenta IX was notable for its openness, its refusal to favor one medium or theme. Catherine David's Documenta X explored the legacy of '68 and failed utopias, as well as the history of photo-documentation. This year's show, organized by Okwui Enwezor and a team of six curators, is even more focused. Its theme is globalization and its discontents – racial strife, class inequity, and the excesses of capitalism. The dominant medium is film and video projection, our current salon form. Much of the work has a documentary format. New Media Social Realism, you could call it.

Many critics have attacked the show's blinkered grimness, and it's true that Documenta 11 is a fairly joyless experience. You see a lot of work that could be described as 'good for you' but little that stimulates the imagination. And yet Enwezor's wager – to present a truly international, politically acute Documenta – results in a watershed show. Like its most famous predecessor, the Minimal/Conceptual art-driven Documenta V (1972), Documenta 11 is a bit tendentious. Seeing so many documentaries of the world's horrors ultimately has a diminished impact, like watching too much CNN. Still, I could not help but admire Enwezor's strong curatorial hand. This was without doubt the most memorable version of the show I have seen. [. . .]

But as I marveled at the lavish installations, I wondered about the show's imbrication with the structures it claims to critique. Is there not an asymmetry between the images of oppression and the impressive apparatus that supports their display? What do the German and Hessian governments – not to mention Deutsche Telekom, Volkswagen, etc. – have to gain from financing a show of such exacting multiculturalism and global reach? These questions are not easily answered (or perhaps too easily answered). But surely this Documenta might have benefited from work that addressed its innovative (and expensive) postexhibition concept.

More troubling is the show's tendency to stress the oppression of certain groups or identities. Fareed Armaly's installation on Palestinian refugees, detailed as it is, should have been balanced by a work exploring the other side of the Israeli/Arab conflict. Even worse is the show's disinterest in

entire categories of political identity. In emphasizing ethnicity, nation, and race, the exhibition gives only passing attention to gender and even less to sexuality, whether straight or queer. Images of identifiably gay men are scarce; lesbian and transgendered subjects, nonexistent. Touhami Ennadre's photograph of two guys hugging on September 11 – one among many images of that tragic day in the show – says nothing specific about gay subjectivity. Even the film installation by Isaac Julien, a leading gay director, veils its queer content. I guess it's a matter of taste – or interest. Yet how disappointing that this ostensibly progressive show is, in the end, a bizarrely heteronormative experience.

The dominance of projection is a more telling manifestation of taste: It almost feels as if the social injustices of our time can only be accessed through the projected image. We have been told for some time that traditional media are in retreat; the presence of a mere handful of painters in the show confirms this assertion. And yet one of the conclusions to be drawn from Documenta 11 is that the 'post-medium condition' lately lamented by Rosalind Krauss is not so pressing a concern. The recent commodification of the projection, the epic-scale picture, and the whole-room installation means that new forms have become established. The old media seem less credible not because we no longer have a concept of medium but because the new media are more so. [. . .]

An occasional break from the projections was welcome: For example, Renée Green's cloth pavilions, *Standardized Octagonal Units for Imagined and Existing Systems*, located in Karlsaue Park, are a nice respite. The main pavilion contains a video monitor documenting Green's concept within the histories of fantastic architecture (gazebos, octagonal houses) and '70s Land art. Images of earth projects at Documenta VI (1977) provide a dimension of reflexivity that the show otherwise lacks. An intriguing mix of media and discursive forms, the project transcends the documentary aesthetic so prevalent at Kassel.

Indeed, some of the better works in Documenta are documentaries that challenge documentary convention. Steve McQueen's *Western Deep* ostensibly deals with a mundane subject: the daily descent of South African miners into a very deep mine. The dark initial drop punctured by slight flickers of light, the subtle sound track, the bizarre images of men foraging for gold or undergoing bizarre physical examinations – of bodies confined to unimaginable spaces, instrumentalized, rendered machine-like – makes a strong impression. The film's microscopic attention to form does justice to its subject while transforming the way we see. McQueen's work strikes a balance between documentary's reality effect and an aesthetic encounter – an unlikely combination. In a show of memorable works it is perhaps the most outstanding.

Glossary

Aborigines Indigenous peoples of a place or region.

Achilles Legendary Greek hero.

Æthelberht, King of Kent *see* **Ethelbert of Kent**

Alberti, Leon Battista (1404–72) Italian artist and architect; author of *On Painting* (1435) and *Ten Books on Architecture* (1452).

Albigensian heresy Albigenses is a medieval term for the inhabitants of parts of southern France. The Albigensians were a Manichean heresy (named after their founder Manes, c.216–276) who rejected the material world as evil and whose numbers grew in the late twelfth and early thirteenth centuries.

Alcibiades Cleiniou Scambonides (450–404 BCE) Greek general during the Peloponnesian War (431–404 BCE).

Alexander VII (1599–1667) Born Fabio Chigi in Siena; served as Pope from 1655 until his death.

Angelico, Fra (1395–1455) Florentine artist and monk.

Antinous Lover of the Emperor Hadrian; sculptures of him were often thought to embody canonical male beauty.

Apelles (active late 4th century–early 3rd century BCE) Greek painter.

Aretino, Pietro (1492–1556) Italian writer, poet and collector.

Aristotle (384–322 BCE) Greek philosopher; student of **Plato** and teacher of Alexander the Great.

Arp, Jean (or **Hans Arp**) (1886–1966) German–French artist, sculptor and poet; prominent member of the Surrealist movement.

Asher, Michael (b.1943) American conceptual and environmental artist, associated with institutional critique, which analyses and explores the historical, aesthetic and social roles of galleries and museums, challenging conventional judgements about taste and value.

Athena (or **Athene**) Pallas Athena, ancient Greek goddess of (among other things) wisdom, civilisation, crafts, skill and war; called **Minerva** by the Romans.

Attiret, Jean-Denis (1702–1768) French missionary in China. His 'Lettre du frère Attiret', which includes an account of the Emperor of China's gardens, is dated 1743.

Augustine (Saint) (354–430) Aurelius Augustinus, one of the most important Doctors of the Roman Catholic Church.

Baburen, Dirck van (c.1595–1624) Dutch painter active in Utrecht, and working in the manner of **Caravaggio**.

Bacchanals Participants in Bacchanalia, ancient riotous and drunken revels in honour of the ancient Greek god of wine, **Bacchus** (also known as Dionysos).

Bacchus Ancient Greek god of wine, also known as Dionysos; Bacchus was the name adopted by the Romans.

Balaam Prophet mentioned in the Torah, the sacred text of the Jews.

Barbaro family Wealthy noble family of the Veneto whose members included politicians, generals, clergymen, scholars and patrons of the arts.

Barberini, Antonio (1607–71) A cardinal of the Catholic Church, patron of the arts and member of the wealthy Barberini family, which came to prominence in seventeenth-century Rome.

Barr, Alfred Hamilton (1902–81) American art critic and writer; the first curator of The Museum of Modern Art (MoMA), New York.

Barrell, John (b.1943) Scholar of pastoral and romantic English literature.

Barret, George (c.1730–1784) Irish landscape artist.

Barry, Robert (b.1936) American conceptual, installation and performance artist.

Benjamin, Walter (1892–1940) German–Jewish writer, literary critic, philosopher and cultural analyst.

Bede, Venerable (672/3–735) Benedictine monk, priest, historian and Doctor of the Church.

Bergson, Henri (1859–1941) French anti-rationalist philosopher. His stress on intuition and the fluidity of time constructs informed the work of modern artists moving away from static representations of the external world.

Berkeley, George (1685–1753) Anglo-Irish philosopher who advocated 'immaterialism', a theory claiming that material things exist only in the mind of the perceiver. He wrote *An Essay towards a New Theory of Vision* (1709) and *A Treatise Concerning the Principles of Human Knowledge* (1710).

Bernini, Gian Lorenzo (1598–1680) Italian Baroque sculptor, architect and painter active in Rome.

Berruguete, Alonso González de (c.1488–1561) Painter, sculptor and architect of the Spanish Renaissance.

Berry, Wendell (b.1934) American writer, academic and cultural critic.

bezant Monetary unit (coin) from the Byzantine Empire, also in use in the Crusader States in the Holy Land in the twelfth and thirteenth centuries.

Boccaccio, Giovanni (1313–75) Florentine author and poet and humanist of the Renaissance.

Borch, Gerard ter (1617–81) Dutch genre painter active in Amsterdam and Haarlem, although he travelled widely throughout Europe.

Borromini, Francesco (1599–1667) Baroque architect active in Rome.

Bosse, Abraham (c.1602–76) Artist, printmaker and watercolourist, and founding member of the French Academy.

Botticelli, Sandro (1444/5–1510) Italian painter and draughtsman, one of the most esteemed in Italy during his lifetime.

braccio (pl. braccia; 'arm') A length of measurement used throughout Italy during the Renaissance. It measured different lengths in different parts of Italy and also according to what was being measured, e.g. a braccio of wool differed in length from a braccio of silk.

Bramante, Donato (1444–1514) Italian Renaissance architect active in Rome, and designer of St Peter's Basilica.

Braque, Georges (1882–1963) French painter, sculptor and printmaker who worked closely with **Picasso** on the development of Cubism.

Broodthaers, Marcel (1924–76) Belgian artist, poet and filmmaker.

Buonarroti *see* **Michelangelo**

Buren, Daniel (b.1938) French conceptual, public and installation artist.

Buytewech, Willem Pieterszoon (c.1591–1624) Dutch genre painter active in Haarlem and Rotterdam.

Caesar Augustus (63 BCE–14 CE) Grandnephew and successor of Julius Caesar, he is considered the first Emperor of the Roman Empire and ruled alone from 27 BCE until his death.

Caesar, Gaius Julius (c.100–44 BCE) Roman general and statesman.

Cage, John (1912–92) American artist, composer, philosopher, poet and printmaker; post-war avant-gardist.

Calmuck (or Kalmuck) Member of a branch of the Mongolian race.

Canova, Antonio (1757–1822) Renowned Italian Neo-classical sculptor.

'Capability' Brown, Lancelot (1716–83) English landscape architect, whose naturalistic style compared to scenes depicted by Italian landscape painters and contrasted with the formal style of earlier English landscape design.

Caravaggio, Michelangelo Merisi da (1571–1610) Italian artist active in Rome, Naples, Malta and Sicily. Famous for his use of **chiaroscuro** and influential on Baroque art.

Caritas (or **Carita**) Allegorical figure of Charity.

Castagno, Andrea del (c.1419–57) Pseudonym for Andrea di Bartolo di Simone, a Renaissance Florentine artist.

Cats, Jacob (1577–1660) Dutch politician and author of moralising poems and emblem books (didactic illustrated volumes).

Cennini, Cennino d'Andrea (c.1370–c.1440) Tuscan painter and author of the early fifteenth-century text *The Craftsman's Handbook*.

Centaur In Greek mythology a composite creature the upper part of which was human and the lower horse.

Cézanne, Paul (1839–1906) French artist associated with Impressionism and Post-Impressionism, whose work was an influence on the development of Cubism and twentieth-century art generally.

Chalchihuites Probably a reference to high-grade silver, lead and zinc, produced in the area of Chalchihuites, also known as Alta Vista, currently an archaeological site in the north-west of Mexico.

Chareau, Pierre (1883–1950) French modernist designer and architect.

Charles II (1630–85) King of England, Scotland and Ireland from 1660, following the death of Oliver Cromwell in 1658 and the Restoration of the Monarchy.

Chiaroscuro In painting, a technique of modelling form using striking tonal contrasts between light and dark.

Chigi family Wealthy Roman family consisting of bankers, princes and cardinals.

chimera Mythological Greek monster, made up of the parts of several animals.

Chios Greek island in the Aegean Sea.

Cicero, Marcus Tullius (106–43 BCE) Roman philosopher, orator and statesman.

Cinquecento Reference to the art, culture or literature of sixteenth-century Italy.

Claude (or **Claude Lorrain**) (c.1600–82) French landscape painter.

Clement IX (1600–69) Christened Giulio Rospigliosi; served as Pope from 1667 until his death.

Cleopatra VII Philopator (or **Cleopatra**) (69–30 BCE) Ancient Greek Queen and last pharaoh of ancient Egypt.

Clovio, Giulio (1498–1578) Croatian artist active in Italy; friend of **El Greco**.

Cloza, Giorgi *see* **Klotzas, George**

Confessions The autobiographical writings of **St Augustine**, written around 398.

Constantine the Great (272–337) Served as Roman Emperor from 306 until his death; issued the Edict of Milan, which proclaimed religious tolerance throughout the Empire.

Corot, Jean-Baptiste-Camille (1796–1875) French landscape painter and printmaker.

Correggio, Antonio Allegri da (1489–1534) Italian artist, active predominantly in Parma.

Cortona, Pietro Berrettini da (or **Peter of Cortona**) (1596–1669) Italian Baroque artist and architect.

Cosimo I de' Medici, Duke *see* **Medici, Duke Cosimo I de'**

Courbet, Gustave (1819–77) French painter and leading figure of the Realist movement; known for the social and political content of his work.

Cupid The mythical Roman god of love (Greek Eros), son of the goddess of love, Venus (Greek Aphrodite) and of the god of war, Mars (Greek Ares).

Dante Alighieri (1265–1321) Florentine poet, author of the *Divine Comedy*, written between 1308 and his death.

Daphne Nymph with whom the ancient Greek sun god Apollo fell in love; he tried to rape her but she asked Earth to help her and was transformed into a laurel tree before Apollo could catch her.

Daumier, Honoré (1808–79) French painter, caricaturist and sculptor, best known for his cartoons and drawings satirising nineteenth-century French society and politics.

David, Jacques-Louis (1748–1825) French artist associated with the Neo-classical style and large-scale history painting.

De Jongh, Eddy (1920–2002) Dutch art historian who practised the iconographic method of interpreting emblems and symbols in painting.

Degas, Edgar (1834–1917) French artist and draughtsman, associated with Impressionism. Enthusiast of early developments in photography.

Delacroix, Eugène (1798–1863) French painter associated with Romanticism.

Delaunay, Robert (1885–1941) French artist, influenced by Cubism and Expressionist styles; co-founder of Orphism, an art movement that, although rooted in Cubist techniques, differed from the muted palette favoured by **Braque** and **Picasso** in its use of bright colours and expressive effects.

Descartes, René (1596–1650) Major rationalist French philosopher whose ideas, philosophical methods and systems are often referred to as 'Cartesian'.

Dewey, John (1859–1952) American philosopher, psychologist, social critic and educational reformist.

Diana (Roman Artemis) The ancient Greek goddess of hunting.

Diderot, Denis (1713–84) French art critic and philosopher, and editor of the *Encyclopédie* (1751–72), the first general encyclopedia to focus on science, arts and crafts.

Doesburg, Theo van (1883–1931) Dutch artist, theorist, poet and designer, founder and leading figure of the De Stijl art movement.

Dou, Gerrit (1613–75) Dutch genre painter of the School of Leiden; student of **Rembrandt** and teacher of **Frans van Meiris the Elder**.

drachma Greek monetary unit in use during several periods in Greek history from the ancient times until 2001, when it was replaced by the Euro.

Dryden, John (1631–1700) English poet, playwright and literary critic during the Restoration.

ducat Monetary unit (coin), introduced by the Republic of Venice in 1284.

Dufy, Raoul (1877–1953) French painter associated with Expressionism and the Fauve group.

Dürer, Albrecht (1471–1528) German artist, printmaker and engraver active in Nuremberg, and author of books on measurement and proportion.

Edward I (1239–1307) King of England from 1272 until his death.

Edward II (1284–1327) King of England from 1307 until his death.

Eesteren, Cornelis van (1897–1988) Dutch architect and urban planner.

El Greco (1541–1614) Born Domenikos Theotokopoulos in Crete and originally trained as an icon painter. He moved to Venice and subsequently settled in Toledo, Spain, where he produced his most famous works.

Eleusinian games Games dedicated to the fertility goddess Demeter.

Elinga, Pieter Janssens (1623–82) Dutch painter active in Rotterdam and Amsterdam, remembered mostly for his peepshow (a box whose interior scenes, when viewed through an eyehole, simulate perspective), now in Museum Bredius, The Hague.

Elis Ancient Greek region located in southern Greece, on the Peloponnese peninsula, where the Olympic Games originated.

Emerson, Ralph Waldo (1803–82) Essayist, poet and leader of the American Transcendentalist movement.

Enwezor, Okwui (b.1963) Nigerian curator, writer and poet; artistic director of Documenta 11 exhibition, Kassel, Germany (June–September 2002).

Ephoroi (or **Ephori**) Magistrates in ancient Sparta.

equestrian statue Statue of a figure on horseback.

Erasmus, Desiderius (Erasmus of Rotterdam) (c.1466–1536) Dutch Renaissance humanist, Catholic priest and theologian.

Ernst, Max (1891–1976) German painter associated with the Dada and Surrealist movements.

Ethelbert of Kent (or **Æthelberht)** (c.560–616) King of Kent from c.580/590 until his death; he was later canonised for establishing Christianity among the Anglo-Saxons.

Euodus (1st century CE) Ancient Greek artist. According to Johann Joachim Winckelmann (see pp.209–14 above), he created a portrait of Flavia Julia Titi (64–91), the daughter and only child of Emperor Titus (39–81; r.79–81).

Europa Maiden with whom **Jupiter** (Greek Zeus) fell in love and, disguised as a bull, carried her off. Europa gave her name to the continent of Europe.

Farnese, Duke Ottavio (1524–86) Duke of Parma and Piacenza from 1547.

Fauni Roman name for the Greek satyrs, attendants to Dionysos, and woodland deities, often with animal features such as goats' hooves, ears and horns.

Félibien, André (1619–95) French chronicler of the arts, academician and critic.

Flora Roman goddess of flowers and spring.

florin Monetary unit (coin), the most renowned of them being the Florentine florin, one of the first gold coins to be issued in Europe (first struck in 1252).

Fontana, Domenico (1543–1607) Italian architect active in Rome.

Fra Filippo of the Carmine *see* **Lippi, Fra' Filippo**

Franks From the Arabic Franj, used to identify westerners in the east from the time of the First Crusade (1096–99) throughout the Middle Ages and the Renaissance.

Fried, Michael (b.1939) American formalist–modernist art critic and historian, and author of the essay 'Art and Objecthood' (1967).

Frossego, Janni de (first half of sixteenth century) Cretan post-Byzantine painter and priest, active in Venetian-dominated Candia (modern Herakleion, capital of Crete). The combination of the two professions is common within the Greek Orthodox tradition.

Fuseli, Henry (1741–1825) Artist and Royal Academician of Swiss origin, who lived and worked in London.

Gainsborough, Thomas (1727–88) English painter of landscapes and portraits active in Suffolk.

Galatea In Greek mythology, nymph with whom the Cyclops **Polyphemos** fell in love; he killed her beloved Acis in an attempt to gain her affections.

Gauguin, Paul (1848–1903) French artist and writer, Post-Impressionist and Symbolist painter.

George III (1738–1820) King of Great Britain and Ireland from 1760 until his death.

Géricault, Théodore (1791–1824) French painter and lithographer, a leading figure in the Romantic movement.

Ghirlandaio (or Ghirlandajo), Domenico (1448/9–94) Italian painter, mosaicist and possibly goldsmith.

Giacometti, Alberto (1901–66) Swiss sculptor, painter, draughtsman and printmaker, associated with Surrealism and best known for his sculptures of the human figure.

Giotto di Bondone (1267/75–1337) Renaissance painter and designer based in Florence.

Giuliano de' Medici *see* **Medici, Giuliano de'**

Glaucera Mythical nymph for whom Mercury (Greek Hermes) transformed into an eagle, in order to get closer to her.

Gleizes, Albert (1881–1953) French painter and co-author with **Jean Metzinger** of *Du 'Cubisme'* (1912), a theoretical tract on Cubism which differentiated between the 'profound' realism of Cubism and the 'superficial' realism of the mid nineteenth-century painters such as **Gustave Courbet**.

Goethe, Johann Wolfgang von (1749–1832) German poet and author of the play *Faust* (1806–32).

Gogh, Vincent van (1853–90) Dutch painter associated with Post-Impressionism and Expressionism, known for his characteristic use of intense colour and vigorous application of paint (*impasto*).

Gonella Celebrated fifteenth-century court jester mentioned in Baldassare Castiglione's *The Book of the Courtier* (1528).

Goya, Francisco (1746–1828) Spanish artist whose paintings influenced the work of many modern artists, including **Manet** and **Picasso**.

Greco, Domenico *see* **El Greco**

Gregory the Great (or Pope Gregory I) (c.540–604) Pope from 590 until his death.

Gris, Juan (1887–1927) Spanish painter and sculptor who lived and worked in France; associated with the development of Cubism.

Gymnasia (or Gymnasies) Schools that originated in ancient Greece; places where people took physical or intellectual exercise in training for public games.

Haacke, Hans (b.1936) German–American artist associated with conceptual art, known for his critical engagement with political and social issues.

Haussmann, Baron (1809–91) The Prefect of Paris in the Second Empire (1852–70) who transformed Paris with new boulevards.

Hazlitt, William (1778–1830) English literary critic and essayist.

Hegel, Georg Wilhelm Friedrich (1770–1831) German idealist philosopher, whose systematic theory of historical development was notably adapted in the writings of Karl Marx and Marx's theory of communist materialism.

Helen of Croton Also known as Helen of Troy; in Greek mythology the daughter of Zeus and Leda.

Hero and Leander Myth narrating the love story between Hero, a priestess of Aphrodite (Greek **Venus**) and a young man (Leander) who swam every night across the Hellespont to be with her.

Hofmann, Hans (1880–1966) German–American Abstract Expressionist painter, teacher and writer.

Homer (8th century BCE) Greek poet and author of the *Iliad* and the *Odyssey*.

Hooch, Pieter de (1629–84) Dutch genre painter active in Delft.

Humber Large tidal estuary (once a river) situated on the east coast of northern England.

Impasto In painting (usually oil), a thick, textured and loose application of paint that stands in relief, emphasising the marks of brush or palette knife.

Ingres, Jean-Auguste-Dominique (1780–1867) French painter working in the Neo-classical tradition.

Iphicles In Greek mythology, half-brother of the demi-god Hercules.

Janus The ancient Roman, two-faced god of beginnings and transitions. With his two faces he looks both to the future and to the past.

Jeanneret, Charles-Édouard *see* **Le Corbusier**

Jeanneret, Pierre (1896–1967) Swiss architect, cousin of Charles-Édouard Jeanneret (**Le Corbusier**), with whom he collaborated on a number of projects.

Jeroboam, King (r. c.931/922–901 BCE) King of Israel.

Jesuit Member of the male Catholic order the Society of Jesus, an evangelical and educational order.

Jones, Inigo (1573–1652) British architect who popularised Italian Renaissance architecture; his works include the Banqueting Hall, Whitehall (1622).

Jordaens, Jacob (1593–1678) Flemish artist of the Antwerp School, who painted mythological and historical subjects, as well as portraits and genre scenes.

Jove *see* **Jupiter**

Jupiter (Roman Zeus), the mythical King and ruler of the Olympian gods.

Kahnweiler, Daniel-Henry (1884–1979) French art collector, dealer, writer and publisher, closely associated with the early development and theory of Cubism.

Kepler, Johannes (1571–1630) German scientist and astronomer who taught in Graz, Prague and Linz.

Kip, William (or **Johannes, Jan**) (1653–1722) Dutch draughtsman and engraver active in London, where he collaborated with **Leonard Knyff** on topographical bird's-eye views of country houses, published in 1708 as *Britannia Illustrata: Or Views of Several of the Queen's Palaces, as Also of the Principal Seats of the Nobility and Gentry of Great Britain*.

Kline, Franz (1910–62) American Abstract Expressionist painter.

Klotzas (or **Klontzas**), **George** (or **Giorgi Cloza**, **Zorzi Cloza ditto Cristianopullo**) (c.1530–1608) Post-Byzantine Cretan painter and miniaturist, active in the capital of Venetian-dominated Crete, Candia.

Knapton, George (1698–1778) English portrait painter who trained at St Martin's Lane Academy, London, the forerunner of the Royal Academy of Arts.

Knyff, Leonard (1650–1721) Dutch draughtsman and painter active in London, where he collaborated with **William Kip** on topographical bird's-eye views of country houses published in 1708 as *Britannia Illustrata: Or Views of Several of the Queen's Palaces, as Also of the Principal Seats of the Nobility and Gentry of Great Britain*.

Kooning, Willem de (1904–97) Dutch–American Abstract Expressionist artist.

Kosuth, Joseph (b.1945) American conceptual artist and theorist.

Latona Roman name for the mythical Greek goddess Leto, mother of Apollo (in both Greek and Roman) and Artemis (Roman **Diana**).

Le Corbusier (1887–1965) Pseudonym used by the Swiss modernist architect, city planner and designer, Charles-Édouard Jeanneret. He used his real name for his work as a painter, working

alongside **Amédée Ozenfant**; together they developed 'purism', a style using strong, simplified basic shapes that embraced technology, the machine and classical ideals of form.

Le Fauconnier, Henri (1881–1946) French painter, influenced by Cubism and Expressionism.

Leander *see* **Hero and Leander**

Leonardo da Vinci (1452–1519) Florentine Renaissance painter, sculptor, architect, designer, theorist, engineer and scientist.

Leoni, Leone (c.1509–90) Italian sculptor and goldsmith.

Liberal arts The fine arts, humanities, languages and literature. Term embracing the arts of measure, or the Quatrivium (arithmetic, music, geometry and astronomy), and the arts of language, or the Trivium (grammar, logic and rhetoric).

Lippi (or **Lippo**), **Fra' Filippo** (**di Tommaso**) (1406–69) Florentine painter of the Renaissance.

Locke, John (1632–1704) English philosopher whose espousal of empiricism and theories of liberalism were fundamental to the Enlightenment; author of *An Essay Concerning Human Understanding* (1690).

Loos, Adolf (1870–1933) Austro-Hungarian architect, designer and theorist who promoted modernist architecture in Europe.

Louis XIV of France (1638–1715) Also known as Louis the Great or the Sun King; he ruled from 1643 until his death. He was a patron of the arts, built the Palace at Versailles, and founded the Académie Française.

Louis XV of France (1710–74) King of France and of Navarre from 1715 until his death.

Louis XVI (1754–93) Succeeded his unpopular grandfather **Louis XV** as King of France and of Navarre until 1791. He was King of the French between 1791 and 1792 and eventually executed in 1793.

Maes, Nicolaes (1634–93) Dutch genre and portrait painter, who studied with **Rembrandt**, and was active in Amsterdam, Dordrecht and Antwerp.

Malevich, Kazimir (1879–1935) Russian avant-garde painter and writer associated with Suprematism.

Manet, Édouard (1832–83) French painter associated with Impressionism and modernism.

Manuel Comnenus (Manuel I Komnenos) (r.1143–80) Byzantine Emperor of the Komnenian family dynasty.

Marathon Place in Greece c.42km north of Athens. At the Battle of Marathon in 490 BCE the severely outnumbered Greek army defeated the Persians.

Martini, Simone (c.1284–1344) Italian painter, active in Siena, Naples and Avignon.

Marx, Karl (1818–83) German socialist thinker and author of the *Communist Manifesto* (1848) and *Das Kapital* (3 vols., 1867–94).

Masaccio (born **Tomasso di Ser Giovanni di Mone Cassai**) (1401–28) Florentine painter.

Mason, William (1724–97) English poet and gardener; author of the long poem *The English Garden* (3 vols., 1772–82).

Matisse, Henri (1869–1954) French artist associated with Fauvism and the expressive effects of line and colour.

Mechelen Dutch-speaking city in the province of Antwerp; significant as an artistic centre during the Northern Renaissance.

Medici, Duke Cosimo I de' (1519–74) Duke of Florence and Grand Duke of Tuscany from 1569.

Medici, Cosimo de' (1389–1464) The first of the Florentine political dynasty and rulers of the city and grandfather of **Lorenzo de' Medici**.

Medici, Giuliano de' (1453–78) Brother of **Lorenzo de' Medici**.

Medici, Lorenzo de' (1449–92) Known as Lorenzo the Magnificent (Lorenzo il Magnifico), art patron, ruler of Florence and member of the Medici dynasty.

Medusa Mythical Greek monster, who turned anyone who looked at her to stone. The Greek hero Perseus beheaded her and presented her head to the goddess Athena, who placed it on her shield.

Megara Ancient city in Attica, mainland Greece.

Memmi, Lippo (active 1317–c.1350) Italian painter active in Siena and Avignon.

Mercury (Roman Hermes) The mythical Greek god of trade and messenger of the gods.

Metzinger, Jean (1883–1956) French painter associated with various avant-garde movements, including Impressionism, Fauvism and Cubism. Co-author with **Albert Gleizes** of *Du 'Cubisme'* (1912).

Michelangelo (or **Michael Angelo**) **di Lodovico Buonarroti Simoni** (1475–1564) Italian Renaissance sculptor, painter and architect.

Mieris the Elder, Frans van (1635–81) Dutch genre and portrait painter active in Leiden.

Minerva Roman for the Greek goddess **Athena**.

Mondrian, Piet (1872–1944) Dutch painter who developed beyond Cubism to produce completely abstract painting, consisting of grid-lines and blocks of pure colour. Associated with the De Stijl group until 1924.

Montezuma (or **Moctezuma II**) (1466–1520) Ninth Aztec Emperor and ruler at the beginning of the Spanish conquest of Mexico.

Motherwell, Robert (1915–91) American Abstract Expressionist artist and writer.

Neptune Roman for the ancient Greek god of the seas, Poseidon.

Netscher, Caspar (or **Gaspar**) (1639–84) Dutch painter of portraits and genre scenes active in The Hague.

Niobe Tragic figure in Greek mythology who boasted that she had more children than the goddess Leto (**Latona**); as a consequence her children were slaughtered as punishment by Leto's own children, Apollo and Artemis (Diana).

Nireus Legendary Homeric hero, renowned for his exceptional beauty.

Orcagna, Andrea di Cione di Arcangelo (c.1308–68) Florentine architect, sculptor, mosaicist, painter and poet.

Ottavio, Duke *see* **Farnese, Duke Ottavio**

Oud, J.J.P. (1890–1963) Dutch rationalist architect.

Ozenfant, Amédée (1886–1966) French artist who worked in collaboration with Charles Édouard Jenneret (**Le Corbusier**) on the development of purist painting.

Pacheco, Francisco (1564–1644) Spanish painter and writer.

Palladio, Andrea (1508–80) Venetian architect and author of *The Four Books of Architecture* (4 vols., 1570).

Pallas *see* **Athena**

Pallavicino, Pietro Sforza (1607–67) Italian Cardinal of the Catholic Church who published treatises on art and the church.

Paris Legendary Homeric hero.

Pegasus Winged horse in Greek mythology, which sprang forth from **Medusa** when the Greek hero Perseus beheaded her.

Pelegrin da Bologna (or **Pellegrino Pellegrini Tibaldi da Bologna**) (1527–96) Italian painter, sculptor and architect.

Phidias (c.480–430 BCE) Ancient Greek artist whose large oeuvre included the statue of Zeus (Roman **Jupiter**) in Olympia, in the Peloponnese, which

was considered one of the seven wonders of the ancient world, and the **Athena** (Roman **Minerva**) Nike on the Acropolis of Athens, both lost.

Philip II (1527–98) King of Spain (1556–98), King of Naples and Sicily (1554–98), King of Portugal (1581–98). He built the monastery palace known as El Escorial.

Philip IV (1605–65) King of Spain between 1621 and his death; patron of **Diego Velázquez**.

Phoebos Another name for the ancient Greek sun god Apollo.

Phryne (4th century BCE) Ancient Greek courtesan.

Picasso, Pablo (1881–1973) Spanish artist, painter and sculptor working principally in France. Co-founder of Cubism with Georges Braque. His immense output in a variety of styles and media testifies to a relentless commitment to creativity and innovation.

Pisano, Giovanni (c.1245/50–1319) Italian sculptor, son of **Nicola Pisano**.

Pisano, Nicola (or **Niccolò**) (c.1220/25–before 1284) Italian sculptor whose work, along with that of his son **Giovanni Pisano** and their workshop, introduced an new sculptural style in late thirteenth- and fourteenth-century Italian art.

Pius V, Pope (Saint) (1504–72) Born Antonio Ghislieri; Pope from 1566 until his death. He is also a Catholic saint.

Plato (c.428–c.347 BCE) Greek philosopher and teacher of **Aristotle**.

Pluto Roman Hades, the ancient Greek god of the underworld.

Polidoro da Caravaggio (or **Polidoro**) (c. 1499–c.1543) Italian painter in the Mannerist style, who moved from Lombardy to Rome in 1515 where he joined **Raphael's** workshop.

Pollaiuolo (or **Pollaiolo**)**, Antonio del** (1429/33–98) and **Piero del Pollaiuolo (Pollaiolo)** (c.1443–96) Brothers who were both painters active in Florence during the Renaissance.

Pollaiuolo (or **Pollaiolo**)**, Piero del** see **Pollaiuolo, Antonio del**

Polygnotos (5th century BCE) Ancient Greek painter.

Polyphemos One-eyed Cyclops, who captured Odysseus and his companions and was subsequently blinded by Odysseus, the legendary Homeric hero.

Poussin, Nicolas (1594–1665) French painter and draughtsman; founder of the French classical tradition.

Proclus (or **Proclus Lycaeus**) (c.417–487) Greek philosopher associated with neo-Platonism.

Proserpina Roman Persephone and daughter of the goddess of fertility Ceres (Demeter in Greek mythology). She was abducted by **Pluto** (Hades in Greek mythology) who made her his wife in the underworld.

Pythagoras (c.570–c.495 BCE) Greek philosopher and mathematician.

Raffaello, Raphaello de Urbino see **Raphael**

Raphael (or **Raffaello Sanzio da Urbino**) (1483–1520) Italian Renaissance painter and architect.

Rehoboam (mid-10th century BCE) Initially King of the United Monarchy of Israel and subsequently, after the ten tribes of Israel rebelled in 932–931 BCE, King of Judah.

Reid, Thomas (1710–96) Scottish philosopher of the Enlightenment, who taught at King's College in Aberdeen.

Rembrandt (or **Rembrandt Harmeszoon van Rijn**) (1606–69) Dutch artist, draughtsman and etcher.

Reynolds, Joshua (1723–92) English painter and first President of the Royal Academy (founded 1768).

Rimbaud, Arthur (1854–91) French poet.

Rodin, Auguste (1840–1917) French Impressionist sculptor.

Romano, Giulio (or **Julio Romano**) (1499–1546) Roman Mannerist painter and architect who studied under **Raphael**.

Rooker, Michael 'Angelo' (1746–1801) English artist of urban and rural landscape scenes who studied under **Paul Sandby**.

Rossellino, Antonio (c.1427/8–79) Florentine sculptor.

Rousseau, Jean-Jacques (1712–78) Genevan philosopher and political theorist.

Rubens, Peter Paul (1577–1640) Flemish painter, court artist and diplomat, associated with Baroque art.

Sandby, Paul (1731–1809) Brother of the architect **Thomas Sandby**, and a landscape painter and founding member of the Royal Academy.

Sandby, Thomas (1721–98) Brother of the landscape painter Paul Sandby, and first professor of architecture at the Royal Academy.

Sandwich Collection Collection of the Earl of Sandwich's Polynesian artefacts, housed in the University of Cambridge's Museum of Archaeology and Anthropology.

Sangallo the Younger, Antonio da (1484–1546) Florentine architect; nephew of the architects Antonio da Sangallo the Elder and **Giuliano da Sangallo**; collaborated with **Raphael** on St Peter's in Rome.

Sangallo, Giuliano da (c.1443–1516) Florentine architect, engineer and sculptor, and part of the Sangallo family of architects. Designed the Villa Medici in Florence.

Sansovino, Jacopo d'Antonio (1486–1570) Florentine architect active in Rome and Venice during the Renaissance.

Sarto, Andrea del (1486–1530) Italian painter and draughtsman, one of the leading Renaissance artists in Florence in the early years of the sixteenth century.

Savonarola, Fra Girolamo (1452–98) Florentine religious leader known for his book-burning and preaching against the immorality of the clergy.

Scamozzi, Vincenzo (1552–1616) Venetian architect and author of *L'idea della Architettura Universale* (1615).

Schmarsow, August (1853–1936) German art historian known for his theories about space not as void but as something that is consciously experienced ('Raumgefühl'). His 1893 lecture 'The Essence of Architectural Creation' was influential in art historical circles.

Schwitters, Kurt (1887–1948) German artist working in a variety of media and associated with the Dada group; produced collages, assemblages, reliefs and posters.

scudo Italian monetary unit (coin) in use until the nineteenth century.

seicento Seventeenth-century Italy.

Serlio, Sebastiano (1475–1554) Italian mannerist architect active in Rome and Venice; he also had a role in the building of Francis I's Palace at Fontainebleau, and was the author of the treatise *Architettura* (1537).

Serra, Richard (b.1939) American minimalist and site-specific sculptor and video artist; known for his work with sheet metal and construction materials.

Seurat, Georges (1859–91) French painter associated with Post-Impressionism. He developed the technique of pointillism or retinal painting, involving the application of small patches and dots of pure colour on to the canvas; these dots are combined by the viewer's eye to form an image.

Shenstone, William (1714–63) English poet and landscape gardener.

Sigüenza, José de (1544–1606) Spanish historian, poet, theologian and Prior of the monastery of El Escorial, founded by **Philip II**.

Sixtus IV (1414–84) Born **Francesco della Rovere** in Liguria; Pope from 1471 until his death.

Smithson, Robert (1938–73) American land artist whose work includes *Spiral Jetty* 1970.

Sophocles (c.497/6–406/5 BCE) Ancient Greek poet; his plays include the tragedies *Oedipus* and *Antigone*.

Stoffels, Hendrickje (c.1626–63) One of **Rembrandt's** models, and later his mistress.

Stravinsky, Igor (1882–1971) Russian composer who lived in France and later in America.

Stubbs, George (1724–1806) English painter famous for his depiction of horses.

sueldo Spanish monetary unit (coin).

Suger, Abbot (c.1081–1151) Abbot Suger of Saint-Denis, near Paris. Cleric and adviser to Louis VI (r.1108–37) and Louis VII (r.1137–80); rebuilt the monastic church of Saint-Denis by 1144.

Sun King *see* **Louis XIV of France**

Sybarite A person dedicated to a life of luxury.

Tate, Allen (1899–1979) American poet, writer and social commentator.

Terborch *see* **Borch, Gerard ter**

Thanet, Isle of Lying at the most easterly point of Kent, England, the Isle of Thanet is no longer an island, since the channel began to silt up from around the late seventeenth century.

Thebans Inhabitants of Thebes, one of the main ancient Greek city states, the other two being Athens and Sparta.

Theotokopoulos, Domenikos *see* **El Greco**

Theseus Legendary Greek hero and founder-king of Athens.

Thespis (6th century BCE) Founder of ancient Greek theatre, having been the first to introduce both actors and the chorus to stage performances.

Timaeus One of **Plato's** Socratic dialogues, dating from c.360 BCE, which discusses the origins of the cosmos. The dialogue takes the form of a monologue by the eponymous real-life Greek Pythagorean thinker, Timaeus of Locri (c.420–380 BCE).

Titian (Tiziano Vecellio) (c.1488/90–1576) Italian painter and printmaker.

Trotsky, Leon (1879–1940) Russian Bolshevik revolutionary, Marxist theorist and political leader.

Tuan, Yi-Fu (b.1930) Chinese–American geographer.

Turner, Joseph Mallord William (1775–1851) English landscape/seascape painter, watercolourist and printmaker, associated with Romantic art.

Ukeles, Mierle Laderman (b.1939) American feminist artist known for her depictions of domestic work and everyday life.

Urban VIII (1568–1644) Born Maffeo Barberini; served as Pope from 1623 until his death.

Valley of Jehoshaphat (or Valley of Josaphat) Place mentioned in the Old Testament where God will supposedly pass judgement on the nations of the world (Jehoshaphat means 'Jehova will judge').

Vasari, Giorgio (1511–74) Italian painter, architect, collector and author of *Lives of the Most Excellent Painters, Sculptors, and Architects* (1550; 2nd, enlarged edn 1568).

Velázquez, Diego (1599–1660) Spanish painter of the Baroque period; active in the court of **Philip IV** of Spain.

Venus Roman for the ancient Greek goddess of love, Aphrodite.

Venus Anadyomene Iconic representation of **Venus**, Roman goddess of love (Greek Aphrodite), rising from the sea.

Vermeer, Johannes (1632–75) Dutch genre painter of domestic scenes; active in Delft and The Hague.

Veronese, Paolo (1528–88) Venetian painter and draughtsman of the Late Renaissance; known for his skills as a colourist and his representation of fabric.

Victoria, Queen (1819–1901) Queen of the United Kingdom of Great Britain and Ireland from 1837 until her death.

Vitruvius (or Marcus Vitruvius Pollio) (c.70–15 BCE) Roman writer, engineer and architect; author of the treatise *De Architectura*, known today as *The Ten Books on Architecture*.

Walpole, Horace (1717–97) English Whig politician, novelist, art historian, antiquarian and commentator; author of the Gothic novel *The Castle of Otranto* (1764). He revised the Gothic style with Strawberry Hill (1749–76), the house he built for himself in Twickenham, southwest London.

Ward, Ned (c.1667–1731) Also known as Edward Ward, an English satirical writer and publican of the King's Head Tavern, next to Gray's Inn, in London,

from 1699; also owner of the British Coffee House in the same area of London, from around 1729.

Werff, Adriaen van der (1659–1722) Dutch painter of portraits and devotional and mythological subjects; head of the Guild of St Lucas in Rotterdam.

Weyden, Rogier van der (1399 or 1400–1464): also known as Roger de la Pasture. Early Flemish master, whose popular religious conceptions exercised influence on subsequent European painting.

William IV (1765–1837) King of the United Kingdom of Great Britain and Ireland from 1830 until his death.

Williams, Raymond (1921–88) Welsh academic and critic associated with the New Left, a political movement that was active in the United Kingdom and America in the 1960s and 1970s.

Wilson, Richard (1714–1782) Welsh landscape painter and one of the founders of the Royal Academy.

Wren, Christopher (1632–1723) English architect who designed St Paul's Cathedral (1710) as well as many churches in the City of London.

Wright, Frank Lloyd (born Frank Lincoln Wright, 1867–1959) American architect and interior designer.

Zervos, Christian (1889–1970) French art collector, scholar, editor and writer of Greek origin; founder of magazine *Cahiers d'art* in 1926.

Zeuxis (5th century BCE) Greek painter best remembered for the contest that he is reported to have had with his contemporary, the painter Parrhasios, to determine who was the best artist; Zeuxis lost the contest.

Zuccaro, Federico (c.1540–1609) Italian Mannerist painter, architect and art theorist; commissioned by **Philip II** to decorate the Palace of El Escorial (1585–8).

Acknowledgements

This volume embodies the labour of many people, who all worked hard towards its realisation. The editors would like to thank the contributors Piers Baker-Bates, Emma Barker, Tim Benton, Michael Corris, Gail Day, Steve Edwards, Jason Gaiger, Catherine King, Elizabeth McKellar, Diana Norman, Gill Perry, Brendan Prenderville, Carol M. Richardson, Linda Walsh, Susie West, Paul Wood and Kim Woods, for their careful and thoughtful selection of texts included here and for providing the respective introductory paragraphs; the translators Tim Benton, Martin Davies, Guido Giglioni, Michelle Marie Homden, Catherine King, Imke Klein, Jan Loop and Diana Norman for producing and helping with English versions of valuable texts; Christianne Bailey, Alan Crookham, Rembrandt Duits, Janet Fennell, Gill Gowans, Rose Mepham, Simon Rodwell, Jennifer Sliwka and Roberta Wood for their advice, help and practical assistance.

Special thanks to Heather Kelly and to Steve Edwards who closely observed and assisted the production of the volume and to Roger Thorp, Judith Severne, Roz Young, Bill Jones and Beth Thomas at Tate Publishing, as well as Mary Scott and OS-B Design, for their significant contributions towards the finished publication.

Obviously any mistakes and shortfalls in this publication are entirely the responsibility of its editors.

List of contributors

PBB: Piers Baker-Bates is a specialist in Florentine and Roman Renaissance Art and has contributed to two Open University art history modules.

PJBH: Pamela Bracewell-Homer joined The Open University in 1988 as an Associate Lecturer, specialising in modern art history, critical theory and philosophical aesthetics. She also works in a range of roles as a consultant for the Department of Art History.

EB: Emma Barker is Senior Lecturer in Art History at The Open University. She is the author of *Greuze and the Painting of Sentiment* (2005).

TB: Tim Benton is Emeritus Professor of Art History at The Open University. His main research areas are twentieth-century architecture and design, and in particular the work of Le Corbusier. In addition to his numerous publications, he has curated a number of important exhibitions in the United Kingdom and elsewhere.

MC: Michael Corris is Professor of Art at Meadows School of the Arts, Southern Methodist University. He has written extensively on American and British art since 1945, bringing his dual experience as artist and historian to bear on work exploring the significance for contemporary practices of the art of the 1960s and 1970s.

GD: Gail Day is Senior Lecturer in the School of Fine Art, History of Art & Cultural Studies at the University of Leeds. She is the author of *Dialectical Passions: Negation in Postwar Art Theory* (2011).

SE: Steve Edwards is Senior Lecturer in Art History at The Open University. His books include *The Making of English Photography: Allegories* (2006) and *Photography: A Very Short Introduction* (2006).

JG: Jason Gaiger is Head of the Ruskin School of Drawing and Fine Art and a Fellow of St Edmund Hall at the University of Oxford. His principal research interests are in aesthetics and art theory from the seventeenth century through to the present day with a special emphasis on theories of depiction and visual meaning.

CK: Catherine King is Emerita Professor of Art History at The Open University. She has written extensively on gender and art patronage in the Renaissance during the last twenty years and taken a leading role in promoting interest in this new field of research.

AL: Angeliki Lymberopoulou is Lecturer in Art History (late and post-Byzantine art) at The Open University. Her research focuses on the art produced on Venetian-dominated Crete (1211–1669) and its social context and cross-cultural interaction between Byzantine East and predominantly Italian West.

EMcK: Elizabeth McKellar is Senior Lecturer in Art History at The Open University. She has written extensively on British architecture, particularly that of seventeenth- and eighteenth-century London, and is a member of English Heritage's London Advisory Committee.

DN: Diana Norman is Emerita Professor of Art History at The Open University. She has written extensively on late medieval and Renaissance Italian art with a particular emphasis on the art and culture of fourteenth-century Siena.

GP: Gill Perry is Professor of Art History at The Open University. She has published widely on modern and contemporary European and American art, and on the relationships between eighteenth-century art, theatre and gender.

BP: Brendan Prenderville is Senior Lecturer in the Department of Visual Cultures, Goldsmiths, University of London. He has published articles on painting and phenomenology, and is the author of *Realism in 19th Century Painting* (2000).

CMR: Carol M. Richardson is Senior Lecturer in Art History at The Open University. Her research focuses on Rome and the patronage of the College of Cardinals.

JR: Joel Robinson is an Associate Lecturer in Art History at The Open University. His research interests extend through art, architecture and landscape design of the modern and contemporary periods. He is the author of *Life in Ruins: Architectural Culture and the Question of Death in the Twentieth Century* (2008).

LW: Linda Walsh is Senior Lecturer in Art History and Staff Tutor in Arts at The Open University. She has published articles on eighteenth- and early nineteenth-century art.

SW: Susie West is Lecturer in Heritage Studies at The Open University. She has a special interest in the English country house, for its place in present issues about the heritage of the built environment and as an object of historical research.

PW: Paul Wood is Senior Lecturer in Art History at The Open University. In addition to writing for many Open University modules, he is co-editor, with Charles Harrison and Jason Gaiger, of the three-volume collection *Art in Theory: An Anthology of Changing Ideas* (1992–2003).

KW: Kim Woods is Senior Lecturer in Art History at The Open University. She is a specialist on northern European late Gothic and Renaissance art, and most of her research is focused on sculpture.

List of illustrations

Credits

We are grateful to authors and publishers who have given permission to reproduce copyright material. Sources are given in the full bibliographic reference before each extract. Every effort has been made to trace and contact copyright holders and to secure replies prior to publication. The publisher apologises for any inadvertent errors or omissions, and if notified will endeavour to correct these at the earliest opportunity.

Texts: additional copyright information
Chapter 1, extract 3. Reprinted with permission of the University of Pennsylvania Press.
Chapter 2, extract 2. © 1990 Massachusetts Institute of Technology, by permission of The MIT Press
Chapter 2, extract 6. Used with permission of George Braziller, Inc.
Chapter 7, extract 3. Reproduced with permission of Palgrave Macmillan
Chapter 11, extract 3. © 1989 Massachusetts Institute of Technology, by permission of The MIT Press
Chapter 18, extract 3. Reproduced by permission of SAGE Publications Ltd., London, Los Angeles, New Delhi, Singapore and Washington DC
Chapter 22, extract 3. © 1962, reprinted by kind permission of Thames & Hudson Ltd., London
Chapter 23, extract 2. © 2002 Massachusetts Institute of Technology, by permission from The MIT Press

Illustrations: Photographic credits
Fig.1 Line drawing scanned from original publication
Fig.2 École Nationale Superieure des Beaux-Arts, Paris, France / Giraudon / The Bridgeman Art Library
Fig.3 © RMN (Musée du Louvre) / René-Gabriel Ojéda
Fig.4 © 2012, Photo Scala, Florence
Fig.5. Courtesy Amsterdam Historical Museum
Fig.6 © By kind permission of the Trustees of the Wallace Collection, London
Fig.7 © Rijksmuseum-Stichting, Amsterdam
Fig.8 © Isabella Stewart Gardner Museum, Boston, MA, USA / The Bridgeman Art Library
Fig.10 © 2012 The Metropolitan Museum of Art / Art Resource / Scala, Florence
Fig.11 © RMN (Musée du Louvre) / Gérard Blot
Figs.12–13 Yale Center for British Art (New Haven), Paul Mellon Collection
Fig.14 © 2012 The Museum of Modern Art, New York / Scala, Florence
Fig.15 © The Art Institute of Chicago
Fig.16 © The Solomon R. Guggenheim Foundation, Peggy Guggenheim Collection, Venice
Fig.17 Courtesy Thomas Amman Fine Art AG, Zurich
Figs.18–22 Courtesy Fondation Le Corbusier, Paris
Figs.23, 24 Line drawings scanned from original publication
Fig.25 © 2012 Museum Associates / LACMA/ Art Resource NY / Scala, Florence

Illustrations: Artist copyrights
fig.15 Georges Braque © ADAGP, Paris and DACS, London 2012
figs.16, 17 Pablo Picasso © Succession Picasso/ DACS, London 2012
figs.18–19, 21–22 Le Corbusier © FLC/ ADAGP, Paris, 2012
fig.25 Amédée Ozenfant © ADAGP, Paris and DACS, London 2012

Index